Charles Demuth

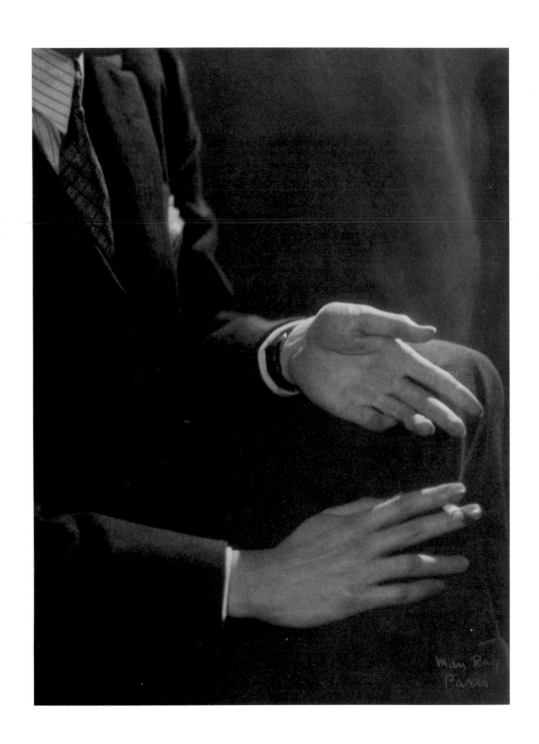

Barbara Haskell

Charles Demuth

Whitney Museum of American Art, New York

in association with

Harry N. Abrams, Inc., Publishers, New York

Exhibition Itinerary: Whitney Museum of American Art, New York
October 15, 1987–January 17, 1988

Los Angeles County Museum of Art
February 25–April 24, 1988

Columbus Museum of Art, Ohio
May 8–July 10, 1988

San Francisco Museum of Modern Art
August 7–October 2, 1988

Library of Congress Cataloging in Publication Data

Haskell, Barbara.
 Charles Demuth.

 Exhibition catalog.
 Bibliography: p.
 1. Demuth, Charles, 1883–1935—Exhibitions. 2. Painting, American
—Exhibitions. 3. Painting, Modern—20th century—United States—
Exhibitions. 4. Painters—Pennsylvania—Biography. I. Demuth,
Charles, 1883–1935. II. Whitney Museum of American Art. III. Title.
ND237.D36A4 1987 759.13 87–18872

ISBN 0–87427–056–1 (paper)
ISBN 0–8109–1135–3 (cloth)

Cover:
From the Kitchen Garden, 1925 (Pl. 88)

Frontispiece:
Man Ray
Charles Demuth Hands and Torso, c. 1921; Silver print, 9⅛ x 6¾ in. (23.1 x 27.1 cm); Private collection

This publication was organized at the Whitney Museum of American Art by Doris Palca, Head,
Publications and Sales; Sheila Schwartz, Editor; Deborah Lyons, Associate Editor; and Vicki Drake,
Secretary/Assistant.

Charles Demuth was designed by Katy Homans, Homans/Salsgiver; typeset in Monotype Bembo
by Michael and Winifred Bixler; and printed in Japan by Nissha Printing Co., Ltd.

Contents

Director's Foreword

Charles Demuth has long been recognized as a central figure among the group of avant-garde artists who emerged as the leading exponents of modernism in America during the first decades of the twentieth century. He is best known as a pioneer of Precisionism and as a consummate watercolorist. Yet the breadth of his wide-ranging interests and achievements had never been fully studied.

We are extremely grateful to the Henry Luce Foundation for a major grant from the Luce Fund for Scholarship in American Art, which made possible the extensive research required for this project. The Foundation's generosity enables us to continue the Whitney Museum tradition of supporting primary research in American art history. It is a pleasure also to thank all of the others who assisted in this effort and the owners of works of art who have graciously shared them with the public.

The Whitney Museum's association with Charles Demuth began with the inclusion of his work in an exhibition at the Whitney Studio in 1923. After 1932 his work was featured regularly in the Museum's annual and biennial surveys of contemporary art. In 1937, two years after his death, the Museum presented the first large-scale survey of his work.

Barbara Haskell's presentation of Charles Demuth represents another example of her skills in revealing the nature of an artist's achievements against the backdrop of contemporary events and the complicated forces in the life of a creative person.

Charles Demuth is the first major publication and exhibition at the Whitney Museum of American Art since the deaths of Lloyd Goodrich and John I.H. Baur, two great American scholars long associated with the Whitney Museum. Their achievements stand as an example to all of us, and we dedicate this book and the exhibition to them as a tribute to the legacy of their work and the standards they established, which we will always seek to emulate.

Tom Armstrong, *Director*

Acknowledgments

Marcel Duchamp once remarked that Demuth was one of the few artists whom all other artists liked as a real friend. Demuth's generosity of spirit and capacity for friendship have graced those who became involved in his art after his death and who have contributed to the success of this project: Kermit Champa, Alvord Eiseman, Betsy Fahlman, and Emily Farnham. I am grateful to them as well as to Faye Badura, Avis Berman, Isabel Brenner, S. Lane Faison, Jean Henry, Ann Hill, Cheryl Liebold, Jack Locher, Dorothy Norman, Harold Rifkin, Daniel Robbins, Bruce Russell, Gail Stavitsky, Jeanette Toohey, and Jonathan Weinberg for providing important information on various aspects of Demuth's life and art. Several residents of Lancaster, Pennsylvania, generously assisted with research problems: Robert LeMin, Gerald and Margaret Lestz, Carol Morgan, and Dorothea Demuth. In addition, Phyllis Reed and Debra Smith performed a yeoman's service in compiling an important stream of genealogical information on the Demuth and Buckius families.

I am fortunate to have had an especially high level of assistance from my staff. The contribution of Marilyn Kushner in particular has been invaluable: she was responsible for assembling and coordinating the photographs and primary documents and for preparing the bibliography and exhibition history. I am extremely grateful to her as well as to the many individuals who compiled research data: Michelle Artiako, Laura Foster, Elizabeth Geissler, Jack Heineman, Ann MacNary, Stewart Nachmias, Jeanne Quinn, Naomi Shapiro, and Virginia Thors. Their thoroughness, diligence, and good humor were absolutely critical to the successful realization of the project. I also extend well-deserved thanks to Lorraine McVey for her herculean efforts in typing and retyping the manuscript. Equally valued are Leon Botstein's observations about Demuth and editorial suggestions about the manuscript.

I deeply appreciate the cooperation and encouragement of my colleagues at the Whitney Museum. The enthusiastic support and commitment of Tom Armstrong and Jennifer Russell have meant a great deal to me. Sheila Schwartz, Deborah Lyons, and Vicki Drake have my heartfelt thanks for their valuable contributions to the editing and production of the book. Steve

Sloman persevered in developing a photographic technique that successfully captured Demuth's elusive color—a task made possible by Anita Duquette's tireless assistance. Special appreciation is due as well to Katy Homans for her sensitive design of the book.

Finally, my greatest debt is to the Henry Luce Foundation, whose research grant made this book possible, and to the private and institutional lenders who believed in the significance of the project and extended themselves in order that important and fragile works be included in the retrospective.

Barbara Haskell, *Curator*

This book is based upon over three years of research made possible by a generous grant from the Luce Fund for Scholarship in American Art, a program of the Henry Luce Foundation.

Additional income for publications has been provided by endowments for publication established by the Primerica Foundation, Henry and Elaine Kaufman Foundation, and Andrew W. Mellon Foundation.

Perhaps this is not a story at all and yet I think it is. Is life ever definite in its answer; is the story ever really finished? We can, all of us, imagine things to come after the end of a story, be the story our own or that of some other.

Charles Demuth

I.

Early Years

Charles Henry Buckius Demuth was born on November 8, 1883, into a patrician family in Lancaster, Pennsylvania.[1] Even though it never achieved conspicuous wealth, the family was extremely successful by small-town standards—enough so that Demuth never had to work for a living. As compelling for Demuth's later self-identity as his family's financial position, was its secure sense of social place. Demuth's ancestors had emigrated from Moravia to America in 1735.[2] By 1770 they had settled in Lancaster, where they established what was, by Demuth's time, the oldest continuing tobacco shop and snuff factory in America. The family's pre-Revolutionary stature ensured its prominence in a community which boasted of once being the capital of the Constitutional Congress and the State of Pennsylvania. The imprimatur of history and tradition even attached to the house into which Demuth and his parents moved six years after he was born: it had been one of the original residences in the city plan laid out in 1750 by Colonial Governor William Hamilton.[3]

Demuth's father, Ferdinand, imbued with this sense of family history, had little use for the typical aspirations of nineteenth-century immigrant populations. The eldest son, he worked in the family business and maintained a peripheral involvement in civic affairs as a volunteer fireman and member of the Lancaster County Historical Society.[4] Within the circumscribed world of Lancaster, he had already achieved social standing, money, and respect.

A more modest and less patrician profile described Demuth's maternal relatives, the Buckius family, whose Lancastrian ancestors could be traced to the early nineteenth century.[5] Demuth's grandfather, Charles Buckius, had risen from shoemaker to superintendent of the shoe department of the Lancaster County Prison, a post he held for almost twenty-five years.[6] More active in the Lutheran Church and more politically engaged than the Demuth family, the Buckius clan nevertheless remained in a financially and socially less

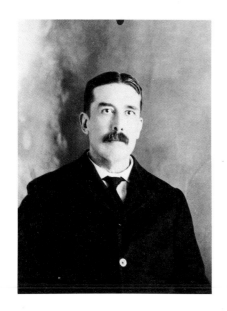

Ferdinand Demuth, 1880

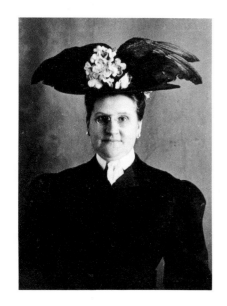

Augusta Demuth, 1880

elevated sphere. Charles Buckius' ownership of some fourteen lower-income rental properties was a form of enterprise considered unbecoming in the Demuth household.[7]

The sense of self-certainty and stability which permeated Charles Demuth's family environment was mirrored by Lancaster itself. The order and neatness of the city's wide streets and unadorned Federal architecture created an impression of refined gentility and understated simplicity—traits no doubt strengthened by the restrained style of the Amish and Mennonite sects, whose fertile and well-kept farms encircled the city. Indeed, Lancaster, despite its industrial development, remained impervious to the psychic disjunctions that beset other nineteenth-century American cities as they joined the modern age. At far remove from the spiritual poverty which infiltrated Theodore Dreiser's urban complexes, Lancaster entered the twentieth century with its tranquility and probity intact.

Given his family background, it is not surprising that Demuth entered into society with prodigal confidence. Secure about his place, he had little need to seek external approval. As Marcel Duchamp said, "it was fun to be with Demuth because he didn't care where he belonged or was in the social scale."[8] While this absence of social or economic ambition gave Demuth enormous freedom, it also contributed to a certain aimlessness. Disdaining ordinary social success, he perfected a flair for frivolity and style. Indeed, until 1921, when he was diagnosed as a diabetic, he found adventure only in total abandon in a cosmopolitan world thoroughly opposed to the sedate milieu of Lancaster.

Demuth's childhood experiences only served to strengthen his disinterest in respectability and traditional forms of social status. From an early age, his self-image was that of an outsider. As an only child, he was more than likely coddled; this condition became exacerbated when, around the age of four or five, he succumbed to a hip illness which left him lame. Various suppositions later arose among Demuth's friends and biographers about the cause of this disability, the most common being that it resulted from tuberculosis of the hip or from a fall when his father threw him up in the air and then failed to catch him.[9] What now seems clear from extant descriptions of Demuth's symptoms and convalescence is that he had contracted Perthes, a disease of the hip that predominantly strikes boys between the ages of four and five. It leaves the child with one short leg and subject to occasional pain due to the deformation of the hip joint.[10] But Perthes was not identified until 1915, when

X-rays became available for diagnostic purposes. Thus the sense of mystery that heretofore surrounded Demuth's early illness stemmed not from his family's desire to hide the facts, as some scholars have suggested, but merely from their ignorance of them.[11]

The illness had a permanent effect on Demuth far in excess of the lameness with which, apparently, he coped quite well as an adult. He is reported to have danced, swum, and hiked as well as anyone; even his need for a cane he transformed into a virtue by perfecting a distinctive sort of ambling gait which found appeal.[12] But more important for the formation of Demuth's personality was the fact that, in his time, the prescribed "cure" for the then mysterious disease was six weeks in traction followed by one to two years in bed. During this protracted period of incapacitation, the young Demuth was totally dependent on his mother, Augusta, for even simple acts such as bathing and relieving himself. He was thus robbed of autonomy and independence at a crucial moment in his psychological development, that is, during the years of a boy's heightened social activity. It left him with a life-long self-image as an invalid, someone different from other people. He became an introvert, absorbed in a private world. This experience not only slowed his social maturation, but created a symbiotic bond between Demuth and his mother that lasted throughout his life—the strength of which may explain his reluctance to ever leave Lancaster permanently. Moreover, Freud identifies the ages of four and five as Oedipal, the period in which a boy competes with his father for his mother's attention. From photographs, one senses that Ferdinand Demuth was a strong, well-built man. Not only was young Charles bedridden for two years, but even after his recovery he remained a frail boy who wore built-up shoes, carried a cane, and was overprotected by the female members of his family. During school recesses he played in the girls' play-ground because his aunt, who taught at his school, feared that the rougher activities of the boys might precipitate a relapse.[13] Thus, unable to compete effectively with the external masculinity of his father, Demuth instead iden-tified himself with his mother's more "feminine" pursuits.

The one area in which these pursuits coincided with those of his father was art. Among his great-aunts and great-uncles on his father's side were a number of amateur painters. One member of this generation married the daughter of Lancaster's preeminent painter, Jacob Eichholtz, and another married Aaron Eshleman, a lesser known local painter. In addition, the family took pride that the wooden sculpture which served as the original sign to the

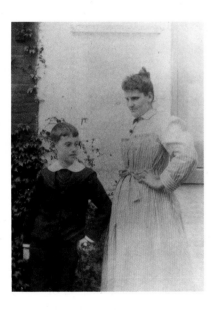

Charles Demuth and his
mother, Augusta, c. 1893

family's tobacco shop had been carved by a family member, Demuth's great-great-uncle John Demuth. Two of the portraits by family members which hung in Demuth's house—one by Eshleman and another by John Demuth—were deemed of sufficient merit to be included in a 1912 exhibition of Lancaster portrait painting.[14] Finally, Demuth's father was an amateur photographer and member of the local camera club, though his interest in photography stemmed from his antiquarian and historical pursuits rather than from a keen interest in the fine arts. He specialized in images of Lancaster's circus parades and architectural monuments, among which was an hour-long exposure of the steeple of the Lutheran Church of the Holy Trinity. In retrospect, such imagery seems to anticipate the circus watercolors and the precisely rendered depictions of church steeples and industrial structures that would later garner his son fame.

That Demuth displayed an unusually precocious gift for art seems evident. Perhaps to encourage the aptitude he had shown with crayons and watercolors while bedridden during his illness, he was sent by his mother to a local painter, Martha Bowman, for private art lessons in still-life and landscape painting.[15] These were later augmented by extracurricular studies with Letty Purple in china painting and pyrography—wood-burning decoration. In subject and style, Demuth's adolescent efforts reflect a world largely governed by the preoccupations conventionally associated with women. Among his earliest extant works are china teacups, saucers, and plates emblazoned with flowers and Chinese dragons, and a drawing book filled with oil studies of flowers similar in motif to those, executed by female relatives, that he saw hanging in his house. In these paintings, Demuth usually isolated a single stem of flowers on the page and, while rendering it botanically plausible, invested it with an anthropomorphic flippancy. While remarkably detailed in execution, these drawings have an asymmetrical balance that shares little with the stylized, hieratic Fraktur work that proliferated in Pennsylvania. Rather, their sensibility suggests an ornamentation and precision almost Chinese in mood. Demuth's decorative instincts and his proclivity for subjective renderings give these studies a delicacy uncommon for the work of a teenage boy.

At sixteen, after a protected and isolated adolescence, Demuth was enrolled by his parents for the last two years of high school in Franklin and Marshall Academy, a prestigious boys' preparatory school in Lancaster. The decision to send him to a private academy, while socially appropriate, was also in keeping with Ferdinand Demuth's own education at Nazareth Hall, a

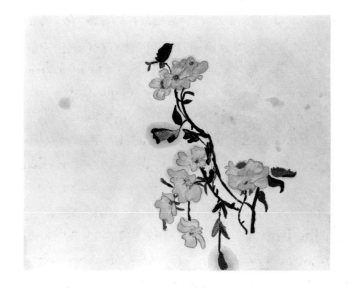

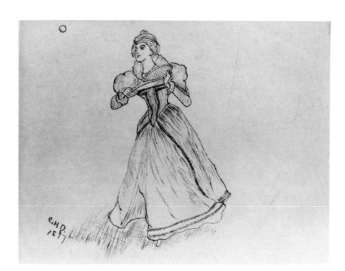

Spray of Pale Pink Mallows: Childhood Drawing Book, c. 1891
Oil on paper, 10½ x 13¼ in. (26.7 x 33.7 cm)
Collection of Harris C. Arnold

Woman Playing Tennis, c. 1897
Ink on paper, 3 x 6 in. (7.6 x 15.2 cm)
Private collection

Moravian private school in central Pennsylvania.[16] That Franklin and Marshall was located in Lancaster was undoubtedly in its favor, for its closeness allowed Demuth to live at home, even though the school was primarily residential. That this situation once again set him apart from his fellow students was less critical to his parents—staunch members of Lancaster's Lutheran community —than the school's rigorous Christian orientation.[17]

Demuth's course of study at Franklin and Marshall was the "scientific track," geared toward mathematics and other subjects suited for the business world, which indicates that his father still held out hope that he would enter the family business. His record at the Academy must have squelched these dreams: although he averaged a B+ in English, history, and language, Demuth's transcript records a mediocre performance in science and mathematics.[18] The disinclination to compete in these latter subjects undoubtedly confirmed for Ferdinand Demuth that his son's aptitude lay outside business concerns. That the young Demuth's preoccupations during this period were addressed to more "feminine" pursuits is revealed by his refined line drawing of an aristocratic woman playing tennis.

After graduating in June 1901 from Franklin and Marshall, Demuth did not, as has hitherto been assumed, enroll immediately in art school but remained at home in Lancaster for more than two school years.[19] Whether there was any family ambivalence about his growing desire to pursue art is unclear. Though Demuth's father enjoyed photography and collected fire-fighting artifacts, it is quite possible that he considered art only appropriate as a hobby. After all, the family's artists had all been amateurs, their aesthetic

15

inclinations less a matter of ambition than of acceptable patrician diversion. The family's one professional painter, Aaron Eshleman, was a decidedly bad role model, for he not only produced little work, but he abandoned his wife and children.[20] Thus, if Demuth was to be an artist, the only plausible choice was to join the growing ranks of professionals doing commercial art. The applied arts fit into an approved work ethic and reflected as well the kind of art with which Demuth had been successful as a child: illustration and china painting. Certainly, the few documented works which remain from his fifteen months at home suggest no ambivalence about this course of study. They attempt to replicate the linear, illustrational style that would typically have been found in turn-of-the century ladies' magazines, a genre to which Demuth later paid tribute by entitling a flower watercolor *Godey's Ladies Book*.

In October 1903, Demuth enrolled in the Drexel Institute of Art, Science, and Industry. Located in Philadelphia, Drexel's stated aim was to train students in a variety of practical skills.[21] It had become nationally prominent in 1894 when it opened the first department of illustration in the country. Howard Pyle, the founder of the department, had left Drexel in 1901, but his influence continued to dominate the school.[22] In his teaching, he advocated the superiority of imagination over rigorous technical training and the judgments of the public over those of the salon. Drexel had graduated many of the illustrators who dominated the field during the years 1895–1910, the period known as the Golden Age of American Illustration.[23] Given Drexel's prominence in the illustration field and the nationwide efflorescence of graphic productivity and innovation, it is no wonder that Demuth chose to travel to nearby Philadelphia to pursue a career in commercial art.

Demuth entered Drexel as an elementary art student, an indication of the limited nature of his Lancaster art lessons. During the summer of 1904, he stayed in Philadelphia to attend the summer session at the Pennsylvania School of Industrial Art. Although the school offered drawing courses, its curriculum was distinctly oriented toward the applied arts and trades.

Demuth returned to Drexel in September 1904 with his basic skills sufficiently advanced to skip from Art Level I to Art Level III. One of his illustration teachers, Mary Fratz (later Andrade), apparently felt that his artistic talent needed a less limited arena than that offered at Drexel.[24] She encouraged him to look beyond commercial art and to transfer to the Pennsylvania Academy of the Fine Arts. In the spring of 1905, he therefore took courses both at the Academy and at Drexel. Sometime during this spring

Charles Demuth, c. 1904

semester, Demuth developed his acquaintance with Dr. Albert Barnes, who later became his patron and whose collection of Post-Impressionist art would one day rank as the largest in the country.[25] By the end of the term Demuth had won two awards at Drexel: a second prize in antique drawing and an honorable mention in illustration-composition.[26] In June 1905, however, Drexel announced the termination of all courses in fine and applied arts in order to consolidate its resources in other departments.[27] Demuth then transferred to the Pennsylvania Academy, where he remained through January 1910.

Through the portals of the Pennsylvania Academy, the oldest art school in America, had passed many of this country's foremost artists. The Academy was steeped in the tradition of realism handed down from Thomas Eakins to his pupil, Thomas Anshutz, who was one of two teachers who dominated the Academy during Demuth's tenure there. The other was William Merritt Chase, director of the school until 1909. Chase encouraged students to develop an ability to work quickly to capture a subject, while Anshutz emphasized the importance of direct observation of life. From the start, Chase's choice of leisure-class subjects and his handling of paint appealed less to Demuth than Anshutz's more controlled realism, which had a marked effect on Demuth during his five years at the Academy.

The dark palette, quick brushstrokes, and truth to observed reality in Demuth's portraits of 1907 reflect the same influences that had shaped the work of four of Anshutz's previous students: Robert Henri, John Sloan, William Glackens, and George Luks, among those known as The Eight or the Ashcan painters. Although their everyday subject matter—urban scenes that revealed sympathy with the lower classes—was radical, their stylistic conservatism was in essential agreement with the realism promoted at the Academy. The work of Henri and Sloan, which was included in several Pennsylvania Academy Annuals during Demuth's student years, decidedly influenced his pictorial effects. He emulated their objective approach to quotidian subjects as well as their commitment to subjective emotional expression. When Academy instructor Hugh Breckenridge criticized one of Demuth's works during a Darby School summer session in 1907, Demuth's retort—"but I *feel* it so" —echoed Henri's decree that the artist's emotional response took precedence over other considerations.[28]

Pictorially, Demuth practiced a variant of Ashcan realism during his Pennsylvania Academy years. Emotionally, however, his loyalties were to a *fin-de-siècle* cultivation of decadence and indifference. To some extent this seemingly dichotomous union prevailed throughout Demuth's circle of friends at the Academy, all of whom affected a posture of ironic detachment while practicing a kind of social realism. As Rita Wellman, one of Demuth's compatriots, described it:

> *When we were very young, we were very old. We were all bored with life; knew everything there was to know, and only condescended to give our time and talents to painting because it seemed to our jaded spirits the one respectable calling left.*[29]

Most Academy students equated their worldweariness with the Aestheticism of James McNeill Whistler who, more than any other artist at the turn of the century, epitomized the cosmopolitanism to which American art students aspired. Not only had he succeeded as an American in a European arena, but his dandyism and dramatic assault against John Ruskin's critical abuse appealed to their anti-establishment sentiments. Moreover, his glorification of aesthetic values over subject matter and its moral and political implications fueled their view of art as an autonomous pursuit having a self-contained value system.

Through their admiration for Whistler, Demuth and his fellow students were also brought in contact with Japanese art. This was particularly critical for Demuth, who was later often applauded for what observers detected as an undercurrent of oriental sensibility in his work. At this point in his career, however, his appropriation of Japanese art was merely social: at the Academy's New Year's Eve dance in 1910, he performed a succession of poses after Japanese prints.[30] Similarly, Whistler had no direct pictorial influence on Demuth at this time; only in 1912 would the young artist begin duplicating Whistler's atmospheric fields of richly modulated color. Before then, Whistler's importance lay primarily in his self-conscious affectations and his insistence that art had no social, moral, or political purpose.

Demuth's attraction to this art-for-art's-sake philosophy was strengthened by his admiration for the Decadent postures of Aubrey Beardsley and Oscar Wilde, both of whom he referred to throughout his life as "great."[31] Demuth had encountered Beardsley's illustrations while at Drexel. Although extremely controversial during his lifetime, Beardsley's work had an uncontested influence on contemporaneous illustration. He had become known to the art world in 1893 when a series of his drawings was published in the

opening issue of *The Studio*, along with a laudatory article by Whistler's advo-
cate, Joseph Pennell—an association with Whistler that esteemed Beardsley to
Pennsylvania Academy students. By Demuth's time, Beardsley's illustrations
were considered paradigms of liberation for commercially trained American
illustrators.

Ironically, Demuth's pictorial borrowings from Beardsley were few:
a willingness to give equal weight to decoration and subject and the power to
harness great strength of feeling to an almost neoclassical coolness. This
seemingly paradoxical combination of opposites became endemic in Demuth's
work, although critics invariably applauded one or the other aspect, while
failing to notice their deft conjunction.[32]

What most magnetized Demuth were Beardsley's attitudes and his
persona. Demuth even attempted to accentuate their physical similarity—
slight builds and attenuated, expressive hands—by parting his hair down the

middle as Beardsley did. Mostly, however, Demuth was entranced by the erotic and subtly grotesque figures in Beardsley's pictorial enterprises. He readily perceived the sense of loss and anger behind the supposed levity and flippant mockery in Beardsley's imagery. The lives of both artists had been marked by illness. In Beardsley's case, the tuberculosis he had contracted when young—and of which he died at twenty-five—left him physically debilitated and harboring a bemused anger toward what he considered the grotesqueness of human behavior.

Demuth's affinities to Beardsley propelled him into the world of *fin-de-siècle* Aestheticism. Once there, he discovered that the life-styles and attitudes of its denizens accorded with his personality. Yet in general, he kept these life views veiled—which may reflect an ambivalence about the Aesthetes' posture that owed to his strict Lancaster upbringing. In any case, "He never spilled over to his friends but kept a tight-lipped and well-groomed appearance always," Marcel Duchamp later remarked.[33] It is only by examining the writers and texts Demuth admired and recommended to his friends that his proclivities can be detected. And those writers to whom he referred most often in conversation and correspondence were Oscar Wilde, Walter Pater, and Joris-Karl Huysmans.[34]

Demuth's lameness and recognition of his homosexuality sustained his early self-image as an outsider, a voyeur, never fully engaged with others. This was also, of course, a common stance of the Aesthetes, who emotionally distanced themselves from a world in which they felt helpless and isolated. They were *flâneurs*—in the crowd but not of it. The heightened perceptions that ensured their success as artists alienated them from full participation in life. Demuth was particularly drawn in this regard to Pater's literary portraits of artists in *Imaginary Portraits* (1887) and he intended at one time to illustrate all of them. Pater's portrayal of individuals as spectators at events, preoccupied with inner experience, deeply impressed Demuth. He identified himself with Pater's antiheroes who yearn for decadent pleasures while they simultaneously remain aloof from them.

Artifice was one way in which Demuth dealt with his feeling of marginality. Like his aesthetic mentors, he tried to perfect a stylized life, to be a "complete type," as he wrote to a friend in 1907.[35] Pater had counseled his readers to treat life itself as a work of art; Wilde extended this by proclaiming that the ideal person was one who had fabricated "another" self out of his passions. "The first duty of life is to assume a pose," he announced.[36] Demuth

echoed the conceit: "I always hope for the grand manner. If one does not acquire this or have it—there is no success in the purely social."[37] Wilde held that only through artifice could one achieve the full realization of one's personality. Art, in this view, was superior to life. It was the "supreme reality" against which life was "a mere mode of fiction."[38] As a young man, Demuth championed Huysmans' *A rebours* as one of his favorite books.[39] Huysmans' protagonist des Esseintes, satiated to the point of sexual impotence by the real sensations of nature, establishes himself in a windowless house and virtually cuts himself off from all contact with the outside world in order to cultivate bizarre and ultra-refined sensations.

Such attitudes provided Demuth with practical models of personal behavior. By capitalizing on his physical exoticism—olive skin, raven-black eyes, thick, glossy hair—he projected an image of originality and distinction which fellow students at the Pennsylvania Academy took for genius.[40] He was the quintessential dandy, fastidious in dress and detached in manner. The style perfectly suited his inherently introverted and evasive personality. His appropriation of the Aesthetes' precious manners and gossipy banter became a means of camouflaging his estrangement and preserving the "curtain of mental privacy" about which friends remarked.[41] Demuth also adopted the Aesthetes' pose of indifference and effortlessness which, combined with his sartorial refinement, gave him a detached, epicurean air that some mistook for dilettantism.

Finally, the Aesthetes' embrace of unrestrained passions implicitly licensed Demuth's attraction to unconventional social types and situations. While his religious upbringing probably inhibited his pursuit of the sensual excess and degeneracy to which the cult of individual passions often led, he nevertheless was regarded, before the onset of diabetes, as something of a debaucher—he drank heavily and frequented nightclubs known for their loose sexual mores. Still, Demuth seems to have experienced unbridled passion less in actuality than through art—his own, that of the writers he read, and of those whose literary texts he would later illustrate. The sensual and social depravity in such texts bespoke a life-style to which Demuth was lured but psychically restrained from indulging in. Nevertheless, as he described it in his last years, he had "given up" most of his life "to finding out about [the world]."[42] He had sought to live Pater's prescription "to burn always with this hard gemlike flame, to maintain this ecstacy. . . ."[43] As George Biddle recalled later, Demuth had been "a man always a little satiated with life,

wanting so much more out of it than painting, yearning perhaps for the sort of debauchery through which he could float with absolute refinement."[44]

The direction which Demuth's personal life and work took during his student years in Philadelphia—his attraction to Aestheticism as well as to Anshutz's strong belief in the benefits of European exposure for American art students—fueled his ambition to travel abroad. In the late summer of 1907, after his second year at the Academy, he wrote to William Carlos Williams, whom he had met while at Drexel, that his "wildest dream [was] at last coming true" and that he was going to Paris that fall.[45] On October 4, 1907, he sailed from Philadelphia for what would be his first view of the French capital.

Demuth's five months in Europe were more eventful than heretofore assumed.[46] The American contingent of expatriate artists was still relatively small and interconnected. By the fall of 1907, its ranks included Alfred Maurer, Arthur B. Carles, Edward Steichen, Patrick Henry Bruce, John Marin, Samuel Halpert, Maurice Sterne, and Lawrence Fellows, a former Pennsylvania Academy student with whom Demuth stayed when he first arrived in Paris.[47] The Americans tended to congregate either at the Café du Dôme (which Demuth frequented, as his drawings with that title, exhibited at the Pennsylvania Academy in 1908, confirm) or at the apartment of the painter-photographer Edward Steichen. Steichen, recently arrived from America, had co-founded the Little Galleries of the Photo-Secession—later known as 291—in New York with Alfred Stieglitz. Three months after Demuth arrived in Paris, Steichen led a group of Paris-based Americans to form the New Society of American Artists as an alternative to the established Society in Paris, which had atrophied into academic conservatism.

Demuth's work was still too tentative then to warrant his participation in this Society or in the Matisse painting class that Sarah Stein organized in 1908 for American painters. Nonetheless, as Fellows' houseguest, he surely attended the 1907 Salon d'Automne, which opened the month he arrived. A reaction against the academic salon, the exhibition reflected the tumultuous change and frenzy that was engulfing the French art world as the primacy of Fauvism began to give way to Cubism. In addition to a large survey of Cézanne's work and the work of many Fauves, the show included the art of Léger, Redon, Ensor, Brancusi, Delaunay, Rousseau, and Kupka, among others. Here too Demuth would have encountered advanced American art— as many as fourteen pictures by John Marin as well as examples by Maurer,

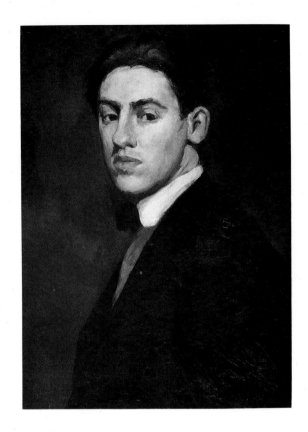

Helen Henderson, 1908
Charcoal on paper, 9¼ x
7½ in. (23.5 x 19.1 cm)
The Pennsylvania Academy of
the Fine Arts, Philadelphia;
Academy Purchase from
Parke-Bernet Auction

Self-Portrait, 1907
Oil on canvas, 26¹⁄₁₆ x 18 in.
(66.2 x 45.7 cm)
Private collection

Weber, Bruce, and Sterne. Later that fall he would have had the opportunity
to see exhibitions of contemporary French painters at the Bernheim-Jeune
gallery and work by the Viennese and German Expressionists on view at the
Secessionist exhibition in Berlin, where Demuth spent Christmas with a
cousin. To these visual experiences were added the debates which took place
among the Americans at the Café du Dôme concerning the validity of Fauv-
ism and the "sculptural" painting precipitated by Cézanne's retrospective and
Picasso's *Demoiselles d'Avignon*. For Demuth, a twenty-four-year-old whose
exposure to art had been provincially circumscribed, all of this was too
advanced to be immediately incorporated into his own aesthetic efforts. But
he stored these heady experiences and they set the stage for his later break with
the aesthetic conventions of American realism.

Demuth had hoped to stay in France for more than a year.[48] But by
the spring of 1908 he had gone through the allowance given to him by his
parents for the trip and was forced to return to America in March. He had
expected that the trip would mark his real start as an artist.[49] Yet the paintings
he executed at the Pennsylvania Academy that April perpetuated the academic
mode in which he had worked earlier. The three paintings he showed in the
Academy's Fellowship exhibition that fall reveal a competent mastery of

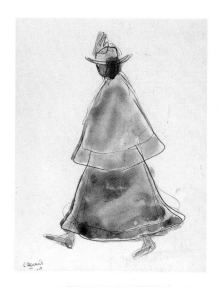

In the Street, Woman Walking,
1910
Watercolor and ink on paper,
8 x 10 in. (20.3 x 25.4 cm)
Collection of Maxwell Oxman

Baron Adolphe de Meyer
Portrait of Robert Locher,
c. 1912–14
Platinum print, 9⅞ x 7⅜ in.
(25.1 x 18.7)
Private collection

drawing fundamentals, but suggest little of the inventive spirit and European influence that would mark his subsequent endeavors. Only in the fluid line of his concurrent watercolor sketches is there even the slightest portent of the linear ease in his later figurative style.

Even the introduction of landscape subjects during the summers Demuth spent in New Hope, Pennsylvania, and Lambertville, New Jersey (1908, 1911, 1912) did little at first to alter his essentially academic approach. Gradually, however, the effect of what he had seen in Paris and his proximity to the American Impressionists (who had been gathering in the Delaware Valley around New Hope since the late nineteenth century) began to show.[50] Stylistically more conservative than their European antecedents, the New Hope Impressionists toned down the bright palette of their French counterparts and used broken brushstrokes to embellish surface rather than to analyze light effects. Although they did not organize into a formal group for the purpose of exhibiting until 1916, their regionally based landscape style had been a respected current in American art as early as the 1890s. The regular inclusion of their work in Pennsylvania Academy exhibitions during Demuth's tenure undoubtedly encouraged his experimentation with their style. By 1911, he had exchanged the somber palette of his early figurative paintings for the pale and restrained tones characteristic of New Hope Impressionism. The separate, discernible brushstrokes that Demuth increasingly employed during this period speak not only for the influence of these artists but as well for his own deeply ingrained sensitivity to the decorative potential of the picture surface.

Demuth left the Pennsylvania Academy in February 1910 but continued to reside in Philadelphia. Not until 1912, a year after his father died, did he return to live in Lancaster.[51] Even then, Philadelphia remained his base since the distance to Lancaster was almost commutable. For the time being, this arrangement was as cosmopolitan as Demuth required. Philadelphia's genteel environment seemed perfectly suited to his personality as well as to the maturation of a talent which was initially somewhat slow and indecisive, perhaps because in these years Demuth was also toying with writing as an art form. Demuth also had some friends in Philadelphia, among them Robert Locher, a fellow Lancastrian then working there as an architectural apprentice.[52] Demuth had met Locher in 1909, and by 1912 their friendship had become—and would remain—a central part of Demuth's life.[53] (At Demuth's death, Locher inherited all of the painter's unsold watercolors and, after the

New Hope Landscape, c. 1908
Oil on canvas, 15 x 24 in.
(38.1 x 61 cm)
Collection of Harris C. Arnold

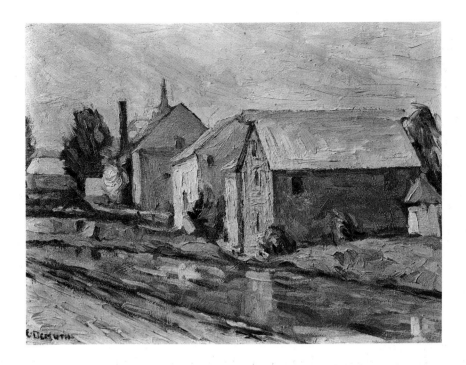

New Hope Landscape, 1912
Oil on canvas, 15 x 24 in.
(38.1 x 61 cm)
Collection of Harris C. Arnold

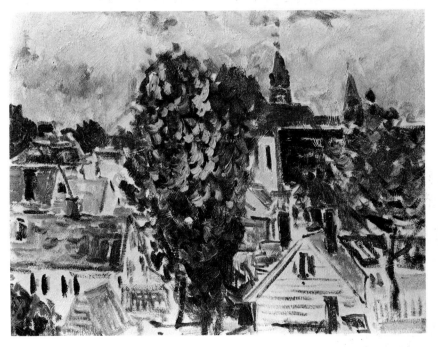

death of Demuth's mother, the Demuth family home in Lancaster.) Although
the two artists were undeniably close, the exact nature of their relationship
remains unclear. Locher was a homosexual and his later marriage to Beatrice
Locher was a social convenience. The portrait of Locher by Baron de Meyer,
for whom he later worked in New York, reveals his considerable style as well
as his willingness to challenge gender-specific boundaries of dress.

Yet the only evidence ever cited that a consummated sexual relationship

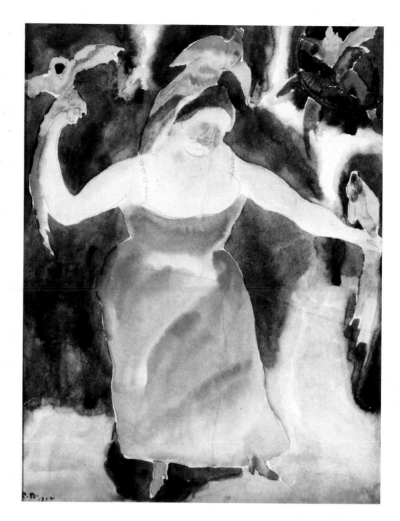

existed between him and Demuth is a 1920 Valentine, found among Locher's belongings after he died, which depicts two men floating in the sky performing fellatio. However, even though the watercolor has long been attributed to Demuth, it bears no stylistic similarity to his work.[54]

During this Philadelphia-based period, Demuth frequently went to New York, where vanguard art revolved almost exclusively around Alfred Stieglitz's 291 gallery.[55] Demuth surely visited Stieglitz's "Younger American Painters" exhibition held in March and April 1910, especially given its inclusion of Lawrence Fellows, Demuth's friend and Paris roommate. Stieglitz had mounted the exhibition as a rebuttal to that year's Independents' show, which was dominated by realists who excluded all advanced tendencies. Most of the vanguard artists within Stieglitz's orbit had a place in the show: Arthur Dove, John Marin, Marsden Hartley, Alfred Maurer, Arthur B. Carles, Edward Steichen, and Max Weber. In February and March of 1911, respectively, Stieglitz hosted Marin and Cézanne watercolor exhibitions. Both were to have a decided impact on Demuth's aesthetic development.

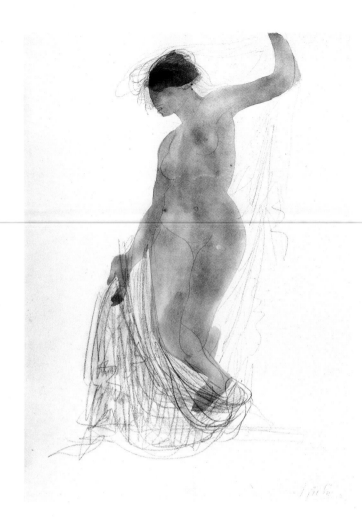

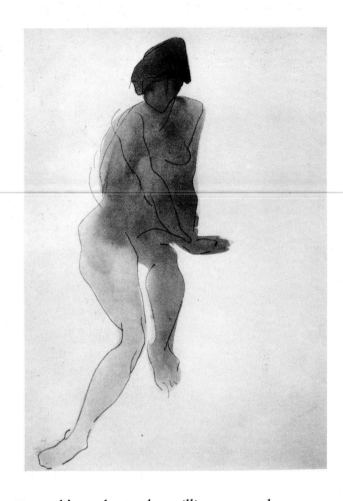

Beginning in 1912, Demuth's work reveals a willingness to adapt modernist tendencies, as if he had been waiting for the right moment to break away from Ashcan painting and make use of the vanguard art he had been visually absorbing. In isolated watercolors such as *Aviariste*, he heightened his color intensities and broadened his color areas. In so doing, he approximated the atmospheric, all-over rhythms of Marin's work. He replaced individual brushstrokes with washes of color that formed into modulated but discrete zones which adhered to the picture plane as patterns. These zones dominated the surface so that representational forms, while retaining imagistic authority, did not take precedence over the atmospheres of color that surrounded them.

The memories of his first European trip and exposure to the avant-garde drew Demuth back to Paris in December of 1912. At twenty-nine, he was far more confident and aesthetically sophisticated than he had been on his earlier trip. As before, the allowance with which he arrived accommodated a sufficient

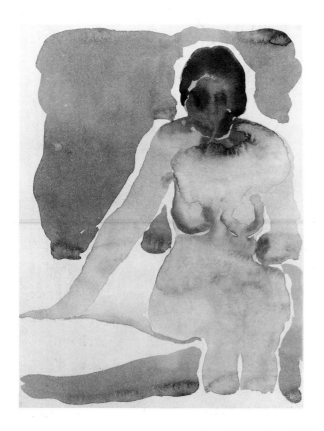

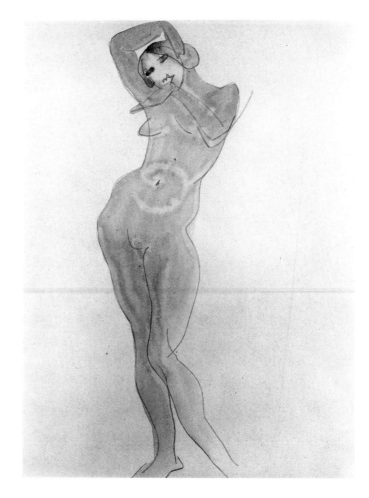

though modest life-style, which included late afternoon and evening drawing sessions at the Académie Moderne beginning in December.[56] Here, following a pedagogical technique developed by Rodin's assistant, Antoine Bourdelle, students were instructed to make quick sketches of female models who changed poses every five minutes. The similarity between Demuth's efforts and Rodin's watercolors suggests that Demuth was now adapting—perhaps under Bourdelle's influence—the style of the Rodin drawings he had seen in 1910 at Stieglitz's gallery.[57] Technically, Demuth's application of a watercolor wash over a fluid, delicate pencil line, laid down to indicate contour, superficially resembled his genre sketches from 1910. Yet his new emphasis on the direct sensuous presentation of the female nude could only have come from Rodin. Although Demuth would never again depict the nude female form with such voluptuous sensuality, the technique of lightly draping washes over skeletal pencil lines would henceforth characterize the majority of his watercolors.

For American artists in the early teens, Rodin's watercolors represented a blatant attack on precisely the aesthetic conventions in which Demuth had

been schooled. Rodin's exhibition at 291 had so shaken the conservative William Merritt Chase that Chase swore never again to visit Stieglitz's gallery. Rodin's example offered American artists such as Demuth, Georgia O'Keeffe, and Abraham Walkowitz a way to depict the figure without forsaking modernism. For Demuth, Rodin's watercolors were also important for their sensuality. Fiercely denounced by critics as salacious, they provided Demuth with a means to foray into erotic subject matter without appearing personally responsible for its selection. This appropriation of sensual subjects and style was a logical outgrowth of Demuth's earlier affection for Beardsley's erotic illustrations.

Sometime during his first few months in Europe, Demuth met Marsden Hartley. From then on he would remain quite attached to the older artist and would benefit greatly from his aesthetic tutelage. Hartley was part of the extended social network that existed among Americans in Paris, and he rapidly drew Demuth into its orbit, this time as an equal participant. As Hartley described it, "it wasn't long before Charles made us particularly aware of him by a quaint, incisive sort of wit with an ultrasophisticated, post eighteenninety touch to it."[58] With Hartley as mentor, Demuth mingled as easily among German artistic circles in Paris as he did among the American ones. He even traveled to Berlin that fall to visit Hartley and Arnold Rönnebeck, whose nephew Hartley would memorialize in his German Officer paintings of 1914–15.

Yet Demuth remained drawn toward the French. Through Hartley he also met Gertrude Stein, whose Saturday evening salons were a locus of American artistic life in Paris. She provided Americans with direct connections to the art and personalities of Europe's vanguard; yet she mitigated their sense of cultural inferiority by asserting her own American identity. According to Stein's account, Demuth, still attracted to writing as a career possibility, was as interested in her literary radicalism as in her painting collection, and he spent much of his time in her company speaking about her new plays.[59] Several years later, Demuth wrote with approval of Stein's efforts to transform aesthetic criticism into literature.[60] His receptivity to Stein's approach owed its origins to Wilde and Pater, for whom criticism was an art independent of its ostensible subject.

In the meantime, Demuth augmented his sessions at the Académie Moderne with independent study at the Académie Colarossi and Académie Julian. The remainder of the time he spent looking at and absorbing the vast

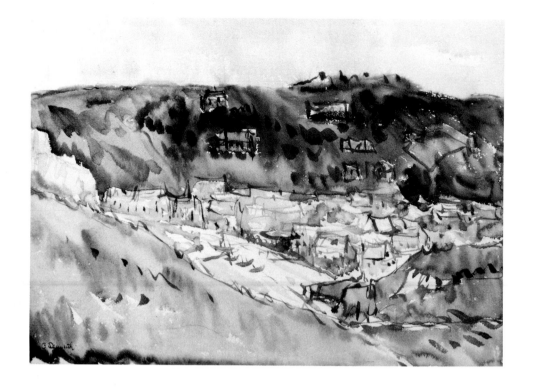

array of art presented in Paris galleries and at the large show of the Indépendants held in March 1913. The only exception was the summer of 1913, when he went to the French coastal village of Etretat, which had earlier provided subject matter for Monet. The paintings he executed there advanced his foothold on modernism. In a series of oils and watercolors based on the cove and surrounding rocks, Demuth's rapidly applied brushstrokes establish a stenographic rhythm over the entire composition. His use of a saturated palette and his willingness to let bare areas of the canvas or paper serve as compositional elements suggest an accommodation between the late Fauvism of Signac and the example of Cézanne's watercolors.

This second European sojourn represents the end of Demuth's art training. In retrospect, it seems to have been of exceedingly long duration. Slow to mature aesthetically, he had done little but assimilate the techniques and conventions of established artists and movements. Only upon his return to America, in the spring of 1914, did he embark on a career as an innovative modernist.

Notes

1. The pronunciation of the Demuth name has been the subject of a great deal of confusion. Those who knew him, such as Georgia O'Keeffe and Dorothy Norman, said he pronounced it Dē-məth, with emphasis on the first syllable. However, Mrs. Christopher Demuth, the wife of Charles' cousin, has said that the family pronounces it Dē-müth, with the first syllable slightly more heavily accented than the last; conversation with the author, November 6, 1985.

2. For a genealogy of the Demuth family, see Emily Farnham, *Charles Demuth: Behind a Laughing Mask* (Norman, Oklahoma: University of Oklahoma Press, 1971), pp. 30–36.

3. Demuth was born and lived the first six years of his life at 109 North Lime Street. When the last of his great-aunts died in 1889–90, 118 East King Street, next to the tobacco shop, became vacant, and Demuth's family moved there; see Alvord L. Eiseman, "A Study of the Development of an Artist: Charles Demuth," 2 vols. (Ph.D. dissertation, New York University, 1976), I, pp. 7, 12–13, and Farnham, *Charles Demuth*, pp. 42–44.

4. See "Obituary: Ferdinand A. Demuth," [Lancaster] *Daily Intelligencer,* January 26, 1911, p. 2; "Ferdinand A. Demuth," *Papers Read Before the Lancaster County Historical Society,* 16 (January 5, 1912), p. 39.

5. Phyllis R. Reed and Debra D. Smith of the Lutheran Church of the Holy Trinity in Lancaster generously supplied birth, communion, marriage, and death records, which elucidated Buckius genealogy.

6. "Charles Buckius," in *Biographical Annals of Lancaster County, Pennsylvania* (Lancaster: J.H. Beers and Company, 1903), pp. 433–34.

7. Harris C. Arnold, attorney for Augusta Demuth, in conversation with the author, November 6, 1985, supplied the information about the Buckius-owned rental properties.

8. Quoted in Emily Farnham, "Charles Demuth: His Life, Psychology and Works," 3 vols. (Ph.D. dissertation, Ohio State University, Columbus, 1959), III, p. 974.

9. William Carlos Williams claimed that Demuth's short leg was caused by tuberculosis; see Farnham, "Charles Demuth," III, p. 989. The idea that Demuth had been dropped as a young child was advanced by Eiseman, "A Study of the Development of an Artist," I, pp. 10–11.

10. Before the identification of Perthes, the disease was often misdiagnosed as tuberculosis; see Jacob F. Katz, *Legg-Calvé-Perthes Disease* (New York: Praeger Publishers, 1984), Charles Weer Goff, Ned M. Shutkin, and Myerma R. Hershey, *Legg-Calvé-Perthes Syndrome and Related Osteochondroses of Youth* (Springfield, Illinois: Charles C. Thomas, 1954); William A. Craig, "The Course of Legg-Calvé-Perthes Natural History

and Pathomechanics," *Orthopaedic Review,* 8 (March 1979) pp. 29–31.

11. Eiseman argued that the Demuth family's reticence to discuss the cause of Demuth's lameness was intentional and derived from their embarassment about Demuth's father having dropped him; Eiseman, "A Study of the Development of an Artist," I, p. 11.

12. Marsden Hartley recalled that "because of a hip infirmity [Demuth] had invented a special sort of ambling walk which was so expressive of him"; see Hartley, "Farewell, Charles: An Outline in Portraiture of Charles Demuth—Painter," in Alfred Kreymborg, Lewis Mumford, and Paul Rosenfeld, eds., *The New Caravan* (New York: W. W. Norton & Co., 1936), p. 554.

13. Louis Golden, a classmate of Demuth, recalled that Demuth was so delicate that he was seated with the girls in his class to avoid injury from the boys' horseplay; Carol Morgan, letter to the author, August 14, 1986.

14. See the catalogue for the "Loan Exhibition of Historical and Contemporary Portraits," organized by The Iris Club and The Lancaster County Historical Society, November 23–December 13, 1912. Included were *Portrait of Anna E. Demuth* by John Demuth (no. 54) and *Bust of Jacob Demuth* by Aaron Eshleman (no. 56).

15. See Farnham, *Charles Demuth,* p. 46.

16. Nazareth Hall is a private academy, elementary through college, founded in 1742 by the Moravian church. Although admission was opened in 1785 to any denomination, the school's orientation was religious; information courtesy Evelyn Huth, Moravian Historical Society, Nazareth, Pennsylvania.

17. Each student at Franklin and Marshall was required to attend daily morning prayers in addition to Sunday services; see Thaddeus G. Helm and Edwin M. Hartman, *Franklin and Marshall Academy (1899–1900)* (Lancaster: Franklin and Marshall College, 1899).

18. Transcript reprinted in Eiseman, "A Study of the Development of an Artist," I, p. 31.

19. Both Farnham, *Charles Demuth,* p. 47, and Eiseman, "A Study of the Development of an Artist," I, p. 30, claim that Demuth went directly to art school after graduating high school. This is contradicted by the records of his art school, the Drexel Institute, which indicate his enrollment in September 1903, as an elementary art student; for Demuth's years at Drexel, see pp. 16–17.

20. Charles Demuth, "Aaron Eshleman," *Lancaster County Historical Society Papers,* 16 (October 1912), p. 250.

21. Edward D. McDonald and Edward M. Hinton, *Drexel Institute of Technology 1891–1941: A Memorial*

History (Philadelphia: Drexel Institute of Technology, 1942), p. 35.

22. Pyle had left Drexel to devote himself full time to the summer school he had established at Chadds Ford in 1898. Thus, Demuth never studied with Pyle as Eiseman, "A Study of the Development of an Artist," I, p. 34, claims.

23. See David E.E. Sloane, "Nineteenth-Century American Popular Magazines and Illustration," in *Drexel's Great School of American Illustration*, exhibition catalogue (Philadelphia: Drexel University Art Museum, 1984), pp. 8–9.

24. It has previously been believed that Mary Andrade was Demuth's teacher at the Pennsylvania School of Industrial Art; see Farnham, *Charles Demuth*, p. 190. In fact, she was teaching at Drexel in those years under her maiden name, Mary Fratz; only later in her career did she teach at the School of Industrial Art (beginning in 1907), first as Mary Fratz, then, after her marriage in 1910, as Mary Fratz Andrade; see Pennsylvania School of Industrial Art, "Circular of the School of Applied Art, 1904–1905," p. 5 (copy, Whitney Museum of American Art archives, New York), and *Year-Book of the Departments and Courses of Instruction* (Philadelphia: Drexel Institute of Art, Science, and Industry, 1902–03, 1903–04, and 1904–05).

25. A previously uncited letter from Albert Barnes to Demuth, dated September 7, 1905, and now in the possession of Pauline Stauffer of Lancaster, confirms the early date of their association. Barnes eventually became a supporter of Demuth's work and purchased large numbers of watercolors and temperas from him during the teens and early twenties. Their longstanding association was rooted in friendship, not business; Demuth often visited Barnes' house in Merion and Barnes, in turn, visited the artist and his mother in Lancaster. After Demuth's death, Barnes continued to correspond with Demuth's mother, who willed him a sculpture that had belonged to her son. (The sculpture was a Mayan toad, which Demuth had lent to Alfred Stieglitz shortly after they had met in 1914; undated letter from Demuth to Stieglitz, Stieglitz Collection, Collection of American Literature, Beinecke Rare Book and Manuscript Library, Yale University, New Haven [hereafter cited as Yale]).

26. Information courtesy Susan Haidar, Drexel University Archives, letter to the author, June 7, 1985.

27. See McDonald and Hinton, *Drexel Institute of Technology*, p. 38.

28. Quoted in Helen Henderson, fragment of a letter, recipient unknown, August 12, 1940, Richard Weyand Scrapbooks, Appendix, p. 69. These scrapbooks contain transcriptions of Demuth's papers and a catalogue of his paintings. At Demuth's death in 1935, his writings came into the possession of his longtime friend Robert Locher. Locher's friend Richard Weyand sub-sequently transcribed the writings and compiled the information about the paintings into twelve scrapbooks. In 1956 they were distributed among Weyand's four siblings; six of the scrapbooks are now lost and six remain with the Weyand heirs.

29. Rita Wellman, "Charles Demuth: Artist," *Creative Art*, 9 (December 1931), pp. 483–84.

30. For the 1910 performance, see "Philadelphia," *Art News*, 8 (January 8, 1910), p. 2. Demuth enacted a similar performance in the summer of 1914 in Provincetown, where he helped Helene Iungerich stage a show titled "Living Japanese Prints"; see Farnham, *Charles Demuth*, p. 81.

31. Demuth to Stieglitz, November 14, 1926, Yale.

32. For example, A.E. Gallatin spoke of the coolness that pervaded Demuth's paintings of fruit, but missed the sensuality of them; Gallatin, *Charles Demuth* (New York: William Edwin Rudge, 1927), p. 9. Paul Rosenfeld, on the other hand, saw the sensuality but missed the strength of will; Rosenfeld, "American Painting," *The Dial*, 71 (December 1921), pp. 662–63.

33. Quoted in Farnham, "Charles Demuth," III, p. 973.

34. Huysmans' *A rebours* has been called Demuth's "handbook"; see, for example, Kermit Champa, "Charles Demuth," unpublished manuscript, 1973, p. 13. Although it was indeed a book Demuth greatly admired, it does not stand alone. References to Wilde and Pater appear more ubiquitously throughout his writings.

35. Demuth to William Carlos Williams, August 30, 1907, collection of William Eric Williams.

36. Quoted in Edward Timms, *Karl Kraus: Apocalyptic Satirist* (New Haven: Yale University Press, 1968), p. 190.

37. Charles Demuth, Untitled writings, Richard Weyand Scrapbooks, Appendix, p. 93.

38. Wilde, quoted in Timms, *Karl Kraus*, pp. 190–91.

39. See Farnham, "Charles Demuth," III, p. 978.

40. Helen Henderson, "Charles Demuth," typescript of a paper read before the Junior League of Lancaster, November 10, 1947, Richard Weyand Scrapbooks, Appendix, p. 159.

41. Marcel Duchamp, quoted in Farnham, "Charles Demuth," III, p. 973. Demuth's attitude toward gossip mirrored the Aesthetes' stance: "Facts concerning people are rarely as interesting as gossip; because gossip, being more or less personal, must always be related to romance, and hence, in capable hands, sometimes rises into the sphere of art"; Demuth, "Aaron Eshleman," p. 249.

42. Demuth to Stieglitz, August 13, 1929, Yale.

43. Walter Pater, quoted in Gerhard Masur, *Prophets of Yesterday: Studies in European Culture, 1890–1914* (New York: Harper and Row, 1961), p. 110.

44. For Biddle, see Herbert S. Levy, "Charles Demuth of Lancaster," *Journal of the Lancaster County Historical Society*, 68 (Easter 1964 [issued March 5, 1965]), p. 54. Marsden Hartley echoed Biddle's remark: "Charles had a flare for the frivolities, but they had to be of elegant tone, a little precious in their import, swift in their results, he spent hours chasing phantoms of an aristocratic nature, and was often overcome by the highly defined appearance of things . . . he thought of things as interesting only by degree of excitement they held for them, to get his own kick out of them. He was a bit proustian in this, he liked fragile gossip, he liked the flare of à la mode emotions, he liked superficialities, but with the difference that being a serious person, he understood the vast implications of the little secrets of life, he rubbed his hands so to speak, if he came close enough to the thin surfaces of them—he was not strictly speaking, a flâneur, but he liked the picture of life which such a position offered"; Hartley, "Farewell Charles," p. 559.

45. Demuth to William Carlos Williams, August 30, 1907, collection of William Eric Williams.

46. Previous scholars have maintained that little is known about Demuth's 1907 trip to Paris; see Alvord L. Eiseman, *Charles Demuth* (New York: Watson-Guptill Publications, 1982), p. 10.

47. Demuth's friendship with Fellows continued into the late teens. In Demuth's play, *Fantastic Lovers: A Pantomine after Paul Verlaine* (pp. 42–44), he indicates that sets were to be done by Fellows.

48. Demuth to William Carlos Williams, September 17, 1907, p. 3, Poetry/Rare Books Collection, State University of New York at Buffalo.

49. Prior to leaving for France he had written William Carlos Williams: "When I come back—*when I come back* well, we may both have a start in a small way then"; ibid.

50. For the New Hope Impressionists, see Sam Hunter, *American Impressionism: The New Hope Circle*, exhibition catalogue (Fort Lauderdale, Florida: Museum of Art, 1984).

51. Most scholars have assumed that Demuth returned to Lancaster in 1911 when his father died; see Eiseman, *Charles Demuth*, p. 11. However, according to information in the Richard Weyand Scrapbooks, Appendix, p. 42, a label on the back of a painting included in a 1911 exhibition at the Pennsylvania Academy lists Demuth's address as Filbert Street, Philadelphia.

52. According to Farnham, *Charles Demuth*, p. 191, Demuth met Locher in Philadelphia in 1909. Eiseman, *Charles Demuth*, p. 11, claimed that they met in childhood in Lancaster and—though he cites no evidence—that they consummated a sexual relationship on a trip to Monhegan in 1910. For additional information on Robert Locher, see Betsy Fahlman, "Modern as Metal and Mirror: The Work of Robert Evans Locher," *Arts Magazine*, 59 (April 1985), pp. 108–13; Susan Fillin Yeh, *Making Tradition Serve Modernism: The Designs of Robert E. Locher (1887–1956)*, exhibition catalogue (Providence: Museum of Art, Rhode Island School of Design, 1982).

53. Demuth, for example, dedicated his play *The Azure Adder* to Locher and was met upon his return from Europe in 1913 by his mother and Locher.

54. Since Demuth had willed Locher all of his unsold works on paper, it was assumed he had executed the watercolor. Locher never established its authorship before his death in 1956.

55. For modern art exhibitions in America between 1907 and 1913, including Stieglitz's and those at other New York galleries, see Judith Katy Zilczer, "The Aesthetic Struggle in America, 1913–18: Abstract Art and Theory in the Stieglitz Circle" (Ph.D. dissertation, University of Delaware, Newark, 1975), pp. 10, 240–44.

56. Mrs. John Malone, a friend of Demuth's in those years, remarked that he "was living [in Paris] on an allowance of sixty dollars a month, which was more than adequate, if one did not become ill"; see Mrs. John E. Malone, "Charles Demuth," *Papers of the Lancaster County Historical Society*, 52 (1948), p. 8.

57. There were thirty Rodin drawings, dating between 1900 and 1910, in Stieglitz's exhibition; see Donald E. Gordon, *Modern Art Exhibitions 1900–1916* (Munich: Prestel-Verlag, 1974, II, pp. 389–90).

58. Hartley, "Farewell, Charles," p. 554.

59. See James Mellow, *The Charmed Circle, Gertrude Stein & Company* (New York: Praeger, 1974), p. 18.

60. "Writing about the paintings of one man or about a number of collected works of different men, should be, when given to the public, at least, literature. Miss Stein respects this artistic truth in our time, raising her writings, however, above literature as Verlaine understood the word in 'Art Poetique'"; Demuth, Untitled writings, Richard Weyand Scrapbooks, Appendix, p. 79.

II.

The Artist as Writer

One explanation for the slowness with which Demuth's painting broke from its realist origins during the period 1910–14 was that much of his time was spent writing. In fact, he seems to have divided his aesthetic efforts during this period equally between the two disciplines. Not only did he present himself to Gertrude Stein in 1912 as more interested in writing than in painting, but he listed himself in the magazine *Camera Work* in 1914 both as a writer and a painter. He thus worked in the two media more openly than the character in one of his plays who announced: "I know that we all do write on the quiet while posing as painters!"[1]

The outpouring of Demuth's creative writing efforts occurred primarily during the teens. By the twenties, his literary output was almost entirely limited to expositions on art and artists: texts for Georgia O'Keeffe and Peggy Bacon exhibitions and a position paper on the literary qualities inherent in pictorial art entitled "Across a Greco Is Written."[2] Only two of his fictional works were ever published: *The Azure Adder* in the December 1913 issue of *The Glebe*, edited by Alfred Kreymborg, and *Filling a Page: A Pantomime with Words* in Allen Norton's short-lived *The Rogue* in April 1915.[3] Notwithstanding this limited public exposure, Demuth associated with the major figures in experimental prose and poetry. His literary endeavors merit examination not only because of their quality, but because—like Demuth's literary preferences—they reveal a great deal about his aesthetic attitudes and preoccupations. His writing articulates his essential ambivalence about the premises of Aestheticism, which he had enthusiastically embraced as a student.

That Demuth wrote as well as painted is not surprising given that his early role models were writers (p. 20). Even Beardsley made a foray into short story writing with his erotic *Venus and Tannhäuser*.[4] Demuth's conviction that one could simultaneously be a painter and a writer also benefited from his friendship with William Carlos Williams, a medical student at the

Charles Demuth, c. 1920
Look Magazine, March 28, 1950, p. 52

University of Pennsylvania in Philadelphia during Demuth's student years. The two apparently had met at Mrs. Chain's rooming house shortly after Demuth entered Drexel, and they immediately became close friends.[5] Williams' later portrayal of their initial encounter reads like a meeting of two lovers, pitted together in their mutual sensitivity against the rest of the world:

> But Mrs. Chain's prunes were the most wonderful. Watery tidbits. It was prunes or applesauce. Her daughter was simple I guess. Did her best to land one of the students, kept it up for twenty years. At that table I met one of my dearest friends. Will you have some bread? Yes. That look. It was enough. Youth is so rich. It needs no stage setting. Out went my heart to that face. There was something soft there, a reticence, a welcome, a loneliness that called to me. And he, he must have seen it in me too. We looked, two young men, and at once the tie was cemented. It was gauged accurately at once and sealed for all time. The other faces are so many prunes.[6]

The affection and professional bond that developed between the two men during these Philadelphia years lasted throughout their lives. Williams' prose is replete with references to Demuth, whom he identified in his autobiography as one of the few intimate male friends he had had during his life.[7] In the teens, Demuth helped Williams make contact with members of the New York avant-garde, and Williams credited him with cultivating his appreciation of painting: "I had long been deep in love with the painted canvas through Charles Demuth."[8] Williams' indecision when they met about whether to be a painter or a writer (in addition to being a doctor) paralleled Demuth's ambivalence about whether to follow a literary career or pursue the visual arts. And even after Williams had declared himself a poet, he remained committed to translating pictorial effects into poetry. His conviction that painting and writing were symbiotic encouraged Demuth to experiment with both disciplines and to find ways in which his painting could appropriate aspects of literature.

Demuth's dual allegiance to painting and writing would be further encouraged between 1914 and 1920 by his participation in the Arensberg salon (p. 58). Not only did the Arensberg circle include a large number of writers—Wallace Stevens, Alfred Kreymborg, Carl Van Vechten, Mina Loy, Max Eastman, and the Baroness Elsa von Freytag-Loringhoven—but the salon's visual artists were oriented toward literature as well. Picabia wrote poetry and founded the magazine *391*; Duchamp introduced literary references into his art and edited the magazines *Rongwrong* and *The Blind Man*; Man Ray edited two magazines, *The Ridgefield Gazook* and *TNT*; and Arensberg himself wrote poetry and financially backed the poetry journal *Others*.

Demuth's own writing was Symbolist in style and spirit. The feeling of worldly disillusionment touched with ennui that was the hallmark of Symbolist writing and the Aesthetic position reverberated throughout his prose and poetry. He emulated the suggestive indefiniteness of Symbolist literature as well as its reliance on atmosphere and diction. In what is probably the continuation to Demuth's 1912 short story "The Voyage Was Almost Over" (pp. 46–47), the young protagonist returns to his stateroom after despairing at his psychic isolation:

> The port-hole was open. He gazed out of it again upon the sea. And close to the ship, almost impossibly close, it seemed, two dolphins appeared for a moment on the surface and then quickly disappeared with their sensuous wriggles.
>
> The port-hole went shut suddenly. The stateroom was at the same time flooded with light from the electric lamp above the dressing-stand. The man was on his knees fumbling with the lock of his steamer trunk. The lock opened with a clink and the lid half-raised of itself. Nervous hands were thrust into the top tray. No, it was not there. The tray and its contents were thrown hurriedly aside. The hands started their work again among the clothes in the bottom of the trunk, hesitated, and brought forth a white box. He remained a moment on his knees and then got upon his feet, half turned as though to attack the trunk; but, after a moment's indecision, he opened the box.
>
> The box contained a book; a rare edition of a modern poet. Opening it at a fly-leaf and reading what was written there caused a faint color to return to his whitened face. He reached toward the dressing-stand, got and lighted a cigarette, threw himself upon the couch, turned the pages of the book until he was almost through them, and then read.

Plot to Demuth was secondary to mood and to the creation of pictorial tableaux. In fact, two of his plays were pantomimes with words. In *Filling a Page: A Pantomime with Words*, Demuth's characters assume poses "arranged after drawings by Beardsley" and recite non sequiturs such as "I have a gilded cage for my yellow bird. The omnibus was crowded."[9] The elusive meaning and almost intentional obscurity in much of Demuth's writing set it against the Naturalists and their pictorial counterparts, the Ashcan painters, who believed that art should serve progress and humanity. The Symbolist position that art had no purpose other than its own existence was congenial with Aestheticism. For Demuth, it was a liberating influence. By providing a literary precedent for the rejection of socially attentive art, Symbolism fueled Demuth's search for an alternative to Ashcan painting. Literature rather than painting became the impetus for his escape from realism to modernism. Moreover, because writing functioned as a forum for his speculations about Aestheticism, much of his prose addresses the relationship between life and art and between life and the artist.

His prose sketch "In Black and White" (pp. 44–45) opens as a quintessentially Naturalist vignette: an altercation between a man and woman in the snow under a street lamp. A dandy, looking down on the scene from a studio window, calls to his friends to "Come and see the Steinlen." Unable to see life save through the veil of art, he is made more impassioned by the aesthetic transformations effected by Théophile Steinlen's realistic style of illustration than by the realities which motivated them. When the man is killed by another who springs from the darkness, the dandy's response is merely off-hand: "I was mistaken, it's a murder." Philosophically, the story asserts that represented things possess a truth which is often absent in real things. It restates in literary terms the Aesthetes' belief that life is more meaningful and intense when translated into art.

Yet Demuth's enthusiastic embrace of Aestheticism was tempered by questions about some of its conceits and ethical implications. An oblique but pointed parody of his flirtation with the elevation of art over life is found in his play *Fantastic Lovers* (pp. 42–44), whose central couple wish to commit suicide "like lovers in Boccaccio." Bored and passive in a world of artifice, even the thought of death generates for them no passion or meaning; after tasting an ice suddenly preferred by the headwaiter, they capriciously decide to postpone their suicides until the following day. Their neurasthenia is established in the play's opening paraphrase of Verlaine: "The air is too mild / Too blue the sky." By exaggerating the fatuousness of characters whose final gesture before their would-be suicides is to polish their nails, Demuth undermines the superiority of those who mindlessly choose art over life.

Demuth's play *The Azure Adder* represented a more refined but still ambivalent treatment of the Aestheticism of his student years. The play concerns the efforts of its characters to start a magazine modeled after *The Yellow Book*, a quarterly publication which Beardsley had edited and illustrated in the 1890s. Like this prototype, *The Azure Adder* magazine was to be a total art environment in which illustration, printing, and layout would be as important as text. Since much of the dialogue of the play concerns the rationale and proposed content of the magazine, the situation offered Demuth a pretext for presenting his views on the doctrine of art-for-art's sake.[10] In the play he parodies those who posture as Aesthetes without authentic conviction or understanding: "I work constantly," his character Alice declares. "The air is my canvas, my nerves are the brushes. . . . To contemplate, to wait, to dream, is not this work? . . . I hope to become like Beauty, myself—a living

creation, a work of art—even though I do nothing ever in paint."[11] The monologue was a direct paraphrase of Wilde's admonition to "create yourself; be yourself a poem."[12] Although Demuth presented his characters as somewhat vacuous and farcical, he never actually refuted Aestheticism: the potential rebuttal to Alice's life-is-art declamation is interrupted by a knock at the door, while the aesthetic alternative, realism, is contemptuously dismissed as "the glorification of beef-steak." When Demuth has George, the magazine's founder, posit that the realists would eliminate those "whom it called abnormal, sick, degenerate" in favor of only the "normal," Demuth clearly has an attack on his own life-style and aesthetic prerogatives in mind. The general message of the play, however, remains unclear because he wavered between accepting and rejecting Aestheticism. Indeed, though he recognized their limitations, Demuth never lost his admiration for Beardsley and Wilde.

In his short story "The Voyage Was Almost Over" (pp. 46–47), Demuth elaborated on his sense of himself as an observer rather than as a full participant in life. The story suggests that literature and painting offered insufficient compensation for this alienation, the assertions of Aestheticism notwithstanding. It details the meditations of a young man (Demuth's alter ego) on the deck of a cruise ship during the last night of the voyage. As he watches one couple after another merge into the shadows, he yearns to be able to do likewise. "He had felt all this before. Felt it in gay and noisy cafés, in crowded parks, at night when the music of a band was wafted to him by the hot summer breeze or on the streets crowded for a holiday or fête." The protagonist despairs at his marginality: "If only a little white hand would beckon from without one of those mysterious shadows" to supplant his "borrowed ideas" about the superiority of art. The section ends with the young man railing against the "unknown Thing" that enjoined him from what would have made him whole: the psychological normalcy of love and intimacy.

The exclusion of the artist from traditional avenues of love and happiness, a bittersweet fact of Demuth's own life, forms a subtext to many of Demuth's stories. It is as if he felt that the artist's undifferentiated love of "everyone and everything" entailed an impersonal relationship to life which necessitated a sacrifice of normal pleasures.[13] At times, Demuth seemed to transform the absence of intimacy into an essential precondition for the making of art. "To see the truth" precluded loving specific individuals. "We love only each other, he must love all," one of Demuth's characters remarks about another of the artist's alter egos in an untitled manuscript (pp. 45–46).

In *The Azure Adder*, the goddess of art—the magazine—is "veiled, alone and sterile." Giving oneself to her—becoming her "priests"—meant "martyrdom and perhaps death," a renunciation of life that was not so much physical as psychic.[14] Art was an effective surrogate only when intimacy failed or remained untested. When George succumbs to Alice's embraces at the close of the play, he transfers his pledge of eternal allegiance from the "great goddess" of Beauty to the "great goddess" Alice. Intimacy, in Demuth's view, undermines the creative drive. It is only when "the individual needs something beyond sex, direct or indirect, [that] he is likely to create," Demuth wrote.[15]

Yet however insufficient art was as a substitute for genuine contact, it nonetheless made life possible to endure. In the prose fragment appended to "The Voyage Was Almost Over" (p. 47), the protagonist finds solace from his loneliness in the numbered edition of a modern poet. Art is thus a refuge, albeit a solitary one. Deprivation may be the motivating spirit behind art, and the artist may have to remain an outcast who can only experience life by translating it into aesthetics.

Notes

1. Charles Demuth, *The Azure Adder*, published in *The Glebe*, 1 (December 1913), p. 13.

2. See brochures for The Intimate Gallery exhibitions "Georgia O'Keeffe Paintings, 1926," 1927; "Peggy Bacon Exhibition," 1928; "Georgia O'Keeffe Paintings, 1928," 1929. "Across a Greco Is Written," *Creative Art*, 5 (September 1929), pp. 629–34.

3. Part of Demuth's literary output was included in Emily Farnham's unpublished dissertation; see Farnham, "Charles Demuth: His Life, Psychology and Works," 3 vols. (Ph.D. dissertation, Ohio State University, Columbus, 1959), III, pp. 924–39.

4. As late as 1929 Demuth extolled Beardsley's short story: "There comes to my mind only one thing written by a painter about his drawings which really added to literature—it is called: 'Venus and Tannhauser'"; Demuth, "Across a Greco Is Written," p. 629.

5. By early 1904 Williams was writing to his mother as if Demuth was already a close friend; see the letter quoted in James E. Breslin, "William Carlos Williams and Charles Demuth: Cross-Fertilization in the Arts," *Journal of Modern Literature*, 6 (April 1977), p. 249 n. 3.

6. William Carlos Williams, *The Autobiography of William Carlos Williams* (New York: Random House, 1951), p. 55. The interpretation that the two were like lovers comes from Breslin, "William Carlos Williams and Charles Demuth," p. 249.

7. Williams, *The Autobiography of William Carlos Williams*, p. 55.

8. Williams' dedications to Demuth were many, among them his 1922 poem "Pot Flowers" and his poem-elegy for Demuth, "The Crimson Cyclamen," based on Demuth's watercolor *Tuberosis* (private collection), which Williams owned. In turn, Demuth inscribed his 1920 painting *Machinery* (Pl. 65) to Williams and based his portrait *The Figure 5 in Gold* (Pl. 89) on Williams' poem, "The Great Figure."

9. Charles Demuth, *Filling a Page: A Pantomime with Words*, published in *Rogue*, 1 (April 1915), p. 13.

10. The ideological legitimization for *The Azure Adder* and *The Yellow Book* was found in the writings of John Ruskin and William Morris, leaders in the English Arts and Crafts Movement, to whom Demuth had been introduced while at Drexel. The desire of the protagonists in his play to create a "perfect" magazine, with the finest quality binding, paper, and page design, echoed Morris' and Ruskin's credos about the aesthetic importance of those activities otherwise denigrated as "crafts."

11. Demuth, *The Azure Adder*, pp. 7–8.

12. Quoted in Edward Timms, *Karl Kraus: Apocalyptic Satirist* (New Haven: Yale University Press, 1968), p. 190.

13. Demuth to William Carlos Williams, August 30, 1907, collection of William Eric Williams.

14. Demuth, *The Azure Adder*, p. 30.

15. Charles Demuth, Untitled epigram, Richard Weyand Scrapbooks, Appendix, p. 80.

Selected Writings

The following selection of writings by Charles Demuth remained unpublished in his lifetime. After Demuth's death, and after his mother's death in 1943, they were transcribed and collected into a scrapbook by Robert Locher's companion, Richard Weyand (see Chap. 1, n. 28). Some of this material was partially published in Emily Farnham's 1959 dissertation, "Charles Demuth: His Life, Psychology and Works" (Ohio State University, Columbus). This selection is taken from the scrapbook marked Appendix, pp. 77–104. Some of the parenthetical information may represent Weyand's transcription notes rather than Demuth's indications.

"You Must Come Over," A Painting: A Play

V.B. And in America—?

B. Oh, in America. Well,—we've had and are having painting in America.

V.B. But, I mean—?

B. I know what you mean, —what is called great painting. I don't know what that is, really. You see, "I only know what I like." If what I like happens to have a famous name attached, —it doesn't worry me. I go on liking it. I like Picasso's work, —still like it.

V.B. I came over to talk about American painting.

B. Couldn't we talk about American musical shows, reviews, —the people who act in them, (—have acted in them), and dance: they really are our "stuff." They are our time, —yes in that sense our paintings are: well, —what you do not call great. You could say the same, and, not hurt my feelings, about our writers for the stage. The world, has called some of these, —at least one of these, —I'm led to believe, great. A child of the church, Longfellow and Freud, —say if those three were not too much of a crowd.

V.B. But really, —

B. Seriously, —I think you mean. That is one of our great defects in painting, —they are, —no I mustn't say all, —paint seriously. They have so little fear (fire). Painting like life to most of them is real, earnest, —to which I add when looking at their work, —you said it, kid.

V.B. I believe you don't think much of the painters and writers, —I was led to believe. —

B. That I did, —well I do. But I love Broadway and —well, and vulgarity, and gin. In fact I love my country.

V.B. You distinguish between like and love?

B. You were talking about painting in America.

V.B. We were to have.

B. Well here goes (I distinguish between my country, and my love for it, and my love for its painters).

(*A long pause*).

V.B. Well there's —

B. Not at all. I'll start at what seems to me to be the beginning, —at least it's the earliest painting I've seen that seems to have, —well what ever it is, what ever that quality is which creates between itself and the beholder an understanding, a sympathy, —call it what you like if you know what I'm talking about, —otherwise, —ask Dr. Barnes. He will both tell you what it is and what I'm talking about. The painting is in the Boston Museum, —it is a self portrait by Washington Allston. No, —

you've never heard of him, —so many American painters have never been heard of, —well, he's not a discovery of mine. Henry James wrote about him. James used him as a proof that America is no land for the artist. Allston went mad after returning to America from years spent in Europe. Perhaps James was right, —I know America is only for the very strong. Hemingway, —yes, he lives in Europe.

V.B. I don't think he's—, but, it's painting we're talking about. We'll take Allston as the first, then I think we had no one for rather a long time. Perhaps until Fuller and Homer Martin, —if they were of the same time, —I think that they were. Fuller never quite comes off, —but what, —remains after a great deal of fumbling is all right, —like Hawthorne. "The Artist of the Beautiful." My God what a time and what a country, —and yet what a country, to wish to do anything in or about.

B. Martin —Homer Martin, —did you say?

V.B. Yes, —Homer Martin, —I always think of Coleridge when I see a Homer Martin, —I too, now wonder why. "I looked upon the nothing (?) sea" —I wonder? No, he painted a country which seemed to be all sand dunes. A dead tree or something suggesting a dead tree in the fore ground, —and three dunes and a sky which seems to be more dunes. All very quiet, all almost of the academy, —but all removed by him into his created world. He seems to have suffered in the grand manner. Now they only talk about it, if they can afford to, to Freud. After these talks they paint something in the manner of Arthur B. Davies.

Fantastic Lovers:

A Pantomime

after

Paul Verlaine

"The air is too mild/Too blue the sky."

Time: *A tomorrow of the future.*

Scene: *A garden in bright sunlight. At back an emerald green drop. At each side of stage a curtain of some darker green. At left center a table with three vacant chairs around it. At extreme right a table at which sits three friends, Pierre, Jacques and Charles. Both tables are shadowed by huge garden umbrellas colored in stripes of raspberry and black. At extreme right stands the head-waiter, "Edward." At center around flower bed in which bloom white tulips. The costumes of the characters and the furniture suggest drawings of Lawrence Fellows.*

Characters: *A Head-waiter, Edward.*
Louis, a waiter.
Jean, a waiter.
Three friends:
(Pierre) (Jacques) (Charles)
Armand - un amant fantastique.
Rosalie - une amante fantastique.
A bird.

The curtain rises quickly, —as it rises "The Bird," which has been perched on the umbrella shadowing the table at left center flutters away; using for its exit a few notes played on a flute, from "St. Anthony's Sermon to the Birds," by Liszt. This music is used by the "Bird" throughout the pantomime. (a pause).

Then Jacques beckons to Edward who crosses the stage to him. The three friends after some indecision order something to drink. While this is taking place enter, languidly Armand and Rosalie, left, they take the table at left center.

Edward crosses stage; exit left. He returns, in a moment, with three drinks for Pierre, Jacques and Charles. After placing these on their table, he crosses to Armand and Rosalie, at center.

Edward:	(*in pantomime*) Bon-jour, Monsieur et Madame. Et quel desirez-vous?

Armand makes it understood that they will have nothing, at the moment, for they attend a friend. Edward withdraws to extreme left, as before. (a pause). After a moment of waiting, Rosalie lights a cigarette and shivers. Armand does the same. They converse languidly, Rosalie toys with a small gold box which contains cosmetics and a tiny powder puff with an ivory stick; Armand fingers nervously the tassels on his cane and also toys with a collection of bijoux at the end of his watch chain.

Edward watches him, using the expression, expected of a knight, anticipating a sight of the "Holy Grail."

Rosalie looks at the flowers and quivers.

Armand looks at the sky and sighs. He puts a smoked monocle to his eye.

The bird returns to the top of the umbrella over the table of Rosalie and Armand, after a moment it starts to sing merrily.

Armand looks at Rosalie in terror. Rosalie is on the point of fainting.

They say:	(*in pantomime*) What shall we do? No friend, "the air is too mild, too blue the sky." Now this.
Armand:	(*in pantomime*) Let's kill ourselves, die like lovers in Boccaccio.
Rosalie:	(*in pantomime*) Yes, —like lovers in Boccaccio, but how?

Armand takes from his pocket a tiny bottle filled with a luminous violet liquid, shows it to Rosalie and places it on the table between them.

Armand:	(*in pantomime*) It is done. We will die, like lovers in Boccaccio.

Rosalie starts to make up with green powder to lend death a greater pallor.

Armand places a card on the table with great nicety; after which act, he commences to polish his nails by nibbing the right hand on the palm of the left and vice-versa.

Edward who has overheard their plan rushes off left and returns, in a moment, in great excitement, with two green ices which he sets before them. Armand and Rosalie show some surprise. Edward stoically retires, to left, as before.

Rosalie:	Ices,
Armand:	Let's before we die.

They eat.

The Bird stops singing and after a moment's rest flies away.

Rosalie:	How good.
Armand:	Marvelous. (*a pause*)

They continue eating.

Rosalie:	(*looking at the flowers*) What lovely flowers.
Armand:	(*looking at the poison*) Come, like lovers in Boccaccio.
Rosalie:	(*looking at the sky*) What blue, how good to live, —no, tomorrow.

Armand: Tomorrow? Yes, —let's go. Tomorrow we will kill ourselves like lovers in Boccaccio.

They slowly prepare to leave. Edward is in ecstasy which is interrupted by Jacques again calling for a drink. Edward crosses stage. Exit left, Rosalie and Armand, less languidly. After them, exit Edward. He returns with drinks for Pierre, Jacques and Charles. After placing them on their table he crosses to the one left vacant by Rosalie and Armand. He sees the poison which has been forgotten by Armand.

Edward: Poison, at last, —at last. He takes it and dies by table at left center.

Jacques who is facing table at left center rises and crosses to him. The bird returns.

Jacques finding that Edward is dead, turns and takes a flower from flower bed, folds the hands of Edward on his chest and places the flower between them. Jacques then tries to find a handkerchief to cover the face of Edward, —he has forgotten or lost his own. He returns to table at right and borrows one from Charles. Charles produces a violet silk one; drawing it from his coat-sleeve. As Jacques returns with handkerchief to Edward, two waiters rush on from left, —he does not notice them, and, after calmly covering the face of Edward with the violet silk, he returns to table and takes his place.

The waiters, Louis and Jean, carry off the body of Edward. The bird meanwhile bursting into violent song.

Charles drinks his drink at one swallow, throws the empty glass over his shoulder and burying his head in his hands sobs convulsively.

The Bird uses a crescendo of trills as the curtain falls.
(curtain)

In Black and White

Three men are talking art around the studio door.

Another stands at the window, silently, looking into the street below.

Outside it is snowing.

He sees this, a high gray wall and a lamp post with lighted lamp.

Under the lamp post around the post itself is a tiny ring of black; around this is a broad one of white light thrown from the lamp above upon the snow.

Emerging out of the nocturnal dark a man is wending his way towards the ring of light.

He is caped and corduroyed, a workman.

As he nears the lamp post a woman appears in the ring of white light.

She has crossed straight from the opposite side of the street.

She speaks to him. He walks on. She puts out her hand to catch his coat.

He throws out his arm from the shoulder to ward her off.

But she clutches it at the bend of the elbow and starts talking and smiling. Holding him.

Against the wall outside the ring of light is seen another man. He is moving slowly; bent forward.

"Come and see the Steinlen?" says the man at the studio window. He looks back to the street. In the light he sees the woman's hands. They grip so tightly the coat sleeve of the stranger that they resemble claws.

The stranger gives his whole body a final shake, freeing himself. He moves on.

From the half light springs the other man.

Something happens.

A scream comes from the street. The stranger falls. A dark spot is forming on the snow.

From the window: "I was mistaken, it's a murder."

Untitled

Perhaps this is not a story at all and yet I think it is. Is life ever definite in its answer; is the story ever really finished? We can, all of us, imagine things to come after the end of a story, be the story our own or that of some other.

A young man, to call him a genius, would have flattered him, was painting in a garden. It was in the fore-noon, a summer-after-noon and the light which flooded the landscape was that of the sun, as it first touches the line of the tree-tops when it is going on its way to light the other side of the world. All the objects in the garden took from the light, for the moment, some of its color and quality and added them to their own. When the young man began to paint, all, things, seemed, to him, to glitter and to float in golden liquid so dazzling was the scene.

The priests walking in their black robes seemed about the same color as the children playing in their white dresses. Black and white, for an instant, were the same. It was this which he showed on his canvas.

A child, who was playing in the garden, watched eagerly by its nurse, came close to him to see what he was doing. "What lovely things he has for painting,—much nicer than mine. But then I never paint in the garden." The painter heard and was sorry for the child; he, too, never painted in the garden when he was its age. His paints had always been reserved for rainy days or for the times when he had been ill and he remembered that even on these rare occasions he only filled in outlines of animals with paint–animals whose twin brothers and sisters were on the opposite page, to be copied from, lurid in printer's ink.

The light became less dazzling, here and there, could be seen a fountain, a statue or person. But the painter saw none of this change. He wished not to see it because he wanted to give on his canvas that which had first impressed him.

A boy passed by him, quickly. "What had he to do with artists." And yet, in all his pride, he did not hesitate to take a flying glance, over his shoulder, at the work before the painter.

People were leaving —it was, now, late afternoon. There a child was taking a tiny sail boat from out the marble basin of the fountain and just behind that statue, a statue of "Jean d'Arc," one was struggling with its nurse and a large balloon. A soldier of the garden was beating a drum to tell the children, both old and young, that it was time to finish their games and to gather together their toys. The mists were forming on grass and streams, nurses were calling their small charges and the birds were singing from the —highest branches.

The painter feeling someone behind him, turned and saw a man, about his own age, and a girl. They were watching him paint. He looked at them in the same way as he had looked at the land-scape before him; to see the truth. They were confused (being really lovers) and started again on their lingering walk. She said: "A painter." But he replied "We love only each other, he must love all." I think perhaps, this other young man was a poet. The girl did not understand the meaning of what he had said, which, however, made her none the less happy. For a moment the garden seemed to regain its former splendor —then the light suddenly faded and it was dusk.

A man passed behind the painter.

And after him an old woman who stopped and looked and whispers to herself. "It is droll." Everyone was leaving the garden, more people passed behind him; some stopped, some passed on, some smiled, some looked at the painting without expression, some whispered and others frowned.

The sketch was finished and the artist, we can call him this in the last paragraph, the word means so little —anyway, put his brushes away, closed the paint box and tried to get some of the paint from off his hands. He was the last person to leave, it was now quite dark. After him the soldier of the garden who watches at the gate closed it for the night, at the same time sending a silly oath in the direction of the artist's back —but he did not hear. He was looking at the lights on the grand boulevard.

The Voyage Was Almost Over

The voyage was almost over. In fact, but a day and a night of it remained. It had been uneventful so far as captain and crew were concerned. The sea had not been disturbed by wind or storm for weeks. Some of the passengers, those who had crossed several times, the ones who really are bored by a slow ocean trip or they affecting this state, had been heard wishing for some "roll," wind, something; even a break in the engines. Ennui is a reckless state—perhaps the most reckless.

The steamer was very slow. The passengers were few. As the voyage came towards its end, they became like a party of old friends; friends out for the day on an excursion boat. It seemed impossible that but two weeks ago, they, with a few exceptions, had been strangers, one to the other. Some, the older ones, had discovered in others the possession of mutual friends, some mutual ideas, some affection. They were all more or less friendly; formality, at least, was laid aside. The women showed their clothes and jewels to each other. The men exchanged their stories, thereby showing themselves to each other.

On this night, the last one of the voyage, dinner had been gay. All planned, among themselves with those they liked best, meeting months or weeks hence in different parts of Europe. Cairo and Constantinople were also mentioned. Laughter and the pop of opening bottles were heard from around the long and narrow table.

Towards the end of the meal the table boys distributed crackers which opened with tiny explosives and contained paper hats wrapped in sentimental verse. Dinner was over. Everyone, wearing their hats, rose and moved towards the stairway which led to the upper decks. The Professor of Greek wore the hat of a Watteau shepherdess, the oldest woman that of a Harlequin and the infant prodigy a doctor's hood. As they ascended the stairs the light from above, touching their fantastic headgear, gave the effect of a beautiful Masque.

When group after group reached the first landing and the light struck their whole figure, showing their everyday clothes together with the paper hats, the picture was droll and sad; sad as comedies are sad.

An hour after dinner all the voyagers were on the upper deck in parties of twos, or of threes, or of fours, enjoying the calm sea, the sight of distant land and the moon-light which covered all. At the intervals when the bells sounded and the watch cried: "All's well," these groups would separate and change. A man from out of a party of two or three other men would rise, throw his cigarette into the sea, and join a girl walking with, but slightly in advance of, her mother or some other older woman. A woman would leave a husband and wife to go and lean alone at the rail.

Finally, after the bell had sounded many times and the moon was overhead, the deck seemed deserted with the exception of one man who still lingered alone. However, if one looked (this he had done) into the shadows cast by stacks and funnels, you would discover vague outlines. Outlines of forms which stood or sat but always in pairs.

The lone man walking the deck, rapidly at times and at others slowly, with head bent, saw the sea, the moon and the couples in the shadows. He gazed in turn at the golden moon, out upon the sea and stole fleeting glances at the lovers in the purple black shadows of the ship. He saw these things; better and more fully than anyone on board, perhaps. Sometimes, stopping by the rail and looking at the moonlit sea, he would think: it is like beautiful placid flesh seen through webs of blue and silver. Or again, as the moonbeams danced more merrily for a moment on its surface, how it resembled a huge purple fish caught in a gilded net. No, after all, it was more like a gigantic blue flower seen through the spray of a waterfall, he decided, and would continue his walk. All the pauses in his wanderings around and around the deck and the wandering, too, were full of these ideas; how like the ocean is to that and how like the golden moon in her turquoise sky is to this.

And the lovers on the deck, what were they like? He wondered. Vague lines of forgotten looks half-awakened in his memory as he glanced into the shadows which held a pair. But, somehow, he could not say of these, they are like this or that, as he could of the sea or night or of the moon.

He had felt all this before. Felt it in gay and noisy cafés, in crowded parks, at night when the music of a band was wafted to him by the hot summer breeze or on the streets crowded for a holiday or fête.

But to-night, above all preceding ones, he realized it more fully than ever before, and as he walked a greater anger against some unknown Thing filled him completely.

"Why, why was everything wonderfully made, perfectly made, and I given the power, above many, to appreciate this wonder and perfection? And yet denied the one thing which would perfect me, truly? If only a little white hand would beckon from without one of those mysterious shadows—then—well, then, to hell with these borrowed ideas. Then the sea would be no silly purple fish or blue flower but only a mighty living thing which somewhere beats against mightier existing coasts. I would know?"

And hate against some unknown Thing filled his soul.

He was passing the door of the ship's café. It was open. He turned toward it and stumbled. "Hello," said a man's voice and a girl's laugh. He went in. "How pale he looked. Surely, not sea-sick," said the same voice to his companion, who had not laughed. "Whiskey," said the lonesome man as he entered the tiny café. A sleepy steward got up from one of the tables where he had been dozing. After a time the drink arrived. "Another." But when the steward came back with the second order the room was empty.

The man went to his stateroom. The port-hole was open. He gazed out of it again upon the sea. And close to the ship, almost impossibly close, it seemed, two dolphins appeared for a moment on the surface and then quickly disappeared with their sensuous wriggles.

The port-hole went shut suddenly. The stateroom was at the same time flooded with light from the electric lamp above the dressing-stand. The man was on his knees fumbling with the lock of his steamer trunk. The lock opened with a clink and the lid half-raised of itself. Nervous hands were thrust into the top tray. No, it was not there. The tray and its contents were thrown hurriedly aside. The hands started their work again among the clothes in the bottom of the trunk, hesitated, and brought forth a white box. He remained a moment on his knees and then got upon his feet, half turned as though to attack the trunk; but, after a moment's indecision, he opened the box.

The box contained a book; a rare edition of a modern poet. Opening it at a fly-leaf and reading what was written there caused a faint color to return to his whitened face. He reached toward the dressing-stand, got and lighted a cigarette, threw himself upon the couch, turned the pages of the book until he was almost through them, and then read.

III.

Demuth in New York 1914-1920

Demuth returned from his second European trip in the spring of 1914 with a personal and aesthetic sophistication that made Lancaster and nearby Philadelphia seem confining. He therefore initiated a practice that would continue through 1920: dividing his time between Lancaster and New York, with summers spent in one of the New England seaside resorts favored by Manhattan's intellectual elite. This new pattern gave him greater social freedom and more extensive contact with the sophisticated, bohemian personalities of New York.

He seems at this time to have effortlessly established professional relationships within the art world. Hartley had written to Alfred Stieglitz from Europe in 1913 that a "chap named Demuth" would contact him.[1] By the fall of 1914 Demuth had become sufficiently friendly with Stieglitz that the dealer asked him to contribute to a special issue of *Camera Work* that would address the question "What is—'291.'"[2] By the spring, their relationship must have been closer, for Stieglitz had sent Demuth the first of several photographs he would make of him. Stieglitz, nevertheless, did not offer to handle Demuth's work, and Demuth turned for representation to Charles Daniel, to whom he had been introduced by Hartley when the older artist visited New York in early 1914.[3]

Daniel, a former saloon proprietor, had opened a gallery in March 1912 for the purpose of showcasing unknown, progressive American artists.[4] He offered Demuth a one-artist exhibition, to open in October 1914, and there began a relationship that would last until the closing of the gallery in 1932. Though Daniel had relatively little knowledge of art or culture, he had, as one of his artists, William Zorach, observed, "an instinct for the real in art and a belief in artists."[5] Yet his lack of intellectual glamour and personal magnetism in comparison to Stieglitz has tended to relegate him to a secondary status, even though his role in nurturing early twentieth-century American

Alfred Stieglitz
Charles Demuth, 1915
Platinum print, 9⅝ x 7⅝ in.
(24.4 x 19.4 cm)
The National Gallery of Art,
Washington, D.C.; The Alfred
Stieglitz Collection

art was equally decisive. And his aesthetic discernment was no less impressive than Stieglitz's: in becoming part of Daniel's gallery, Demuth joined company with Man Ray, Rockwell Kent, Yasuo Kuniyoshi, William Glackens, Stuart Davis, Max Weber, and William Zorach. Moreover, in the period between the closing of 291 in 1917 and the opening of Stieglitz's second gallery in 1925, Daniel supported many of Stieglitz's artists, especially Hartley and Marin.[6] During the 1920s, Daniel gained deserved recognition for identifying and promoting what became known as Precisionism; artists such as Charles Sheeler, Preston Dickinson, Niles Spencer, and Elsie Driggs were given their first exposure under his auspices.

Demuth's October 1914 exhibition consisted of twenty-five watercolors of the dunes and bay at Provincetown, Massachusetts, where Demuth had spent the summer. In these works, Demuth extended the vibrant color spectrum he had tentatively introduced in his Etretat landscapes (p. 30) and replaced his staccato syncopations with slow, undulating rhythms. The results, commended by critics, irrevocably established Demuth as a modernist. But they also recalled Marin's 1910 Tyrolean watercolors—enough that *The New York Sun*'s critic, Henry McBride, while acknowledging the quality of Demuth's Provincetown efforts, questioned whether they differed sufficiently from Marin's work.[7] Such comparisons would plague Demuth even after he and Marin had stylistically parted company. Daniel always maintained that these comparisons were the cause of Stieglitz's initial reluctance to handle Demuth's work. Thirteen years Demuth's senior, Marin had been one of Anshutz's stellar students at the Pennsylvania Academy; by 1914 he was enjoying spectacular success in vanguard art circles under Stieglitz's

auspices. Demuth had first seen Marin's work at Academy annuals while still a student.[8] Throughout his life, he consistently applauded Marin's achievements to Stieglitz and others and eventually owned five of the older artist's watercolors. In the teens, Marin's free, improvisatory handling of the watercolor medium offered Demuth a bridge between his earlier landscape style and a modernist vocabulary. Yet even in these watercolors, which approximated Marin's robust, extroverted expressions, Demuth was more restrained and aristocratic. Even he was aware of the greater delicacy and economy of his own work. He later commented that "John Marin and I drew our inspiration from the same sources. He brought his up in buckets and spilled much along the way. I dipped mine out with a teaspoon but I never spilled a drop."[9]

What Demuth's 1914 watercolors disclosed were his singular gifts as a colorist. He elevated color impressions over subject and allowed color to exercise compositional authority. His high color intensities bespoke his successful though idiosyncratic assimilation of the Fauves and of Kandinsky, whose painting-music analogies pervaded everything in American critical discourse that emphasized color sensations. Such intensities also mirrored the physical conditions of Provincetown, which Stuart Davis described as having "a brilliancy of light greater than I had ever seen and while this tended to destroy local color, it stimulated the desire to invent high intensity color-intervals."[10]

Demuth's commitment to color as a vehicle of mood and emotional content accelerated in 1915 as he added flowers to his pictorial repertoire. In contrast to his Provincetown landscapes, these floral images and their surrounding background space were brought close to the surface. By manipulating his motifs and the areas between and around them with equal intensity, Demuth created all-over patterns. Deftly controlling the amount of water he added to the medium, he also achieved mottled surfaces and subtle variations of tone which caused color to advance and recede. These are not florals in the traditional sense of still life but are explosive, animate landscapes which exude life; his bleeding of warm and cool colors further intensified the sense of a moving, breathing surface. Demuth varied enormously the amount of pencil outlining in these watercolors: some works contained none; in others the image was rendered almost entirely in pencil, with wash overlay employed only for surrounding or negative space.

These floral images simultaneously evoke figure and landscape forms. In *Three Figures in a Landscape*, Demuth treated outlined female bodies and body parts as if they were flowers or plants submerged in a landscape (Pl. 3).

Floating Flowers, 1915
Watercolor on paper, 17 x
11 in. (43.2 x 27.9 cm)
Grand Rapids Art Museum,
Michigan; Gift of Mr. and
Mrs. H.J. Bylan

Odilon Redon
Roger and Angelica, c. 1910
Pastel on paper mounted
on canvas, 36½ x 28¾ in.
(92.7 x 73 cm)
The Museum of Modern Art,
New York; Lillie P. Bliss
Bequest

A precedent for the anthropomorphizing of flowers was to be found in the *fin-de-siècle* literature Demuth admired. Emile Zola's *The Sin of Father Mouret* (1875), for example, described "The living flowers opened like naked flesh, like bodices revealing the treasures of breasts. There were yellow roses shedding the gilded skin of savage girls, straw roses, lemon roses, roses the color of the sun, all the subtle shades of necks bronzed by burning skies."[11]

Demuth's appropriation of literary sensibilities did not cease with the anthropomorphic transformation of flowers. In his 1915 floral studies with near-black backgrounds (Pl. 4), he pictorially approximated the sinister and melancholic mood that permeated Baudelaire's *Les Fleurs du mal*. While Baudelaire's theory of correspondences encouraged Demuth to try and create pictorial metaphors—images which implied comparison to other things—it was primarily the Symbolists' emphasis on introspection and emotional experience that found visual expression in Demuth's floral works. Demuth perceived a similarly introspective vision in the work of Odilon Redon, whom Huysmans' protagonist in *A rebours* had signaled out as among his favorite moderns. Demuth's friendship with Hartley in Europe would have furthered his conviction of Redon's worth. Hartley's appropriation of Redon's wash effects in his 1912–13 Cosmic Cubist paintings and his enthusiastic claim that he was "with" Redon, were not lost on the younger painter. Indeed, it is the ecstatic, almost tremulous, inner life with which Redon infused his work that provides an ancestry for Demuth's early floral studies.

Also influential on Demuth during this period, though not evident in his work until later (p. 129), was Walter Pater's call for an art that transcended the limits of a specific discipline and passed into the realm of other arts. Demuth had sought to achieve this as a writer through visually evocative texts; as a painter, he would eventually attempt to produce pictures that went beyond the static nature of painting and incorporated the temporal qualities more associated with literature. Such a synthesis had been implicit in Baudelaire's theories and in the equal prominence given illustration, format, and text in Demuth's model magazine, *The Yellow Book*, and in the would-be journal from his play *The Azure Adder*. "All great art is one in its complete state," as one of the play's characters stated.[12]

Even after 1917, when Demuth's floral images became tighter and more sparely conceived, they continued to evoke sentiments beyond those of the actual subject matter. In formal terms, Demuth replaced amorphous, all-over washes of color with clearly prescribed color areas. Figure and

ground were no longer integrated and the space surrounding the centralized motif was left blank; color, once highly saturated, became subdued. Nevertheless, these watercolors still retained intimations of the "cabalistic" secrets, vice, and Rosicrucian mystery Carl Van Vechten ascribed to them.[13] And certain observers, among them William Carlos Williams, perceived Demuth's post-1917 flower subjects as creating an explicitly sexual analogy between flowers and male genitals.[14]

The drive to create works that triumphed over pictorial specificity to enter the world of metaphoric allusion found an equally fertile outlet in the figurative watercolors which began to share Demuth's attention in 1915. These watercolors were essentially limited to vaudeville and circus themes and to genre portraits of the nightclubs, cafés, and bathhouses that Demuth frequented in Greenwich Village.

Thematically, Demuth's vaudeville watercolors (Pls. 23, 25, 27–35) reflected his appreciation of the troupes that he saw during this period at Lancaster's Colonial Theatre. He was not alone in his admiration; by 1905 vaudeville was America's most popular form of entertainment, with thousands of acts touring theaters across the country. Vaudeville was particularly suited to Demuth, for its integration of the spoken word with visual effects appealed to him as a playwright. Too, vaudeville's hiring of female impersonators (who drew a homosexual audience) made it, for Demuth, a subject simultaneously illicit and safe.

Vaudeville and circus acts had enjoyed a special place in the visual tradition. The clown, whether depicted by Watteau, Toulouse-Lautrec, or Picasso, embodied the tragic gap between life's outward glitter and its inner sadness. The clown thus became a symbol of the artist—isolated from, yet entertainer of, society. In Demuth's work, these European precedents became conflated with the vaudeville and circus subjects American realists took up around the turn of the century. Disinclined as Americans were to symbolic portraiture, the theme gave them a vehicle with which to herald popular American culture. And, indeed, vaudeville did seem a particularly American form of entertainment, notwithstanding its roots in the English music hall. Hartley lauded it as such in several articles and Demuth identified it and its successors as "really our stuff."[15] It was primarily to its Americanness that vaudeville owed its popularity among artists in the Arensberg clique: witness Picabia's 1913 watercolors of black jazz players, Gleizes' versions of the same subject of 1915, and De Zayas' illustrations of entertainers for the 1914 book

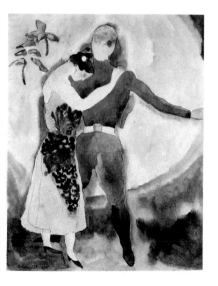

In Vaudeville: Soldier and Girlfriend, 1915
Watercolor on paper, 10¾ x 8¼ in. (27.3 x 21 cm)
Collection of Steve Martin

Vaudeville. Demuth and Hartley were sufficiently enthralled with the genre to generate a rumor about their future collaboration on an illustrated book on the topic.[16] Although the book never materialized, Demuth remained fascinated with the American popular stage and executed several "poster portraits" with Broadway themes in the 1920s (Pls. 95, 96).

Stylistically, Demuth's vaudeville and circus watercolors resembled his contemporary floral studies: high-intensity color deployed in all-over compositions in which foreground and background received equal emphasis. He treated the supple pencil lines which established the figures' general contours merely as loose armatures through which colors bled. The only exceptions were facial areas, which retained a more precise and illustrational style. As with his floral watercolors, value contrasts and variations in color density within amorphous color areas created an animate, atmospheric surface that visually advanced and receded. Demuth's conjunction of a Fauve palette, pulsing rhythms, and figurative subject matter linked him to concurrent Expressionist tendencies in Europe.

By 1917, the free handling of color stains in these vaudeville watercolors had given way to more decisive compositions, forceful color, and an even greater expressive power. Demuth replaced amorphous color stains with an abstract rhythmic structure of concentric bands of light emanating from a circular center—a structure which suggests the influence of his contemporaries Arthur Dove and Georgia O'Keeffe. In *Acrobats* (Pl. 35), for example, Demuth's spotlights of intense yellow and orange, graduated in concentric bands which died away into mauve, silhouetted the arched, dark-colored body of his acrobat. Yet unlike Dove and O'Keeffe, Demuth did not present his elegant orbs as organic symbols for light; rather, they were meant to evoke intimacy and perfumed decadence.

The undercurrent of sensuality which permeates Demuth's post-1917 vaudeville and circus scenes owes its presence to the bohemian world of New York in which he had been living since 1914. Demuth first encountered the leading personalities of New York's vanguard during the summer of 1914 in Provincetown. Then still a small fishing village off the tip of Cape Cod, it had been quietly heralded as a retreat several years earlier by a group of vanguard writers, among whom were Mary Heaton Vorse, Hutchins Hapgood, his wife Neith Boyce, and Susan Glaspell and her husband, George Cram Cook. By 1914, this nucleus had expanded to include much of the staff of *The Masses*, a left-wing, collectively owned magazine that became known in

the teens as one of America's "dangerous" periodicals because of its opposition to capitalism and to American participation in World War I.[17] Politically radical, the magazine was dominated by the visual aesthetic of Ashcan Realism, particularly that of John Sloan.[18] Among those within the orbit of *The Masses* in Provincetown that summer were New York salon hostess Mabel Dodge, and Polly Holliday, whose Greenwich Village Inn in New York was a meeting place for *The Masses* staff. Holliday's boarding house in Provincetown, where Demuth roomed that summer with Stuart Davis, provided him with his initial introduction to these Greenwich Village radicals. The challenge these people presented to the existing social order was not limited to politics. Their quest for liberation was also acted out in sexual and artistic arenas. It was, as Mabel Dodge wrote, "one stream whence many currents mingled together for a little while."[19] It was an optimistic time, when the betterment of the world through political and social change seemed not only possible but imminent; when, as Max Eastman remarked: "There was a sense of universal revolt and regeneration, of the just-before-dawn of a new day in American art and literature and living-of-life as well as politics."[20] Although Demuth remained untouched by the militant political ideologies advocated by the Provincetown group, he seems to have responded enthusiastically to their life-styles and to their philosophies of art and literature.

Demuth returned to Provincetown four times over the next six years (in 1915, 1916, 1918, and 1920). Each year the circle of Provincetown habitués grew as travel abroad became increasingly curtailed by the war in Europe. In 1916 Hartley, having returned from Germany, was there as the guest of John Reed and Louise Bryant. That summer also saw the beginning of Demuth's friendship with Eugene O'Neill and the inception of the Provincetown Players. Demuth was a peripheral member of this theater troupe. He played a lead part as Marmeduke Marvin, Jr., a young artist, in George Cram Cook's *Change Your Style* and appeared in Mary Heaton Vorse's *A Girl on the Wharf*, reciting the line "Oh my God."[21] He continued his association with the group that fall in New York when the members followed Reed's suggestion to organize as the Provincetown Players in Greenwich Village.

Greenwich Village was the nexus of cultural rebellion during the teens. And it was there that Demuth rented an apartment (on Washington Square South) during the winter of 1915–16; he later stayed for extended periods at the Brevoort Hotel. His haunts were those of the Village's intellectual elite:

Charles Demuth and Eugene O'Neill in Provincetown, 1916
Photograph courtesy Louis Schaeffer

Mabel Dodge's salon at 23 Fifth Avenue, the Hotel Brevoort's basement café, which attracted French artists who had fled war-torn Europe, and the Village's two famous saloons, The Working Girl's Home and The Hell-Hole. Here and at Polly Holliday's and Christine Ell's restaurants, Demuth established friendships with those who were seeking to change the cultural and political climate of America. He was also a regular at Louise Bryant and John Reed's apartment and, further uptown, at the salons of Walter and Louise Arensberg, the Stettheimer sisters, and Edgar Varèse.

For Demuth, these years in New York were filled with heavy drinking and late-night forays to underground nightclubs.[22] Drugs, too, were part of this ambience, and there was at least one rumor that he experimented with heroin.[23] Barron Wilkin's in Harlem and Marshall's, the black-owned jazz club on Fifty-third Street, were two of Demuth's favorite haunts. These nightclubs, although fashionable to some, were considered outside the limits of bourgeois propriety. Yet it was precisely the intermingling of races and the clubs' identification with an exotic community in which uninhibited and passionate instincts seemed to be allowed free rein that attracted a sophisticated, white audience. They also provided a milieu in which both homosexual and heterosexual openness found sanction.[24] Demuth was forthright about his patronage of these establishments and executed at least one watercolor of himself, Duchamp, Van Vechten, and Edward Fiske enjoying themselves at these clubs. The response of conservative society to this subculture is epitomized in Henry McBride's ironic review of Demuth's work in 1917: "How revolting for instance must have been Baron Wilke's [sic] establishment? It has been closed by the police some time since. . . . Yet I hold it was entirely right of Mr. Demuth to have studied it so evidently in the interests of higher morality. What excuses young Mr. Duchamp and young Mr. Fiske can offer for descending into such resorts I cannot imagine. . . . It is all very well for the great Baudelaire to do such things but in America there is an entirely different conception of what is and what is not permissible. . . . I candidly confess that the view of Baron Wilke's restaurant . . . alarms me."[25]

Demuth's crowd embraced sexual permissiveness as a means of setting itself apart from bourgeois mores and conventional respectability. In this effort, New York's bohemians were encouraged by Freud, whose ideas were ubiquitously promulgated in the Village. On a purely social level, the techniques of psychoanalysis became a form of entertainment: games of free

association and dream interpretation abounded at Village parties, and members of The Liberal Club—located above Polly Holliday's restaurant—played parlor games of "associating" their thoughts with lists of words and then trying to unravel their meaning according to the "Freudian formula."[26] Such habits were so widespread that, as Susan Glaspell complained, "you could not go out to buy a bun without hearing of someone's complex."[27]

More significant in establishing the atmosphere of sexual leniency in Demuth's crowd were the articles Max Eastman and Floyd Dell wrote on Freud and the interpretations advanced by Dr. A.A. Brill, the English translator of Freud's clinical reports and book on dream analysis.[28] Brill, who delivered the first American lecture on psychoanalysis at Mabel Dodge's salon, felt that Freud had equated sexuality with the life-force. Following Brill, Village radicals quickly appropriated the notion that inhibitions were unhealthy and that social freedom and sexual permissiveness were prerequisites of personal liberation. Freud's concept of repression, they believed, had provided a scientific defense of free love. As one Village denizen noted, "we all had a rationale about sex—we had discovered Freud—and we considered being libidinous a kind of sacred duty."[29]

Although most of this libertinism was heterosexual, homosexuality found a more tolerant atmosphere here than it did in mainstream America. While it was not even explicitly discussed in *The New York Times* until 1926, the theories of sexologist Havelock-Ellis on the viability of homosexuality as an alternative life-style were widely championed in Greenwich Village circles, and homosexual literature was extensively debated—so much so that Margaret Anderson, the lesbian editor of the widely read journal *The Little Review*, lambasted a guarded portrayal of homosexuality given by Ellis' wife because it failed to recognize that the audience was already well steeped in homosexual issues.[30]

Nevertheless, outside of these limited circles homosexuality was still a liability. Oscar Wilde's imprisonment for homosexual acts in 1895 was recent enough to make the motivation for "passing" as straight extremely high, especially in America, where such an act could bring up to twenty years in prison. Even benign expressions of intimacy between males engendered assault: in 1916 *The Masses* published Sherwood Anderson's poignant story "Hands," about the lifelong torment undergone by a sensitive schoolteacher who had been beaten and almost lynched in a small Pennsylvania town for affectionately touching his male pupils.

Camouflaging homosexuality was therefore a frequent recourse for members of the gay subculture. Demuth seems to have managed to do it quite well, for the contemporary accounts of these years associate him more with female infatuations than with male ones.[31] There even existed a tale—told by Demuth—of an aborted marriage proposal to a "ruined" woman.[32] At this stage in his life, Demuth may well have been in conflict about his sexual orientation and on one level wished that he could be straight. That he enjoyed female companionship is clear from the number of female friends he had throughout his life.[33] O'Neill, in modeling the character of Charles Marsden in *Strange Interlude* after Demuth, portrayed him as sexually ambivalent.[34] Unable to separate himself from a strong, protective mother, Marsden is unsure about his sexual inclinations, "one of those poor devils who spend their lives trying not to discover which sex they may belong to!"[35]

Nevertheless, a likely explanation for Demuth's heterosexual image is that his homosexual adventures were lived out more in his imagination than through actual encounters. If so, these internalized fantasies would have found an outlet in his art, thereby giving it the undercurrent of sexuality most critics have observed. Such visual allusiveness had a parallel in the work of Demuth's friend Marcel Duchamp. Duchamp was a key figure in the circle around Louis and Walter Arensberg (which was, not incidentally, a nucleus for discussions of Freud and dream analysis).[36] The Arensbergs had moved to New York in 1914 and had immediately begun to amass a major collection of works by Picasso, Braque, Rousseau, Gleizes, Matisse, and Brancusi. Their close association with Duchamp, begun when the French artist arrived in America in June 1915, had catapulted the couple into a pivotal role as host to an international coterie of artists and writers who were fleeing the war in Europe.[37] Demuth spent a great deal of time in Duchamp's company in New York; together they frequented Village dives and Harlem jazz clubs. Both artists possessed a wry sense of humor and a hatred of pretense; both were dandies who exploited elegance and aloofness as shields against self-knowledge and an exterior world which they deemed inferior.[38] In their art, their sedulously maintained aversion to obvious effort masked an almost obsessive attention to work and craft.

Duchamp exerted an important influence on Demuth. During the teens, he provided a model for the simultaneous flaunting and camouflaging of sexual imagery. The theme of Duchamp's construction, *The Bride Stripped Bare by Her Bachelors Even* (*The Large Glass*), which Demuth characterized as

"the greatest picture of our time," was the pursuit of woman by man.[39] Like Demuth, Duchamp was pessimistic about sexual fulfillment, for he left the piece unfinished in precisely those areas in which the bachelor was to unite with the bride and consummate his sexual desires. More scatological was *Fountain*, the ready-made Duchamp submitted under the name R. Mutt to the 1917 Society of Independent Artists. *Fountain*, an everyday white porcelain urinal, was the perfect erotic object: female in form yet designed exclusively for male functions.[40] As a symbol it exuded an obvious yet undefinable eroticism for which the artist could not be held fully responsible. Demuth's understanding of Duchamp's accomplishment is revealed in his poem "For Richard Mutt," which was published in *The Blind Man*: "One must say everything—then no one will know. To know nothing is to say a great deal."[41] Duchamp's excursions into erotic territory also extended to trans-sexualism. Its first manifestation was his androgynous version of the *Mona Lisa*, a self-conscious allusion to Leonardo's homosexuality as posited by Freud; its title *L.H.O.O.Q.* Duchamp translated as "there is a fire down below." More explicit was Duchamp's cross-sexual alter ego Rrose Sélavy— itself a pun on "eros c'est la vie." Dressed as a woman and documented as such in a Man Ray photograph, this "female" persona signed (or co-signed) much of Duchamp's work after 1920.[42]

Duchamp was not the only artist in the Arensberg group to be pre-occupied with sex. Picabia's machine drawings from the period are equally rich with symbolic references to sexual conquest, as are Man Ray's sculptures.[43] Arensberg himself was engaged in deciphering the sexual symbolism of *The Divine Comedy*; he evolved a theory that hell, purgatory, and paradise represented parts of Dante's mother's reproductive organs, through which Dante was to be reborn, via incestuous love.[44]

It was the bohemian New York milieu—its libertine as well as its relatively innocuous aspects—that Demuth's genre watercolors documented. *The Purple Pup* (Pl. 17) finds Demuth in one of the swish new tearooms that began to proliferate in the Village in the late teens. In *At the Golden Swan*, Demuth depicted himself, Duchamp, and Edward Fiske in the popular but dingy saloon dubbed "The Hell-Hole" by its clientele of writers, thugs, and petty thieves (Pl. 18). Mary Vorse described the saloon's atmosphere as "something at once alive and deadly . . . sinister. It was as if the combined soul of New York flowed underground and this was one of its vents."[45] The Hell-Hole was

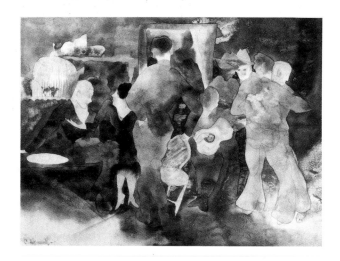 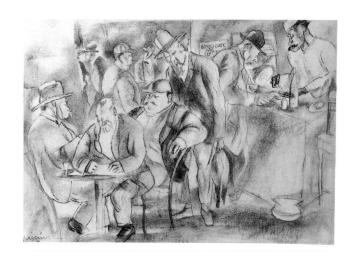

O'Neill's favorite Village haunt and its patrons furnished models for most of the major characters in *The Iceman Cometh*. During Prohibition, its proprietor's "pull" with Tammany Hall made it one of the few places in New York that served liquor.

Though the realist approach to these genre subjects harked back to Demuth's tutelage at the Pennsylvania Academy, their rendering recalls the work of Jules Pascin, who spent the war years in America. Both artists exploited the same informal, free drawing and the same comingling of sensitive mood and sophistication. In both, the play of delicate stains and blushes of tone against sinuous contours suggests an aura of romantic decadence. This aura is pronounced in Demuth's watercolors of the Harlem jazz clubs he frequented. In *Negro Jazz Band* (Pl. 19), dark background tones join with contorted gestures and masklike visages of black performers to suggest the steamy atmosphere, exoticism, and sense of densely pressed bodies associated with the establishments that McBride described with such horror.

Demuth ventured even more overt representations of illicit subjects in his watercolors of male bathhouses.[46] While such establishments were not necessarily homosexual, they did offer possibilities for voyeurism and contact with a gay clientele. The Lafayette Baths, whose homosexual orientation precipitated a 1929 police raid, is reputed to have been the source for Demuth's 1918 *Turkish Bath* (Pl. 20).[47] The inclusion of a probable self-portrait in the center foreground, coupled with the genital exposure at left and suggestion of incipient fellatio in the background, overtly speaks for Demuth's identification with a homosexual milieu. Yet in other depictions of baths, Demuth was less explicit and the implications of sexual intimacy are presented in ways that

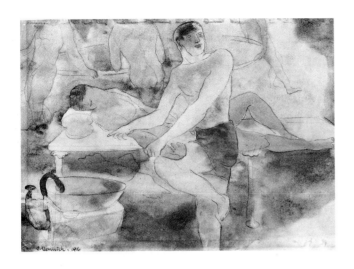

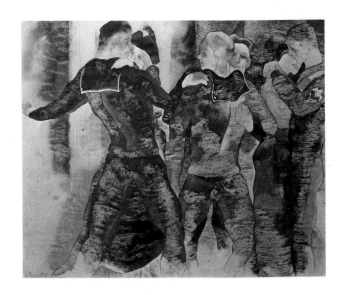

Left

Turkish Bath, 1916
Watercolor on paper, 7⅝ x
11 in. (19.4 x 27.9 cm)
Private collection, on loan to
the Harvard University Art
Museums, Fogg Art Museum,
Cambridge, Massachusetts

Right

Dancing Sailors, 1918
Watercolor and pencil on
paper, 7⅞ x 9⅞ in. (20 x
25.1 cm)
The Museum of Modern Art,
New York; Abby Aldrich
Rockefeller Fund

make alternative readings possible. *Turkish Bath* from 1916 initially appears simply to describe a massage being given to a nude man. A closer reading, however, reveals that Demuth has exaggerated the spout of the wash basin to mimic a penis.[48]

Veiled references to intimacy and erotic symbolism abounded also in Demuth's post-1917 vaudeville watercolors. In works such as *In Vaudeville, the Bicycle Rider* (Pl. 33), whose bicycle handlebar is a genital surrogate, the symbolism is homoerotic. In isolated instances such as *In Vaudeville* (private collection) with its overt representation of a female dancer's vagina, Demuth shows a willingness to portray heterosexual eroticism. More characteristically, in *Tumblers* (Pl. 34), Demuth alluded to sexual intimacy between woman performers by intertwining their acrobatic bodies. This coded portrayal of same-sex relationships also found expression in Demuth's images of sailors dancing together. Although he depicted two heterosexual couples in *Dancing Sailors*, the women are compositionally incidental: the focus of the work is the sexual attraction between the sailors—described both by longing gazes between two of them and by the physical intimacy of the two who are actually dancing together. Sailors had long been associated with loose sexual activity. As Herman Melville put it in *White Jacket*, "sailors, as a class, entertain the most liberal notions concerning morality . . . or rather, they take their own views of such matters."[49] While Demuth's depictions drew on these associations, his own involvement was disguised by reality: the buildup of military personnel occasioned by the war filled the night spots of port cities with sailors; on one level, therefore, these watercolors could be simply pictorial documentations of an actual environment.

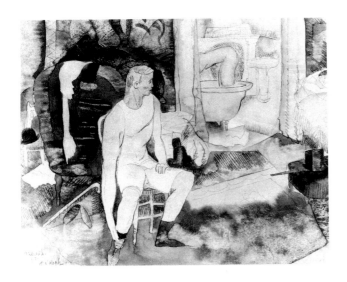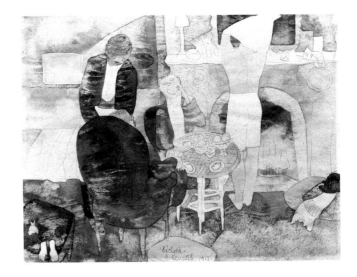

Left

Eight O'Clock (Morning #2), 1917
Watercolor on paper, 7⅞ x 10³⁄₁₆ in. (20 x 25.9 cm)
Wadsworth Atheneum, Hartford; The Philip L. Goodwin Collection

Right

Eight O'Clock (Evening), 1917
Watercolor on paper, 8 x 10⅜ in. (20.3 x 26.4 cm)
Wadsworth Atheneum, Hartford; Gift of George J. Dyer

All of Demuth's figural works in this period are essentially narrative—they imply a story and seem to be fragments of a larger plot which the viewer is invited to complete. In some groups of works, Demuth made sequentiality explicit by including the same characters at different times of the day—as in his 8 O'Clock Morning and Evening series (Pl. 24), with its implications of homoerotic activity about to happen or having already occurred. Demuth also pictorialized the implications of a past and present through the representation of movement in a single picture. He did this in his circus and vaudeville scenes by integrating the gesturally animated figures with the background. Just as in long-exposure photographs of moving bodies, here the separation between background and image is made indistinct by bleeding the motioned parts of figures into the background, thereby fusing the two spaces. This concept echoed, albeit indirectly, Futurism's melding of an object with its surroundings. Although Demuth eschewed the Futurists' representation of simultaneity, he was as keen as they were about expressing movement and the passage of time. Even his choice of themes was similar: the cabaret and the dance-hall were orthodox Futurist subjects because they represented city life at its brightest and most "kinetic." But whereas the Futurists focused on the simultaneity of action, Demuth, perhaps influenced by his involvement with playwriting and performance, attempted to distill in a single work of art the kind of reflective memory of past actions associated with the experience of theater.

Even more kinetic is the group of fish watercolors Demuth executed between 1916 and 1917 (Pls. 10, 11).[50] These pictures depend exclusively for their structure on color, which floods the paper in wet, shifting tints. Meandering

pencil outlines of fish provide the only image in what otherwise is a field of richly colored wash. In their all-over compositions and reliance on color as structure, these works are extensions of the formal characteristics of Demuth's 1915 flower subjects. They demonstrate Demuth's willingness to move freely around different subject matters and styles to explore pictorial issues and means—an approach that would become more pronounced as he began experimenting with a Cubist vocabulary.

Notes

1. Quoted in Pamela Edwards Allara, "The Water-Color Illustrations of Charles Demuth" (Ph.D. dissertation, Johns Hopkins University, Baltimore, 1970), pp. 20–21. Hartley functioned as a social conduit for many during this period; he introduced William Carlos Williams and Alfred Kreymborg to Stieglitz as well.

2. This issue of *Camera Work* was dated July 1914 but was not published until January 1915. Demuth's contribution must have been relatively late, for his essay mentions an exhibition of African sculpture which was held at 291 between November 3 and December 8, 1914.

3. For further information on Daniel, see Elizabeth McCausland, "The Daniel Gallery and Modern American Art," *Magazine of Art*, 44 (November 1951), pp. 280–85; "Daniel's Return," *Newsweek*, 20 (November 1942), p. 24; William Zorach, *Art Is My Life* (New York: The World Publishing Company, 1967), pp. 38–39.

4. According to McCausland, "The Daniel Gallery and Modern American Art," p. 280, Daniel opened his gallery in December 1913; that date has heretofore been accepted. It was in March 1912, however, that Daniel opened his gallery; see "Around the Galleries," *American Art News*, 10 (March 16, 1912), p. 8.

5. Zorach, *Art Is My Life*, p. 39.

6. The sales of Marin watercolors to Daniel's gallery patron Ferdinand Howald kept Marin financially solvent during the 1920s. For Howald, see Mahonri Sharp Young, "Ferdinand Howald and His Artist," *The American Art World*, 1 (Fall 1969), pp. 119–28.

7. Henry McBride, "What Is Happening in the World of Art," *The New York Sun*, November 1, 1914, section 6, p. 5. Reprinted in Daniel Catton Rich, ed., *The Flow of Art: Essays and Criticisms of Henry McBride* (New York: Atheneum Publishers, 1975), p. 69.

8. Demuth to Alfred Stieglitz, June 18, 1928, Stieglitz Collection, Collection of American Literature, Beinecke Rare Book and Manuscript Library, Yale University, New Haven (hereafter cited as Yale).

9. Quoted in George Biddle, *An American Artist's Story* (Boston: Little, Brown & Company, 1939), p. 216. Robert Locher disattributed this quotation and protested that the bucket analogy was not one Demuth would have used; see Locher in Emily Farnham, "Charles Demuth: His Life, Psychology and Works," 3 vols. (Ph.D. dissertation, Ohio State University, Columbus, 1959), III, p. 959. Locher was wrong, however, for Marin referred to it in a letter to Alfred Stieglitz on July 30, 1933: "I find that I begin to think about (Oil paint) when the wells begin to get low—which bears out Demuth's vision of Marin and his slopping water buckets"; see Dorothy Norman, *The Selected Writings of John Marin* (New York: Pellegrini & Cudahy, 1949), p. 151.

10. Quoted in E.C. Goossen, *Stuart Davis* (New York: George Braziller, 1959), p. 16.

11. Quoted in Bram Dijkstra, *The Idols of Perversity* (New York: Oxford University Press, 1986), p. 242.

12. Charles Demuth, *The Azure Adder*, published in *The Glebe*, 1 (December 1913), p. 11.

13. Carl Van Vechten, "Pastiches et Pistaches: Charles Demuth and Florine Stettheimer," *The Reviewer*, 2 (February 1922), pp. 269–70.

14. Williams, quoted in Farnham, "Charles Demuth," III, p. 990. Williams may have encouraged the sexual undertones in Demuth's work since his own poetry is replete with sexual metaphors. He consistently equated flowers with sexual parts and once likened the artist's use of subject matter from life to the implantation of sperm; see William Marling, *William Carlos Williams and the Painters: 1909–1923* (Athens, Ohio: Ohio University Press, 1982), pp. 133, 164.

15. For the full text of the quoted passage from Demuth's *"You Must Come Over," A Painting: A Play*, see pp. 41–42 above. Harley's three articles on vaudeville are: "The Twilight of the Acrobat," *The Seven Arts*, 1 (January 1917), pp. 287–91; "Vaudeville," *The Dial*, 68 (March 1920), pp. 335–42; "The Greatest Show on Earth: An Appreciation of the Circus from One of Its Grown-up Admirers," *Vanity Fair*, 22 (August 1924), pp. 33, 88.

16. See A.E. Gallatin, *American Water-colourists* (New York: E.P. Dutton & Company, 1922), p. 24.

17. For *The Masses*, see Rebecca Zurier, *Art for The Masses 1911–1917: A Radical Magazine and Its Graphics*, exhibition catalogue (New Haven: Yale University Art Gallery, 1985).

18. The epithet "Ashcan Realism" had, in fact, first been used by Art Young to describe reproductions in *The Masses* of "pictures of ash cans and girls hitching up their skirts in Horatio Street"; quoted in ibid., p. 119.

19. Quoted in Judith Katy Zilczer, "The Aesthetic Struggle in America, 1913–18: Abstract Art and Theory in the Stieglitz Circle" (Ph.D. dissertation, University of Delaware, Newark, 1975), p. 6.

20. Quoted in Zurier, *Art for The Masses*, p. 77.

21. *Change Your Style*, playbill courtesy Adele Heller, Provincetown. For *A Girl on the Wharf*, see Farnham, "Charles Demuth," I, p. 88 n. 35.

22. See Farnham, "Charles Demuth," III, pp. 952, 984. Even after Prohibition Demuth looked back fondly on these days of free-flowing alcohol. He wrote to Eugene O'Neill in 1919 that he was spending February in New York "for what reason I'm sure I don't know, these days of wood alcohol"; he couched his desire to travel to London in these terms: "I must have a drink on some street corner of the world soon, or burst"; Demuth to O'Neill, n.d. [December 1919], Yale. Demuth's sense of his own degeneracy is revealed by his ironic response to a question in 1924 about his happiest and unhappiest moments. Neither answer, he felt, could be printed: "Of course, you got away with 'Ulysses' but you couldn't really, with my answers to these two"; *The Little Review*, 10 (May 1924), p. 30.

23. Louis Sheaffer, *O'Neill: Son and Playwright* (Boston: Little, Brown and Company, 1974), p. 410.

24. For Harlem as a territory of the homosexual subculture during this period, see Gerard Kosovitch, "A Gay American Modernist: Homosexuality in the Life and Art of Charles Demuth," *The Advocate*, June 25, 1985, pp. 50–52.

25. Henry McBride, "An Underground Search for Higher Moralities," *The New York Sun*, November 25, 1917, section 5, p. 12. The watercolor of Barron Wilkin's to which McBride referred has not been found.

26. See Lois Rudnick, *Mabel Dodge Luhan* (Albuquerque: University of New Mexico Press, 1984), p. 71. For The Liberal Club, see Robert E. Humphrey, *Children of Fantasy: The First Rebels of Greenwich Village* (New York: John Wiley & Sons, 1978), p. 228.

27. Susan Glaspell, *The Road to the Temple* (New York: Frederick A. Stokes Company, 1927), p. 250.

28. See Floyd Dell, "Speaking of Psycho-Analysis," *Vanity Fair*, 5 (December 1915), p. 53; Max Eastman, "Exploring the Soul and Healing the Body," *Everybody's Magazine*, 32 (June 1916), pp. 741–50; Eastman, "Mr. -Er-Er-Oh! What's His Name? Ever Say That?" *Everybody's Magazine*, 33 (July 1915), pp. 95–103.

29. An unidentified friend of Eugene O'Neill, quoted in Arthur and Barbara Gelb, *O'Neill* (New York: Harper and Brothers, 1962), p. 324.

30. Margaret C. Anderson, "Mrs. Ellis's Failure," *The Little Review*, 2 (March 1915), pp. 16–19.

31. During the years 1909–19 several of Demuth's friends commented on his female relationships. Stuart Davis observed that in Provincetown Demuth "had kind of a crush on her [Helene Iungerich], you might say"; see Farnham, "Charles Demuth," III, p. 971. Similarly, Helen Henderson said that "Charles, at this time [summer 1914] was smitten with Helene Iungerich"; see Henderson, fragment of a letter, recipient unknown, August 12, 1940, Richard Weyand Scrapbooks (see Chap. 1, n. 28), Appendix, p. 70. Hutchins Hapgood remarked that Polly Holliday "gave herself over to the subtle charm of Demuth"; see Hapgood, *A Victorian in the Modern World* (1939; ed. Seattle: University of Washington Press, 1972), p. 390. Robert E. Humphrey reported that Demuth was romantically interested in Holliday; see Humphrey, *Children of Fantasy*, p. 76. Georgia O'Keeffe stated: "I knew one of his girl friends who gave me a beautiful shell because she knew he had always wanted it, and she wanted him to see that she gave it to me"; quoted in Abraham A. Davidson, "Demuth's Poster Portraits," *Artforum*, 17 (November 1978), p. 54. In 1915 William Carlos Williams decided that some deep scratches on Demuth's back had been made by a woman; *The Autobiography of William Carlos Williams* New York: Random House, 1951), p. 151.

32. An account of Demuth's aborted marriage proposal is found in Helen Henderson, fragment of a letter, recipient unknown, August 12, 1940, Richard Weyand Scrapbooks, Appendix, pp. 69–70. According to Henderson, Demuth told her that one summer in New Hope he fell in love with and proposed to Emmasita Register, who refused him on the plea that she was "ruined and could never honourably become any man's wife." Demuth, who adduced that she had syphillis, described being so alarmed that he immediately exited out her back window in an attempt to avoid any friends who may have been waiting for him to come out the door. Farnham claimed that Demuth was associated with another marriage proposal, based on a photograph of a young woman that Farnham believed Demuth had sent to his cousin Pauline Cooper. Written on the back was the message "Marco Sullivan as she is. Incidentally, this will serve to announce the fact that we are engaged"; Farnham, *Charles Demuth: Behind a Laughing Mask* (Norman,

Oklahoma: University of Oklahoma Press, 1971), p. 128. The postcard was found among Locher's possessions and Farnham assumed it had been written by Demuth. However, the writing on the card is not Demuth's.

33. See Farnham, "Charles Demuth," III, pp. 971, 973. Demuth's close friends at the Pennsylvania Academy and in Lancaster were women, in particular Helen Henderson, Letty Malone, and Dorothy Schroeder. Susan Street, whom Demuth met in Provincetown in 1914, Florine Stettheimer, and Georgia O'Keeffe were among his closest friends in later years.

34. Although associated with Hartley because of the name, the character of Charles Marsden possesses few of Hartley's traits. That he is based primarily upon Demuth is confirmed by O'Neill scholars; see Louis Sheaffer, *O'Neill: Son and Artist* (Boston: Little, Brown and Company, 1973), p. 242.

35. Eugene O'Neill, *Strange Interlude*, in *Three Plays of Eugene O'Neill* (New York: Vintage Books, 1959), p. 86. The character of Marsden obviously extended beyond Demuth and even incorporated fragments of O'Neill's personality—his fear of impotence, his strain of hostility to women, and his disdain for the commercial aspects of art. O'Neill's comment that he had "known many Marsdens on many different levels of life and it has always seemed to me that they've never been done in literature with any sympathy or real insight" would indicate that the character reflected many of O'Neill's general ruminations; see Sheaffer, *O'Neill: Son and Artist*, p. 242.

36. Freud and dream analysis were frequent subjects of discussion at the Arensberg salon due to the habitual presence of Dr. Elmer Ernest Southard, director of the Boston Psychopathic Hospital and a close friend of Arensberg.

37. For the Arensbergs, see Francis Naumann, "Walter Conrad Arensberg: Poet, Patron, and Participant in the New York Avant-Garde, 1915–20," *Philadelphia Museum of Art Bulletin*, 76 (Spring 1980), pp. 2–32. For Demuth's close association with the Arensbergs, see also Mina Loy, "O Marcel . . . Otherwise I Also Have Been to Louise's," *The Blind Man*, no. 2 (May 1917), p. 14.

38. See Moira Roth, "Marcel Duchamp in America: A Self Ready-Made," *Arts Magazine*, 51 (May 1977), pp. 92–96.

39. Demuth to Stieglitz, February 5, 1929, Yale.

40. For the urinal as the perfect erotic subject, see Kermit Champa, "Charles Demuth," unpublished manuscript, 1973, p. 19, and Champa, "'Charlie Was Like That,'" *Artforum*, 12 (March 1974), p. 58.

41. Charles Demuth, "For Richard Mutt: One must say everything,—then no one will know. / To know

nothing is to say a great deal. / So many say that they say nothing,—but these never really send. / For some there is no stopping. / Most stop or get a style. / When they stop they make a convention. / That is their end. / For the going every thing has an idea. / The going run right along. / The going just keep going. "; in *The Blind Man*, no. 2 (May 1917), p. 6.

42. New York Dadaists engaged in similar cross-dressing. The April 1921 issue of *New York Dada*, for example, announced the debutante "coming out" of Hartley and Joseph Stella and described Hartley's female dress; see "Pug Debs Make Society Bow," *New York Dada*, April 1921, p. 3.

43. See Francis Naumann, "Cryptology and the Arensberg Circle," *Arts Magazine*, 51 (May 1977), pp. 127–33. Picabia's *Voilà Elle* depicts a pistol and a target, linked by a mechanical device. The pistol's alignment with the target keeps it from hitting the bull's-eye if fired; the mechanical link between the gun and the target implies that the gun would be re-cocked and re-fired every time it hit the target, thereby instigating a repetitive action reminiscent of the automatic lovemaking in Duchamp's *Large Glass*. Man Ray's sculpture *Presse-papier à Priape* resembled an erect phallus and scrotum. Its title, "paper weight for Priapus," makes its sexual allusion even more compelling, since Priapus was the fertility god of Greek and Roman legend whose most notable feature was his enormous genitalia.

44. Arensberg's theory was greeted in the press with the charge that "the writer of *The Divine Comedy* was not a gynecologist; he was a poet"; quoted in Naumann, "Cryptology and the Arensberg Circle," p. 128.

45. Quoted in Sheaffer, *O'Neill: Son and Playwright*, p. 332. The Hell-Hole's clientele was also memorialized in a 1917 John Sloan etching entitled *Hell Hole*.

46. For discussion of homosexuality and Demuth's genre subjects, see Jonathan Weinberg, "'Some Unknown Thing': The Illustrations of Charles Demuth," *Arts Magazine*, 61 (December 1986), pp. 14–21.

47. Richard Weyand identified Demuth's *Turkish Bath* as the Lafayette Baths in New York; see Farnham, "Charles Demuth," III, p. 399.

48. For this interpretation, see Weinberg, "'Some Unknown Thing,'" p. 14.

49. Quoted in Thomas Sokolowski, *The Sailor 1930–45: The Image of an American Demigod*, exhibition catalogue (Norfolk, Virginia: The Chrysler Museum, 1983), p. 14.

50. The relationship between movement and swimming fish was implicit in *The Soil*'s announcement of an "Exhibition of the Freedom of Movement in Light and Space" at the Battery Park aquarium, New York, in July 1917.

Opposite above

1. **Abstract Landscape**, 1914
 Watercolor on paper, 11¾ x
 16¼ in. (29.8 x 41.3 cm)
 Collection of Dr. and
 Mrs. R.C. Levy

Opposite below

2. **Provincetown Dunes**, 1914
 Watercolor on paper, 12 x
 16⅝ in. (30.5 x 42.2 cm)
 Saginaw Art Museum,
 Saginaw, Michigan

3. **Three Figures in a Land-
 scape**, 1915
 Watercolor on paper, 18⅛ x
 11¾ in. (46 x 29.8 cm)
 Private collection

4. **Zinnias**, 1915
 Watercolor on paper, 8⅝ x 10⅞ in. (21.9 x 27.6 cm)
 Memorial Art Gallery of the University of Rochester, New York;
 Gift of Gertrude Herdle Moore and Isabel C. Herdle in memory of their
 father George L. Herdle

5. **Leaves and Berries**, 1915
 Watercolor on paper, 11 x 8½ in. (27.9 x 21.6 cm)
 The Detroit Institute of Arts; Gift of John S. Newberry

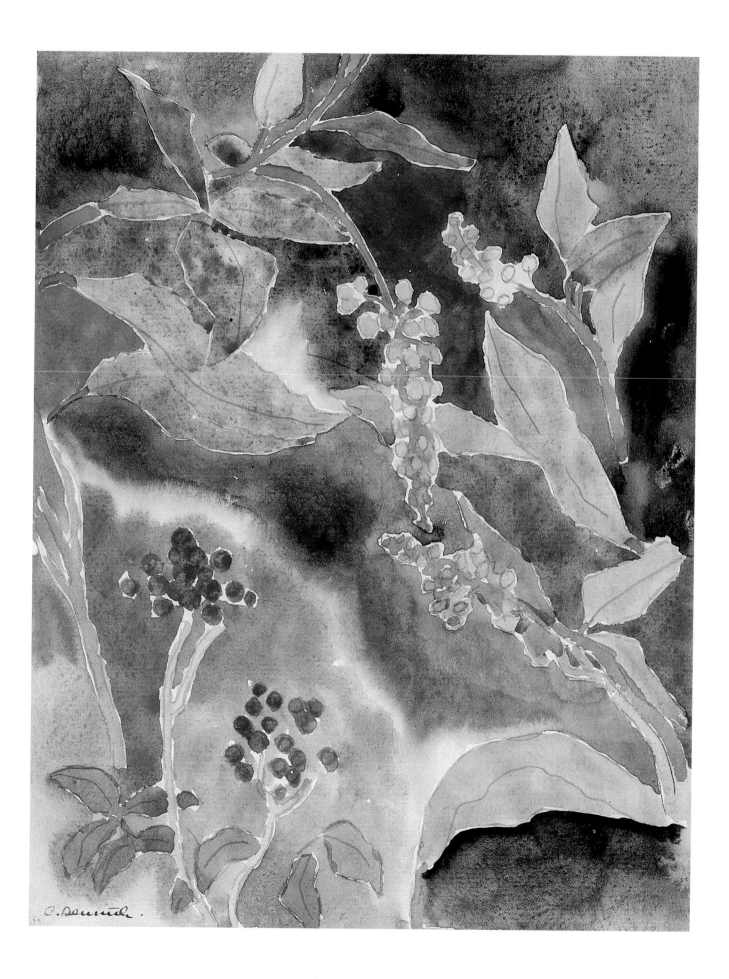

6. **Pansies,** 1915
 Watercolor on paper, 13¾ x
 9⅞ in. (34.9 x 25.1 cm)
 Private collection; courtesy
 Barbara Mathes Gallery,
 New York

7. **Strawflowers (Flowers #2),**
 1915
 Watercolor on paper, 10⅝ x
 8¼ in. (27 x 21 cm)
 Private collection

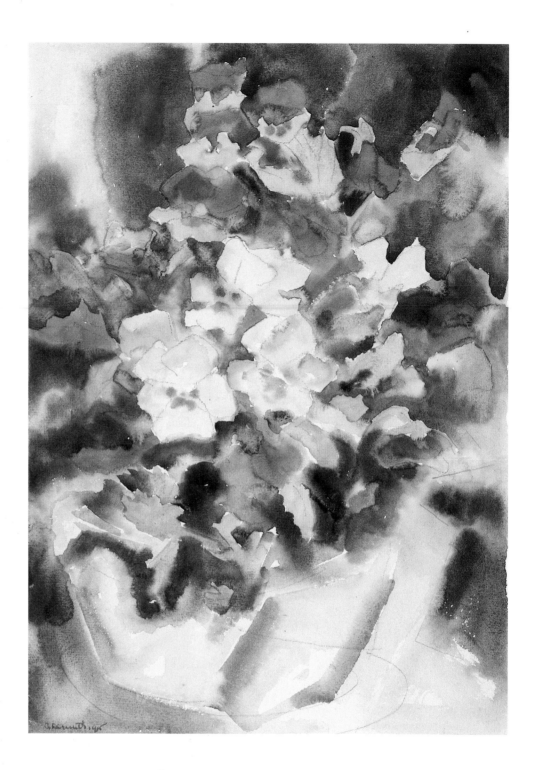

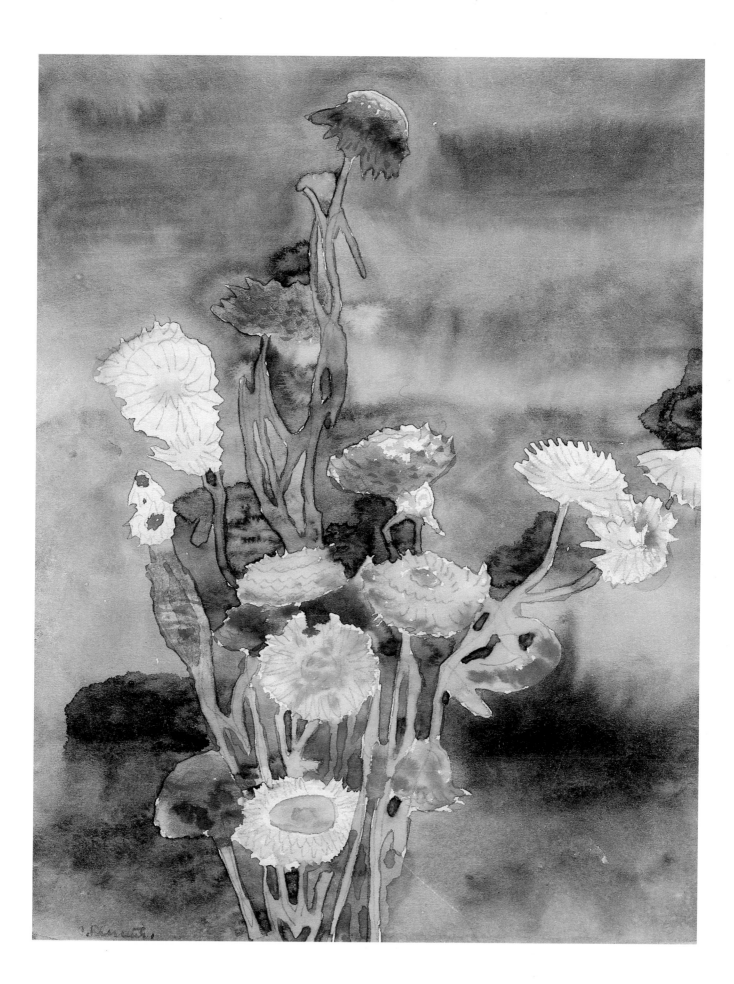

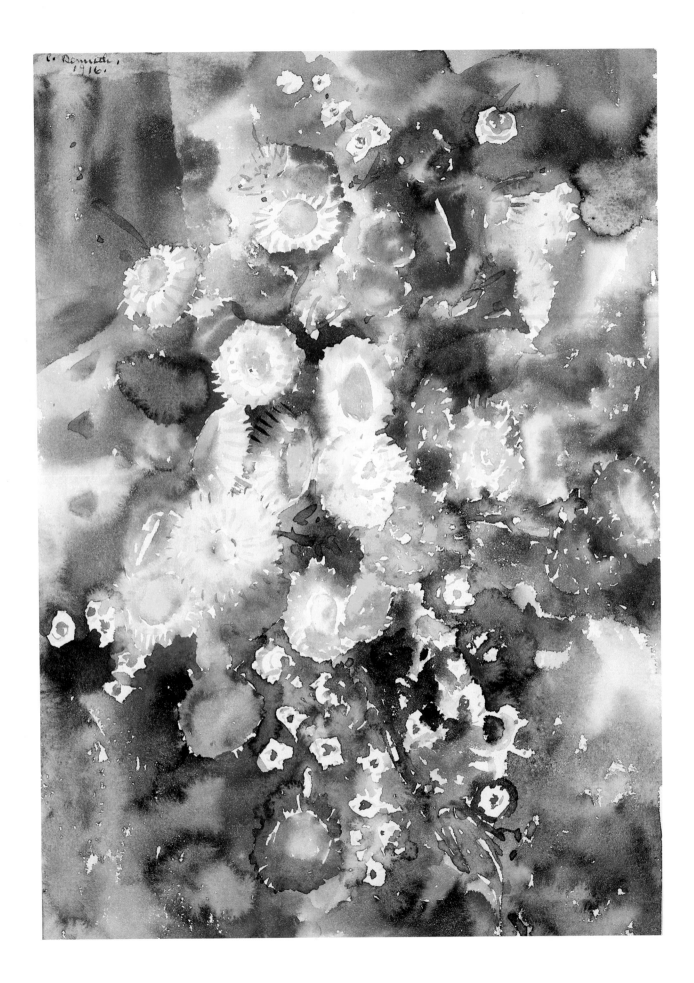

Opposite page

8. **Wild Flowers**, 1916
 Watercolor on paper, 13¾ x
 9⅞ in. (34.9 x 25.1 cm)
 Private collection

9. **Yellow and Blue**, 1915
 Watercolor on paper, 14 x
 10 in. (35.6 x 25.4 cm)
 The Metropolitan Museum
 of Art, New York; Alfred
 Stieglitz Collection

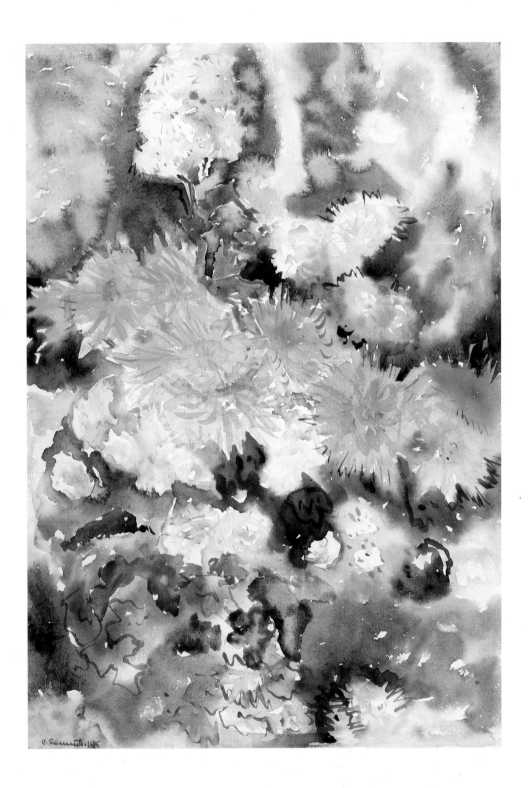

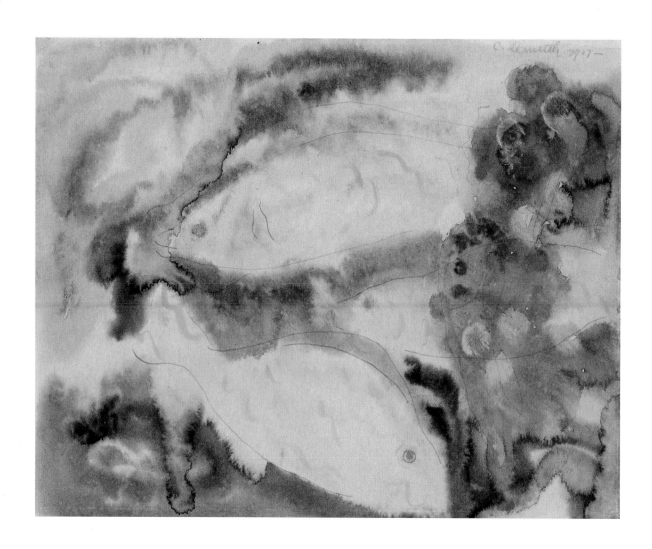

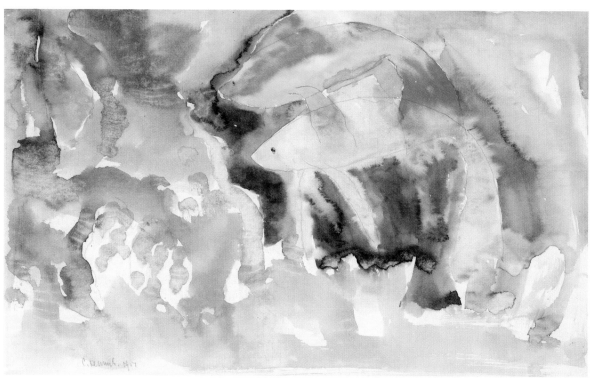

Opposite above

10. **Fish Series No. 1**, 1917
Watercolor on paper, 7⅞ x
9⅞ in. (20 x 25.1 cm)
The Metropolitan Museum
of Art, New York; Alfred
Stieglitz Collection

Opposite below

11. **Fish Series No. 5**, 1917
Watercolor on paper, 7⅞ x
12¹⁵⁄₁₆ in. (20 x 32.9 cm)
The Metropolitan Museum
of Art, New York; Alfred
Stieglitz Collection

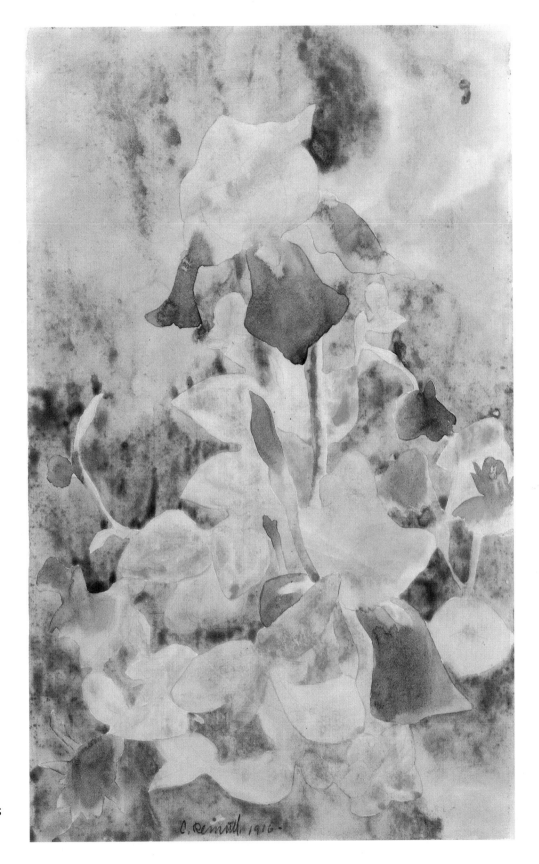

12. **Irises**, 1916
Watercolor on paper, 13 x
8 in. (33 x 20.3 cm)
The Cleveland Museum of Art;
Norman O. Stone and Ella A.
Stone Memorial Fund

13. **Daisies**, 1918
 Watercolor on paper, 17¼ x
 11⅜ in. (43.8 x 28.9 cm)
 Whitney Museum of American Art, New York; Gift of
 Gertrude Vanderbilt Whitney
 31.423

14. **Flowers**, 1919
 Watercolor on paper, 13¾ x
 9¹¹⁄₁₆ in. (34.9 x 24.6 cm)
 Columbus Museum of Art,
 Ohio; Gift of Ferdinand
 Howald

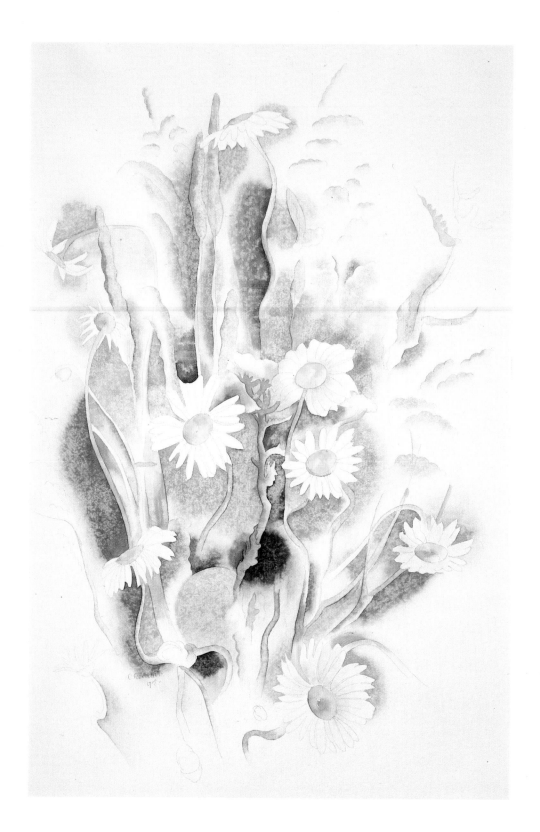

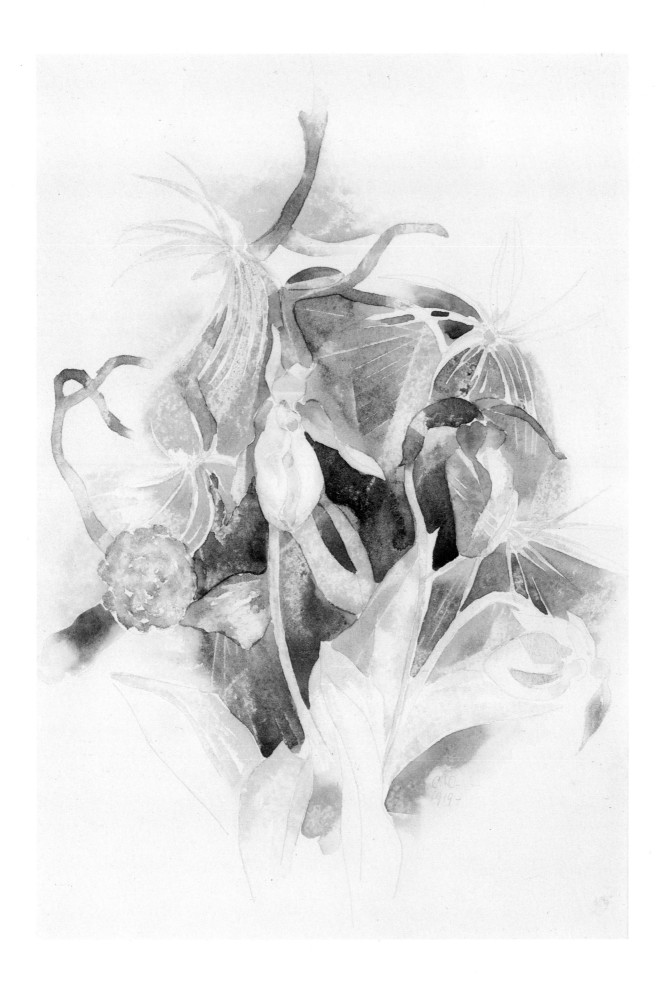

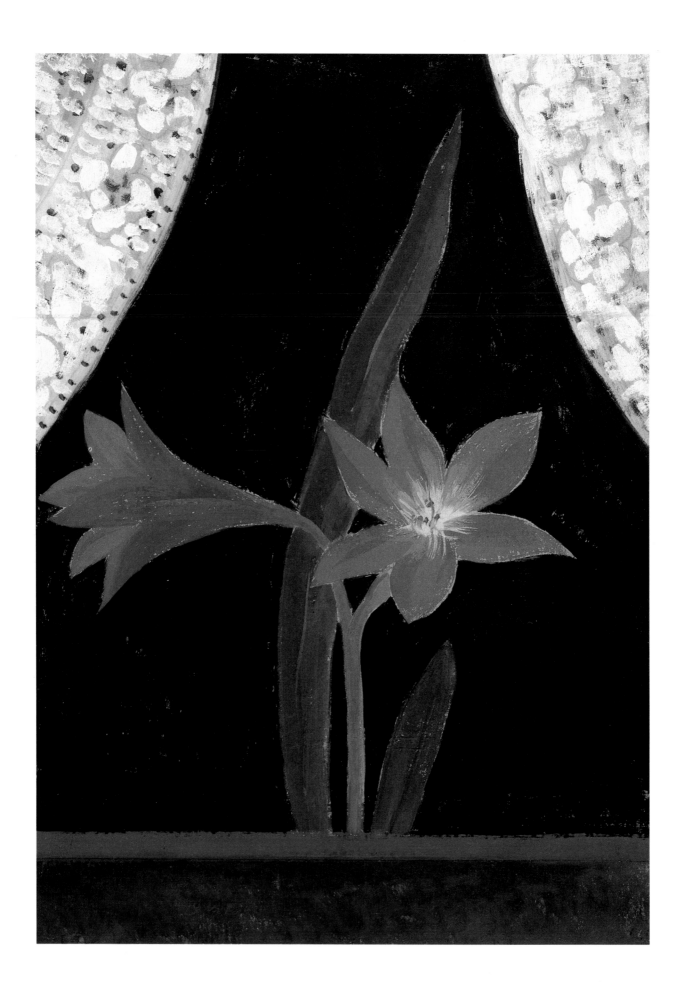

Opposite

15. **Cottage Window**, c. 1919
Tempera on board, 15⅜ x
11⁵⁄₁₆ in. (39.1 x 28.7 cm)
Columbus Museum of Art,
Ohio; Gift of Ferdinand
Howald

16. **Amaryllis**, c. 1923
Watercolor on paper, 18 x
12 in. (45.7 x 30.5 cm)
The Cleveland Museum of
Art; The Hinman B. Hurlbut
Collection

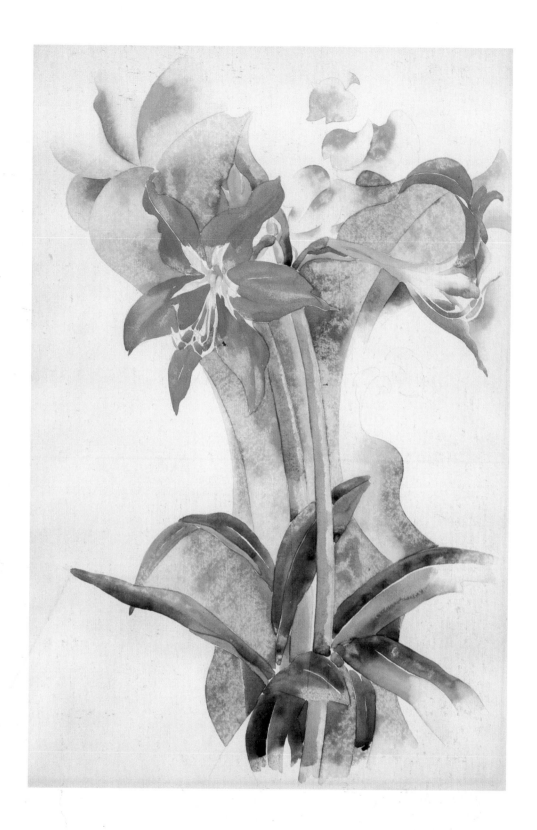

17. **The Purple Pup**, 1918
Watercolor and pencil on
paper, 8 x 10⁷⁄₁₆ in. (20.3 x
26.5 cm)
Museum of Fine Arts,
Boston; Charles Henry
Hayden Fund

18. **At the Golden Swan**, 1919
Watercolor on paper, 8 x
10½ in. (20.3 x 26.7 cm)
Collection of Irwin
Goldstein, M.D.

Opposite page

19. **Negro Jazz Band**, 1916
Watercolor on paper, 12⁷⁄₈ x
7⁷⁄₈ in. (32.7 x 20 cm)
Collection of Irwin
Goldstein, M.D.

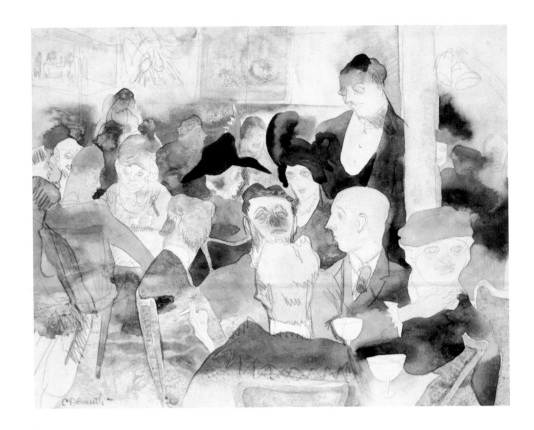

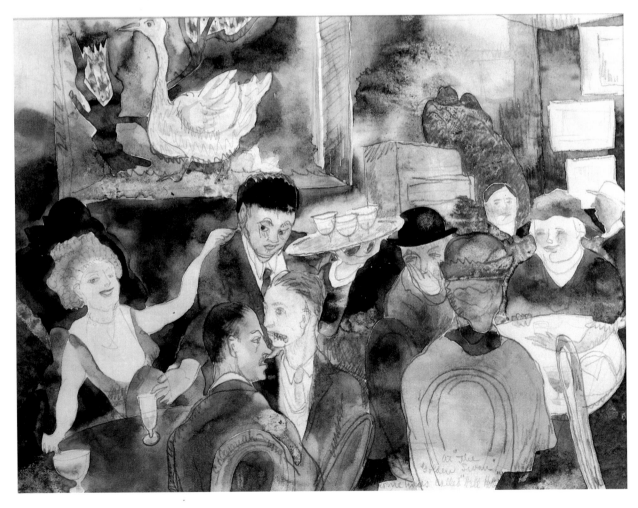

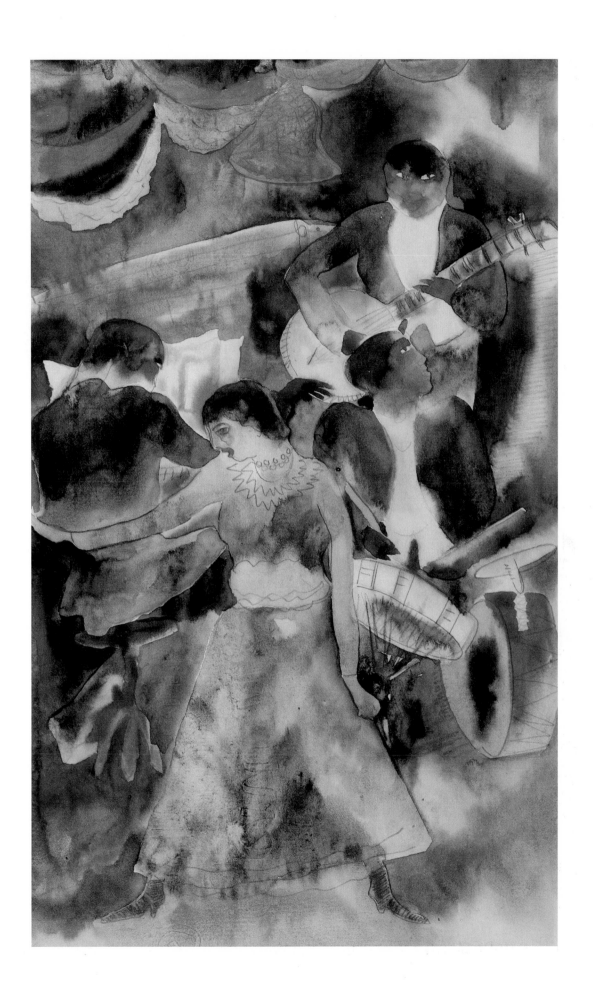

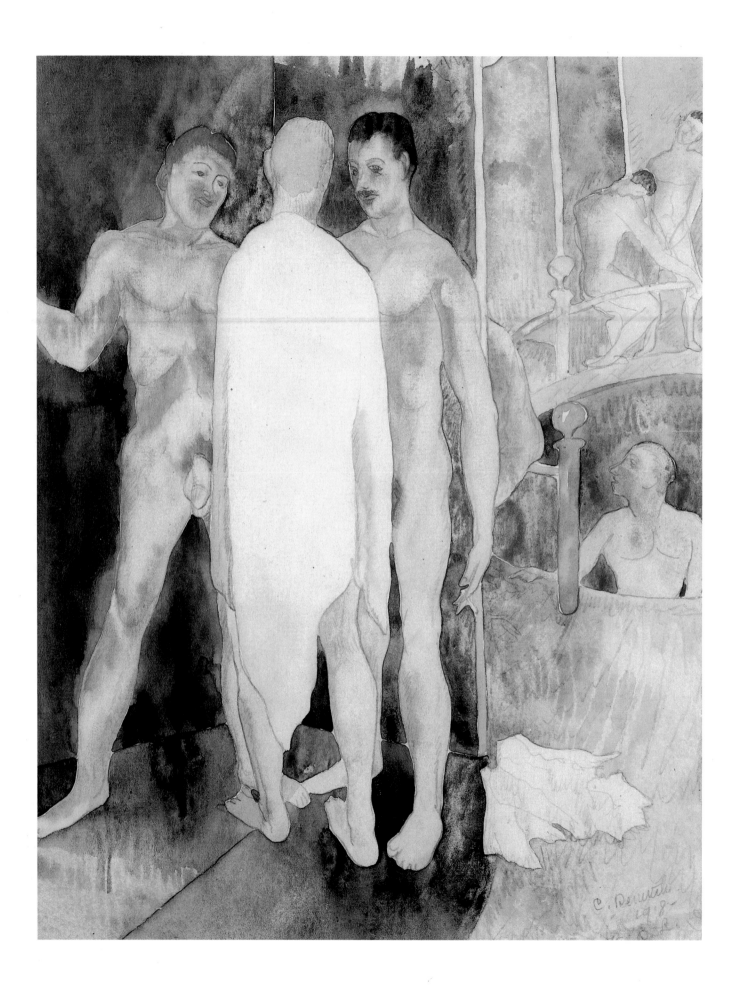

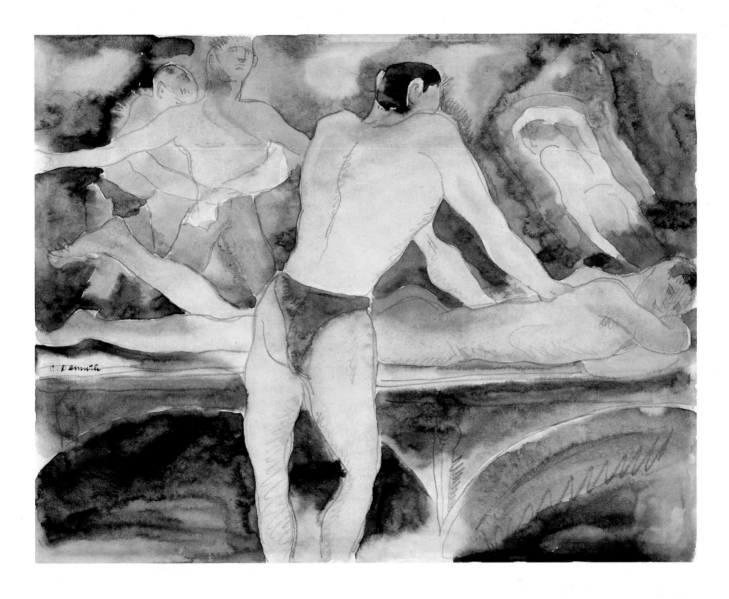

Opposite page 20. **Turkish Bath**, 1918
 Watercolor on paper, 11 x 8½ in. (27.9 x 21.6 cm)
 Kennedy Galleries, New York

Above 21. **Turkish Bath**, 1915
 Watercolor on paper, 8 x 10½ in. (20.3 x 26.7 cm)
 Private collection

22. **Cabaret Interior with Carl Van Vechten**, c. 1918
Watercolor on paper, 8 x 10¾ in. (20.3 x 27.3 cm)
Private collection

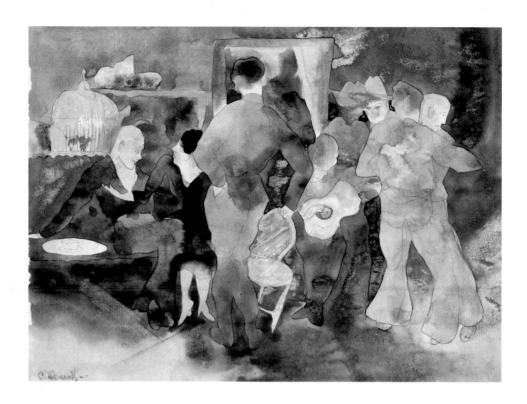

23. **Vaudeville Comediennes**, 1917
Watercolor on paper, 10⅝ x 9 in. (27 x 22.9 cm)
Private collection

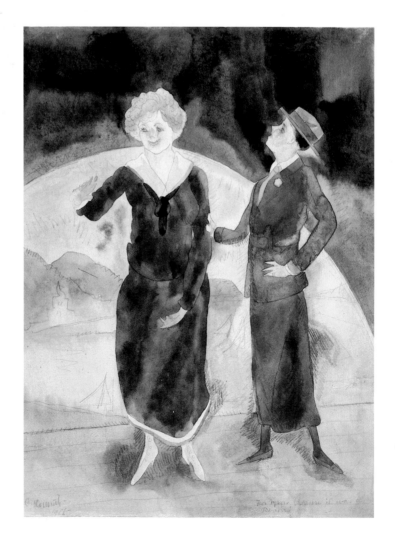

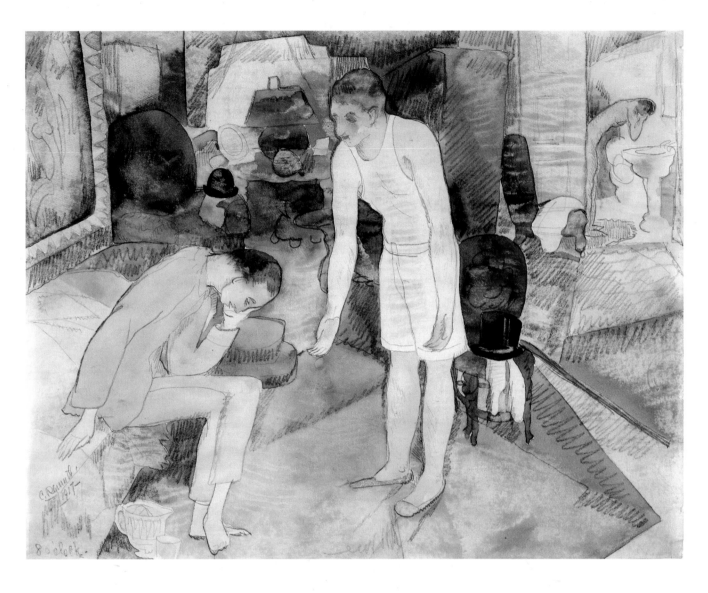

24. **Eight O'Clock (Early Morning)**, 1917
 Watercolor and pencil on paper, 8 x 10¼ in. (20.3 x 26 cm)
 Collection of Mr. and Mrs. Carl D. Lobell

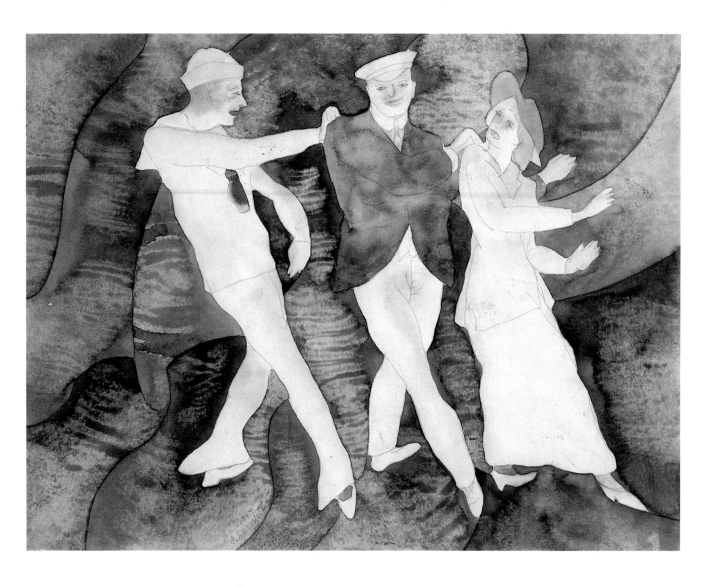

25. **Vaudeville**, 1917
 Watercolor and pencil on paper, 8 x 10½ in. (20.3 x 26.7 cm)
 The Museum of Modern Art, New York; Katherine Cornell Fund

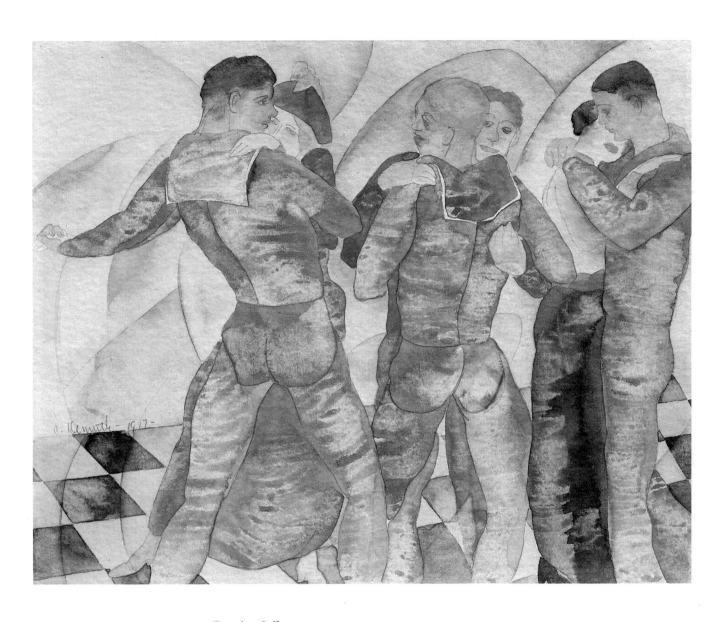

26. **Dancing Sailors**, 1917
 Watercolor and pencil on paper, 8⅟₁₆ x 10⅛ in. (20.5 x 25.7 cm)
 The Cleveland Museum of Art; Mr. and Mrs. William H. Marlatt Fund

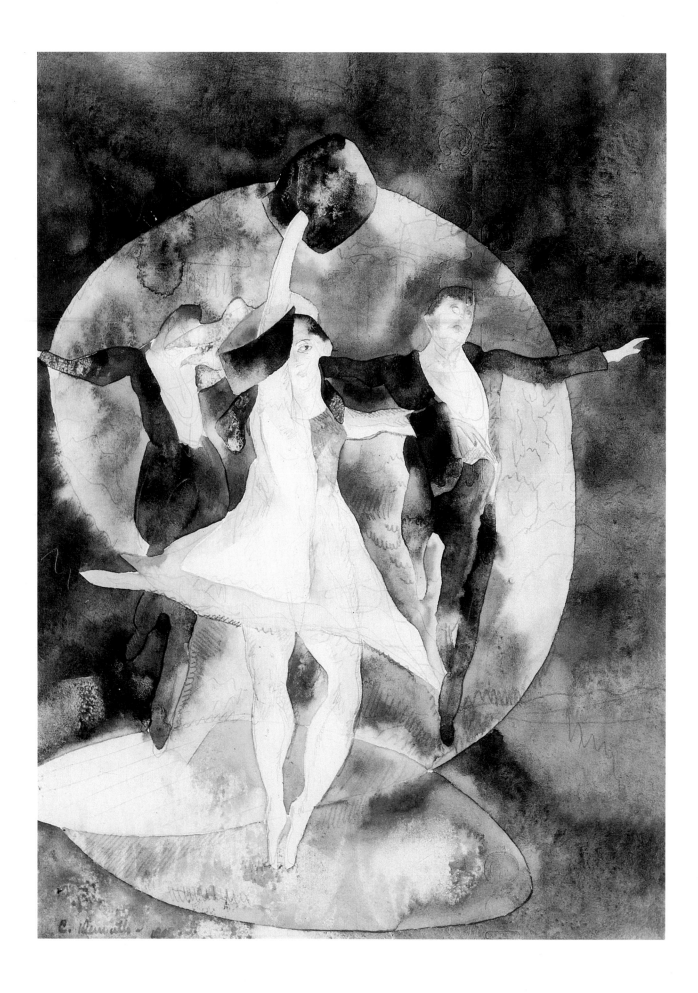

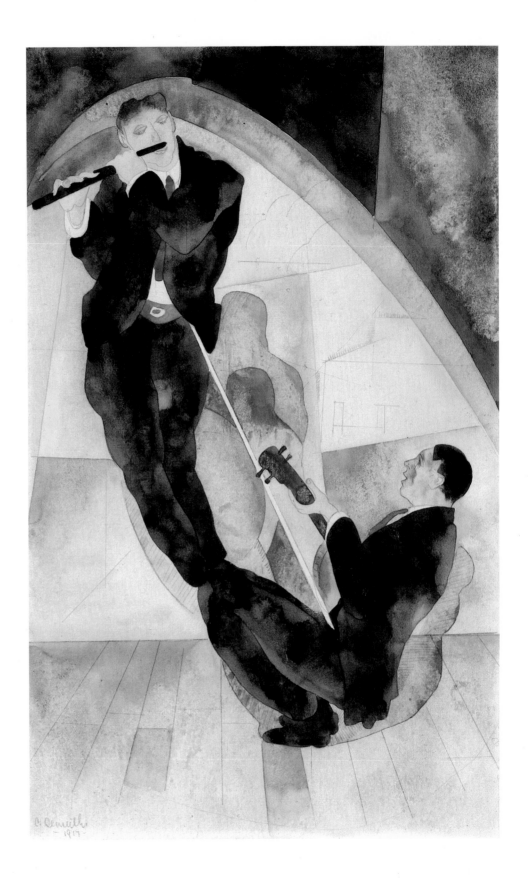

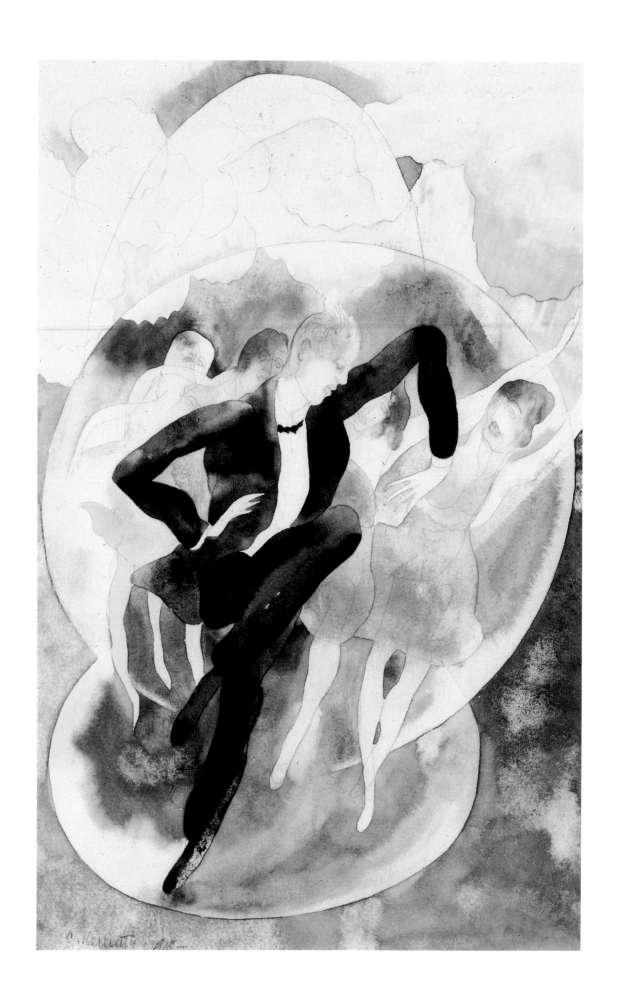

Opposite page

29. **In Vaudeville: Dancer with Chorus**, 1918
Watercolor and pencil on paper, 13 x 8⅛ in. (33 x 20.6 cm)
Philadelphia Museum of Art; A.E. Gallatin Collection

30. **Two Acrobats**, 1918
Watercolor on paper, 10⅞ x 8⅜ in. (27.6 x 21.3 cm)
Walker Art Center, Minneapolis; Gift of Mrs. Edith Halpert

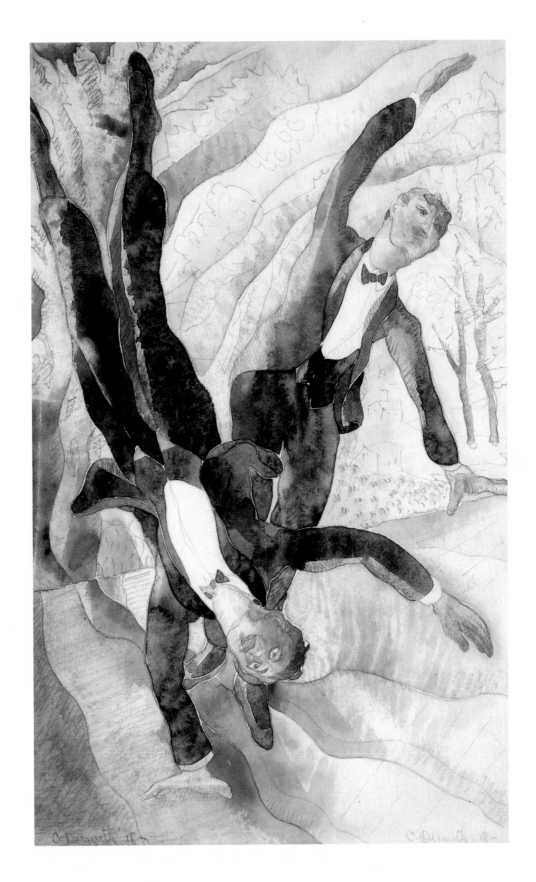

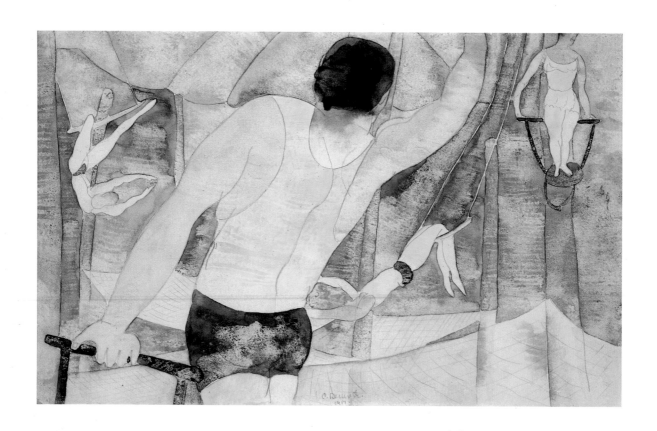

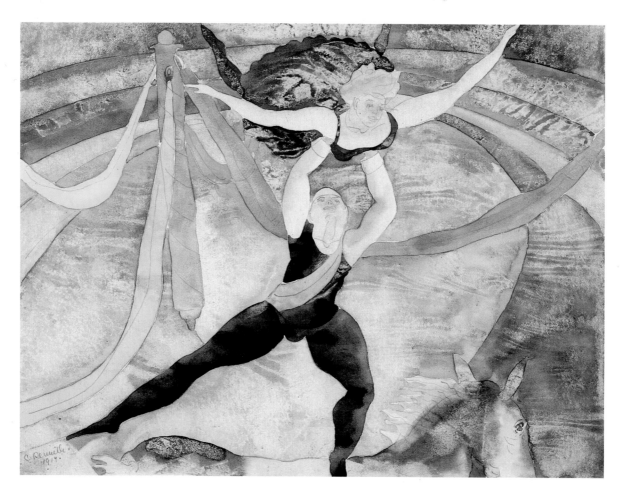

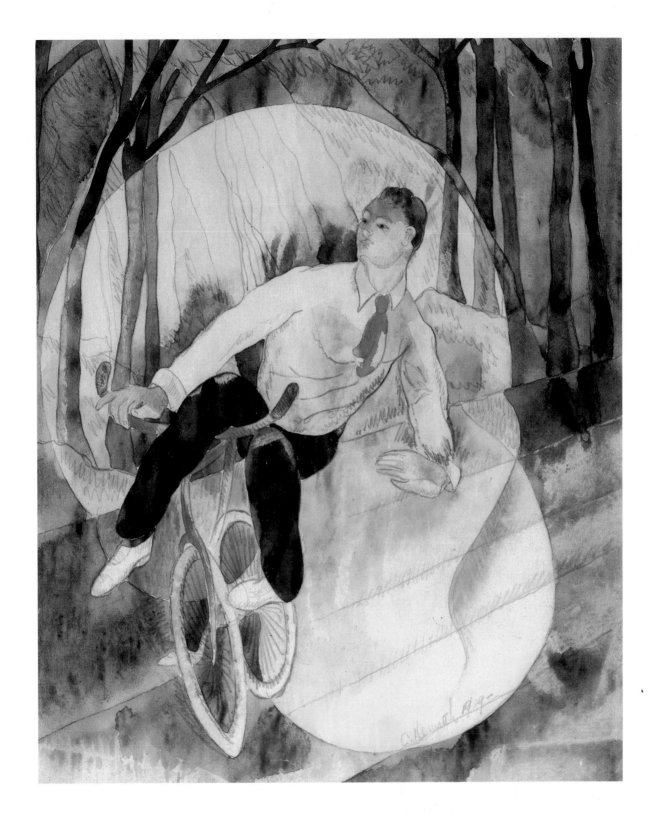

Opposite above 31. **Circus,** 1917
 Watercolor and pencil on paper, 8 1/16 x 13 in. (20.5 x 33 cm)
 Hirshhorn Museum and Sculpture Garden, Washington, D.C.; Gift of Joseph H. Hirshhorn Foundation

Opposite below 32. **The Circus,** 1917
 Watercolor and pencil on paper, 8 x 10 5/8 in. (20.3 x 27 cm)
 Columbus Museum of Art, Ohio; Gift of Ferdinand Howald

Above 33. **In Vaudeville, the Bicycle Rider,** 1919
 Watercolor and pencil on paper, 11 x 8 5/8 in. (27.9 x 21.9 cm)
 The Corcoran Gallery of Art, Washington, D.C.; Bequest of Mr. and Mrs. Francis Biddle

34. **Tumblers**, 1917
 Watercolor on paper, 12¾ x
 8 in. (32.4 x 20.3 cm)
 Private collection

35. **Acrobats**, 1919
 Watercolor and pencil on
 paper, 13 x 7⅞ in. (33 x
 20 cm)
 The Museum of Modern Art,
 New York; Gift of Abby
 Aldrich Rockefeller

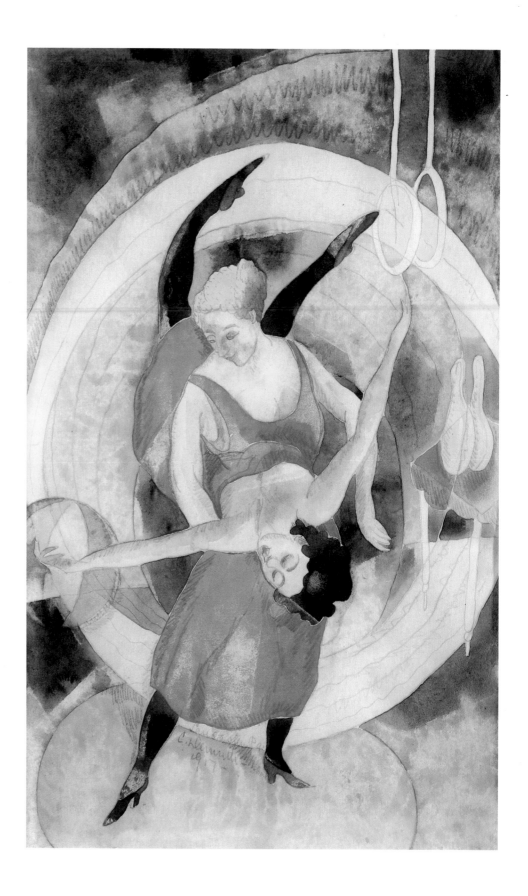

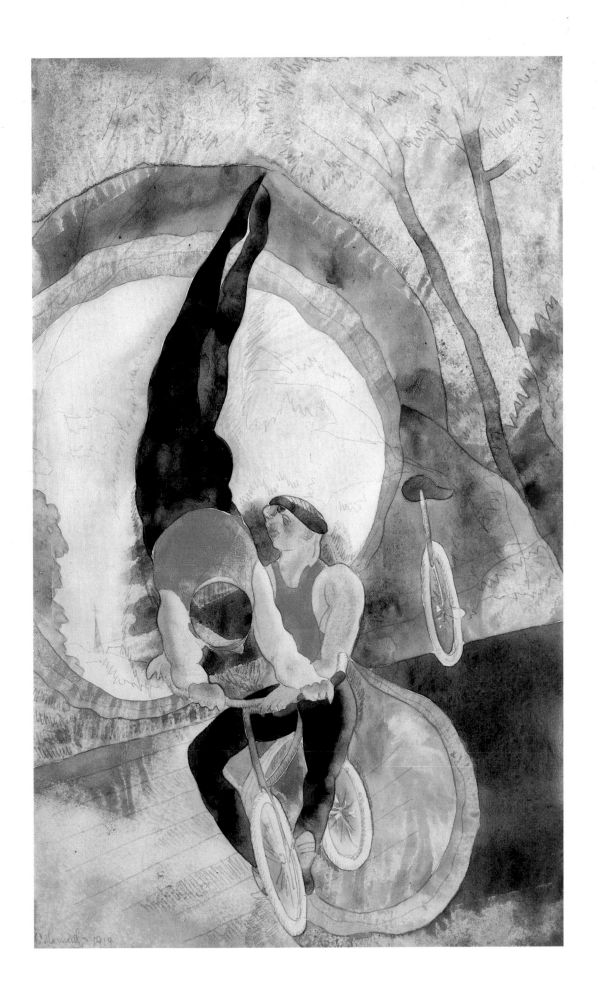

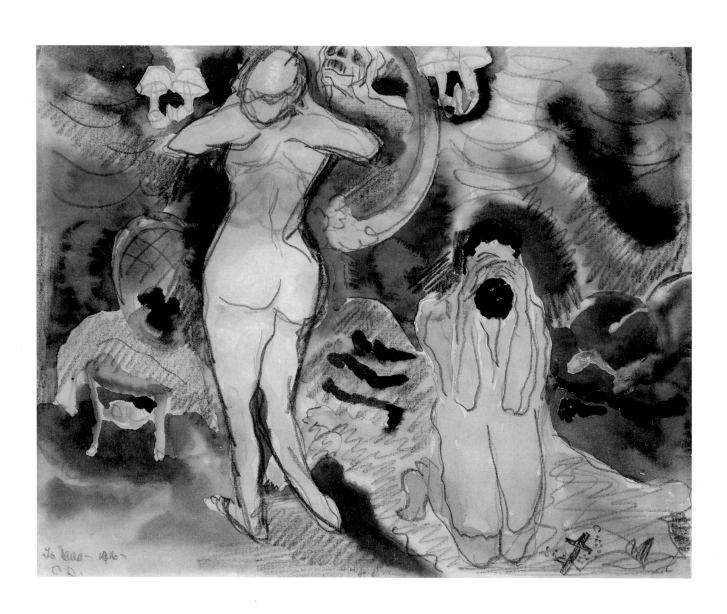

IV.

Literary Illustrations 1914-1919

The sensual undercurrent of Demuth's vaudeville and bohemian world scenes came to the surface in his concurrent watercolors based on literary texts: between 1915 and 1919 he executed eleven illustrations for Zola's *Nana*, one for his *L'Assommoir*, one for Balzac's "Girl with the Golden Eyes," six for Frank Wedekind's Lulu plays, five and three respectively for Henry James' "The Turn of the Screw" and "The Beast in the Jungle," one for Poe's "Masque of the Red Death," and one for Walter Pater's imaginary portrait of Antoine Watteau entitled "A Prince of Court Painters."[1] Quite apart from their quality, which ranks them among Demuth's finest accomplishments, these works are critical for an understanding of Demuth as an artist because of what they reveal about his aesthetic and psychological preoccupations.

Pictorially raiding literature allowed Demuth to edge closer to an art that would integrate the temporal sequence inherent to literature with the single-moment character of painting. He wanted his literary illustrations to be more than pictorial paraphrases of text; his goal was to encapsulate something of the condition of literature in his work. This desire to have one art form emulate another, not in subject, but in form and effect on the viewer, was more prevalent between music and painting—from Pater's pronouncement that all art strives toward the condition of music to Kandinsky's color-music analogies. Demuth's preoccupation paralleled comparable efforts being made within the music world between 1890 and 1920 by composers such as Charles Ives in America and Richard Strauss, Gustav Mahler, and Arnold Schönberg in Europe. They were experimenting with the formal properties of music and its potential for conveying a narrative. But for analogies between literary and pictorial forms, few precedents existed. Earlier illustrations—George Conder's for "Girl with the Golden Eyes," Théophile Steinlen's for *L'Assommoir*, and John La Farge's for "The Turn of the Screw"—had been little more than pictorializations of the text. Only Beardsley and Blake achieved anything like

36. **Te Nana (Nana before the Mirror)**, illustration for Emile Zola's *Nana*, 1916 Watercolor and pencil on paper, 8 x 10 in. (20.3 x 25.4 cm) Lafayette Parke Gallery, New York

The Real Thing, 1908
Ink wash on paper, 5 x 8⅛ in.
(12.7 x 20.6 cm)
Private collection

an approximation of literature's verbally encoded imagery. Their example, if not their style, became Demuth's model.

Demuth's first foray into literary illustration occurred in 1908, when he inscribed "The Real Thing," after one of Henry James' first short stories, onto one of his drawings. The story's plot revolves around an artist commissioned to illustrate a serialized novelette about upper-class English life. He attempts to replace his "street" models with a married couple who are impeccably linked in background and appearance to the society he is to illustrate. They would not have to "make believe," as they tell him; they are the "real thing." At the close of the story the artist realizes that the "real" couple stifled his creativity by being so fixed in their identities as to make his transformation of them into art impossible. "She was the real thing, but always the same thing," James wrote of his heroine.[2]

The conclusion of the story—that the representation of reality through art is more "real" than reality itself—paralleled the theme of Demuth's nearly contemporaneous short story "In Black and White" (pp. 44–45). In Demuth's drawing, three life studies—a nude woman half-reclining, a male and a female head—ironically comment on the Ashcan painters' direct transcription of everyday life, a position from which Demuth, then still an art student, had not yet fully broken. Imposing James' title offered him a way of affirming his allegiance to James' aesthetic stance and, at the same time, of criticizing the ugliness that ensued from the Ashcan painters' mandate for "the real thing." Forced, like James' protagonist, to chose between art as duplication or as transformation of reality, Demuth sided with James: only by transforming reality through art could essential truths be revealed.

By 1915, when Demuth turned again to literature as subject, his aesthetic alignments were secure and he was prepared to tackle more psychologically faceted themes. His choice of texts is revealing. Thematically, the works he "illustrated" revolve almost exclusively around sex and sin, death and salvation. This preoccupation should be understood against the backdrop of Demuth's early involvement in the Lutheran church. Augusta Demuth and her family were highly devout Lutherans, actively engaged in the Church of the Holy Trinity in Lancaster.[3] Demuth was baptized at thirteen and, through Easter of 1915, consistently attended church and took communion. His subsequent failure to take communion while in Lancaster does not indicate a clean retreat from Lutheran teachings, but rather underlines the great emotional and moral conflict that must have been generated by the contrast between his

strict upbringing and his family's pious church-going and the decadent life he was leading in New York. Demuth's selection of literary subjects suggests that he saw damnation as the consequence of his behavior. His obsession with themes involving promiscuity and punishment thus reflects his residual moral ambivalence about sexual pleasure and a concomitant fear of its all-consuming power.

The competition between sexuality and religion for a central place in human affairs found a masterful literary expression in *Nana*, Zola's sexually charged novel about the inescapability from and dangers of unbridled physical attraction. For Zola, Nana was a mindless social force; her instinctual sensuousness destroyed the moral fabric of society. Zola's protagonist, Count Muffat, intractably lost before the force of Nana's sexuality, is convinced of his damnation at her hands but remains powerless to resist her.

Although Zola intended *Nana* as an attack on the hypocrisy and decadence of the Second Empire, the book was received in America as a symbol of sexual degeneracy. Stieglitz, for example, gave it to his scandalized nieces and grandnieces to further their sexual "enlightenment," and Henry McBride described it as "reprehensible" to prewar Victorian sensibilities and warned clergymen to shun Demuth's illustrations of it.[4]

Zola's portrayal of sensual subject matter by means of Naturalism—the literary equivalent of pictorial realism—offered Demuth a ready-made union of Aestheticism and realism. Illustrating *Nana* allowed him to work within the genre tradition promulgated at the Pennsylvania Academy without forfeiting the erotic sensationalism of Wilde and Beardsley. Not only was *Nana* Demuth's first explicitly literary subject, it was also the one in which he was most prolific.[5] In these eleven illustrations, he heightened his expressive handling and introduced symbolic details that would henceforth characterize his work. In *Te Nana* (Pl. 36), he created a twentieth-century *vanitas* image by depicting the moment in Zola's novel when a nude Nana soliloquizes about the physical decay that attends death, oblivious to the count, who despairingly kneels in prayer in the lower right corner. Demuth captured both Nana's autoerotic absorption and her fearful contemplation of death by posing her in front of a mirror that reflects back an image of her skull.[6] The swirling movement of highly saturated, pulsing colors establishes the mood of the scene. They join with an agitated surface produced by vigorous pencil lines beneath steamy, colored washes to project the decadent physicality Nana exuded and the emotional torment and conflict of the count. Demuth

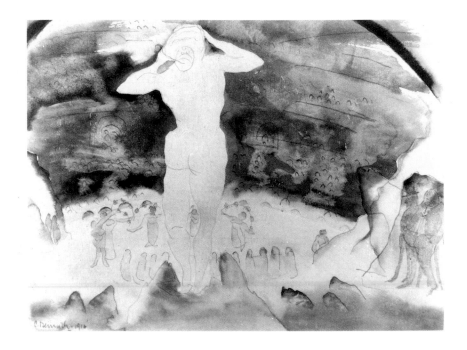

Count Muffat's First View of Nana at the Theatre, illustration for Emile Zola's *Nana*, 1915
Watercolor on paper, 8½ x 10¾ in. (21.6 x 27.3 cm)
The Barnes Foundation, Merion, Pennsylvania

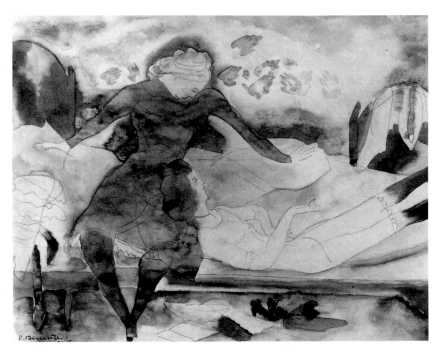

Nana Visiting Her Friend Satin, illustration for Emile Zola's *Nana*, 1915
Watercolor on paper, 8½ x 10¾ in. (21.6 x 27.3 cm)
The Barnes Foundation, Merion, Pennsylvania

conveyed the text's emotional tone by physically estranging the two figures and linking each with death—Nana through her mirrored skull and Muffat through the black mass created by his hands pressed to his beard. Combined with Nana's voluptuous nudity and the discarded crucifix beside the kneeling count, the image consolidates the themes of death, religion, and sexuality.[7]

In a scene with Nana and Satin at Laure's restaurant (Pl. 38), Demuth stylistically reached back to the example of Lautrec. By reducing his color

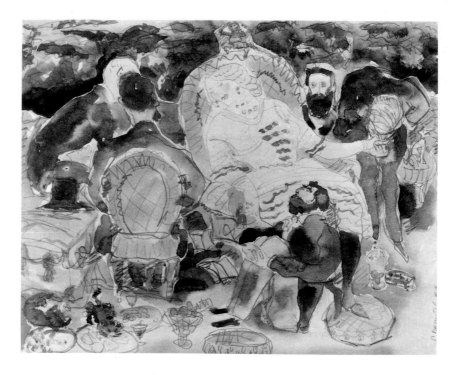

Nana and Her Men, illustration for Emile Zola's *Nana*, 1916
Watercolor on paper, 8½ x 10¾ in. (21.6 x 27.3 cm)
The Barnes Foundation, Merion, Pennsylvania

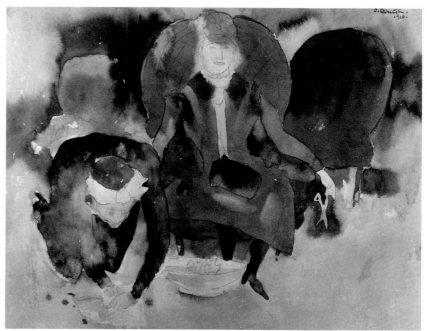

Scene after George Stabs Himself with the Scissors, illustration for Emile Zola's *Nana*, 1916
Watercolor on paper, 8½ x 10¾ in. (21.6 x 27.3 cm)
The Barnes Foundation, Merion, Pennsylvania

schemes to black, white, and red and by treating the gestures and expressions of both women as lifeless and blank, Demuth captured the bored aimlessness of Nana and Satin, her lesbian lover. In selecting a bar scene, Demuth may have sought to link the milieu of *Nana* to that of New York's demimonde. That Nana was a second-rate singer and actress further associated her with the underground world of Barron Wilkin's and Marshall's.[8]

After completing his *Nana* series, Demuth turned to *L'Assommoir*,

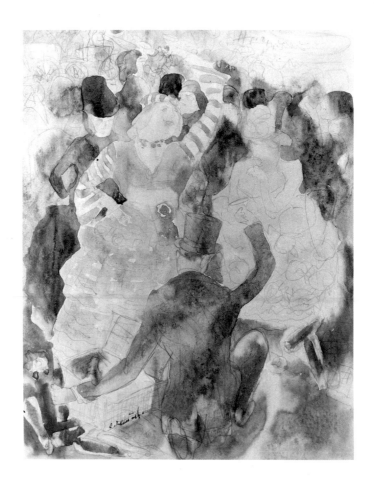

Zola's earlier novel about Nana's parents and her childhood (Pl. 39). Demuth chose to illustrate the moment when Nana first became aware of sex, as his half-erased inscription in the watercolor's lower right, "le debut de Nana," indicates. He depicted Nana observing her mother's seduction by a former husband while her current husband, Nana's father, lies passed out nearby. Nana gazes down at the scene through the transom window with a flushed, cherubic face and half-closed eyes. By streaking the wash so that it radiated from the hallway light in a halo effect, Demuth reinforced the comingling of religion and sex insinuated by the picture of a saint on the table near the slumped form of Nana's father.

Demuth pursued his pictorial meditations on sexual experience in his illustration for Balzac's *Comédie humaine* story, "Girl with the Golden Eyes." Here, too, sex is the center of fascination, worship, and death. Balzac's protagonist, Henri de Marsay, was the archetypal Decadent: physically beautiful, intellectually smug, believing in nothing but his own pleasure and amusement. His cruelty and narcissism were perfect illustrations of Balzac's view of life as filled with corruption and delusion. The story, recounted in a turbid stream of

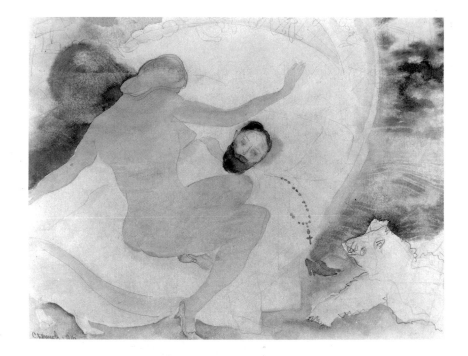

Nana and Count Muffat,
illustration for Emile Zola's
Nana, 1916
Watercolor on paper, 8½ x
10¾ in. (21.6 x 27.3 cm)
The Barnes Foundation,
Merion, Pennsylvania

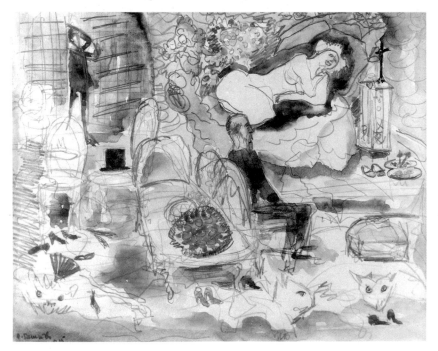

*Count Muffat Discovers Nana
with the Marquess de Chouard,*
illustration for Emile Zola's
Nana, 1915
Watercolor on paper, 8½ x
10¾ in. (21.6 x 27.3 cm)
The Barnes Foundation,
Merion, Pennsylvania

sensuality, concerns the seduction by de Marsay of a mysterious, golden-eyed
girl, Paquita, whom he later realizes is being kept by another lover. His lust is
transformed into cold frenzy and he decides to kill her, only to find that his
twin sister, separated from him since childhood, has butchered her to death
after discovering her betrayal. Demuth illustrated the story's climactic closing
scene in which de Marsay recoils in horror from the frenzied struggle that has
covered both women with blood. Once again, Demuth marshaled swirling

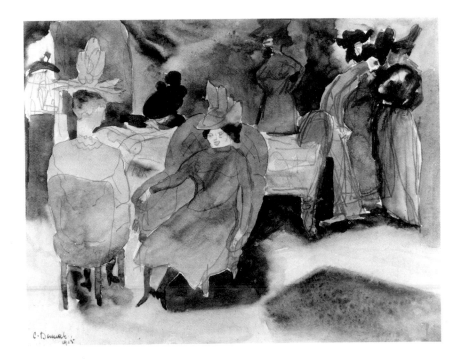

The Death of Nana, illustration for Emile Zola's Nana, 1915
Watercolor on paper, 8½ x 10¾ in. (21.6 x 27.3 cm)
The Barnes Foundation, Merion, Pennsylvania

forms, mottled washes, and evocative color to convey the indefatigable alliance of death and sexuality.

Another of Demuth's single illustrations was for Edgar Allan Poe's "Masque of the Red Death." Written in a proto-Symbolist style, the story describes the revelry of Prince Prospero and a group of friends as they contemptuously try to wait out the virulent plague that is decimating the prince's domain. Demuth's illustration convincingly retained the nightmarish quality of Poe's final masqued ball at the moment when the Red Death enters. Exploiting the writer's color and sound symbolism, Demuth intertwined attenuated, writhing figures in rhythmic patterns within a black and red color scheme, while positioning the vertical form of the Red Death in the background next to a clock, Poe's symbol for the inevitability of death. Although Poe's exposition is without overt erotic implications, it exudes wanton degeneracy and decay.

This theme of the destructive effect of sensuality—particularly in the form of the seductive woman as corruptor—was central to Demuth's most extensive series of illustrations after Nana—that for Frank Wedekind's two Lulu plays. The German playwright had come to Demuth's attention through Hartley when the two Americans were in Europe together in 1913.[9] The two plays—Earth Spirit (1895) and Pandora's Box (1904)—were first published in English in The Glebe in 1914, several months after Demuth's The Azure Adder had appeared there. In 1918, the coincidence of Wedekind's death and the

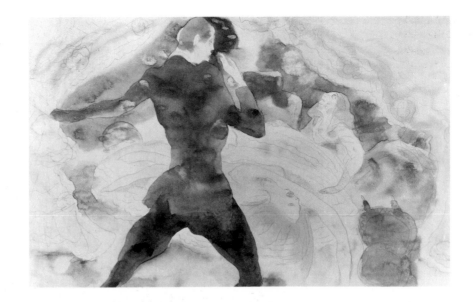

Girl with the Golden Eyes, illustration for Honoré de Balzac's *Comédie humaine*, 1916
Watercolor on paper, 8½ x 10¾ in. (21.6 x 27.3 cm)
The Barnes Foundation, Merion, Pennsylvania

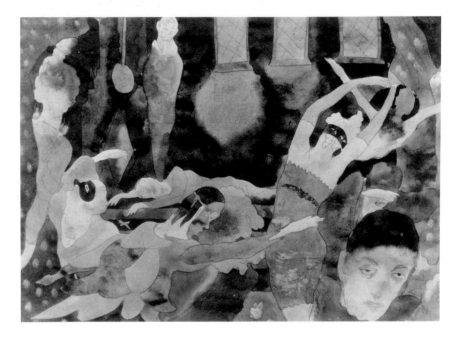

The Triumph of the Red Death, illustration for Edgar Allan Poe's "Masque of the Red Death," 1918
Watercolor on paper, 8½ x 10¾ in. (21.6 x 27.3 cm)
The Barnes Foundation, Merion, Pennsylvania

publication of his Lulu plays in book form probably encouraged Demuth to commence his illustrations. If he wished to explore the interconnections among power, death, and sex and between civilized morality and the sexual instinct he could have found no better vehicle. An Expressionist equivalent of Nana, Lulu embodied the female sex drive from which men—and women in Lulu's case—are powerless to escape.[10] Unleashed on society, this instinct devastates and demoralizes the values and stability on which rational civilization is constructed. In Lulu's presence, logic and sense depart: "I no longer know how or what I'm thinking. When I listen to you I cease to think at all," one of her suitors remarks.[11] Lulu is the polymorphous earth spirit; she pierces

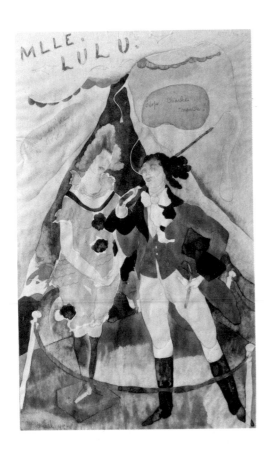

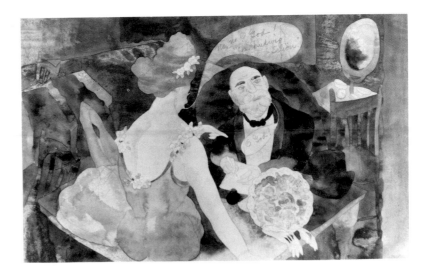

the veneer of individuality which justifies romantic love. She is everywoman
and hence known under a variety of names. One man calls her Mignon,
another Nelli, a third, appropriately, Eve. Even more than in *Nana*, all who
succumb to her power die.[12] For Wedekind, the play's tragic central figure
was Countess Geschwitz, Lulu's lesbian conquest, whom the playwright
described as a human being burdened with the "curse of abnormality," whose
"affliction" was derided and mocked by the "vulgar uneducated."[13] Wede-
kind's aim was to rescue this homosexual affliction "from its fate of ridicule
and bring it home to the sympathy and compassion of those not affected by
it."[14] Although Zola's description of Nana included her homosexual experi-
ences, Wedekind's more sympathetic treatment of these instincts had obvious
appeal to Demuth. So too did the play's anti-naturalistic quality and absurdist
humor, for it licensed Demuth to strengthen the union of pictorial and lit-
erary forms. Departing from conventional illustrative techniques, he treated
his figures as animate dolls and included a red curtain on either side of the
images to suggest the theatricality of the action. He also put fragments of
dialogue in balloons in a more prosaic effort to combine the effect of the visual
with the literary.

*Lulu and Alva Schoen in the
Lunch Scene*, illustration for
Frank Wedekind's Lulu play
Earth Spirit, 1918
Watercolor on paper, 8½ x
10¾ in. (21.6 x 27.3 cm)
The Barnes Foundation,
Merion, Pennsylvania

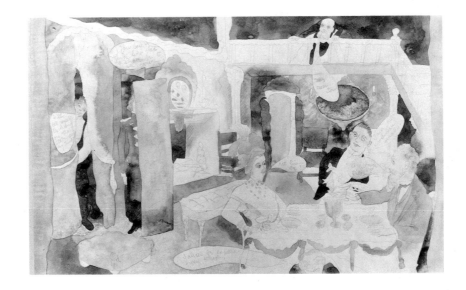

Lulu and Alva Schoen, illustra-
tion for Frank Wedekind's Lulu
play *Pandora's Box*, 1918
Watercolor on paper, 8½ x
10¾ in. (21.6 x 27.3 cm)
The Barnes Foundation,
Merion, Pennsylvania

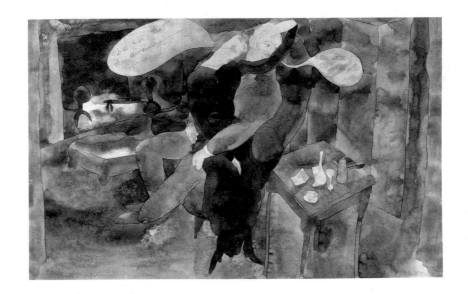

*The Ladies Will Pardon My
Mouth's Being Full*, illustration
for Frank Wedekind's Lulu
play *Pandora's Box*, 1918
Watercolor on paper, 7⅞ x
12¹⁵⁄₁₆ in. (20 x 32.9 cm)
The Barnes Foundation,
Merion, Pennsylvania

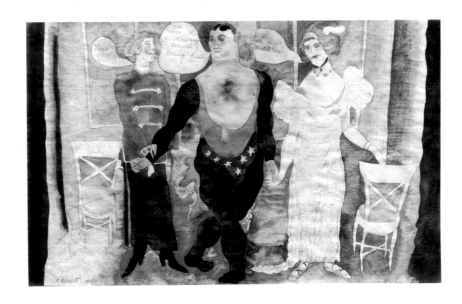

Demuth seems to have projected himself into the role of one of Lulu's victims by including the play's lines "Hop, Charlie March!" in the first watercolor of the series. Nevertheless, the literary works which most closely mirrored his behavior and personality were the two Henry James stories he illustrated—"The Turn of the Screw" and "The Beast in the Jungle." Characterologically, James and Demuth shared certain traits. Both deemed themselves aristocrats and were highly private individuals who never formed long-standing, sexually intimate relationships. Both emerged from passive, rather suffocating childhoods to create work whose stylistic fastidiousness and refinement belie their searching intellects. Moreover, James sought, as did Demuth, a symbiosis between visual and literary art; he understood that the purview of writing included the creation of "pictures."[15]

In "The Turn of the Screw," Demuth found an oblique evocation of sex that suited his own passive nature. The story's protagonist—a governess— becomes increasingly convinced that her two pupils are haunted by the ghosts of their former valet and governess, both of whom had died. In the final scene, as she presses Miles, her male charge, to tell her why he was expelled from school, she sees the ghost of the valet at the window. Her hysteria in trying to make the boy also see it frightens him to death.

Initially James' story was read as a ghost tale; only later was it noticed that the governess was the only one to see the ghosts.[16] The implication is that the source of these apparitions is terror about sexuality.[17] This sexual subtext is established initially by the governess' infatuation with her employer. It is extended with innuendos that the ghost's corruption of the children was

sexual: the governess reputedly had had an affair with the valet who, in turn, used to "play with the boy . . . to spoil him." Moreover, the "secret disorders" and "vices" of the valet, which presumedly were imparted to Miles and contributed to his delinquency, are certainly sexual and can even be construed as including homosexuality. And, while Edmund Wilson's claim that the governess represented a "neurotic case of sex repression,"[18] might be an overstatement, there is no doubt that her actions, especially in the story's final scene, are charged with sexual energy. When her interrogation of Miles elicits the apparition of the valet at the window, her response is that of a victorious lover: "What does he matter now, my own?" she cries. "What will he *ever* matter? *I* have you, but he has lost you forever!"

Demuth's five illustrations for "The Turn of the Screw" capture James' subtle evocation of sexual currents.[19] Like James, Demuth veiled his depictions in order to force viewers to internalize the implications.[20] In *At a House on Harley Street* (Pl. 40), he suggests the overwhelming impact which the employer had on the governess by the almost claustrophobic clutter of the room and by making the employer's figure loom above her, near enough for his hands to touch her clothes. Demuth's portrait of the governess first seeing the ghost of the valet depicts her in a state of quasi-sexual rapture (Pl. 42). In *Flora and the Governess* (Pl. 43), the governess' fright can be read as a terrorized recoiling from sexual encounter, a reading that is made even more explicit by the visual parallel Demuth draws between the "flat piece of wood" the girl picks up and a phallus. In another illustration (Pl. 41), the housekeeper stands back from the scene with her mouth ajar as if to question the relationship between the governess and her charges. Finally, in the last scene, *Miles and the Governess* (Pl. 44), Demuth renders the governess' sexuality by depicting her interrogation of Miles as seductive.

In "The Beast in the Jungle," Demuth found a story that embodied his ambivalence about missing out on conventional emotional experiences and traditional forms of happiness. The story's protagonist, Marcher, is a man who forfeits love and an engagement with life out of a conviction that some unknown "thing" is going to happen to him. Too late, he realizes that he has missed out on life; that his predestined tragedy is precisely that nothing will ever happen to him. The assessment represented a re-phrasing of James' remonstration to Lambert Strether in *The Ambassadors* to "live all you can; it's a mistake not to. It doesn't so much matter what you do in particular as long as you have your life."[21]

Demuth's first illustration, *The Boat Ride from Sorrento* (Pl. 46), describes May Bartram's flashback recollection of a boat ride she and Marcher had taken years earlier when he first told her of his premonition.[22] Demuth suggests the sense of potential intimacy between the two individuals by compacting their forms within the arch of the boat's prow and introducing into the background a volcanic eruption that was not present in James' narrative. Contrasting to their optimism is the hunched and ominous figure of the oarsman—perhaps an omen of Marcher's future. In *The Revelation Comes to May Bartram in Her Drawing Room* (Pl. 47), Bartram, still in love with Marcher but near death, realizes what his "beast" has been. Through physical separation and hand gestures, Demuth aptly captures the unbridgeable gulf between them, but he also subliminally conveys the step Marcher almost took toward love by tilting Marcher toward Bartram. In the final illustration, *Marcher Receives His Revelation at May Bartram's Tomb* (Pl. 48), Marcher throws himself on Bartram's tomb as he too finally confronts the "jungle" of his life and its lurking "beast." Whether Demuth unconsciously portrayed himself in this final scene, as some historians have suggested, or had James in mind, as he told the owners of his illustrations, there is little doubt that the unnamed "beast" that Marcher ultimately encounters in the cemetery bears great similarity to the unknown "thing" against which Demuth's protagonist railed in his story "The Voyage Was Almost Over".[23]

The most clearly self-referential of all Demuth's literary illustrations is the one he executed for Pater's "A Prince of Court Painters," the portrait of Antoine Watteau in his *Imaginary Portraits* of 1887 (Pl. 45).[24] Pater's Watteau was a mirror image of Demuth. The pictorial styles of both artists shared delicacy, nuance, and a facile, refined technique. Psychologically, their works evoked the fleeting nature of happiness and the intertwined character of theater and real life. As with Demuth, Pater's Watteau was "a lover of distinction and elegance" who was hungry for life yet unable to fully participate in it or give himself over to the expression of passion.[25] Outwardly amused by society and its frivolities, he was actually an introvert who suffered deep-seated feelings of isolation and melancholy.

Demuth's illustration respects the story's emphasis on character rather than action. In order to suggest the fashionable society that Watteau painted and through which he moved, Demuth depicted the artist standing alone in a Rococo room of light blue and rose, facing away from an easel on which stands his painting *Gilles*.[26] Demuth took liberties with the story by conflating

Pater's female narrator, who is in love with Watteau, with the female model whose discarded clothes imply that she is changing behind the screen. The absent gaze that Watteau directs toward the model's shoe suggests the psychological distance that he retained between himself and the adoring narrator. In Watteau's failure to return her affection—and to accept intimacy and love—lies the "beast" of Marcher and Demuth. Although it is too much to claim that Demuth's illustration is actually a self-portrait, there is no doubt that Demuth saw in Pater's description of Watteau a likeness of himself which the vehicle of literature allowed him to reveal. The closing lines of Pater's portrait summarized the essential sadness of Watteau's—and Demuth's—life: "He had been a sick man all his life. He was always a seeker after something in the world that is there in no satisfying measure, or not at all."[27] That Demuth transcribed these lines onto his watercolor affirms their centrality both to his conception of Watteau and to his own personal and artistic identity.

Notes

1. For a complete discussion of each illustration, see Pamela Edwards Allara, "The Water-Color Illustrations of Charles Demuth" (Ph.D. dissertation, Johns Hopkins University, Baltimore, 1970).

2. Henry James, "The Real Thing," in *The Short Stories of Henry James*, ed. Clifton Fadiman (New York: Random House, 1945), p. 201.

3. Information on the involvement of the Demuth and Buckius families with the church comes from photocopies of church records of baptisms, marriages, communions, deaths, and annual reports provided by Phyllis R. Reed and Debra D. Smith; see Chap. 1, n. 5. Augusta Demuth was a pewholder, regular contributor, and Missionary Society member. Her sister Kate Buckius held every membership position available, including that of Sunday school teacher and member of the Luther League. The third sister, Elizabeth Buckius, was a regular contributor as well as a pewholder. Augusta Demuth bequeathed approximately $15,000 to paint and maintain the church's steeple. Two thousand dollars of this donation she designated to fund a new stained-glass window in memory of her parents and her sisters.

4. For Stieglitz, see Amy Davidson Lowe, *Stieglitz* (New York: Farrar Straus Giroux, 1983) p. 79. For McBride, see "Watercolors by Charles Demuth," *Creative Art*, 5 (September 1929), p. 635. In this review McBride apparently forgot that he had included mention of Demuth's *Nana* series in a review in *The New York Herald*, December 5, 1920, section 3, p. 9, stating instead that they were being exhibited for the first time.

5. Because Demuth executed his *Nana* illustrations on paper of poor quality, many writers have inferred that he did not intend them for public display. McBride's statement that "the artist himself must have looked at them as essentially private entertainments" is typical; see Henry McBride, "Demuth: Phantoms from Literature," *Art News*, 49 (March 1950), p. 21. However, the extensive exhibition history of these works in Demuth's lifetime suggests otherwise. Demuth liked them well enough to allow Albert Barnes to buy eight and to send the remaining one to Stieglitz in 1929, claiming that it "wasn't bad"; see Demuth to Alfred Stieglitz, May 9, 1929, Stieglitz Collection, Collection of American Literature, Beinecke Rare Book and Manuscript Library, Yale University, New Haven (hereafter cited as Yale). Demuth also exhibited the *Nana* series at the Daniel Gallery in 1916 and 1920. When the Whitney Studio organized an exhibition at the Grafton Galleries in London as a supplement to the Venice Biennale in 1921, eight of them were exhibited. The *Nana* illustrations were also consistently acclaimed in the press. In 1921, Forbes Watson wrote that a "man who obtains tickets to this group of illustrations is a lucky man"; see Forbes Watson, "At the Galleries," *Arts & Decoration*, 14 (January 1921), p. 215.

6. On the use of the mirror for describing narcissism, see Bram Dijkstra, *The Idols of Perversity* (New York: Oxford University Press, 1986), p. 139.

7. Zola himself called upon various images to cement the religious-sexual equation. For example, "The desires of his [Count Muffat's] flesh, the requirements of his soul mingled. He abandoned himself to love and faith, whose double lever animates the world. . . . He

Opposite above

37. **Scene after Georges Stabs Himself with the Scissors** (second version), illustration for Emile Zola's *Nana*, 1916
Watercolor and pencil on paper, 7⅞ x 11¾ in. (20 x 29.8 cm)
Museum of Fine Arts, Boston; Charles Henry Hayden Fund

Opposite below

38. **Nana, Seated Left, and Satin at Laure's Restaurant**, illustration for Emile Zola's *Nana*, 1916
Watercolor and pencil on paper, 8½ x 11 in. (21.6 x 27.9 cm)
The Museum of Modern Art, New York; Gift of Abby Aldrich Rockefeller

shiveringly succumbed to the all-powerfulness of her sex, the same as he felt lost before the vast unknown of heaven." Zola further described Nana's bed as "an altar of Byzantine sumptuousness, worthy of the almighty puissance of Nana's sex, which at this very hour lay nudely displayed there in the religious immodesty befitting an idol of all men's worship"; Emile Zola, *Nana* (New York: Illustrated Editions Company, 1933), p. 457.

8. Lulu, the central character in Demuth's next most extensive series of literary subjects, also began her career as an actress.

9. Hartley mentioned going to visit Wedekind in a 1913 letter to Stieglitz; see Allara, "The Water-Color Illustrations of Charles Demuth," p. 133.

10. Behind the characters of Nana and Lulu stood the figure of Salomé, who was for the Symbolists the archetypal woman—indifferently destroying the male soul while remaining nominally innocent; see Dijkstra, *The Idols of Perversity*, p. 384.

11. Frank Wedekind, *Earth Spirit*, in *The Lulu Plays and Other Sex Tragedies*, trans. Stephen Spender (New York: John Calder, 1977), p. 78.

12. That the destructive agents in *Nana* and the Lulu plays are female does not mean that Demuth was a misogynist as some scholars have suggested; see Emily Farnham, "Charles Demuth: His Life, Psychology and Works," 3 vols. (Ph.D. dissertation, Ohio State University, Columbus, 1959), III, p. 992. Such a reading violates the complexity of Demuth's attitudes toward sex and ignores the evidence of his genuine friendships with women (see above, Chap. 3, n. 33).

13. Wedekind, Introduction to *Pandora's Box*, in Wedekind, *The Lulu Plays*, p. 104. The translation used by Demuth (as evidenced by the words in his introductory watercolor) was the 1918 Boni and Liveright edition, translated from the German by S.E. Elliott.

14. Ibid.

15. See Edna Kenton, "Henry James to the Ruminant Reader: The Turn of the Screw (with Four Drawings by Charles Demuth)," *The Arts*, 6 (November 1924), p. 245.

16. Edna Kenton, ibid., who accompanied her article with Demuth's illustrations, was the first to point this out. For an analysis of the story, see *A Casebook on Henry James' The Turn of the Screw*, ed. Gerald Willen (New York: Thomas Y. Crowell Company, 1960).

17. As Edmund Wilson asserted, "What becomes more sinister and obscure the more exquisitely it is suppressed is the simple existence of sex"; Wilson, "The Ambiguity of James," *Hound and Horn*, 7 (April–June 1934), p. 396.

18. Ibid., p. 385.

19. Sherman E. Lee discussed Demuth's "Turn of the Screw" illustrations in "The Illustrative and Landscape Watercolors of Charles Demuth," *The Art Quarterly*, 5 (Spring 1942) pp. 163–68. Following his analysis, a Demuth watercolor entitled *Boy and Girl* (1912) came to be considered a frontispiece for "The Turn of the Screw"; however, I agree with Allara that based on its style and the adult appearance of the figures, it is more likely an unrelated genre sketch; see Allara, "The Water-Color Illustrations of Charles Demuth," pp. 175–76.

20. In the preface to "The Turn of the Screw," James wrote, "As long as the events are veiled the image will ruminate and depict all sorts of horror, but as soon as the veil is lifted, all mystery disappears and with it the sense of terror. . . . I want to make the reader's general vision of evil intense enough . . . make him *think* the evil, make him think it for himself"; quoted in Kenton, "Henry James to the Ruminant Reader," p. 255.

21. Henry James, *The Ambassadors* (New York: The New American Library of World Literature, 1964), p. 134.

22. For a detailed discussion of Demuth's illustrations for "The Beast in the Jungle," see John L. Sweeney, "The Demuth Pictures," *The Kenyon Review*, 5 (Autumn 1943); pp. 522–32.

23. See p. 47, above. Jonathan Weinberg stated that the "thing" which haunts Demuth is his homosexuality; see "'Some Unknown Thing': The Illustrations of Charles Demuth," *Arts Magazine*, 61 (December 1986), p. 14. Allara, "The Water-Color Illustrations of Charles Demuth," p. 234, identifies the figure of Marcher in this watercolor as a self-portrait of Demuth. However, according to Frank Osborn, letter to Hermon More, November 11, 1937, Whitney Museum of American Art archives, New York, Demuth intended the figure to be Henry James and only learned later that the author was a man of weight.

24. For a detailed discussion of Demuth's illustration of Pater's work, see Allara, "The Water-Color Illustrations of Charles Demuth," pp. 114–65.

25. Walter Pater, "A Prince of Court Painters," in *Imaginary Portraits* (1887; ed. London: MacMillan and Co., 1914), p. 11.

26. There were originally two versions of Demuth's illustration. According to Richard Weyand, in the other version, now lost, the back of the painting on the easel bore the inscription *Gilles*; see Allara, "The Water-Color Illustrations of Charles Demuth," p. 129.

27. Pater, "A Prince of Court Painters," p. 44.

39. **Le Debut de Nana**, illustration
for Emile Zola's *L'Assommoir*,
1916
Watercolor on paper, 8 x
10½ in. (20.3 x 26.7 cm)
Philadelphia Museum of Art;
A.E. Gallatin Collection

40. **At a House on Harley
Street**, illustration no. 1 for
Henry James' "The Turn of
the Screw," 1918
Watercolor and pencil on
paper, 8 x 11 in. (20.3 x
27.9 cm)
The Museum of Modern
Art, New York; Gift of
Abby Aldrich Rockefeller

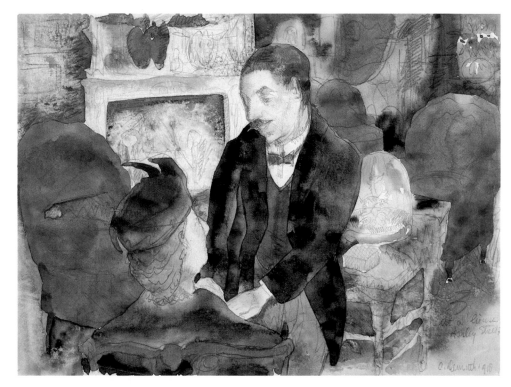

41. **The Governess, Mrs. Grose, and the Children**, illustration no. 4 for Henry James' "The Turn of the Screw," 1918
Watercolor and pencil on paper, 8¼ x 10³⁄₁₆ in. (21 x 25.9 cm)
Philadelphia Museum of Art; Gift of Frank and Alice Osborn

42. **The Governess First Sees the Ghost of Peter Quint**, illustration no. 2 for Henry James' "The Turn of the Screw," 1918
Watercolor on paper, 8 x 10³⁄₈ in. (20.3 x 26.4 cm)
Philadelphia Museum of Art; Gift of Frank and Alice Osborn

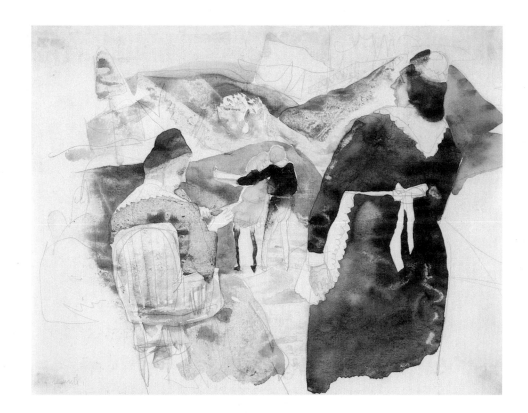

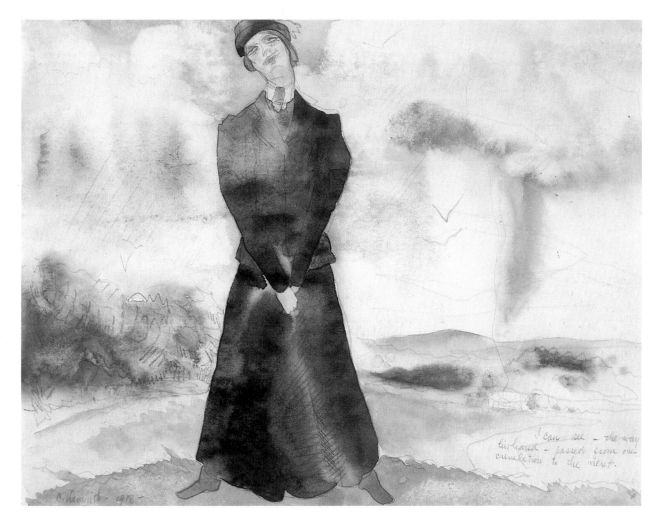

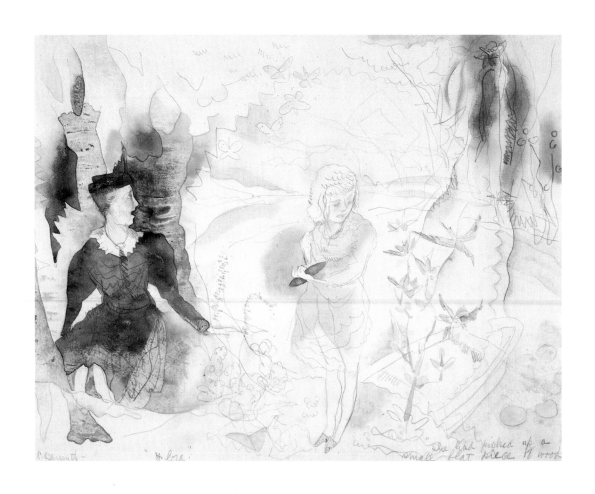

C. Demuth— "Flora" "She had picked up a
 small flat piece of wood

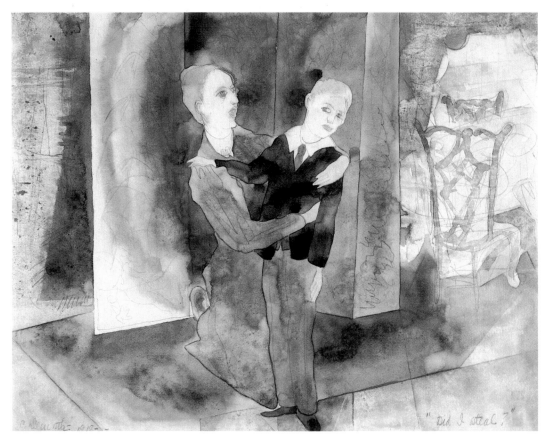

C. Demuth 1918 "Did I steal?"

Opposite above

43. **Flora and the Governess,**
illustration no. 3 for Henry
James' "The Turn of the
Screw," 1918
Watercolor and pencil on
paper, 8½ x 10⅜ in. (21.6 x
26.4 cm)
Philadelphia Museum of Art;
Gift of Frank and Alice Osborn

Opposite below

44. **Miles and the Governess,**
illustration no. 5 for Henry
James' "The Turn of the
Screw," 1918
Watercolor and pencil on
paper, 8 x 10⅜ in. (20.3 x
26.4 cm)
Philadelphia Museum of Art;
Gift of Frank and Alice Osborn

45. **A Prince of Court Painters
(after Watteau)**, illustration
for Walter Pater's *Imaginary
Portraits*, 1918
Watercolor on paper, 8 x
11 in. (20.3 x 27.9 cm)
Collection of Joan Crowell

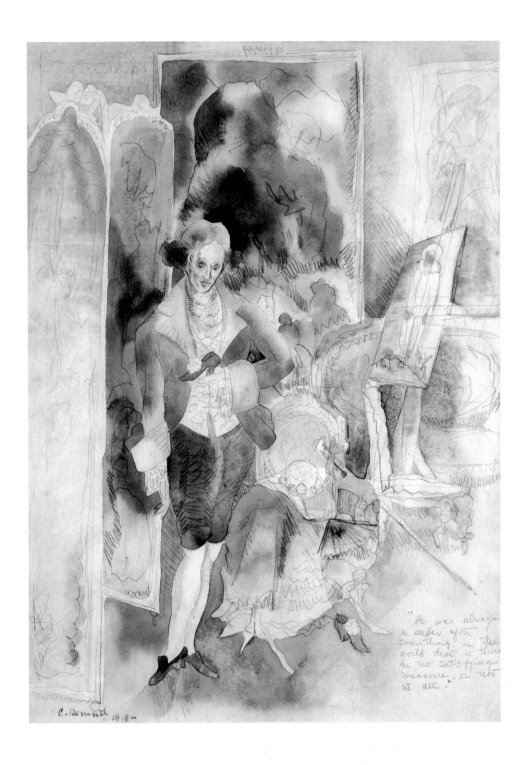

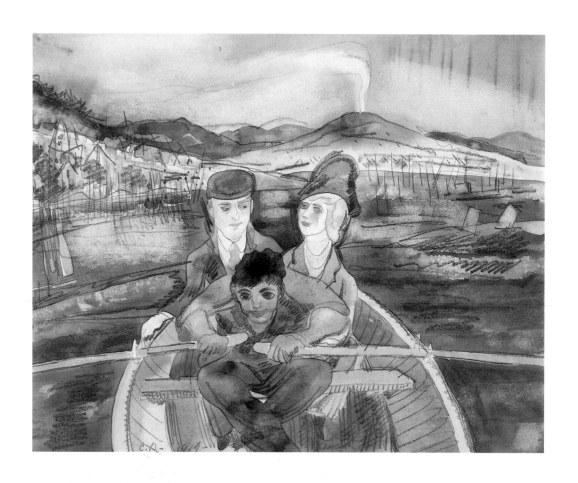

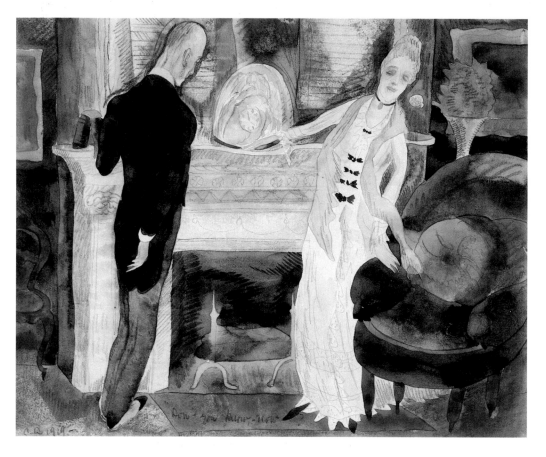

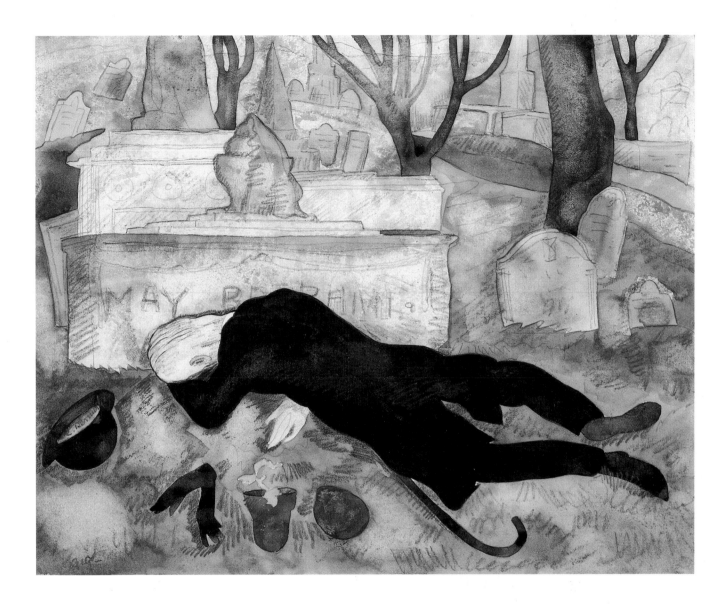

Opposite above 46. **The Boat Ride from Sorrento,** illustration no. 1 for Henry James'
"The Beast in the Jungle," 1919
Watercolor and pencil on paper, 8 x 10⅛ in. (20.3 x 25.7 cm)
Philadelphia Museum of Art; Gift of Frank and Alice Osborn

Opposite below 47. **The Revelation Comes to May Bartram in Her Drawing Room,**
illustration no. 2 for Henry James' "The Beast in the Jungle," 1919
Watercolor and pencil on paper, 8 x 10⅛ in. (20.3 x 25.7 cm)
Philadelphia Museum of Art; Gift of Frank and Alice Osborn

Above 48. **Marcher Receives His Revelation at May Bartram's Tomb,**
illustration no. 3 for Henry James' "The Beast in the Jungle," 1919
Watercolor and pencil on paper, 8 x 10⅛ in. (20.3 x 25.7 cm)
Philadelphia Museum of Art; Gift of Frank and Alice Osborn

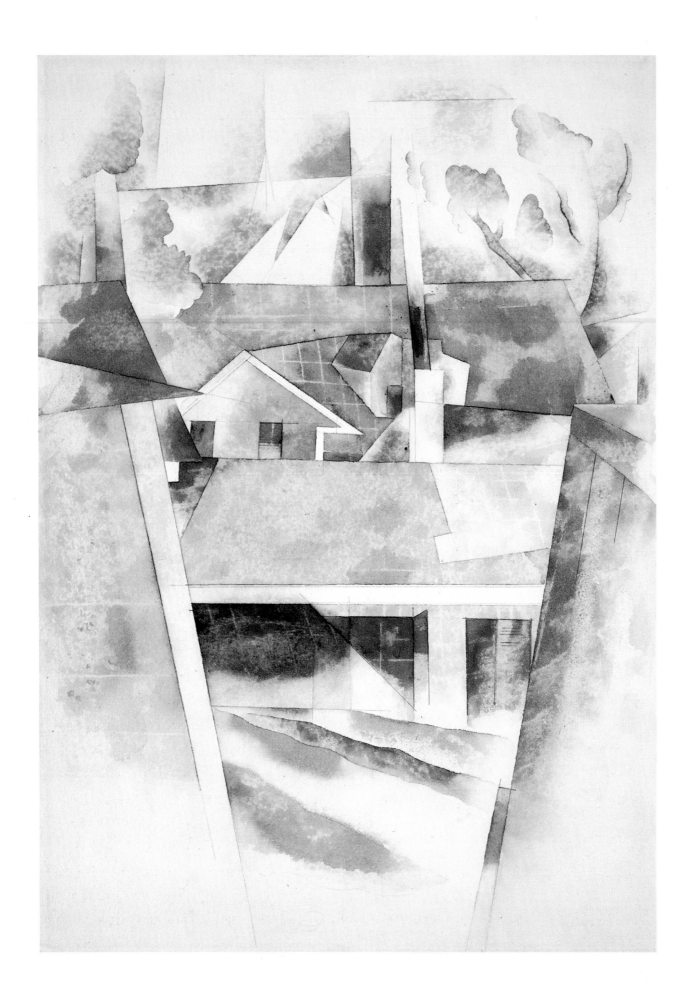

V.

Origins of Precisionism 1916–1922

Bathers Viewing the Sea, 1916
Watercolor and pencil on
paper, 12 x 9 in. (30.5 x
22.7 cm)
Collection of Dr. and
Mrs. John J. Mayers

At the height of Demuth's involvement with watercolors of New York life
and literary themes, he simultaneously began to produce a group of non-
figurative watercolors, distinct in style no less than in subject. In these works
lay the origins of the Precisionist paintings that some scholars identify as his
greatest achievement.

Demuth began taking the road toward Precisionism in the summer of
1916 in Provincetown under the influence of Hartley, who was there working
on a series of Constructivist-derived geometries unified around sailboat motifs.
He and Demuth spent a great deal of time in each other's company and
Hartley's work-in-progress may have inspired the younger artist to explore a
new direction.[1] Demuth had begun the summer with a group of watercolors
of sunbathers that duplicated the documentary impulses of his New York
subjects. But by mid-September, Hartley reported that Demuth's current
work "has taken on a less frivolous quality and now they are more dignified
with more real aesthetic in them."[2] Demuth's shift may, in part, have been
motivated by the sentiments evident in Hartley's comments. The circle
around Stieglitz had not yet come to take Demuth's work seriously. His
ambition was to gain their approval.

The work of Demuth's to which Hartley referred approvingly was a
series of tree-filled landscapes in which Demuth replaced his characteristic
freely handled wash with more distinctly demarcated color areas that inter-
locked in a moderately shallow space. As before, Demuth manipulated the
relationship between foreground and background, but here, since the subjects
are inanimate, the effect is not of time passing. And, because color tones are
more delicate and the structure tighter, the mood seems more restrained.
The pebbly texture of the blotting technique which he introduced at this time
joined with interweaving organic planes to animate the surface. In isolated
works such as *Trees and Rooftops* (Pl. 52), Demuth integrated curving tree

49. **Sailboats and Roofs**, c. 1918
Watercolor and pencil on
paper, 13¹⁵/₁₆ x 9¹⁵/₁₆ in. (35.4 x
25.2 cm)
Museum of Fine Arts,
Boston; Anonymous Gift

50. **Tree Trunks**, 1916
Watercolor on paper, 14½ x
10¼ in. (36.8 x 26 cm)
Richard York Gallery,
New York

Opposite above

51. **Bermuda Landscape**, 1917
Watercolor on paper, 9½ x
13½ in. (24.1 x 34.3 cm)
Columbus Museum of Art,
Ohio; Gift of Ferdinand
Howald

Opposite below

52. **Trees and Rooftops**, 1916
Watercolor on paper, 9¾ x
13½ in. (24.8 x 34.3 cm)
Collection of Antonette and
Isaac Arnold, Jr.

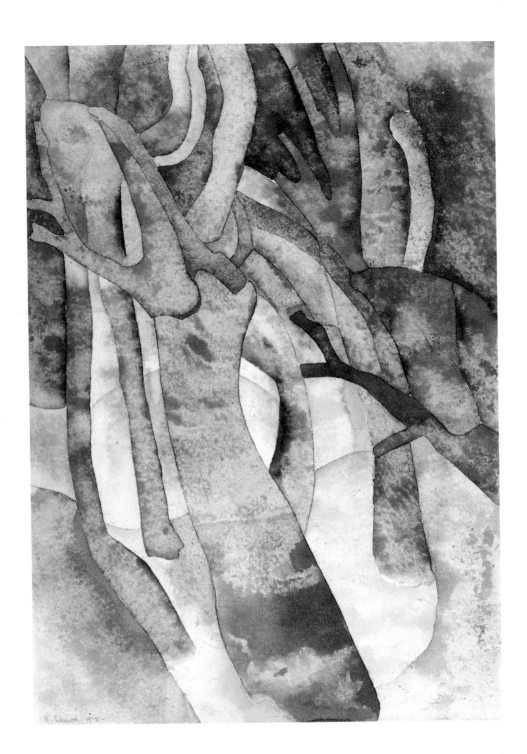

forms with the angular shapes of buildings to create a conjunction between the
organic and geometric that would soon become predominant in his work.

In September, when John Reed, whose houseguest Hartley had been
during the summer, closed his Provincetown home, Demuth and Hartley
moved in together in a rent-free cottage near the sea that belonged to John
Francis.[3] They planned to stay there until November and then travel to
Bermuda for the winter, but cold weather drove them back to New York

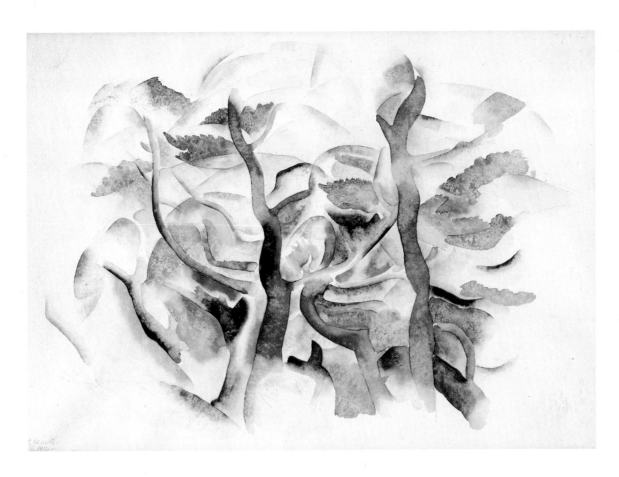

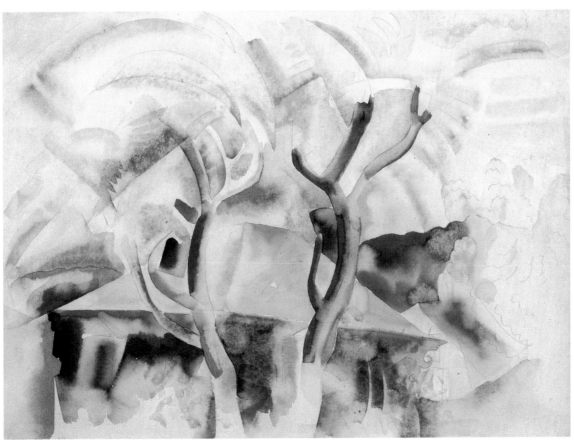

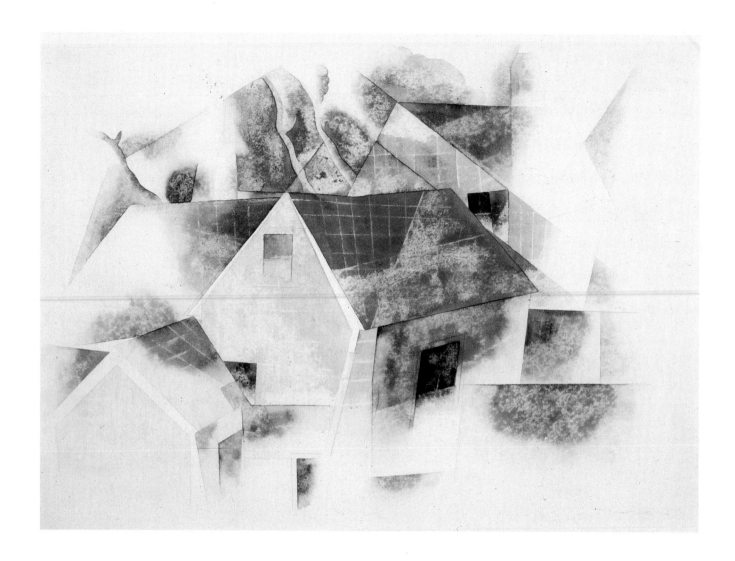

53. **Red-Roofed Houses**, 1917
Watercolor and pencil on
paper, 9¾ x 14 in. (24.8 x
35.6 cm)
Philadelphia Museum of Art;
The Samuel S. White, 3rd,
and Vera White Collection

Opposite page

54. **Red Chimneys**, 1918
Watercolor on paper, 9¾ x
13¾ in. (24.8 x 34.9 cm)
The Phillips Collection,
Washington, D.C.

early. Hartley spent the fall with Locher and his wife on Staten Island and
arrived in Bermuda in late December. Demuth followed the first week of
February 1917.[4] They soon found accommodations in an inexpensive hotel on
the top of the hill in St. Georges that they preferred over their initial base in
Hamilton.[5] Demuth and Hartley spent a wonderful month and a half sunbath-
ing and working, a period during which Demuth extended the angular vocab-
ulary he had introduced in his Provincetown paintings.

The presence of Albert Gleizes in Bermuda that winter may have been
an additional stimulus for Demuth's new style. Demuth had known Gleizes
through Arensberg and may have seen his paintings in group presentations at
the Carroll Gallery in New York. He would also have seen the group exhi-
bition of the artists the press dubbed the "Four Musketeers"—Gleizes,
Duchamp, Picabia, and Jean Crotti—which the Montross Gallery presented in
April 1916. This show featured Gleizes' paintings of circus and nightclub

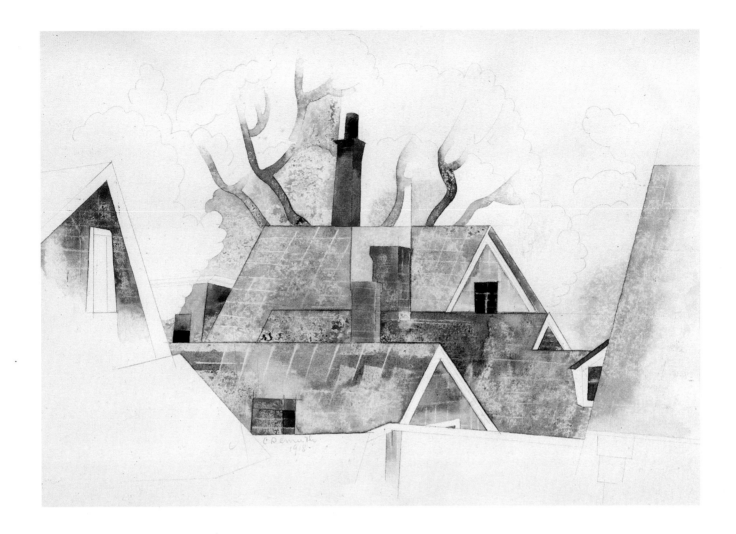

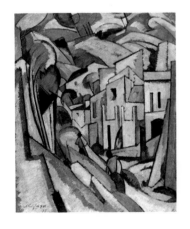

Albert Gleizes
Bermuda Scene, 1917
Oil on board, 32⅛ x 25½ in.
(81.6 x 64.8 cm) Private collection

performers and one gouache from his Brooklyn Bridge series, which antici-
pated Demuth's use of a linear network cutting across and defining planes of
space. The two artists made contact in Bermuda, and works such as Gleizes' *Ber-
muda Scene* could well have pushed Demuth toward a more abstract, planar style.[6]

If the work of Hartley and Gleizes provided the impetus for this new
style, Cézanne's late watercolors were Demuth's guides. Demuth's first
awareness of the importance of Cézanne's watercolors probably came through
Hartley, who was transposing their wash effects into his paintings when
Demuth met him in 1912 in Paris. The memory of Hartley's enthusiasm was
rekindled by Duchamp's conviction during these years that Rodin's drawings
"may last for twenty years but next to those of Cézanne they are impossible."[7]
These accolades, coming from Demuth's chief mentors, would have primed
him for the survey exhibition of Cézanne's watercolors that the Montross
Gallery presented in 1916.

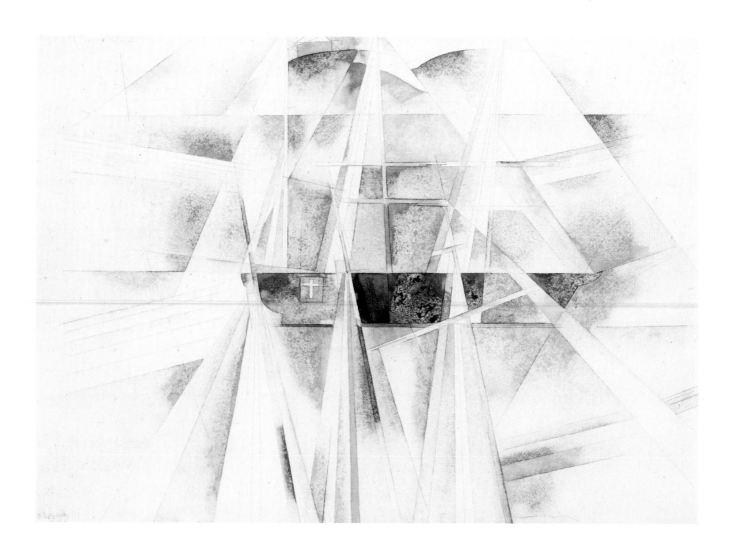

Cézanne's work offered Demuth a model for integrating angular forms
with the kind of sensuous, organic shapes with which he had worked earlier.
In this way he eased into Cubism, setting the biomorphic forms of trees and
branches within a subtly shifting structure of ruler-drawn lines and planes.
In contrast to Demuth's figurative watercolors, these works paraphrase
Cézanne's shallow space and his habit of leaving parts of the paper bare.
Demuth's continued exploitation of the blotting technique created delicate,
modulated surfaces that echoed the mildewed irregularities of the Bermuda
rooftops. His sensitivity to the particularities of place was equally evidenced in
his palette, which mirrored the olive green of Bermuda's indigenous cedars
and the pale yellows, rose pinks, pale blues, and terra-cottas of its residences.

Occasionally, however, Demuth went beyond Cézanne: in *Bermuda
No. 2, the Schooner* (Pl. 55), he extended lines past the natural boundaries of his
motifs to graphically animate the space around the centralized forms in a criss-

cross weft of intersecting diagonals. It is this adoption of a Futurist technique that would characterize his post-1918 architectural studies.

Unlike John Marin's more expressive experiments with Cubism, Demuth's combination of formalized geometry with pale color and diaphanous light effects elicited a fragile elegance from the Cubist vocabulary. For some viewers, such refinement violated accepted canons: Paul Strand praised the "virility" in Marin's work while questioning Demuth's "delicate niceness"; Paul Rosenfeld likewise voiced suspicions about the "almost female refinement in [Demuth's] wash."[8] Others, however, judged these "Interpretative Landscapes," as Demuth termed the Bermuda works, in the artist's favor. When they were shown in the fall of 1917, in a two-person exhibition at the Daniel Gallery with Edward Fiske, Henry McBride, chief critic for the influential *Sun*, became Demuth's most outspoken partisan.[9]

The introduction of a more structural style and landscape as subjects did not spell an end to Demuth's floral and figurative work. He concentrated on indoor subjects between October and June, and devoted his attention in the summers to outdoor architectural themes based on his venues: 1918 and 1920 in Provincetown; 1917 and 1919 in Gloucester, Massachusetts. In Provincetown in 1918 he advanced even further toward Cubism by forcefully asserting the clean, linear precision and refined integration of geometric and organic forms that had been inherent but not fully exploited in his earlier Bermuda views. He joined the mechanical outlines of scalloped trees with angular lines to create richly complex surfaces. As if describing an energy force emanating from objects, Demuth extended the lines of his buildings and masts into space. These filaments, which decoratively enrich the surface with an overall rhythm, function like the washes that had previously swirled about his figures.

Demuth's appropriation of a Cubist vocabulary was probably also a response to the ubiquity of Cubism in the vanguard aesthetic environment of New York. Everyone who was "modern" was influenced either by Cubism or by Futurism—the two movements being undifferentiated in American art circles. McBride put it simply: "America has a fine dashing way of naming things to suit itself and over here when we say 'Cubism' we mean everything and anything that is unacademic."[10] Any residual doubt about Cubist domination of modernism within Demuth's milieu had been quelled by the seminal Forum Exhibition of March 1916, which surveyed nineteen of America's leading vanguard artists, and by the Cubist collections being amassed by Arensberg and Katherine Dreier under Duchamp's guidance. Yet because

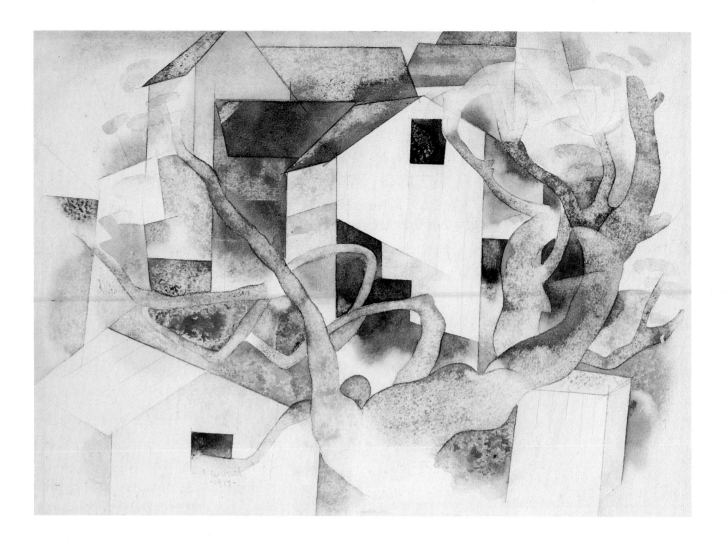

56. **Trees and Barns, Bermuda,**
 1917
 Watercolor on paper, 9½ x
 13½ in. (24.1 x 34.3 cm)
 Williams College Museum
 of Art, Williamstown,
 Massachusetts; Bequest of
 Susan W. Street

Cubism was known only secondhand, American interpretations of it were often dilutions of the Cubism practiced in Europe. Moreover, the French Cubists who resided here—Gleizes, Duchamp, and Picabia, in particular—themselves created works that were less fragmented and, in the case of Gleizes, more oriented toward landscape than those of Picasso or Braque.[11] All of this gave Demuth—and other Americans—enormous leeway to formulate personal versions of Cubism.

By 1919, Demuth was experimenting with predominantly rectilinear forms. In place of diaphanous zones that faded out at the edges, his color areas became crisply delineated. In some compositions he employed architectural motifs; in others, it was the sails, masts, and riggings of ships that provided the compositional scaffolding. His force lines came to function less as linear extensions than as rays of light whose colors changed as they passed through objects or other shafts. The results coupled formalized geometry with a soft, diffused radiance. What often appear as canopies of light beams surrounding central-

ized motifs reinforce the geometry of the compositions by creating a multi-plicity of angular planes that resemble the facets of Cubism. However, in contrast to the sculpted dimensionality of traditional Cubism, Demuth's intersecting diagonal lines never penetrate the surface or fracture objects. Even when he tips a section of a building façade in order to suggest its view from a different angle, it never implies depth but remains parallel to the pic-ture plane. And, although Demuth's lines are similar to Futurist lines of force and were identified as such as early as 1916, their effect is altogether differ-ent.[12] His are closer in their planar, decorative aspect to the work of C.R.W. Nevinson, an English associate of Marinetti and the Italian Futurists, whose painting *Mitrailleuses* Demuth would have seen on the September 1917 cover of *The Masses*.[13]

Adopting a Cubist style also allowed Demuth to further explore his longstanding interest in the relationship between painting and literature. Paintings are usually experienced as static because they appear to capture a single temporal moment, whereas literature, in its narrative mode, presents a sequence of such moments. The Cubist principle of multiplicity of viewpoints enabled Demuth to distill down to a single subject a variety of elapsed experi-ential perspectives. The result approximated the experience of reading a novel or sitting through a theater performance, where characters develop and even places change within the framework of a single work of art. Demuth inter-preted this experience on the flat plane of the canvas by layering accumula-tions of different experiences of the same object. With this technique he found an effective pictorial analogue to literature—the absence of which he addressed in an untitled contemporaneous prose piece: a painter sits in a park through-out the day while ordinary life passes by, filled with changes of character, emotion, action, and quality of light. The story ends with the image of the lonely artist, placed before his chosen landscape, unable to represent this flow of experience.[14] By adopting the Cubist principle of multiplicity, Demuth succeeded where his literary alter ego had failed.

Demuth also investigated the connection between words and images by attaching titles to his 1919 paintings that seemed to be unrelated to the pic-ture's apparent subject. By thus engaging the viewer conceptually, he alluded to the nondescriptive and suggestive experience of poetry. *Box of Tricks*, with its church nestled among waterfront buildings, concerns the artist's sleights of hand in visually transforming reality. Artifice, Demuth implies, is inherent to the process of making art; just as writers use language to transform the world, so too does the artist use light, color, and shapes to alter what is seen with

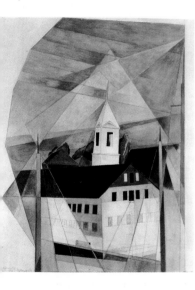

Box of Tricks, 1919
Gouache and pencil on board,
19⅞ x 15⅞ in. (50.5 x 40.3 cm)
The Pennsylvania Academy of
the Fine Arts, Philadelphia;
Acquired from the Philadelphia
Museum of Art in partial
exchange for the John S.
Phillips Collection of
European Drawings

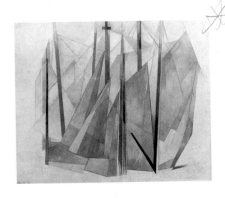

Sailboats (The Love Letter), 1919
Watercolor on board, 15½ x
19⅜ in. (39.4 x 49.2 cm)
Santa Barbara Museum of Art;
Gift of Wright Ludington

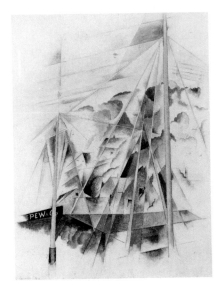

Rise of the Prism, 1919
Tempera on paper, 19¼ x
15¾ in. (48.9 x 40 cm)
Wichita Art Museum, Kansas;
The Roland P. Murdock
Collection

ordinary vision. *Piano Mover's Holiday* (Barnes Foundation, Merion, Pennsylvania), another architectural image, and *Sailboats* (*The Love Letter*), recalled the poetic titles Duchamp and Picabia had given their works: Duchamp's shovel inscribed *In Advance of a Broken Arm*, his cage of marble sugar cubes entitled *Why Not Sneeze Rose Sélavy?*, and Picabia's spark plug called *American Girl in a State of Nudity*. The titles of some of Demuth's other architectural pieces from that year—*Rise of the Prism*, *A Sky after El Greco* (Arizona State University, Tempe), and *In the Key of Blue* (collection of Vincent Garozza) —functioned essentially as commentaries on painting's formal vocabulary.[15]

Demuth had shifted his medium in these 1919 architectural works from watercolor to tempera. By applying it lightly and allowing areas of the board to show through, he attempted—not always successfully—to elicit the same transparency that he had previously achieved with watercolor. Yet he was never as comfortable with tempera, or with oil, which he adopted in 1921.[16] His use of tempera may reflect a desire for greater control and precision in the handling of small geometric units. He may also have viewed the opacity of tempera as more appropriate to the weight and substance of architectural subjects. Or he may have felt that working exclusively in watercolor put him at a disadvantage in an art world where watercolor was still considered less significant than more opaque media.[17]

Demuth's tempera experiments from 1919 included a small group of roughly executed flower subjects that differed dramatically from those he had done in watercolor. He eliminated depth by using larger, more uniform areas of discrete color deployed in forceful, overall patterns that covered the surface. He reinforced the two-dimensionality of the picture field by including window and curtain elements in the foreground—a favorite technique of Matisse and Derain and, later, of Hartley, who had used it in some of his Bermuda works. That Demuth produced very few of these flower temperas (Pl. 15) suggests that he was uncertain about their success; when he returned to oil still life in the mid-1920s with his poster portraits (pp. 173–91), it would be with greater conviction and authority.

Between 1920 and 1922 Demuth introduced into his architectural depictions a planar format created by flattening space, broadening his forms, and extending his compositions to the perimeters of the canvas. He no longer "floated" motifs or prismatically handled ambient space. Instead, he elevated shape over line as the primary compositional device. And with his substitution of oil for

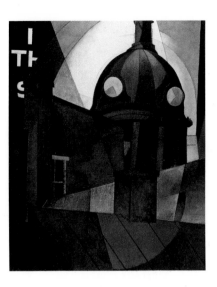

Welcome to Our City, 1921
Oil on canvas, 24½ x 19⅜ in.
(62.2 x 49.8 cm)
Private collection

watercolor, the once soft radiance of his paper-thin ray lines gave way to a more opaque and uniform surface. By overlapping geometric planes to collapse depth and describe motifs, Demuth established the style that would later be known as Precisionism.

Demuth's pre-1920 architectural paintings had been precisely drawn. He now created a sense of order and calm by combining this precision with geometric planes and smooth color handling. The clarity and impersonal elegance of this new style paralleled a major trend in post-World War I European art. The brutality of the war had ripped the veil off nineteenth-century civility and the conceits of high culture and tradition. It engendered on the part of artists a two-pronged reaction: on the one hand, pessimism, and, on the other, an aggressive desire to create something self-consciously modern, to shed historicism and celebrate the materials and inventions of the modern world. The seeds of this ambition—to make art out of what made one's life modern—had been planted before the war, but they now shot forth with a vengeance. Science and technology, the mechanical and the ordered, became the new cultural mentors.

Of these postwar assertions of the ethical and aesthetic lessons to be learned from machines, Demuth seems to have felt the greatest affinity for Purism, formulated in 1918 by Le Corbusier and Amédée Ozenfant in their book *Après le Cubisme*.[18] Demuth undoubtedly read either the 1919 English translation of the book or the lengthy review of it by McBride.[19] He was also well-versed in Purist images through the journals *L'Esprit nouveau*, edited by Ozenfant and Le Corbusier, and *L'Amour de l'art*.[20] Demuth confirmed his admiration for these artists in his 1921 letter to Stieglitz in which he grouped "all the French painters, the great ones," with "the men interested in the two magazines."[21]

The machinelike craftsmanship in Demuth's new work owed, in part, to the example of those French artists he had encountered through Arensberg, particularly Duchamp, whose painting *The Large Glass* he termed "the greatest picture of our time" (p. 58). Here and elsewhere, Duchamp had sought to replicate the rationality and impersonal processes of the machine by employing mechanical drawing techniques and sleek materials such as glass and metal. Picabia, too, had exploited machine imagery and a machinist style as a means to comment upon human behavior. "Almost immediately upon coming to America," Picabia had stated in 1915, "it flashed on me that the genius of the modern world is machinery. . . . In seeking forms through which to interpret ideas or by which to expose human characteristics I have come at length upon

the form which appears most brilliantly and fraught with symbolism. I have enlisted the machinery of the modern world and introduced it into my studio."[22] The crisp shapes and the elimination of modulated and brushy paint surfaces in the work both of Picabia and Duchamp became models for Demuth's new idiom. The formal rigor which their example encouraged turned him from the comparatively decorative lushness of his previous work toward an austerity associated with classicism.

A change in subject matter accompanied Demuth's stylistic break. Instead of vernacular nineteenth-century architectural structures, he now depicted the modern industrial landscape. Encouraged by William Carlos Williams' crusade for indigenous subjects and forms of expression, Demuth had searched for a theme that encapsulated his American experience. Williams had argued that artists must derive their subjects and viewpoints from their own period and place. "It is the degree of understanding about, and not situations themselves, which is of prime importance," Williams had written in *Contact*, the magazine he and Robert McAlmon published from December of 1920 through 1923.[23]

Nor were Williams' assertions about "place" and "indigenous experience" singular in postwar America. In 1919 John Dewey, proclaiming that "the locality is the only universal," had admonished artists to find universal truth in "the localities of America as they are."[24] By 1920, the call for a national form of expression, whether realist or modernist, had become a near-obsession—due in large part to the new importance of America on the postwar international scene. As the preeminent industrial power, America was a symbol of the future. Americans had returned home after the war confident that "America is just as God-damned good as Europe."[25] "We have just fallen heir to the proud position of world supremacy," McBride announced in 1922; "All the intellectuality of the world is focused on New York."[26] America's superiority was heralded with equal force by those Europeans to whom Demuth was most drawn during this period. Having fled Europe during the war, the French artists who gathered around Arensberg identified America as the artistic hope of the future. "I could not work in Paris," Gleizes observed. "I could not concentrate on the canvas. I could not think. . . . We came to America and what a change! . . . Here art is possible."[27] "It seems very possible to me that New York is destined to become the artistic center of the world," Jean Crotti noted. "Art certainly isn't possible in Europe and will not be for a long time. But art is very thrillingly possible over here."[28]

The push for a national expression was equally strong within the Stieglitz circle. On this score, Demuth's marks were not particularly high. Although he was moving toward an indigenous expression, he had included a group of earlier watercolors in a 1921 survey exhibition. It was these works which Paul Strand unflatteringly compared to Marin's: Demuth "has yet to disentangle himself from the sophistication of contemporary French influence," while Marin expressed "America and nowhere else. His [work] assert[ed] again the direct reaction to an immediate environment."[29] "Whether Demuth," Strand concluded, "would achieve a deeper penetration into his environment remains to be seen."

In response to this climate of nationalism, Demuth did begin to "penetrate deeper into his environment," seeking an indigenous expression of "place." He found it in the industrial buildings of Lancaster. Whereas the Europeans—and their American counterparts—had focused on New York skyscrapers as the symbols of America, Demuth remained true to Lancaster, thus creating his personal symbol of America.

Demuth's focus on the industrial character of Lancaster represents his interpretation of the country's contemporaneous romance with skyscraper cities and production-line efficiency. Prewar American artists, following the Futurists' lead, had identified the city with dynamism and progress. The almost religious fervor with which the American descendants of Futurism embraced industrial mechanization was epitomized by Joseph Stella's Brooklyn Bridge series of 1917–18.[30] Stella spoke for many when he later described the experience of walking across the bridge at night and feeling "deeply moved . . . as if on the threshhold of a new religion or in the presence of a new divinity."[31]

Apotheoses of the industrial city also appeared in the art and pronouncements of members of the Arensberg salon. Picabia proselytized endlessly about the beauty of New York, and Duchamp, who declared American skyscrapers more beautiful than anything France had to offer, rested his defense of *Fountain* on the contention that "the only works of art America has given are her plumbing and her bridges."[32] Gleizes claimed: "The genius who built the Brooklyn Bridge is to be classed alongside the genius who built Notre Dame de Paris."[33]

The identification of America with the machine and industrialization had also been championed by Robert Coady in *The Soil*, which he published between 1916 and 1917. In attempting to popularize American culture, Coady filled his magazine with photographs of every manifestation of American life

from industrial machines to sports. He defined American art as "yet outside of our art world. It's in the spirit of the Panama Canal. It's in the East River and the Battery. It's in Pittsburgh and Duluth. It's coming from the ball field, the Stadium and the ring."[34] Demuth's familiarity with Coady's exhortations helped encourage his decision to present the modern industrial landscape as a legitimate cultural expression of America.

By 1927, the exaltation of the machine and industry through art became the occasion for the landmark "Machine Age Exposition" in New York, sponsored by Jean Heap's *Little Review*. International in scope, it modeled itself on an exhibition of modern art and industry which had been held in Paris two years earlier. Demuth was an exhibitor as well as a member of the artists' board, along with Duchamp, Sheeler, and Louis Lozowick, all of whom were viewed as having used the order, calculation, and efficiency of modern technology to transcribe the American landscape. The exhibition juxtaposed paintings and constructions with actual machines and photographs of factories, grain elevators, and power plants. All were installed in galleries decorated with hand tools hung on chains from the ceiling. Calling the machine "the religious expression of today" and engineers "the great new race of men," the organizers identified artists of the first rank with those who were transforming the reality of the age—the machine—into dynamic beauty, by pictorially rendering the pure form and design of American architecture that was expressed in smokestacks, factories, and gas tanks.[35]

Seven years before the "Machine Age Exposition," however, Demuth had been almost alone in uniting precise drawing, unmodulated color, and tightly interlocking forms with industrial subject matter. Although he was in the habit of absorbing influences into his own work, here was a crucial instance in which he became the influencer. By 1921, a year after he had begun his architectural series, Demuth had made considerable strides in advancing this new industrial vocabulary. Wolfgang Born, who coined the word "Precisionism," identified him as the artist who had paved the way for a style appropriate to the new industrial reality. The only artist working in the early twenties in a comparable style was Charles Sheeler, a fellow Pennsylvanian exactly Demuth's age, whose tenure at the Pennsylvania Academy overlapped with Demuth's, as had his friendships with Arensberg and William Carlos Williams. Yet enough of Sheeler's early Precisionist work postdates Demuth's to suggest to some that the influence traveled from Demuth to Sheeler.[36]

By the mid-1920s, the new vocabulary which Demuth pioneered in 1920–21 had gained converts. Never cohesive in intent or technique, the

style was differently defined and named in the 1920s and 1930s. Among other designations, the artists were called New Classicists and Immaculates. The term that finally prevailed was "Precisionism," although its definition was so amorphous as to include virtually every artist who reduced an industrial theme to geometric shapes.[37]

Most artists identified with Precisionism viewed industrial mechanization and the modern city as an affirmative model of order and rationality and even as the apotheosis of a new religion. Sheeler considered factories "our substitute for religious expression,"[38] and Lozowick announced that "beneath all the apparent chaos and confusion is . . . order and organization which find their outward sign and symbol in the rigid geometry of the American city."[39]

Demuth regarded industry with more ambivalence. Although he accepted industrialization, he never lost his nostalgia for the sense of tradition and continuity that was endemic to Lancaster. As a result, many critics interpreted his industrial images as negative comments on machine technology. With the onset of the Depression, the ranks of these critics grew as industrialization itself came to be distrusted.[40]

Yet Demuth never viewed industrialization as corrupting or menacing. His true attitude resembled that of Duchamp and Picabia, who had taken advantage of the machine's absence of will and passion to express aspects of the human condition, but who had not mocked or decried the machine *per se*.[41] Like the transplanted French artists, Demuth used factory images as opportunities to force viewers to confront the disjunction between the verbal and the visual by attaching enigmatic and ostensibly unrelated titles to them. Some of his titles, however, remained descriptive: *In the Province* (Pl. 64) and *From the Garden of the Château* (Pl. 69) were terms he used in correspondence when referring to Lancaster. But, in general, his verbal overlays were more heavily weighted with intellectual nuance.

In *Incense of a New Church* (Pl. 62), Demuth ambivalently exploited what had become a ubiquitous correlation of industry and religion. He ironically equates incense with the billowing, stylized smoke that swirls menacingly around the cathedral-like forms of the Lukens Steel yards. A large chalice in the painting's foreground cements the religious-industrial symbolism: the transubstantiation of Christian communion is now enacted in the industrial arena.

The backdrop of *Incense of a New Church* is not only America's admiration for industrial technology, but for its source in capitalist business enterprise. Dazzled by the prosperity of postwar America and by the proliferation of new gadgets and machines, Americans by the 1920s had raised

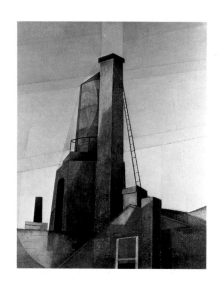

Aucassin and Nicolette, 1921
Oil on canvas, 24⅛ x 20 in.
(61.3 x 50.8 cm)
Columbus Museum of Art,
Ohio; Gift of Ferdinand
Howald

business into a national religion. As Calvin Coolidge declared, "the man who builds a factory builds a temple. The man who works there, worships there."[42] Bruce Barton's book *The Man Nobody Knows*, which epitomized the secularization of religion and the religiosity of business, was the best-selling non-fiction title in 1925 and 1926—an indication that many Americans identified the triumvirate of science, industry, and technology with a new era of prosperity and hope. Barton described Jesus as the founder of a modern enterprise who had "picked up twelve men from the bottom ranks of business and forged them into an organization that conquered the world."[43]

In *Aucassin and Nicolette*, Demuth implicitly equates a smokestack and water tower, pressed together against the Lancaster sky, with the star-crossed medieval lovers whose union defied society. The ladder, leaning gently against the erect (male) form of the smokestack, alludes to the eventual union of the lovers. The painting's animate-inanimate analogy recalls the mechanomorphs of Picabia and Duchamp, wherein machinelike apparatuses suggested human characteristics by means of the title. Such anthropomorphizations likewise paralleled Demuth's personal habit, as described by Susan Street, of walking down the street and comparing people and things to works of art or literary characters.[44] Demuth's interest in the French medieval romance, initiated perhaps by William Carlos Williams, who had been enthusiastic about it in college, may have been rekindled in 1922 when Walter Pater's essay on it was republished.[45] Pater's interpretation of *Aucassin and Nicolette* would have appealed to Demuth: a tale embodying the opposition between the moral-religious ideas of the medieval era and a system of belief in which the "beauty and worship of the body" impelled people "beyond the bounds of the Christian ideal."[46]

To another of his architectural motifs Demuth gave the cryptic title *Nospmas. M. Egiap Nospmas. M.* (Pl. 67). Based on his exposure to the acrostic and cryptographic techniques that Arensberg employed to decipher texts which he believed contained secret codes, such as the *Divine Comedy* (p. 59), the "message" of Demuth's title might be unraveled by reversing the order of letters so that it reads M. Sampson Paige. M. Sampson. It is possible that this refers to one of Demuth's friends or, more likely, that it is intentionally unintelligible. If so, it would relate directly to the self-consciously undecodable message that Duchamp inserted into his sculpture *With Hidden Noise* (which Arensberg owned), to the postcards of nonsequential prose that Duchamp sent to Arensberg, and to the poetry that he and Arensberg produced which purposely defied coherence.[47]

Demuth introduced a technique in these paintings that he had experi-

mented with in his Lulu watercolors (pp. 106–08): the incorporation of letters and broken words. Artists such as Léger and Stuart Davis had included numbers, letters, and words in their cityscapes as a means of evoking the ambience of billboards and advertising. Demuth would simulate the commercial signs of the urban landscape in only one painting—*Rue du Singe Qui Pêche* (Pl. 68), which he executed on his third trip to Paris. Otherwise, his linguistic fragments seemed often to be invented rather than culled from existing subjects. Slightly obliterated from view, these broken words underscore the existence of a symbolic structure in Demuth's architectural motifs by suggesting, as do his titles, arcane messages. Hidden and therefore never fully intelligible, they have given rise to endless speculations and assumptions. It is possible that these letters and fragments contained secrets, but all clues to their meanings have vanished. What fascinated Demuth about letters and broken words was their capacity to communicate on several levels without involving any kind of self-revelation. In this sense, what he found in art paralleled his life-style— flamboyant on the exterior, yet intensely private on an emotional level.

Demuth had been working in his innovative architectural idiom for less than two years when, in August 1921, he left for what would be his last trip to Europe. The previous summer in Provincetown he had been periodically incapacitated with an undiagnosed malady that left him with little energy and a craving for sweets.[48] In January 1921, he reported to Stieglitz: "most of the time, well,—I'm not up to doing very much about anything. Will see you I hope some time soon when things are more or less—more or less—God knows what." Demuth went to Europe in the hope that he might "'stop the wheels' going around backwards," but a month after his arrival his condition had not improved and he had not gone out much, feeling "none too well."[49]

Still, he was not socially isolated. The enactment of Prohibition in America had precipitated an exodus to Europe; so many people seemed to be there that Demuth could not imagine who was left in the Village. He wrote that Paris was so full of Americans that it reminded him of Christine's or the Brevoort on a rough night.[50] With Hartley, Duchamp, Robert and Bea Locher, and Susan Street there, it is no wonder that Demuth felt that being in Paris was "almost too grand."[51]

The Paris Demuth encountered in 1921 was far different from the one he had left in 1913 and of which he had retained idealized memories. Notwithstanding his introduction of American subject matter in 1920, he had never entirely lost his attachment to European traditions nor his affection for Europe. In the course of his 1921 trip, however, Demuth confronted the reality

of the postwar shift in world leadership from Europe to America. When he professed nostalgia for Paris, Duchamp and Gleizes exclaimed, "Oh! Paris. New York is the place,—there are the modern ideas,—Europe is finished."[52]

For Demuth, such pronouncements, coming as they did from artists he admired, encouraged him to take a more affirmative view of American culture. It was a turnaround he likened to the apotheosis of Poe in this country after Baudelaire translated and championed his works in France.[53] Although he considered Europe more wonderful than ever, he acknowledged that he also "never knew, really,—not so surely, that New York, if not the country, has something not found here."[54] This realization inspired a desire to return home and "do something about it."[55] Yet he still perceived that America could be culturally vacuous and that it was still difficult for an artist to work there. In his play *"You Must Come Over," A Painting: A Play,* he cited Washington Allston having gone mad after returning from Europe as proof that "America is no land for the artist."[56] "I know America is only for the very strong," one of the play's two interlocutors muses. Yet Demuth found solace even in that, for he came increasingly to believe that America's very indifference and disregard for art might, in itself, contribute to his artistic power. But he was not certain whether his newfound conviction about his identity as an American artist had shown yet in his work. When he recommended oil painting following his return from Europe, this conviction would dominate his attention.

Demuth's voluntary embrace of America was to be rendered involuntary by the drastic deterioration in his health that occurred during his Paris sojourn. Less than a month after he had arrived in the French capital, Demuth admitted himself to the American Hospital, where he remained for twelve days.[57] Medically, he had taken a chance in going to Europe since his unexplained weight loss the previous summer, coupled with ongoing exhaustion and cravings for sweets and carbohydrates, did not offer an optimistic physical prognosis. "I suppose things will go all right," was the only reassurance he had been able to give his mother.[58] During his hospitalization in Paris he must have received the diagnosis of diabetes, for it was then that he informed Hartley of the seriousness of his illness. Hartley's rather melodramatic account of the scene has Demuth looking out of a dormer window in the upper room of the Hotel Lutetia: "Charles is at the right of this amazing dormer window, I at the left, and the disheartening news has been revealed, he saying to me, and I recall it so well—O well, I've seen it all—I've done it all, and the throat thickened with the sense of sudden revealment—Charles learns that he is

really ill, and that he must go home."[59] The fact that Demuth remained in
Europe for two more months suggests either that he was not fully aware of the
seriousness of his condition or that he did not believe that returning to America
would help. But he did return in November 1921, realizing that he had been
"lucky" to get several months in Europe "the way things are at present."[60]

In June 1922, eight months after his return to America, Demuth
entered the Physiatric Institute in Morristown, New Jersey, which Dr. Fred-
erick Allen had established in 1920 for the research and treatment of diabetes,
high blood pressure, and Bright's disease.[61] In the years before insulin, Dr.
Allen was one of several leading authorities on diabetes. Under his system,
diabetic patients fasted until the sugar disappeared from their urine samples;
then they rigorously reduced their caloric intake to near starvation in order to
keep sugar from reappearing in the blood. Although the regimen increased a
patient's life expectancy by less than six years, Allen's system was so widely
adopted that the years between 1914 and 1921 are known in the history of
diabetes as the Allen era.[62]

Contrary to former assertions, Demuth remained on Allen's near-
starvation regimen for ten months.[63] He had stayed at the Institute under
Allen's supervision for one month, after which he returned to Lancaster where
his mother kept his food and alcohol intake strictly controlled. Demuth soon
became emaciated and his eyesight, according to one source, was greatly
impaired.[64] However, these ten months under Allen's care prolonged
Demuth's life until insulin was available to him. The serum had been discov-
ered in Canada in January 1921; in August 1922 Dr. Allen became the third
doctor in America to administer it. Even then, Demuth was not an immediate
beneficiary, for he did not re-enter Allen's Institute until March 1923. By
April the effect of the insulin treatment seemed miraculous: Demuth reported
to Stieglitz that "the serum seems to be—well it seems like a sort of trick. I
feel—I will wake—it is not possible. If it be true what it is doing—then, well
then, I can hardly imagine."[65]

By the time Demuth left the clinic in May he had gained nearly fifteen
pounds. Nevertheless, his life was henceforth marked by illness. Not only did
he need to give himself two hypodermic injections daily and to have all his
food weighed but, because insulin was not yet administered according to
sugar levels, Demuth remained subject to sudden hypoglycemic attacks. He
was more prey to these attacks when he ventured from Lancaster to New
York. In the city, away from the protective eye of his mother, he delayed
meals, did more exercise (which affected his sugar levels), and did not care-

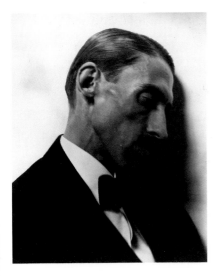

Alfred Stieglitz
Charles Demuth, 1922
Gelatin silver print, 9⅜ x
7⅜ in. (23.8 x 18.7 cm)
The Museum of Modern Art,
New York; Gift of Samuel M.
Kootz

fully regulate his food intake. Friends recalled having to quickly procure orange juice or sugar for Demuth when they sensed the onset of an attack or, if they failed to respond rapidly enough, having to witness his paroxysms until the digested sugar took effect. Through it all, Demuth remained as elegant and seemingly unperturbed as ever. But physical survival precluded the resumption of his former life-style.

This new reality was strangely reminiscent of Demuth's childhood struggle with Perthes. Diabetes deepened his sense of himself as marginal, as an outsider. Just as in grammar school he had been unable to play with children his own age, he was now forced to give up a way of life that had been crucial to him and kept him in contact with his contemporaries. While diabetes would not completely incapacitate Demuth, he would always live under the threat of recurrent, severe illness and death. In this emotional state, he chose to return to the environment of his childhood. Always drawn to Lancaster, he now—in 1922—seized the occasion to make it his sole residence. In an almost bizarre re-enactment of his childhood, Demuth, at thirty-eight, once again began living at home, dependent on his mother for monitoring his food intake. Only in this way could he reserve his waning energies for painting.

Demuth's remove from his life in New York coincided with a radical change in that milieu after the war. *The Masses* closed; Mabel Dodge moved to Taos; the Arensbergs moved to Los Angeles; Duchamp and Picabia returned to Europe. Prohibition, passed in December of 1917, closed many clubs. Greenwich Village became a "tinselly peep show" for the uptown rich who wanted a taste of bohemia.[66] More significantly, the despair and loss of idealism caused by the war destroyed the humanist spirit of the teens; the drive for individual pleasure became the behavioral norm. As Malcolm Cowley described it: "We had lost our ideals at an early age . . ." and "now were eager to lavish [our youth] even on trivial objects."[67] The disenchantment and world-weariness of the Jazz Age had been implicit in the Aestheticism and Symbolism to which Demuth had subscribed as a young man.[68] Ironically, the spirit of the times caught up with his *fin-de-siècle* posture at precisely the moment when his precarious health made it impossible for him to physically afford the luxury of such decadence.

Demuth's health forced him, for the two years following his return from Europe, to temporarily abandon oil painting. He managed to produce a few oils, among them Paquebot *"Paris"* (Pl. 66), for which he

Spring, 1922
Oil on canvas, 22⅛ x 24⅛ in.
(56.2 x 61.3 cm)
Hirschl & Adler Galleries,
New York

had drawn studies on his home voyage, and *Spring*, an atypical work based on samples of shirt material in which he attempted to achieve a truly two-dimensional picture by depicting objects which were themselves two-dimensional. But, in general, Demuth's pictorial activities were limited to watercolor. "I've only painted in watercolour," he notified Stieglitz in September 1923. "The strain is greater, but I don't have to return and fuss if it goes bad as one always does in oil or tempera."[69]

In subject matter, Demuth's new watercolors joined images of fruits and vegetables to those of flowers. Larger in size than his previous watercolors, these works structurally recalled his Bermuda landscapes. His juxtaposition of curves and intersecting diagonals echoed the interplay he had established in these earlier works between the biomorphic forms of trees and branches and the subtly shifting structure of lines and planes. As before, Demuth contrasted delicately modulated color and diaphanous forms with a gentle Cubist overlay of serpentine lines and receding planes that radiated toward the edges of the paper. The results fused objects with their surrounding space.

By 1924, Demuth had begun experimenting with still lifes composed exclusively of fruits and vegetables. In these instances, his device of interweaving motif and background plane into a complex pattern gave way to a restrained format in which images were deployed against uninflected backgrounds that contained only fragmentary arcs and curved planes. In all cases, Demuth captured the reflection of light as it played over the rounded surfaces of fruits and vegetables, thereby creating voluptuous, three-dimensional shapes reminiscent of those in Cézanne's still lifes. So anthropomorphic are these images that even Demuth admitted to unconsciously having transformed an eggplant into a heart in the course of painting it. Not surprisingly, such fruits and vegetables were often perceived as willful evocations of body parts.[70] Demuth continued to blot the wet watercolor medium in order to create texture, but he now also became more inclined to allow pencil-drawn silhouettes to remain free of color.

These compositions were more refined and elegant than Demuth's previous watercolors but, curiously, they reflected none of the intellectual search for American themes that had occupied him since 1920. Henceforth, oil alone would be the medium in which he experimented pictorially and in which he sought to encapsulate a truly American subject matter and style.

Notes

1. Bereft of his European friends, Hartley had sought out Demuth's company as a refuge from what he described as the "world of mediocrity" which surrounded him; Hartley to Alfred Stieglitz, August 10, 1916, Stieglitz Collection, Collection of American Literature, Beinecke Rare Book and Manuscript Library, Yale University, New Haven (hereafter cited as Yale).

2. Hartley to Stieglitz, September 19, 1916, Yale.

3. Emily Farnham, *Charles Demuth: Behind a Laughing Mask* (Norman, Oklahoma: University of Oklahoma Press, 1971), p. 107, incorrectly stated that Demuth and Eugene O'Neill lived together at the Francis Apartments in Provincetown. However, Hartley stated in a letter to Stieglitz, September 19, 1916, Yale, that he and Demuth had moved into John Francis' house. No evidence has been found by O'Neill scholars that O'Neill ever lived with Demuth at the Francis Apartments.

4. Farnham, ibid., p. 193 (followed by other scholars), assumed that Demuth spent the fall of 1916 in Bermuda. Consequently, his Bermuda paintings usually have been dated to 1916. However, Demuth did not arrive until February 1917; for notice of Demuth's arrival, see Hartley to Stieglitz, February 8, 1917, Yale.

5. O'Neill intended to follow Demuth to Bermuda during the second week of February 1917. Hartley described it as a perfect mix: O'Neill, who liked them both, would be a foil to Demuth, whose "charming moods" made him so companionable; see Hartley to Stieglitz, February 8 and 17, 1917, Yale. Ultimately, O'Neill decided against the trip.

6. Daniel Robbins, letter to the author, May 14, 1986, provided information (derived from Mme. Gleizes) on the contact between Gleizes and Demuth in Bermuda.

7. Quoted in Pamela Edwards Allara, "The Water-Color Illustrations of Charles Demuth" (Ph.D. dissertation, Johns Hopkins University, Baltimore, 1970), pp. 57–58. Cézanne's watercolors were universally touted. In reviewing his exhibition at the Montross Gallery in 1916, the critic for *The New York Sun* wrote, "The Cézanne episode is almost being turned into a religious festival by the young artists of advanced tendencies, who openingly acknowledge this artist to be the fountainhead of modern art"; "What Is Happening in the World of Art," *The New York Sun*, January 16, 1916, section F, p. 8.

8. Paul Strand, "American Water Colors at The Brooklyn Museum," *The Arts*, 2 (January 20, 1922), pp. 151–52; Paul Rosenfeld, "American Painting," *The Dial*, 71 (December 1921), p. 663.

9. Henry McBride, "What Is Happening in the World of Art," *The New York Sun*, November 1, 1914, section 6, p. 5. Reprinted in Daniel Catton Rich, ed., *The Flow of Art: Essays and Criticisms of Henry McBride* (New York: Atheneum Publishers, 1975), pp. 69–70.

McBride became Demuth's ardent champion even though he continued to prefer Demuth's figurative watercolors over his geometric efforts.

10. Henry McBride, "The Growth of Cubism," *The New York Sun*, February 8, 1914, section 5, p. 7.

11. *Cubism*, which Gleizes authored with Jean Metzinger, had opposed Picasso's superficial fragmentation or "impressionism" of forms. Available in English in 1913, the book dominated discussions on Cubism among members of the Arensberg group.

12. Willard Huntington Wright was the first to link Demuth's ray lines with Futurism in "The Aesthetic Struggle in America," *Forum*, 55 (February 1916), p. 213.

13. Demuth would not have been able to see more examples of Nevinson's art until the winter of 1920, when they were exhibited in New York; see Joshua C. Taylor, *America As Art* (Washington, D.C.: Smithsonian Institution Press, 1976), p. 190.

14. For the text of Demuth's untitled manuscript, see pp. 45–46.

15. *In the Key of Blue* referred to an essay of that title on aesthetics by John Addington Symonds, published in *The Key of Blue and Other Prose Poems* (New York: Macmillan & Company, 1893), pp. 1–16.

16. As late as 1928, Demuth admitted to Stieglitz that "with oil-colour" he needed assistance; Demuth to Stieglitz, June 18, 1928, Yale.

17. McBride expressed this view forcefully: "In fact I share in the conventional prejudice against an artist's career that shall be worked out exclusively in water color. . . . But I do share the feeling that it is a bad medium to grow up in, a bad medium in which to acquire knowledge, and that your true water colorist must get 'values' and 'breadth' and 'anatomy' and the thousand and one other things upon which technic depends in some other manner—preferably oils"; see Henry McBride, "Works of Charles Demuth Shown in Daniel Galleries," *New York Herald*, December 2, 1923, section 8, p. 7.

18. For a discussion of Purism as a utopian vision traceable to the war, see Kenneth E. Silver, "Purism: Straightening Up after the Great War," *Artforum*, 15 (March 1977), pp. 56–63.

19. Henry McBride, "News and Comment in the World of Art," *The New York Sun*, May 25, 1919, section 7, p. 12.

20. *L'Amour de l'art* cited Demuth as one of the practitioners of a new American style later called Precisionism; see W[aldemar] G[eorge], "Les Expositions," *L'Amour de l'art*, 4 (November 1923), p. 763. In 1928 Demuth included the journals in a painting entitled *Longhi on Broadway* (Pl. 96).

21. Demuth to Stieglitz, October 10, 1921, Yale.

22. Picabia, quoted in "French Artists Spur on an American Art," *The New York Tribune*, October 24, 1915, section 4, p. 2.

23. William Carlos Williams, *Contact*, no. 1 (December 1920), title page; quoted in Patrick Leonard Stewart, Jr., "Charles Sheeler, William Carlos Williams and the Development of the Precisionist Aesthetic, 1917–1931" (Ph.D. dissertation, University of Delaware, Newark, 1981), p. 17. Williams' belief about indigenous subject matter and his conviction that the artist could transform even the sordid and drab into compelling beauty through the force of imagination had a profound influence on Demuth. Nevertheless, Demuth was less than enthusiastic about all aspects of *Contact*. In a letter to O'Neill he wrote, "Did Williams send you copies of 'Contact,' if he didn't I'll send you them through him. It's not much, still, we must be in on our contemporaries"; Demuth to Agnes and Eugene O'Neill, 1926, Yale.

24. John Dewey, "Americanism and Localism," *The Dial*, June 1920, p. 687.

25. Malcolm Cowley, *Exiles Return* (New York: Penguin Books, 1976), p. 107.

26. First quote, Henry McBride, "Art News and Reviews," *New York Herald*, October 15, 1922, section 7, p. 6. Reprinted in Daniel Catton Rich, ed., *The Flow of Art: Essays and Criticisms of Henry McBride* (New York: Atheneum Publishers, 1975), p. 165. Second quote, McBride, "Modern Art," *The Dial*, 86 (April 1929), p. 354.

27. Quoted in "French Artists Spur on an American Art."

28. Quoted in ibid.

29. Paul Strand, "Reviewing December 1921," *The Arts*, 2 (January 20, 1922), p. 151.

30. The series, though painted between 1917 and 1918, was not exhibited until 1920. But Stella's membership in the Arensberg group meant that his work was seen earlier by Demuth.

31. Quoted in Dickran Tashjian, *Skyscraper Primitives* (Middletown, Connecticut: Wesleyan University Press, 1975), p. 193.

32. For Duchamp's comment on skyscrapers see Francis Naumann, "Walter Conrad Arensberg: Poet, Patron, and Participant in the New York Avant-Garde, 1915–20," *Philadelphia Museum of Art Bulletin*, 76 (Spring 1980), p. 15. His remarks on American plumbing and bridges are quoted in "The Richard Mutt Case," *The Blind Man*, no. 2 (May 1917), p. 5.

33. Albert Gleizes, quoted in "French Artists Spur on an American Art."

34. *The Soil* ran for five issues; see Judith K. Zilczer, "Robert J. Coady, Forgotten Spokesman for Avant-Garde Culture in America," *American Art Review*, 2 (September–October 1975), pp. 85–86. Coady's juxtaposition of illustrations of machinery with the phrase "Who will paint New York? Who?" implicitly equated America with the machine in one of the magazine's first issues; see Coady, "American Art," *The Soil*, 1 (December 1916), pp. 16–18.

35. Jane Heap, "Machine Age Exposition," *The Little Review*, 11 (Spring 1925), p. 36. The proposition that the age of the machine was a reality was so thoroughly assimilated in art circles by 1927 that *The New Masses* distributed a questionnaire following the exhibition which asked "How should the artist adapt himself to the machine age?"; see *The New Masses*, 2 (January 1927), p. 6.

36. Sheeler historian Susan Fillin Yeh, for example, has concluded that works of Sheeler's such as the 1922 *Yachts* drew heavily on Demuth's 1919 temperas of sailboats for inspiration. The same is true for Sheeler's *Upper Deck* from 1929, which resembles Demuth's 1921–22 *Pacquebot "Paris"* (Pl. 66); she also asserts that Demuth's art helped make Duchamp's ideas accessible to Sheeler; see Susan Fillin Yeh, "Charles Sheeler and the Machine Age" (Ph.D. dissertation, City University of New York, 1981), p. 176.

37. For discussion of these terms, see Karen Tsujimoto, *Images of America*, exhibition catalogue (San Francisco Museum of Modern Art, 1982) pp. 21–22.

38. Quoted in ibid., p. 85.

39. Louis Lozowick, "The Americanization of Art," from *The Machine Age Catalogue*, in *The Little Review*, 12 (May 1927), supplement, p. 18.

40. For opposition reaction to the machine and technology, see Susan Fillin Yeh, "Charles Sheeler and the Machine Age," pp. 10–11.

41. For this analysis of Picabia's and Duchamp's attitudes toward the machine, see William Camfield, "The Machinist Style of Francis Picabia," *The Art Bulletin*, 48 (September–December 1966), pp. 309–22.

42. Quoted in William E. Leuctenburg, *The Perils of Prosperity* (Chicago: University of Chicago Press, 1958), p. 188.

43. Quoted in ibid., p. 189.

44. Susan Street, quoted in S. Lane Faison, Jr., "Fact and Art in Charles Demuth," *Magazine of Art*, 43 (April 1950), p. 126.

45. Walter Pater, "Two Early French Stories" (1873), reprinted in *The Renaissance: Studies in Art and Poetry* (London: Macmillan and Co., 1922). Williams was fascinated with *Aucassin and Nicolette*, for which reason Karal Ann Marling, "My Egypt: The Irony of the American Dream," *Winterthur Portfolio*, 15 (Spring 1980), p. 32, identified the painting as representing a reunion between Williams and Demuth sometime after ill health had reduced Demuth's social life in

Opposite page

57. **In the Province #7**, 1920
Tempera, watercolor, and
pencil on board, 20 x 16 in.
(50.8 x 40.6 cm)
Amon Carter Museum,
Fort Worth

New York. She claimed that Demuth's confrontation
with death "framed by the ripening friendship with
Williams," explained the title. The painting, however,
was executed in 1921—before Demuth's social life in
New York was curtailed by serious diabetic symptoms.

46. Walter Pater, "Two Early French Stories," p. 19.

47. Arensberg's poetry from 1917 to 1919 took phrases
from diverse contexts and arranged them in random
sequences in order to emphasize the physical rather
than the narrative aspect of words; for Arensberg's and
Duchamp's poetry, and for the four postcards sent by
Duchamp, see Naumann, "Walter Conrad Arensberg."

48. See Farnham, *Charles Demuth*, p. 123. In the sum-
mer of 1920, Demuth told Susan Street: "I don't know
what it is, Susie, but I have a craving for canned pine-
apple, for canned sweets." When he sailed for Europe
the following year, it was with a supply of biscuits
from his mother that he hoped would "hold out" for
the duration of the voyage; Demuth to Augusta
Demuth, August 12, 1921, Archives of American Art,
Smithsonian Institution, Washington, D.C.

49. Demuth to Stieglitz, January 2, 1921, Yale;
Demuth to Agnes and Eugene O'Neill, September 17,
1921, Yale.

50. Demuth to Stieglitz, August 13, 1921, Yale.

51. Demuth to Stieglitz, October 10, 1921, Yale.

52. Ibid.

53. Ibid.

54. Demuth to Stieglitz, August 13, 1921, Yale.

55. Ibid. See also Demuth to Stieglitz, November 28,
1921, Yale: "What work I do will be done here: terri-
ble as it is to work in this 'our land of the free'. . . .
Together we will add to the American scene, more
than has been added since the 60s and 70s—maybe
more than they added."

56. This same view was proposed by Van Wyck
Brooks about Mark Twain. In *The Ordeal of Mark
Twain*, he argued that Twain had been crushed and
corrupted by the distorted values of a country whose
emphasis on the useful was hostile to artists; see
Leuctenberg, *The Perils of Prosperity*, pp. 145–46.

57. Demuth entered the hospital on September 9 and
was discharged on September 21; information courtesy
Shari Leslie Segall, The American Hospital of Paris.
Farnham's assertion that Demuth stayed in the hospital
one week and left on October 3, has been repeated by
virtually all subsequent historians.

58. Charles Demuth to Augusta Demuth, August 12,
1921, Pauline Stauffer Collection, Archives of Amer-
ican Art, Smithsonian Institution, Washington, D.C.

59. Marsden Hartley, "Farewell, Charles: An Outline
in Portraiture of Charles Demuth—Painter," in Alfred

Kreymborg, Lewis Mumford, and Paul Rosenfeld,
eds., *The New Caravan* (New York: W. W. Norton &
Co., 1936), p. 559.

60. Charles Demuth to Augusta Demuth, October 15,
1921, Pauline Stauffer Collection, Archives of Ameri-
can Art, Smithsonian Institution, Washington, D.C.

61. For information on Dr. Allen's Physiatric Institute,
see Frederick M. Allen, "The Physiatric Institute,"
Journal of the Medical Society of New Jersey, 8 (June
1921), pp. 189–93; Alfred R. Henderson, "Frederick
M. Allen, M.D., and the Psychiatric Institute at Mor-
ristown, N.J. (1920–1938)," *Academy of Medicine of
New Jersey Bulletin*, 16 (December 1970), pp. 40–49.

62. For Dr. Allen's treatment of diabetes, see Fred-
erick M. Allen, "The Present Status of Diabetic Treat-
ment," *Journal of the Medical Society of New Jersey*, 20
(January 1923), pp. 1–15.

63. Farnham, *Charles Demuth*, p. 196, and others claim
that Demuth received insulin treatments shortly after
entering the Physiatric Institute in the spring of 1922.
However, it is clear from his correspondence with
Stieglitz and from the photographs Stieglitz took of
him in early March 1923 that Demuth remained on the
initial starvation treatment until his second visit to the
Institute in March 1923.

64. On May 2, 1923, Demuth wrote to Stieglitz about
these photographs: "You have me in a fix: shall I
remain ill retaining that look, die, considering 'that
moment,' the climax of my 'looks,' or, live and change.
I think the head is one of the most beautiful things that
I have ever known in the world of art. . . . The hands,
too,—Stieglitz—how do you do it?" (Yale). Informa-
tion about Demuth's impaired eyesight from James W.
Sherrill, Jr., M.D., son of Dr. Allen's assistant, conver-
sation with Marilyn Kushner of the Whitney Museum
of American Art, April 16, 1986.

65. Demuth to Stieglitz, April 16, 1923, Yale.

66. Floyd Dell, quoted in Allen Churchill, *The
Improper Bohemians* (New York: E.P. Dutton and
Company, 1959), p. 170.

67. Malcolm Cowley, *Exile's Return*, pp. 71, 72.

68. Edmund Wilson described the similarity between
the Jazz Age and the 1890s: "The disillusion and the
weariness which we recognize as characteristic of the
eighties and the nineties were in reality the aspect of the
philosophy which, implicit in the writings of the Sym-
bolists, was to come to its full growth and exercise its
widest influence during the period that followed the
World War." Edmund Wilson, *Axel's Castle* (New
York: Charles Scribner's Sons, 1931), p. 285.

69. Demuth to Stieglitz, September 4, 1923, Yale.

70. See William H. Gerdts, *Painters of the Humble
Truth* (Columbia: University of Missouri Press, 1981),
p. 269.

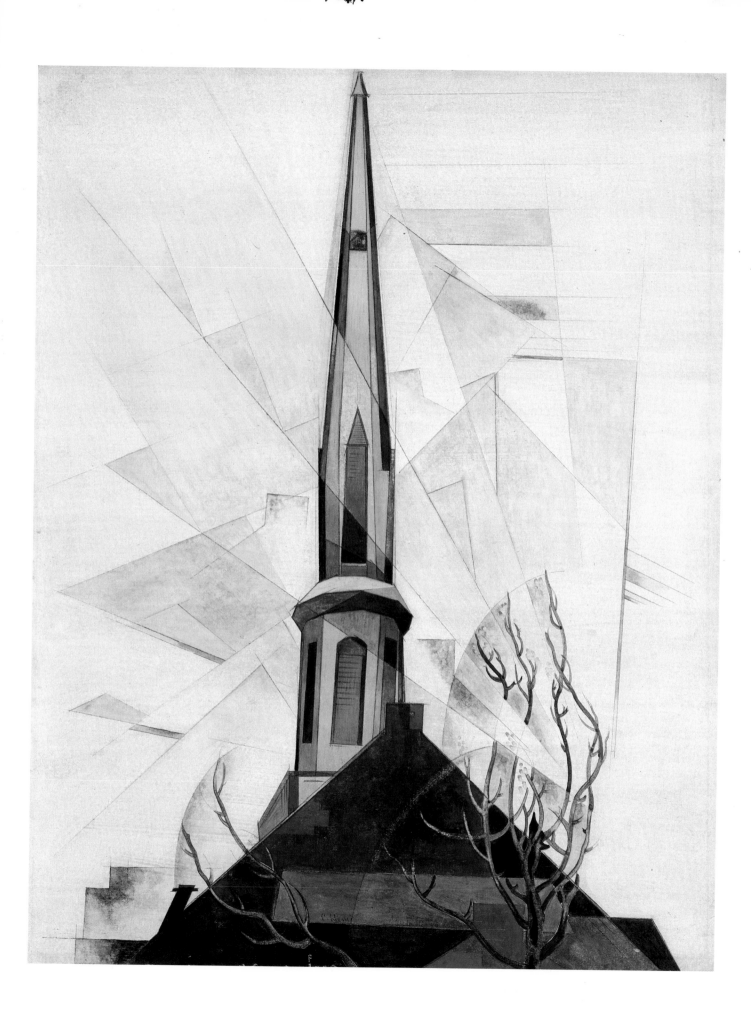

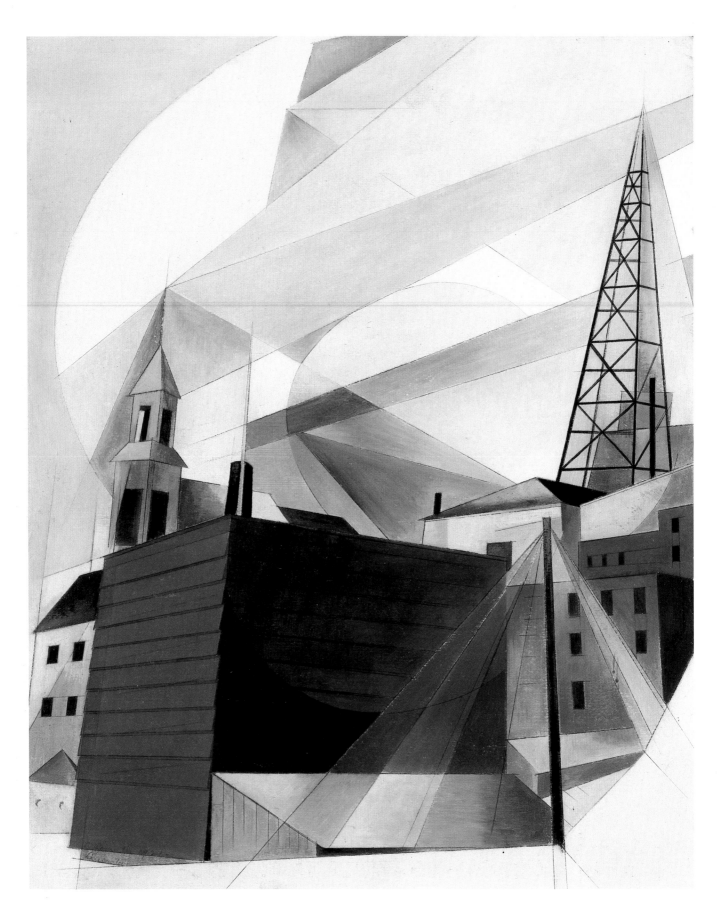

58. **Lancaster**, 1921
Tempera on board, 15 x 15½ in. (38.1 x 39.4 cm)
Albright-Knox Art Gallery, Buffalo, New York; Room of Contemporary Art Fund

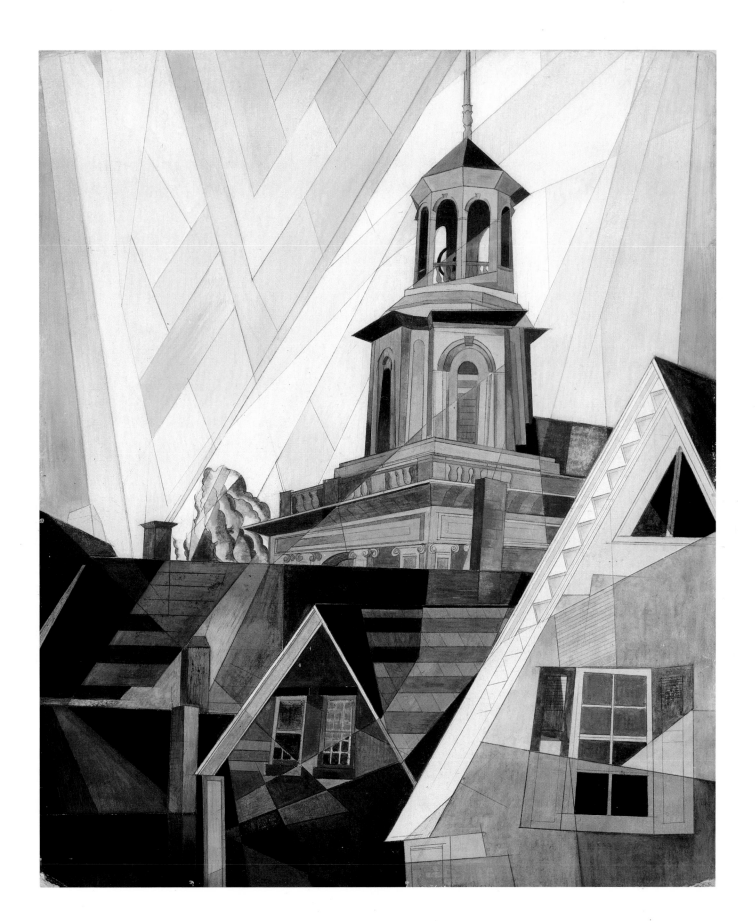

59. **After Sir Christopher Wren**, 1920
Watercolor, gouache, and pencil on board, 24 x 20 in. (61 x 50.8 cm)
The Metropolitan Museum of Art, New York; Bequest of Scofield Thayer

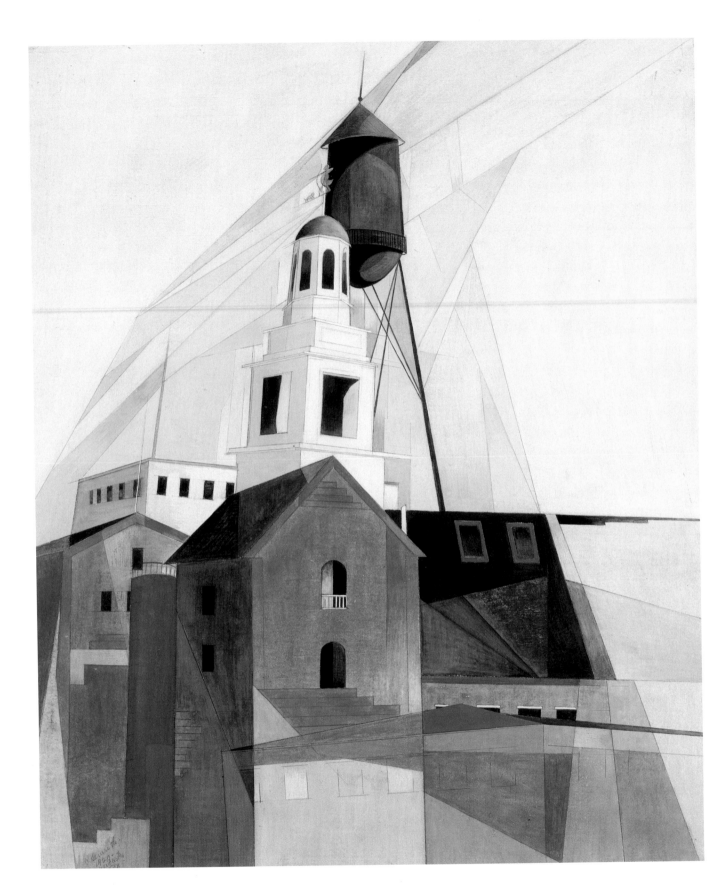

60. **Lancaster**, 1920
Tempera, gouache, and pencil on paper, 23 11/16 x 19 7/8 in. (60.2 x 50.5 cm)
Philadelphia Museum of Art; The Louise and Walter Arensberg Collection

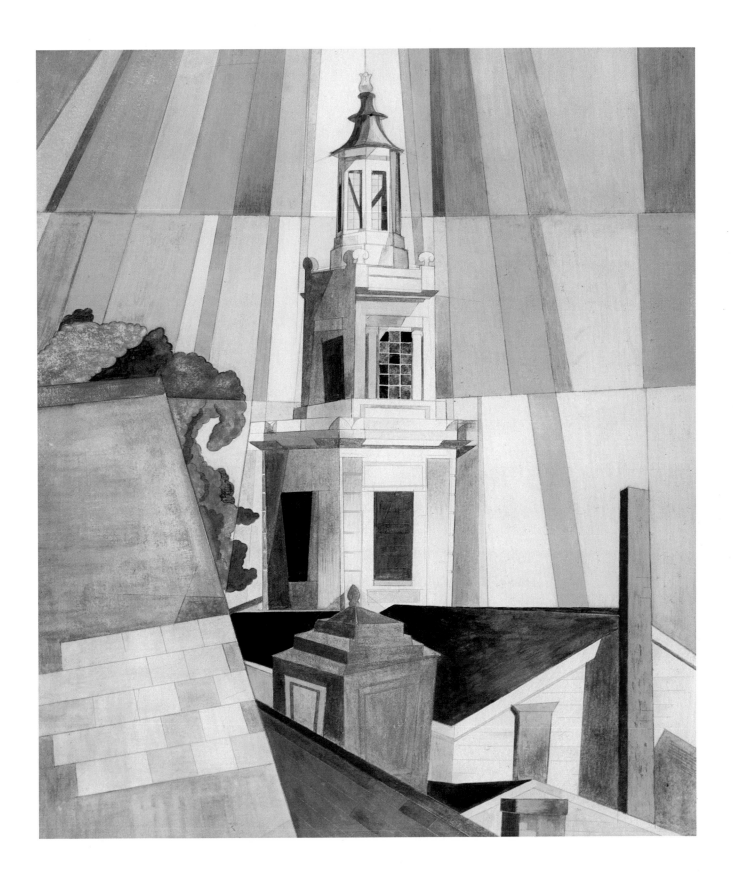

61. **The Tower**, 1920
Tempera on board, 23 x 19⁷⁄₁₆ in. (58.4 x 49.4 cm)
Columbus Museum of Art, Ohio; Gift of Ferdinand Howald

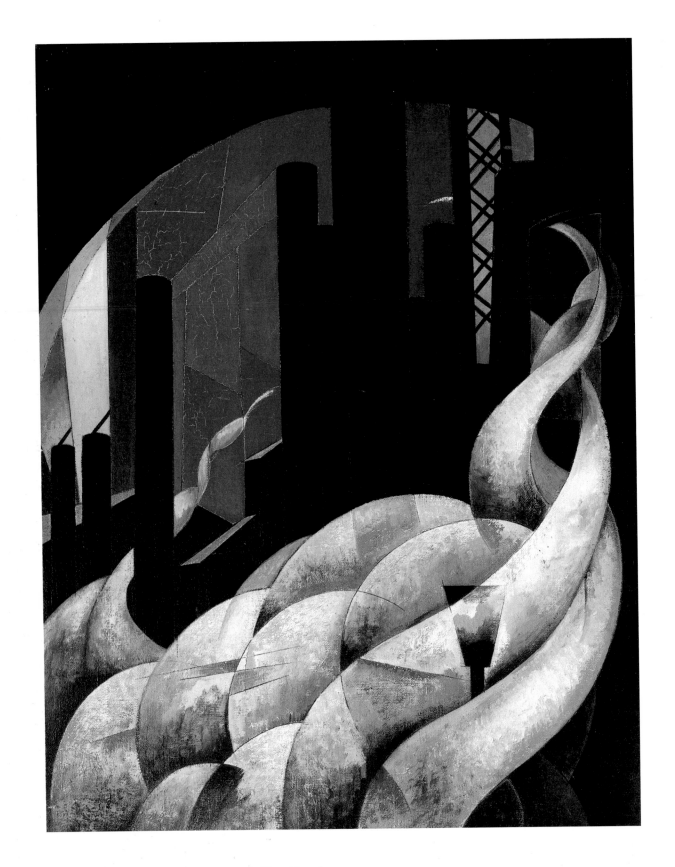

62. **Incense of a New Church**, 1921
Oil on canvas, 26 x 20⅛ in. (66 x 51.1 cm)
Columbus Museum of Art, Ohio; Gift of Ferdinand Howald

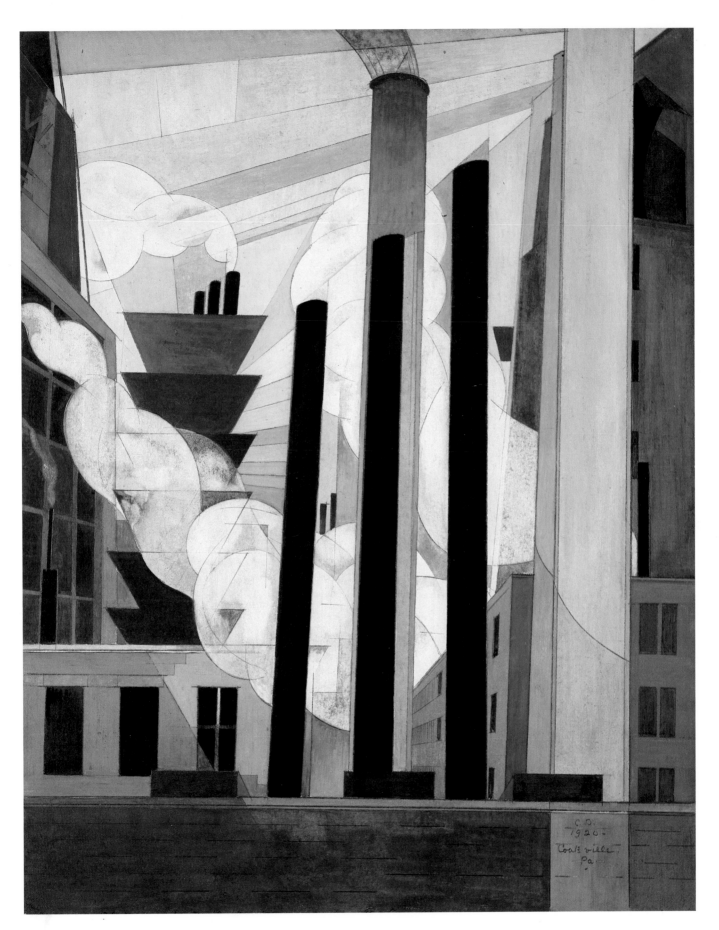

63. **End of the Parade, Coatesville, Pa.**, 1920
Tempera and pencil on board, 19⅞ x 15¾ in. (50.5 x 40 cm) The Regis Collection, Minneapolis

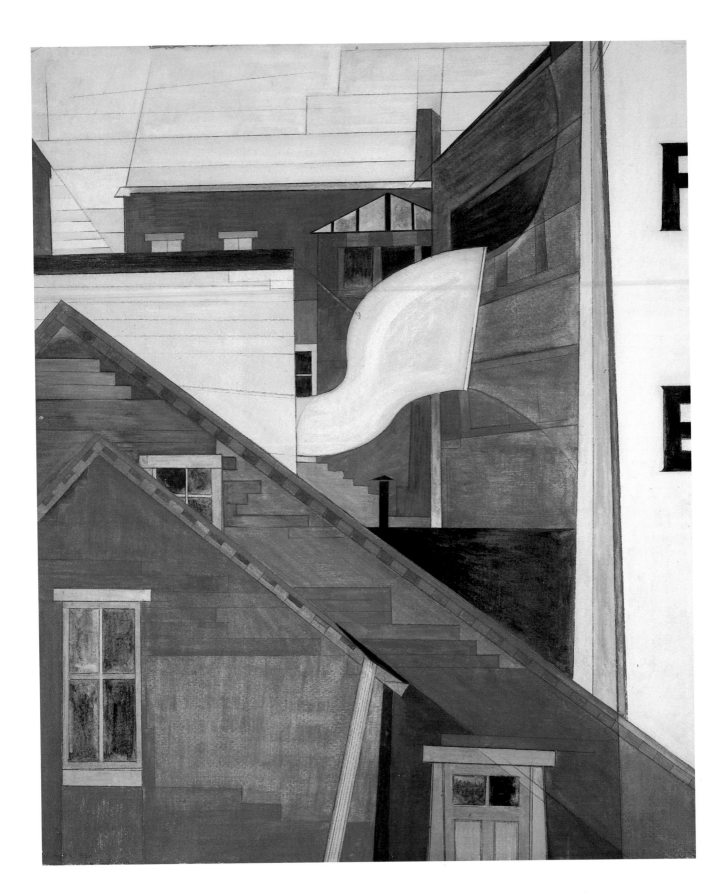

64. In the Province, 1920–21
Gouache and pencil on paper, 23 ⅛ x 19 ³⁄₁₆ in. (58.7 x 48.7 cm)
Museum of Fine Arts, Boston; Anonymous Gift in memory of Nathaniel Saltonstall

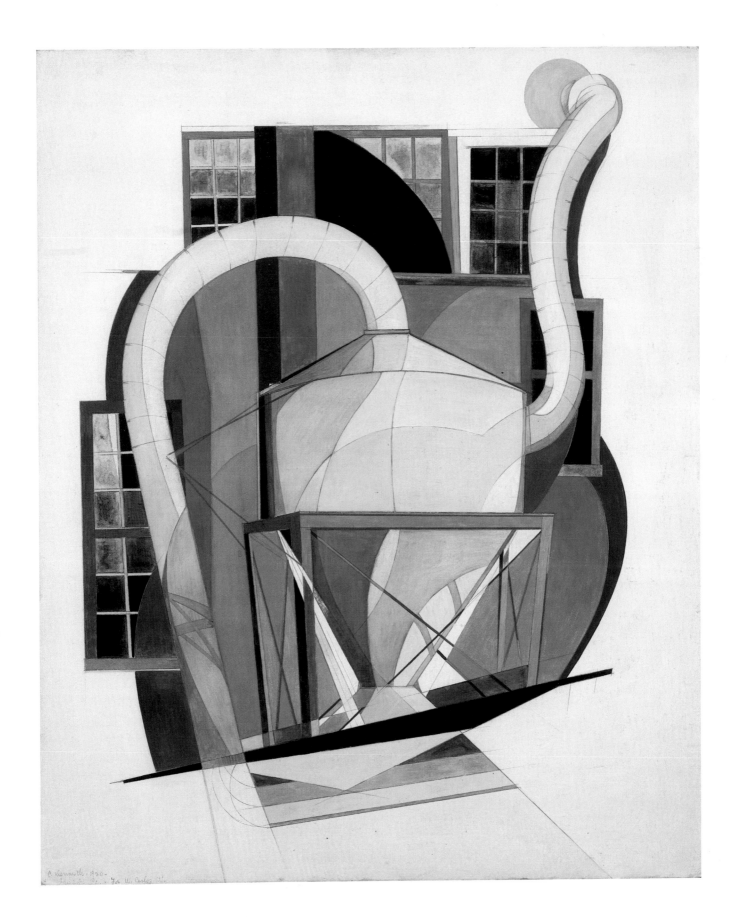

65. **Machinery**, 1920
Tempera and pencil on board, 24 x 19⅞ in. (61 x 50.5 cm)
The Metropolitan Museum of Art, New York; Alfred Stieglitz Collection

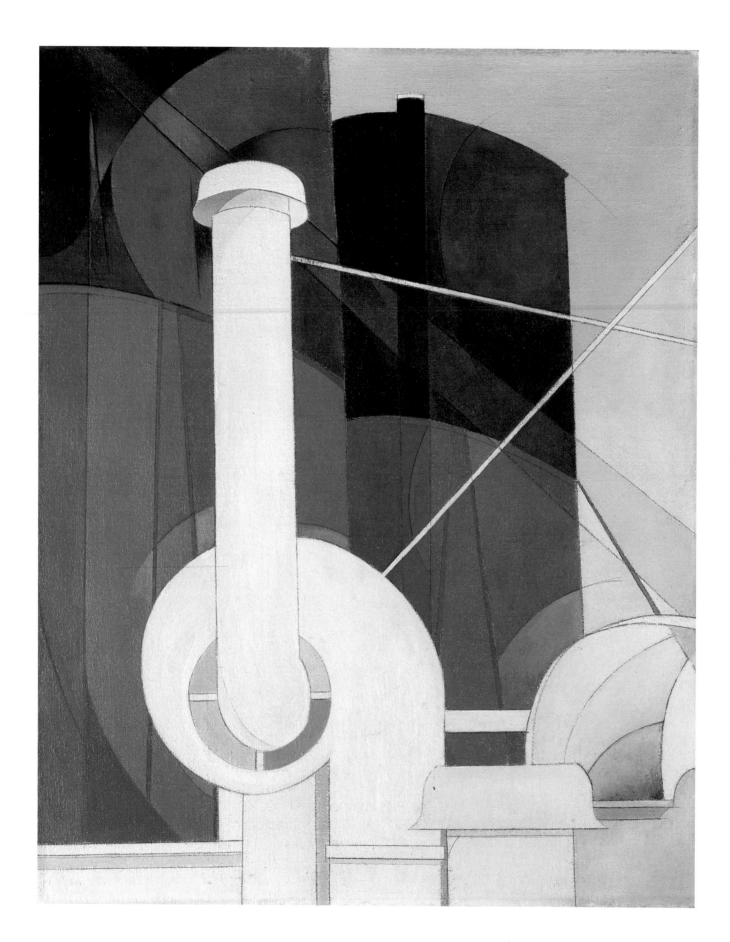

66. **Paquebot "Paris,"** 1921–22
Oil on canvas, 25 x 20 in. (63.5 x 50.8 cm)
Columbus Museum of Art, Ohio; Gift of Ferdinand Howald

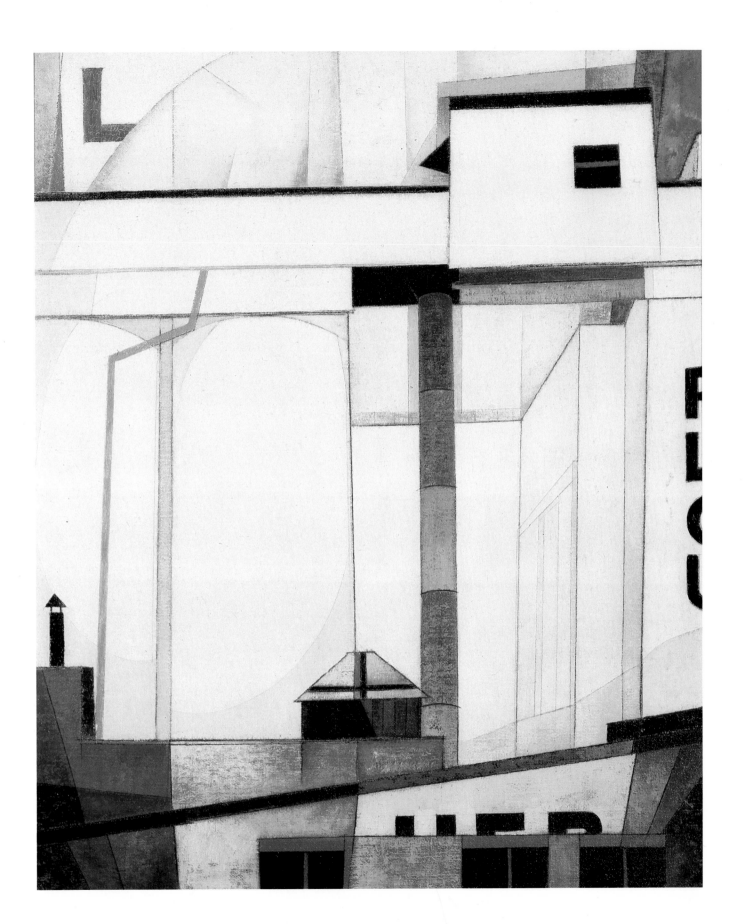

67. **Nospmas. M. Egiap Nospmas. M.**, 1921
Oil on canvas, 20¼ x 24 in. (51.4 x 61 cm)
Munson-Williams-Proctor Institute Museum of Art, Utica, New York

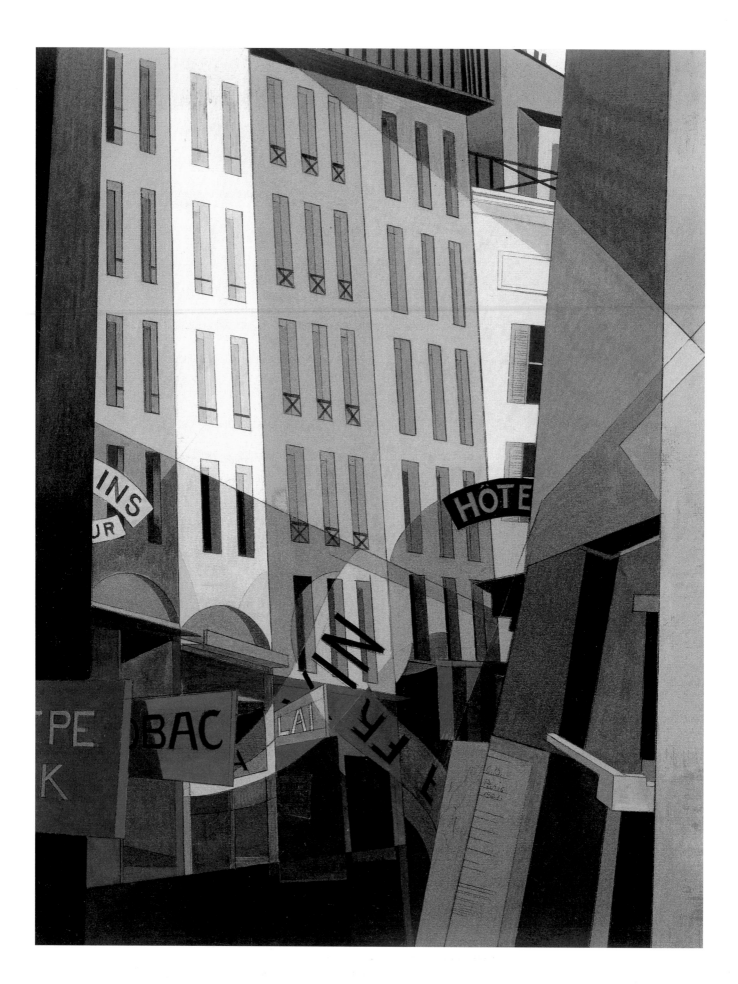

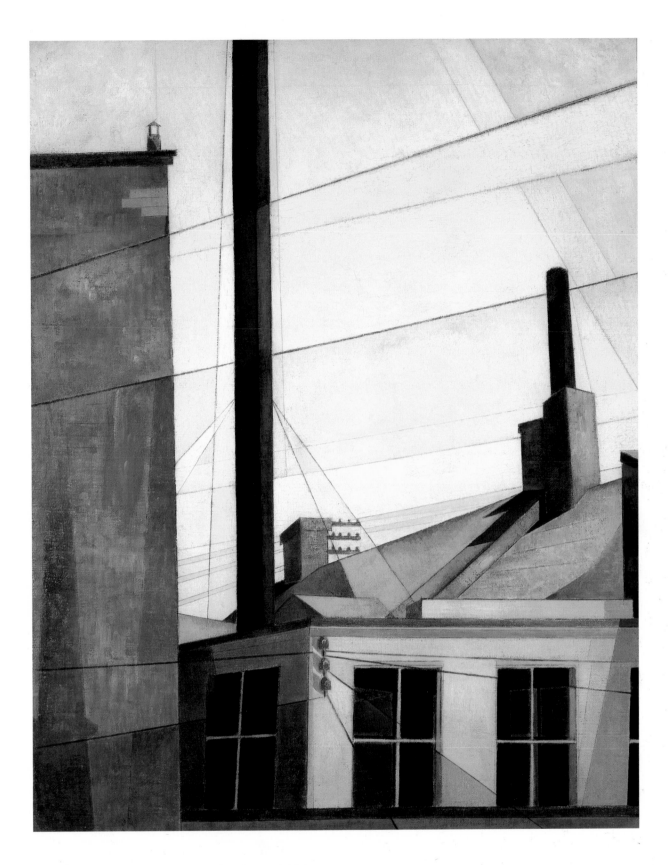

Opposite page 68. **Rue du Singe Qui Pêche**, 1921
Tempera on board, 21 x 16½ in. (53.3 x 41.9 cm)
Terra Museum of American Art, Chicago; Daniel J. Terra Collection

Above 69. **From the Garden of the Château**, 1921–25
Oil on canvas, 25 x 20 in. (63.5 x 50.8 cm) Private collection

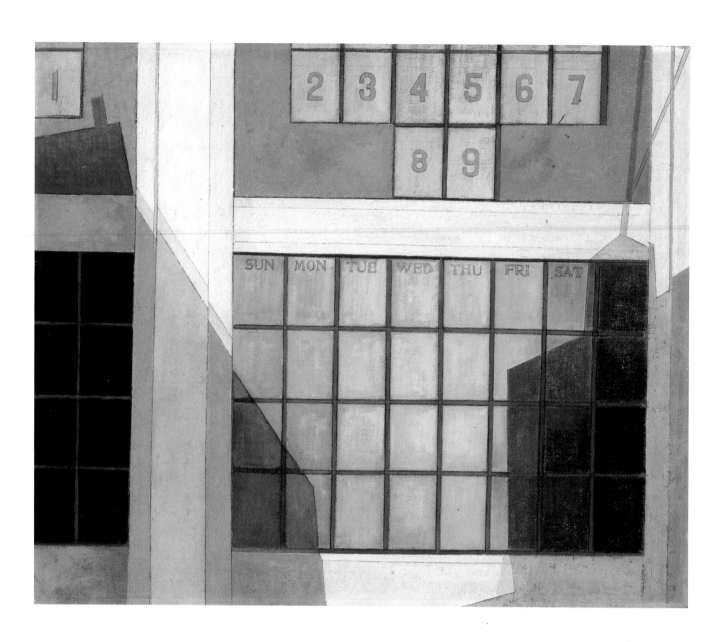

70. **Business**, 1921
 Oil on canvas, 20 x 24½ in. (50.8 x 62.2 cm)
 The Art Institute of Chicago; The Alfred Stieglitz Collection

71. **Youth and Old Age**, 1925
 Watercolor and pencil on paper, 17½ x 11⅝ in. (44.5 x 29.5 cm)
 Museum of Fine Arts, Boston; Frederick Brown Fund

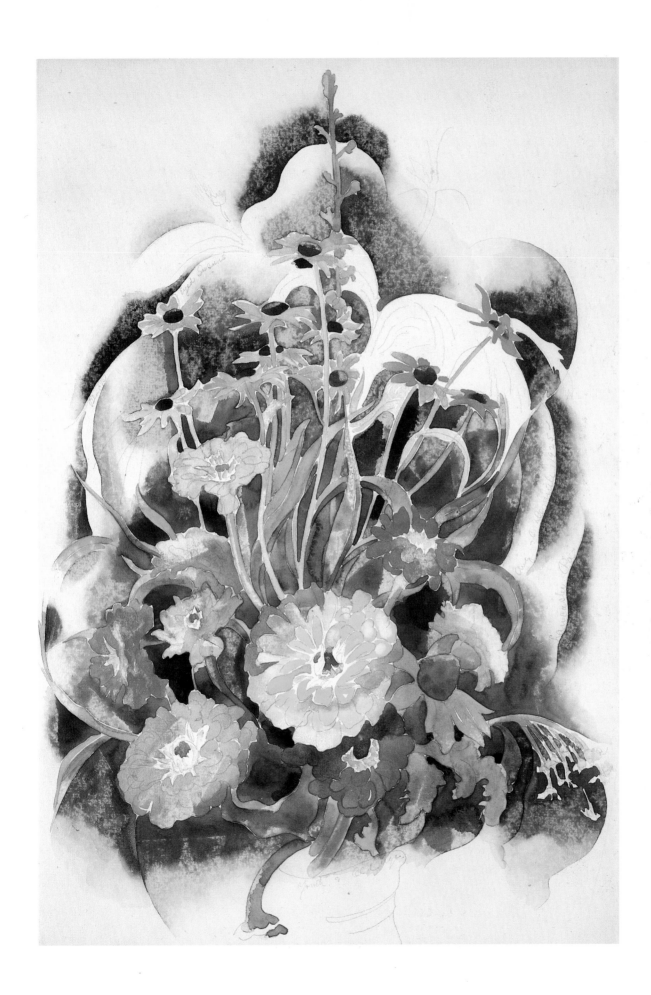

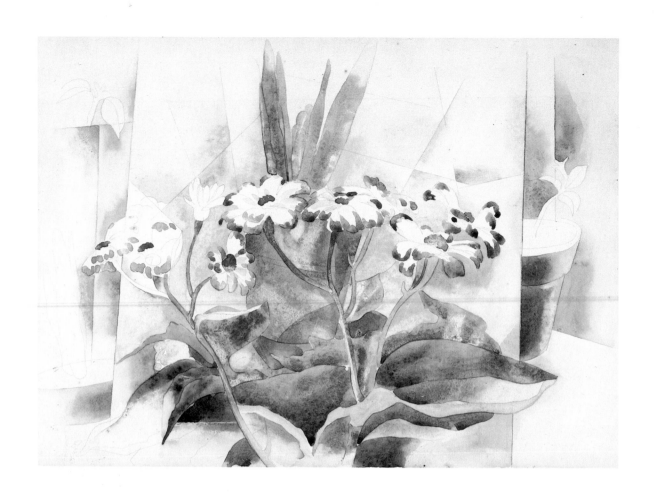

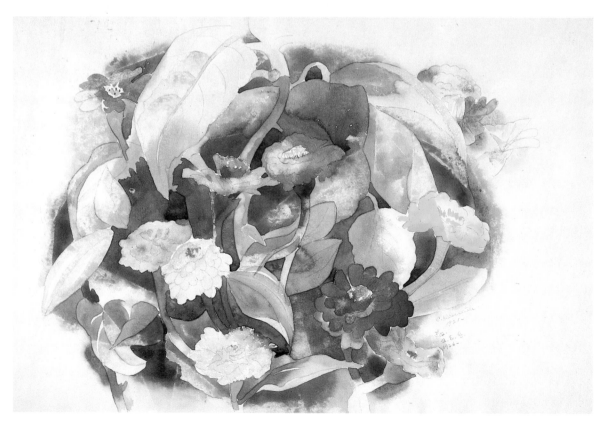

Opposite above

72. **Cineraria**, 1923
 Watercolor and pencil on
 paper, 10 x 14 in. (25.4 x
 35.6 cm)
 Amon Carter Museum,
 Fort Worth; Purchased with
 Funds Provided by Nenetta
 Burton Carter

Opposite below

73. **Zinnias**, 1921
 Watercolor on paper, 11⅞ x
 18 in. (30.2 x 45.7 cm)
 Philadelphia Museum of Art;
 A.E. Gallatin Collection

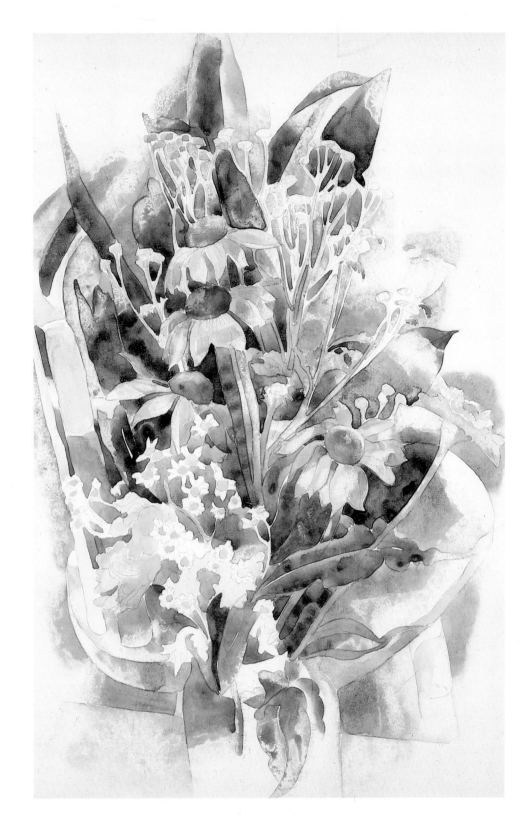

74. **African Daisies**, 1925
 Watercolor on paper, 17¾ x
 11¾ in. (45.1 x 29.8 cm)
 Wichita Art Museum, Kansas;
 The Roland P. Murdock
 Collection

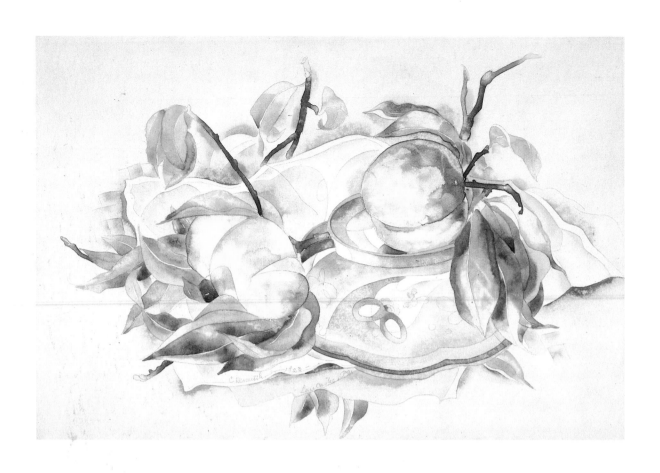

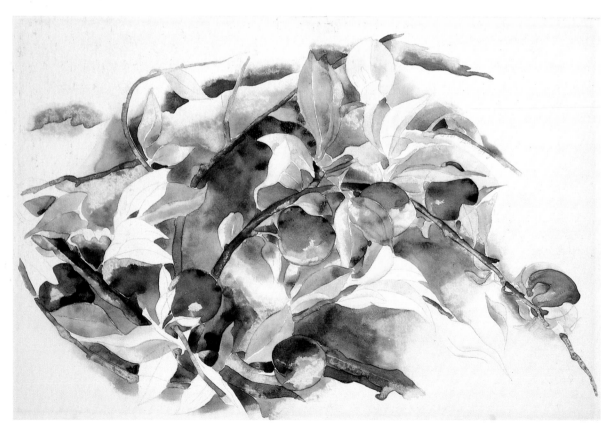

Opposite above

75. **Peaches,** 1923
 Watercolor and pencil on
 paper, 12 x 18⅛ in. (30.5 x
 46 cm)
 Philadelphia Museum of Art;
 A.E. Gallatin Collection

Opposite below

76. **Plums,** 1925
 Watercolor and pencil on
 paper, 12⅛ x 8⅛ in. (30.8 x
 20.6 cm)
 Addison Gallery of American
 Art, Phillips Academy,
 Andover, Massachusetts

77. **Flowers: Irises,** c. 1925
 Watercolor on paper, 13½ x
 9½ in. (34.3 x 24.1 cm)
 Collection of William Kelly
 Simpson

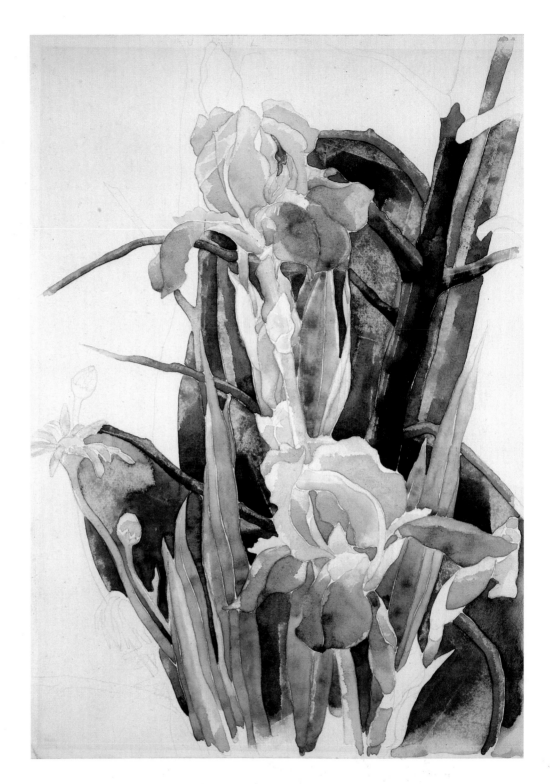

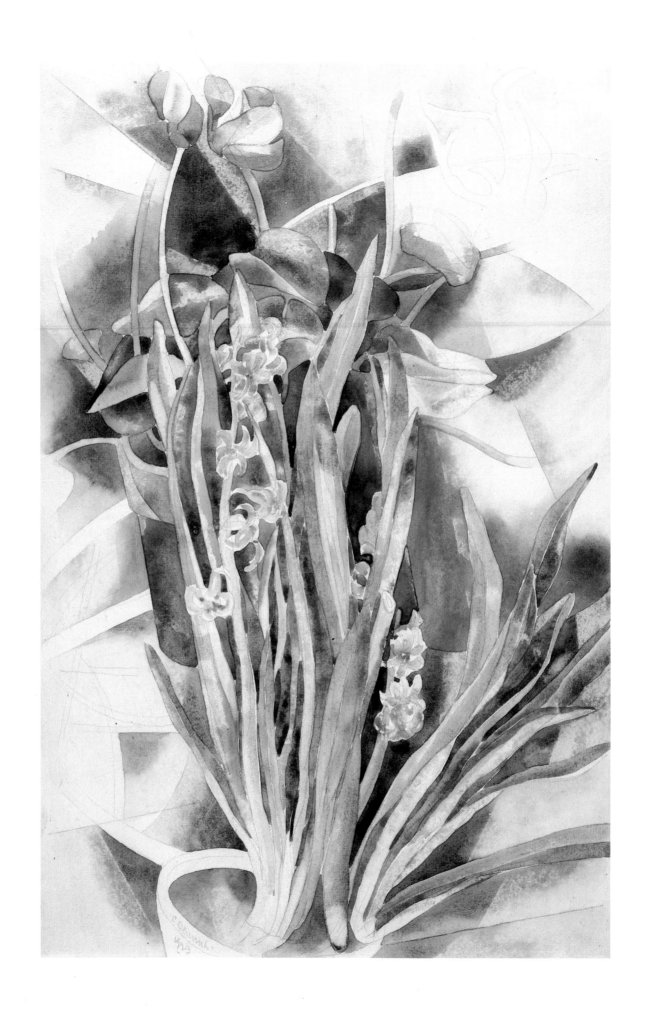

Opposite page

78. **Flower Study No. 1
(Cyclamen and Hyacinth)**,
1923
Watercolor on paper, 17¾ x
11¾ in. (45.1 x 29.8 cm)
The Art Institute of Chicago;
Gift of Annie Swan Coburn
in memory of Olivia Shaler
Swan

79. **Gladiolus**, c. 1923
Watercolor and pencil on
paper, 18½ x 12 in. (47 x
30.5 cm)
The Pennsylvania Academy
of the Fine Arts, Philadelphia;
Presented by John F. Lewis, Jr.

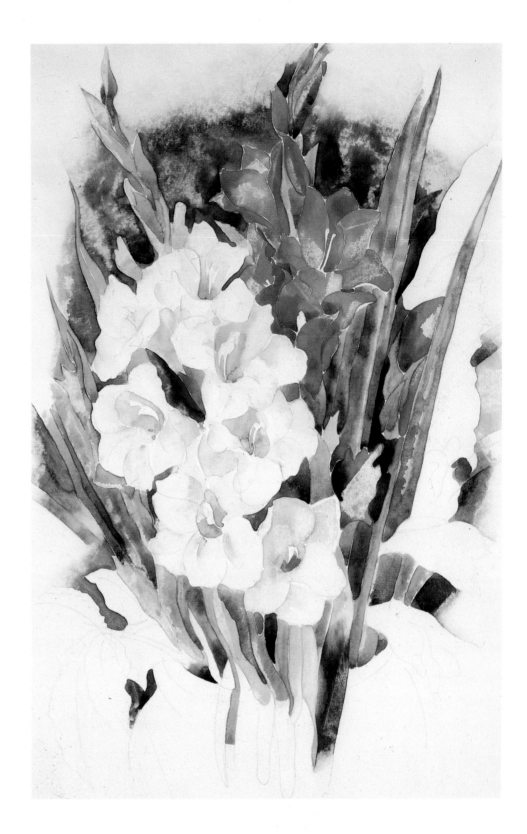

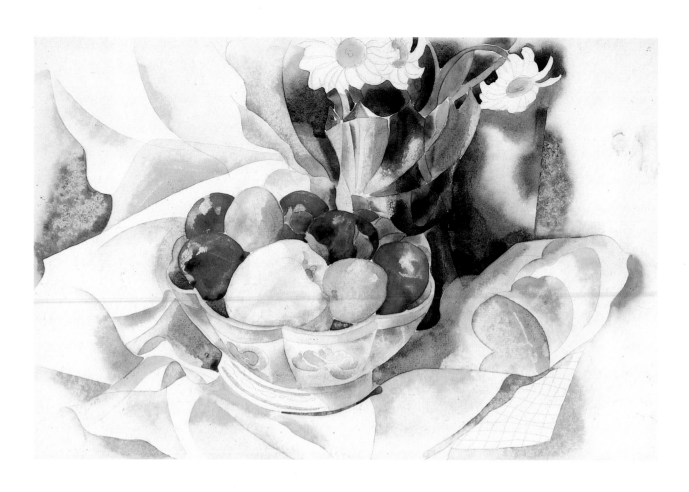

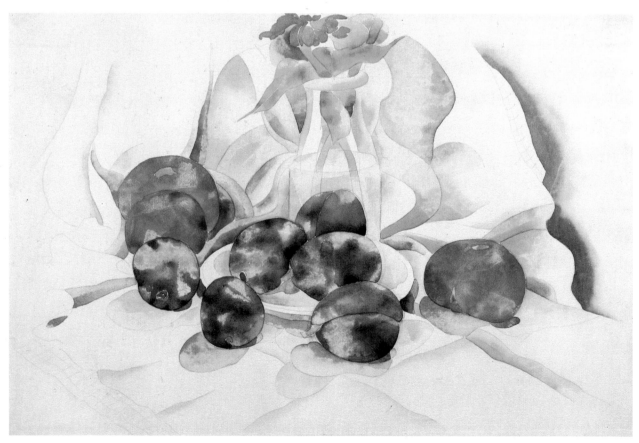

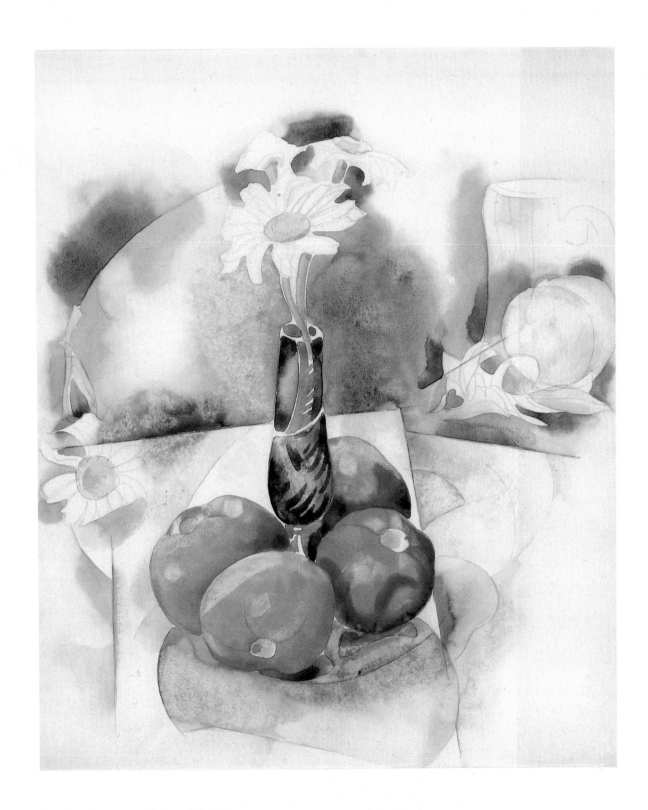

Opposite above 80. **Fruit and Daisies,** 1925
 Watercolor on paper, 12 x 18 in. (30.5 x 45.7 cm) Harvard University Art Museums,
 Fogg Art Museum, Cambridge, Massachusetts; Purchase from the Louise E. Bettens Fund

Opposite below 81. **Fruit and Flower,** 1928
 Watercolor on paper, 12 x 18 in. (30.5 x 45.7 cm) Collection of Mr. and Mrs. Barney Ebsworth

Above 82. **Daisies and Tomatoes,** c. 1924
 Watercolor and pencil on paper, 13 ¾ x 11 ¾ in. (34.9 x 29.8 cm)
 Collection of Mr. and Mrs. Meyer Potamkin

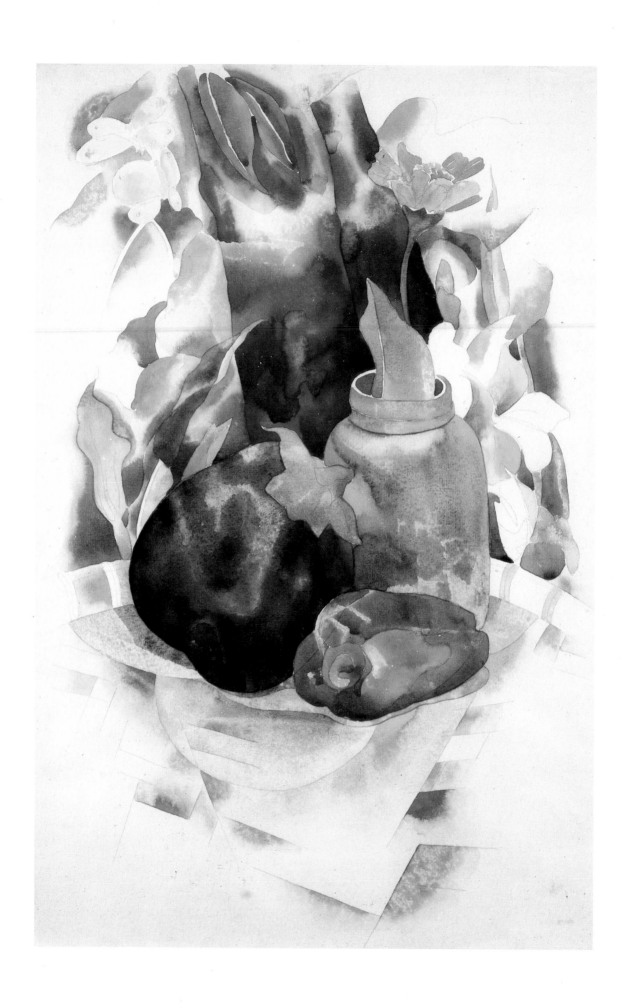

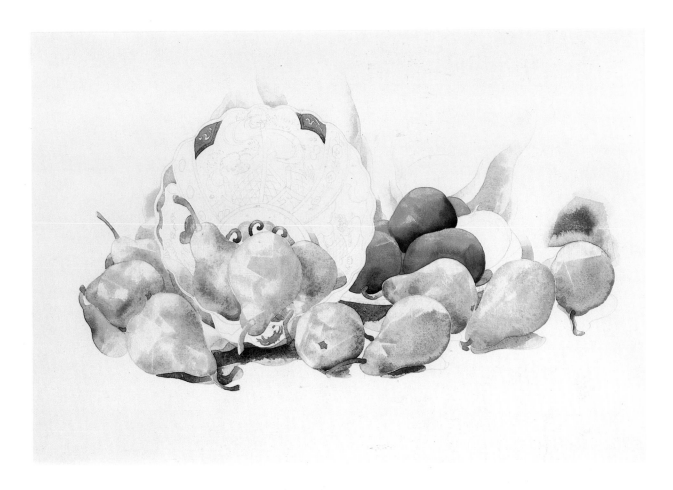

Opposite page

83. **Eggplant and Green Pepper**,
 1925
 Watercolor and pencil on
 paper, 18 x 11¹⁵⁄₁₆ in. (45.7 x
 30.3 cm)
 The Saint Louis Art Museum;
 Purchase: Eliza McMillan
 Trust Fund

84. **Still Life: Apples and Pears**,
 1925
 Watercolor on paper, 13¾ x
 19¾ in. (34.9 x 50.2 cm)
 Yale University Art Gallery,
 New Haven; Bequest of Mrs.
 Kate Lancaster Brewster

85. **Still Life: Apples and Green
 Glass**, 1925
 Watercolor on paper, 11¾ x
 13¾ in. (29.8 x 34.9 cm)
 The Art Institute of Chicago;
 Gift of Annie Swan Coburn
 in memory of Olivia Shaler
 Swan

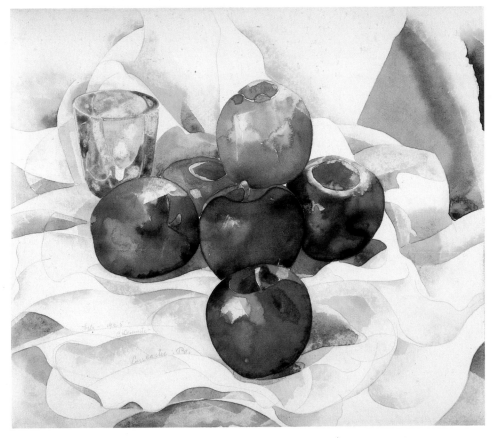

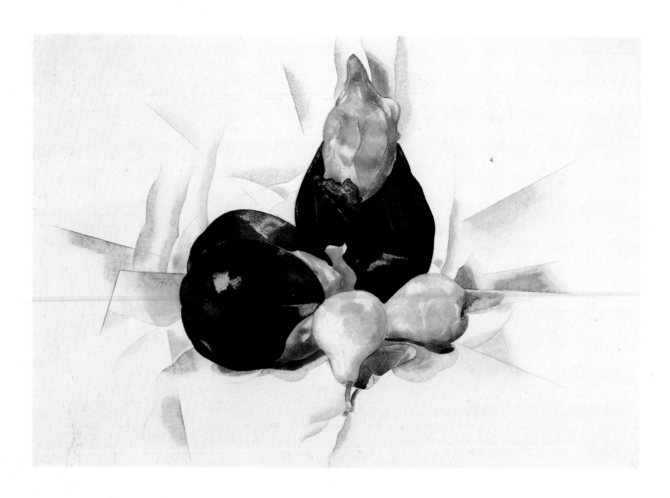

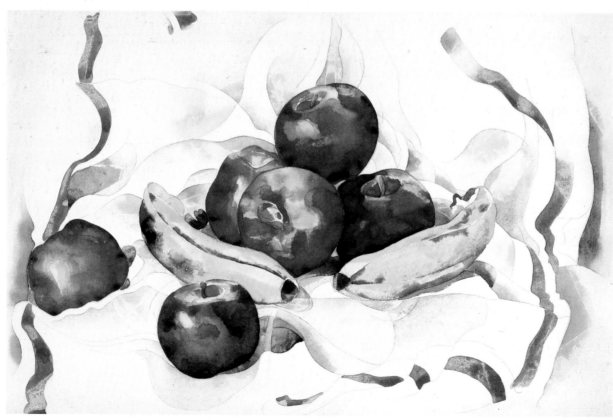

Opposite above

86. **Eggplants and Pears**, 1925
Watercolor and pencil on
paper, 13⅝ x 19 9/16 in. (34.6 x
49.7 cm)
Museum of Fine Arts,
Boston; Bequest of John T.
Spaulding

Opposite below

87. **Apples and Bananas**, 1925
Watercolor and pencil on
paper, 11⅞ x 18 in. (30.2 x
45.7 cm)
The Detroit Institute of Arts;
Bequest of Robert H.
Tannahill

88. **From the Kitchen Garden**,
1925
Watercolor and pencil on
paper, 18¼ x 12 in. (46.4 x
30.5 cm)
Marion Koogler McNay Art
Museum, San Antonio;
Bequest of Marion Koogler
McNay

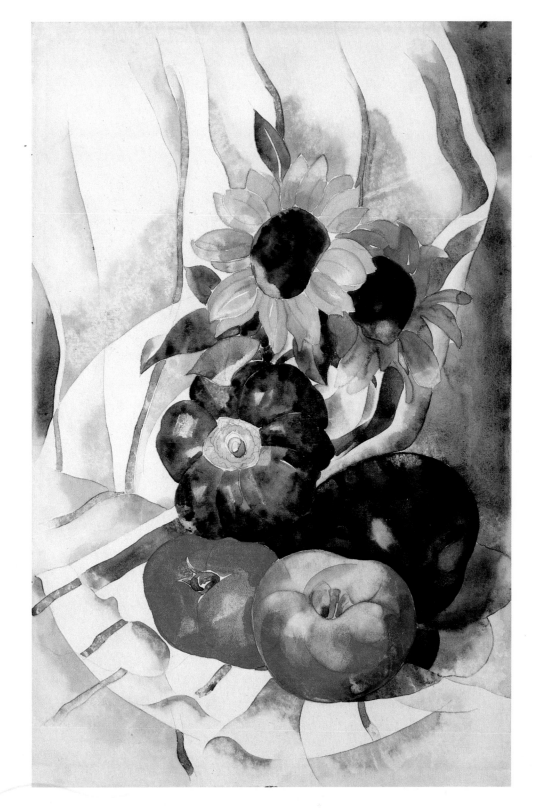

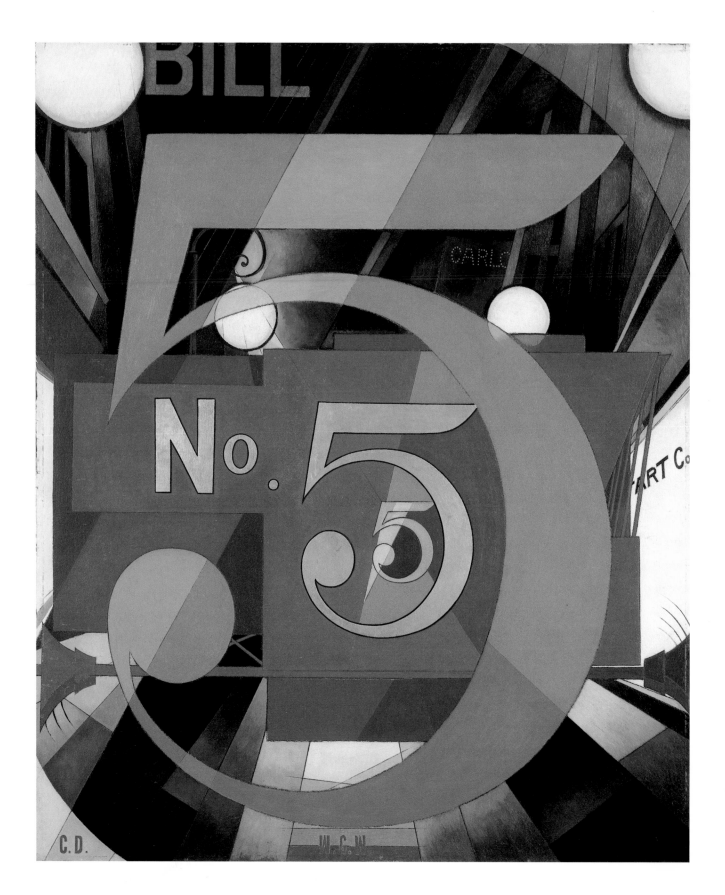

89. **The Figure 5 in Gold**, 1928
Oil on board, 35½ x 30 in. (90.2 x 76.2 cm)
The Metropolitan Museum of Art, New York; Alfred Stieglitz Collection

VI.

Poster Portraits 1923-1929

Marius De Zayas
Alfred Stieglitz, c. 1912–13
Charcoal on paper, 24¼ x
18⅝ in. (61.6 x 47.3 cm)
The Metropolitan Museum of
Art, New York; Alfred
Stieglitz Collection

Francis Picabia
"Ici, C'est Ici Stieglitz," 1915
Ink on paper, 29⅞ x 20 in.
(75.9 x 50.8 cm)
The Metropolitan Museum of
Art, New York; Alfred
Stieglitz Collection

In November 1923, Demuth began a series of "posters"—emblematic portraits of American artists who were his friends and contemporaries.[1] Perhaps as an outgrowth of his experimentation with the dichotomy between the actual content—implied by title—and the depicted image, in these portraits Demuth did not intend to render physical likenesses, but rather to convey something of the subject's psychological and artistic character by means of commonplace objects. In pursuing this approach to portraiture, Demuth traversed a territory charted by the Arensberg circle—by Picabia, De Zayas, Crotti, Man Ray, and Duchamp. As early as 1912, De Zayas had created caricatures of various personalities in the Stieglitz circle by using geometric shapes, algebraic equations, and typographical characters as "equivalents" of the thoughts and psychological spirit of his subjects.[2] Equally influential were the mechanomorphic portraits by Duchamp and Picabia in which machine forms were used as anthropomorphic equivalents. Picabia's portrayals of specific persons and events by means of advertising images scavenged from mail-order catalogues had been reproduced and theoretically defended in *291* in July 1915 and exhibited at De Zayas' Modern Gallery in January 1916. These portrayals, among them one of Stieglitz as a broken camera, provided the impetus for the object-portraits of Crotti and Man Ray. Demuth was familiar with these precedents as well as with Hartley's 1914–15 abstract portraits that used numbers, letters, and objects to memorialize a young German officer killed in the war. He also had seen Florine Stettheimer's narrative portraits at the salon over which she and her sisters presided. In her 1922–23 portraits, Stettheimer surrounded realistic likenesses of a subject with emblems of the subject's avocations and interests. In her later portrait of Stieglitz, she placed the dealer amid the names of artists and causes he had supported; Demuth appears in the picture as a cane and foot entering from the left. Demuth also knew of Arthur Dove's contemporaneous portrait assemblages.

Florine Stettheimer
Portrait of Alfred Stieglitz, 1928
Oil on canvas, 38 x 26½ in.
(96.5 x 67.3 cm)
The Carl Van Vechten Gallery
of Fine Arts at Fisk University,
Nashville; From the Alfred
Stieglitz Collection, Gift of
Georgia O'Keeffe

That Dove was also experimenting with object-portraits suggests that such emblematic equivalents to conventional portraiture were both pervasive and accepted.

Demuth intended his object-portraits to encompass the major personalities of American painting and writing. In this sense, the undertaking restated his conviction that the future of art rested in American hands; that modernism had been transplanted from Europe and was being transformed by the American experience. During the five years he worked on this series, he initiated portraits of three men of letters—Williams, O'Neill, and Wallace Stevens—and five artists associated with Stieglitz—O'Keeffe, Marin, Dove, Hartley, and Charles Duncan. He had met Wallace Stevens only casually at the Arensbergs, and out of the five painters was personally close only to O'Keeffe and Hartley. Demuth never pursued the portrait of Duchamp that he initially wrote about to Stieglitz.[3]

Demuth's decision to focus on prominent "American" artists rather than only on close friends emanated from his renewed sense of identification with America (pp. 132–34). Paying homage to American artists through his poster portraits offered him the means to celebrate American achievements and affirm his national identity. His search for an indigenous expression led him to format his posters to resemble advertisements, thus linking them to what was viewed as a singularly American genre. In 1922, the journal *Broom* had publicized the idea that America's consumer goods, advertising copy, and billboards were unique expressions of her culture. "The advertisements contain the fables of this people," *Broom* editor Matthew Josephson had declared.[4] Demuth replicated advertising style by emblazoning his subject's name on the canvas and rendering the related objects in flat, highly saturated colors. As a result, these works are radically different in style from his previous paintings. That he intentionally imitated advertising is corroborated by his O'Neill portrait sketch, which he claimed to have begun as an announcement for the playwright's *The Moon of the Caribbees*, and also by the obvious resemblance between theater placards and *Stockbridge Stocks*—the latter not a poster portrait, but stylistically related to the series.

Demuth's first seven posters—those for Dove, O'Keeffe, Marin, Duncan, Hartley, O'Neill, and Stevens—are clearly portraits of specific individuals. Yet, they retain much of Picabia's hermeticism. Although the component "props" Demuth used are clearly decipherable, their symbolism is sufficiently cryptic to elude conclusive interpretation. As with the object-

Stockbridge Stocks, 1926
Tempera on board, 25½ x
21 in. (64.8 x 53.3 cm)
Private collection

portraits of the more literary-minded Dadaists, decoding Demuth's portraits requires viewers' intellectual engagement, thus forcing them into a more active role.

O'Keeffe's portrait (Pl. 90), the first in the series, is dominated by a potted sansevieria plant, several pears or acorn squash, and a sunburst formed by the rearranged letters of her name. That Demuth chose O'Keeffe as his first portrait subject indicates her place of honor not only in Stieglitz's world, but in his own as well. By 1924 O'Keeffe and Demuth had developed a special bond. O'Keeffe thought Demuth was more fun than the other artists she knew, and she considered him to be "a better friend with me than any of the other artists."[5] Demuth, in turn, wrote several essays on O'Keeffe's work and designated her in his will as the recipient of all his unsold oil paintings. In his portrait of her, he may have intended the clustered letters of her name to symbolize the strength of her personality, which scorches even the hearty sansevieria. That this plant is commonly known as a snake plant could also indicate Demuth's awareness that O'Keeffe's strength was not always benign.

In Demuth's second portrait, that of Dove (Pl. 91), the arching sickle and the earth tones denote the painter's career as a farmer and his oneness with the earth. Paul Rosenfeld had written in *Port of New York* that "there is not a pastel or drawing or painting of Dove's that does not communicate some love and direct sensuous feeling of the earth."[6] After reading Rosenfeld's essay on Dove, Demuth told Stieglitz that it "ran along side by side" with his portrait—so much so that he vowed not to read the rest of the book until he had completed the remaining posters. "It will be fun to see if they, the essays and my posters, all agree."[7] Thus once again Demuth seems interested in exploring the parallels between painting and writing. Various iconographic meanings have been affixed to the painted ribbon around the sickle in Dove's portrait. It has been interpreted as a signal of Dove's "domestication" by Helen Torr, the former wife of Clive Weed, one of Demuth's close friends at the Pennsylvania Academy, for whom Dove left his first wife.[8] The ribbon has also been interpreted as depicting the "castrating weapon of a woman," a warning to Dove of the consequences of having established a domicile with Torr.[9]

The third portrait Demuth completed was that for Charles Duncan (Pl. 92). It presents more of a problem in interpretation than its predecessors because so little is known about Duncan. A poet and good friend of Marin, he had exhibited abstract paintings in 1916 at 291 and later earned a living by

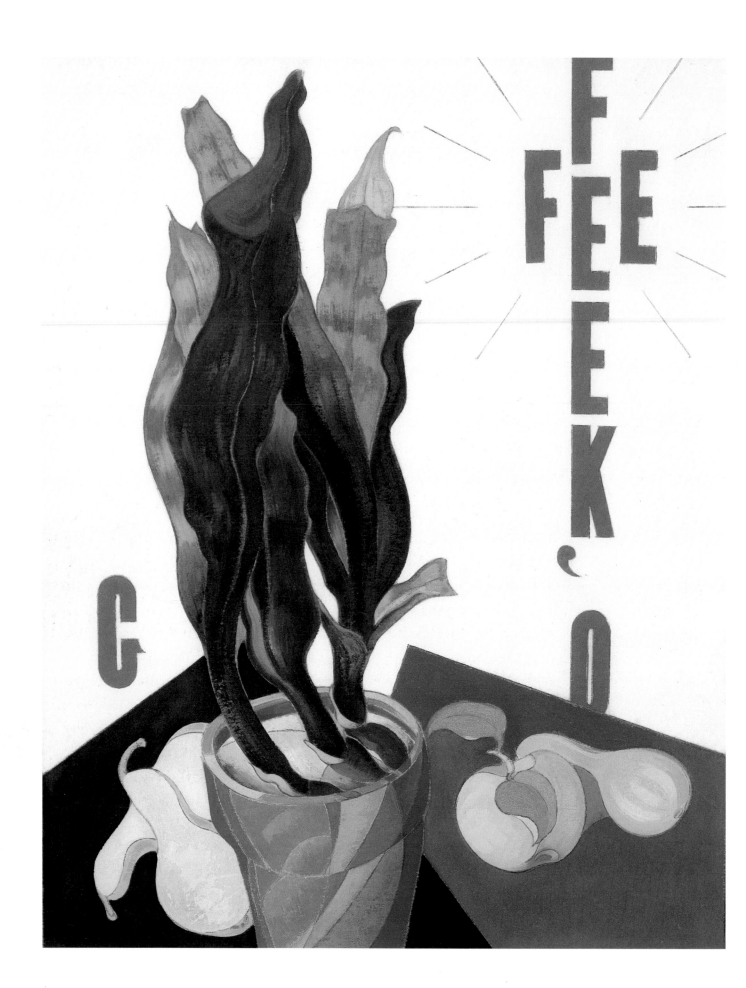

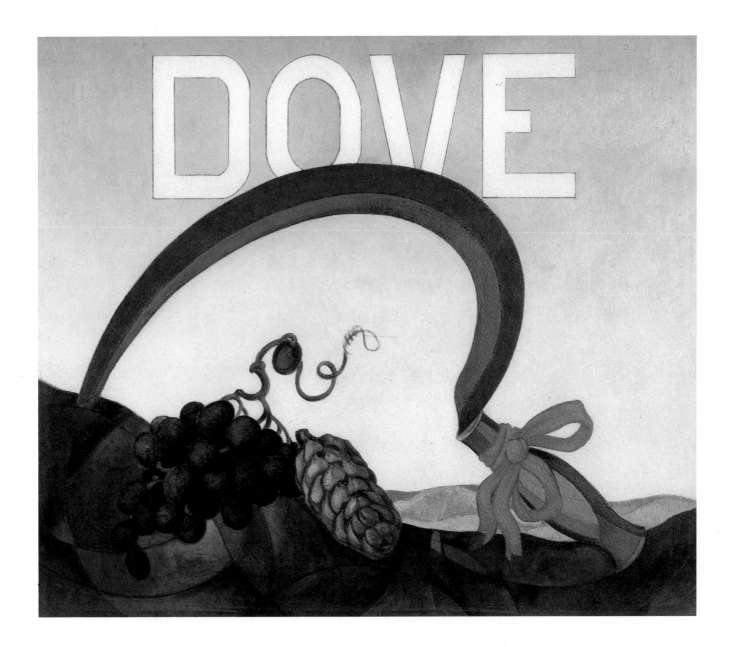

painting billboards. During the period of Demuth's poster portraits, he seems to have been part of the Stieglitz circle, for Demuth mentioned him in several letters to Stieglitz. Duncan's name appears above a flower design in a cartouche arrangement, which suggests the title page of a nineteenth-century book. The rainbowlike application of paint in a band that divides the work at center might allude to the spray-paint technique used by sign painters, but otherwise the poster remains as enigmatic as its subject.[10]

Demuth completed three poster portrait sketches during this period. The study for Hartley relied on the open-window format that Hartley had used in his work in Bermuda when the two painters wintered there together in 1917. The calla lily and the winter scene outside the window

exemplified Hartley's typical subjects.[11] In the portrait sketch of O'Neill, initially intended as a poster for *The Moon of the Caribbees*, the palm fronds respect the Carribean setting of the play, while the inclusion of mast forms and a half-pint bottle relates to the plot, which revolves around the bringing of illicit rum to sailors on board ship. Finally, Demuth's sketch for the Wallace Stevens poster suggested the poet's occupation by means of an ornate ink stand, and the cerebral, cryptic quality of his verse through the black-and-white chessboard pattern which dominates the background.

A year and a half after Demuth began his poster series, he had only completed portraits for O'Keeffe, Dove, and Duncan. This represented a measurable decrease in productivity, probably due to deteriorating health. Insulin injections kept him alive, but they did little to relieve his now chronic exhaustion. He succumbed easily to colds and infections and, even without these maladies, his energy seemed "used up after two or three hours of work and maybe a walk."[12] Apologizing to Stieglitz for not drafting an essay that the dealer had asked him to contribute to *M.S.S.*, he confessed there was "very little left after I do my daily (sometimes, now) weekly painting—."[13] Consequently, when Stieglitz's "Seven Americans" exhibition opened in March 1925 the only new oils Demuth was able to include were his three completed posters.[14]

The inclusion of these three poster portraits in the "Seven Americans" show marked Demuth's first commercial connection with Stieglitz.[15] Prior to sailing for Europe in 1921, Demuth had removed most of his watercolors and

temperas from the Daniel Gallery. Although Daniel continued to handle occasional pieces, Demuth's trust in the financial integrity of his first dealer had all but vanished, and he shifted the primary responsibility for representing his oils to Stieglitz.[16] He contacted Stieglitz whenever he came to New York and, beginning in 1921, corresponded with him frequently between visits. Stieglitz, for his part, supported Demuth's work through purchases and exhibitions. Nevertheless, Demuth always remained tangential to Stieglitz's inner circle. Although he exhibited regularly at The Intimate Gallery, he was not one of the six artists for whom the gallery proclaimed its support.[17] Stieglitz even encouraged Demuth to have the newly opened Kraushaar Gallery handle his watercolors, a bifurcated system he would never have condoned for his gallery's core artists and about which he seemed defensive: "For remember," he wrote to Demuth in 1930, "my fight for O'Keeffe and Marin is my fight for you as well. You may not understand but somehow or other I'm sure you must feel what I've said to be absolutely true."[18] Stieglitz's psychological investment in Marin may have prevented his full endorsement of Demuth, for the two painters were often compared (p. 127). Whatever the reason for Stieglitz's reticence to fully champion Demuth's work, his preferential treatment of his other artists, particularly Marin, probably hindered Demuth's critical success.[19] Demuth's watercolors were always well received, but few of his oils sold during his lifetime. And although his finances were less precarious than those of other artists, he nonetheless depended on sales.[20] Despite Stieglitz's restraint, Demuth always trusted him and valued the protection he provided against an American art public generally indifferent toward modern art.

This public seemed particularly inhospitable to the three posters Demuth included in the "Seven Americans" show. Although published reactions to the posters were neutral, Demuth's letters to Stieglitz indicate that reservations were expressed privately about the posters' success. To some extent this is understandable; however significant the posters seem now, they differed radically in subject and style from Demuth's previous work. Even his close friends were puzzled by his multivalent approach to portraiture and by his experimentation with new compositional devices.[21] That his intentions were misunderstood piqued Demuth. "I wish I could afford to work without ever showing," he wrote. "I think they don't deserve to see our work, most of them anyway. I wish we could all 'strike.'"[22]

Despite Demuth's vow to complete the series and exhibit all the portraits the following winter, a year later he had only finished two more

92. **Poster Portrait: Duncan,**
1924–25
Poster paint on panel, 20 x
23 ½ in. (50.8 x 59.7 cm)
Collection of American
Literature, Beinecke Rare
Book and Manuscript Library,
Yale University, New Haven

posters. One, an oil painting of calla lilies (Pl. 94), was compositionally idiosyncratic and enigmatic in subject. Demuth had executed several oil still lifes during this period, but their composite images differed from *Calla Lilies* which featured a single flower arrangement silhouetted against a monochromatic field. The only precedent for such a treatment was a 1922 oil painting entitled *Our Mary in 'As You Like It'* (whereabouts unknown), which was described in reviews as a decorative, two-dimensional arrangement of green leaves. That *Calla Lilies* was thematically something other than what it seemed was suggested by McBride in his review of Demuth's 1926 exhibition at Stieglitz's gallery. McBride reported a rumor that the painting was

93. **Poster Portrait: Marin**, 1926
Poster paint on panel, 27 x
33 in. (68.6 x 83.8 cm)
Collection of American
Literature, Beinecke Rare
Book and Manuscript Library,
Yale University, New Haven

"intended by the artist as a tribute to the memory of a strange, erratic figure in the theatrical world who recently passed, as they say, to his reward."[23] This "figure" has been associated with Bert Savoy, one of Broadway's most successful female impersonators, who died in 1923. Demuth had met Savoy through Locher, who designed the 1920 Greenwich Village Follies at which Savoy and his partner Jay Brennan were the chief attractions. Demuth so admired Savoy that he entitled his play "*You Must Come Over,*" *A Painting: A Play* after the performer's catchphrase. In his play, a dialogue about American art, Demuth exalted American musical shows and reviews—and the people who acted and danced in them—and acknowledged that he "love[d]

Broadway and—well, and vulgarity, and gin".[24] If Demuth had wished
to pay homage to this world, Bert Savoy offered a perfect vehicle.
Edmund Wilson described feeling "in the presence of the vast vulgarity of
New York incarnate and almost heroic" when Savoy "reeled on the stage, a
gigantic red-haired harlot . . . reeking with the corrosive cocktails and the
malodorous gossip of the West Fifties."[25] In choosing calla lilies to symbolize
Savoy, Demuth took advantage of the flower's allusions both to male and
female sexuality. That he depicted the lilies rising from an open shell, itself a
symbol of female procreation, further reinforced his reference to Savoy's
occupation as a female impersonator.

 The last portrait Demuth completed, in 1926, was for John Marin
(Pl. 93). In this portrait, Demuth set the words MARIN and PLAY against
horizontal bands of red, white, and blue. The addition of white stars to the
blue field makes the reference to America unmistakable. Since Marin's work
was constantly being extolled for capturing the "American experience," it
seems obvious that Demuth meant to highlight this aspect of Marin and his
work. Some writers, however, suggest a slightly pernicious reading wherein
Demuth's color scheme alludes to Marin's conservative politics.[26] The word
PLAY is generally accepted as a reference to the ebullient quality in Marin
and his work, while the arrow has been cited as evidence of Marin's sureness
of direction and, somewhat inexplicitly, as referring to the "meaningful, even
destructively posed messages" that lurked "beneath Marin's well-known
bravura."[27] By the time Demuth completed the Marin poster, the criticism of
his earlier portraits had begun to undermine his confidence. He shipped
Stieglitz the Marin poster with the caveat that if he liked it, "you and I will be
the only two living things that do!"[28]

 Demuth was astute about the response to the Marin and Savoy por-
traits, which were critically disliked—the first such reaction to his work in his
career. Coupled with the physical difficulty of making the posters, their neg-
ative reception dampened his enthusiasm for continuing the series. "I've never
felt so 'low,'" he wrote to Stieglitz in July 1926. "There seems to be nothing,
nothing. I haven't painted for weeks. Everything seems to have been painted. . . .
My lack of, whatever it is, which has been going on for some months, has
made me think seriously of a trip abroad. A very unwise idea for me,—still."[29]

 Demuth's desire to take a trip may reflect his search for inspiration;
travel had always helped him formulate a new agenda for his art. This time,
however, he was unable to travel. But he did find the inspiration he sought—

not in Europe but in his native Lancaster, and in his lifelong attraction to literary sources.

In 1926, Demuth began work on what would become one of his best known and most significant paintings. He had set aside the concept of portraiture, but he continued to explore ways in which to synthesize on a single canvas multiple viewpoints of one subject. *The Figure 5 in Gold* (Pl. 89) paid indirect tribute to William Carlos Williams and his poetry by making a "portrait" of Williams' poem "The Great Figure":

> *Among the rain*
> *and lights*
> *I saw the figure 5*
> *in gold*
> *on a red*
> *firetruck*
> *moving*
> *tense*
> *unheeded*
> *to gong clangs*
> *siren howls*
> *and wheels rumbling*
> *through the dark city* [30]

Williams described the origin of the poem in his autobiography: "Once on a hot July day coming back exhausted from the Post Graduate clinic, I dropped in as I sometimes did at Marsden [Hartley's] studio on Fifteenth Street for a talk, a little drink maybe and to see what he was doing. As I approached his number I heard a great clatter of bells and the roar of a fire engine passing the end of the street down Ninth Avenue. I turned just in time to see a golden figure 5 on a red background flash by. The impression was so sudden and forceful that I took a piece of paper out of my pocket and wrote a short poem about it." [31] In the poem, Williams had sought to eliminate narrative sequence in order to replicate the kind of instantaneous perception that is possible in painting. He achieved this by treating each line as an "object" rather than as part of an enumerative succession.

Demuth's painting reversed this process by portraying the sequentiality inherent in the poem's subject. Using ray lines and receding images of a figure five, he conveyed the insistent forward movement of the fire truck as it passed Williams on the street. By means of densely overlayed images, Demuth successfully captured the cacophony of gongs, sirens, and rumbling wheels

94. **Calla Lilies (Bert Savoy),**
1926
Oil on board, 42⅛ x 48 in.
(107 x 121.9 cm)
The Carl Van Vechten Gallery of Fine Arts at Fisk University, Nashville; From the Alfred Stieglitz Collection, Gift of Georgia O'Keeffe

that accompanied the firetruck as it shot by the street lights and city buildings in the rain. He reinforced his depiction of movement and elapsed time by portraying the fragmented images that would have been seen from the perspective of someone on the moving truck. Within this flashing imagery, Demuth inserted references to the poet: Williams' initials, the words BILL, CARLO[S]" (Demuth's nickname for Williams), and ART CO, an allusion to Williams' contacts with the New York art world and to the companionship that he and Demuth had shared within that world. The latter phrase is preceded by a truncated letter, which is most likely a T. TART CO could be a wry analogy between prostitution and the promotion of careers in the art world.

95. **Love, Love, Love**, 1929
Oil on panel, 20 x 20¾ in.
(50.8 x 52.7 cm)
Thyssen-Bornemisza Collection, Lugano, Switzerland

Demuth included *The Figure 5 in Gold* in his 1929 exhibition at The Intimate Gallery.[32] Even then, however, he must have felt tentative about its completion, for Williams referred to it as "unfinished" in a letter to the painter after the show.[33] Yet if Demuth made any changes after the exhibition, they were slight. The painting was already, according to Williams, "the best American picture of its time."[34] It did indeed brilliantly distill Demuth's life-long efforts to generate equivalencies between literary and visual art. Through the use of symbols, fragmented forms, and the Futurist vocabulary of his earlier architectural work, Demuth successfully captured the multiplicity of experience inherent in a single moment.

The *Figure 5 in Gold* is among the post-1926 paintings that rank among Demuth's most spectacular. Although his productivity declined after that date, the quality of his output grew richer. In still life, a genre which Demuth generally reserved for watercolor, he created an oil painting, *Longhi on Broadway* (Pl. 96), which even he admitted was his "best still life so far."[35] Demuth sent the painting to Stieglitz immediately after its completion in 1928, but he did not title it *Longhi on Broadway* until shortly before his 1929 exhibition. Thus its relationship to the eighteenth-century Venetian painter after which it was named was tangential rather than intrinsic. Longhi, who was famous for his depictions of upper-class Venetians at masked balls, theaters, parties, and carnivals, was known to New York audiences through his painting *The Meeting of the Procurator and His Wife* at the Metropolitan Museum of Art. Demuth's wish that he could go around New York "masked, as in eighteenth-century Venice," was undoubtedly inspired by Longhi's depictions.[36] Attaching Longhi's name to a still life of Broadway thus served to link the world of theater to that of painting.

Nevertheless, perhaps because Demuth's *Calla Lilies* had reputedly contained a hidden subject, speculations were later offered about the meaning of *Longhi on Broadway*. Ever since Demuth's retrospective at the Museum of Modern Art in 1950, the painting has been identified as an homage to Eugene O'Neill, the subtitle it was given at the exhibition.[37] That Demuth had intended to make a portrait of O'Neill (p. 178) only encouraged the identification of *Longhi on Broadway* with O'Neill. That the painting pays homage to Broadway theater and to art rather than specifically to O'Neill can be established by an analysis of its composite elements and by Demuth's comments about the picture in correspondence. In all of his letters, he continually referred to the picture as a still life; he never once mentioned it in connection with O'Neill.[38] In a letter to Stieglitz of February 1929, he described himself and Florine Stettheimer attending the opening of O'Neill's *Dynamo* and, then, in the letter's second paragraph, asked the dealer to show Stettheimer his new still life.[39] If the painting had any relationship to O'Neill it seems inconceivable that he would have failed to mention it at that moment.

Reading the painting as a gloss on Broadway, the blue and red masks become quite legitimate references to the historical association between masks and the theater rather than symbols of O'Neill's limited experimentation with them in *The Great God Brown*. This more generalized Broadway interpretation is borne out by the two books, –IF and ELSIE, which figure prominently in the composition. *If* was a play by Lord Dunsany that Demuth had seen and

enjoyed in London in 1921.[40] It premiered in New York in 1927 and its plot, which concludes with the idea of reconciliation to one's circumstances, may have appealed to Demuth in 1927, for he was at that very moment reconciling himself to the physical necessity of making Lancaster his primary residence. ELSIE, the second book pictured in the composition, may have referred to the musical comedy of that name which opened in New York in April 1923. Its protagonist—an actress who spends her first night with her new husband's family emotionally seducing all the men with her talents—was marginally evocative of Nana and Lulu. Demuth, an avid theatergoer, might well have seen this play. Another possible reference is to Elsie Janis, whose song and dance revue was extremely popular during the 1910s and 1920s. Demuth must have admired the performer, for it was probably she to whom he referred in a 1926 letter in which he stated his wish to visit New York in order to see "Miss E. dance."[41]

Buttressing the claim that the painting was intended as a commentary on the extended world of theater and art are the periodicals spread out around the bottle—*The Arts*, *L'Art vivant*, *This Quarter*, and *L'Amour de l'art*—all but one of which dealt with painting issues.[42] In fact, the issue of *L'Amour de l'art* that Demuth pictured was the very one which named him as one of the foremost practitioners of an emerging American art.[43] The issue of *This Quarter* that appears in the painting was dedicated to the American composer George Antheil. Antheil had been championed by Ezra Pound in 1924, and had chosen Williams as the librettist for one of his operas. Moreover, Aaron Copland had published an article on Antheil in the same 1925 issue of *The League of Composers Review* which featured Demuth's sketch of the opera singer Mme. Raymonde Delaunois. Antheil had won fame in Purist painting circles for his use of everyday objects as instruments and his call for music to sound like "an incredibly beautiful machine."[44] Ferdinand Léger had created a film to be shown in synchronization with Antheil's *Ballet Méchanique*, written for seventeen player pianos, two airplane propellers, and kettledrums. The European performance of this music-film ensemble was warmly received; its American debut—without Léger's film—at Carnegie Hall in 1927 was a fiasco. That the critical reception to Demuth's poster portraits had been unfavorable made him particularly sensitive to the plight of another vanguard artist whose work had been spurned by an American audience. The poignancy of Antheil's critical failure in America fueled Demuth's hope that "some 'movie star' or, whatever, would make the art of the United States fashionable. Appreciation is too much to hope for. . . ."[45]

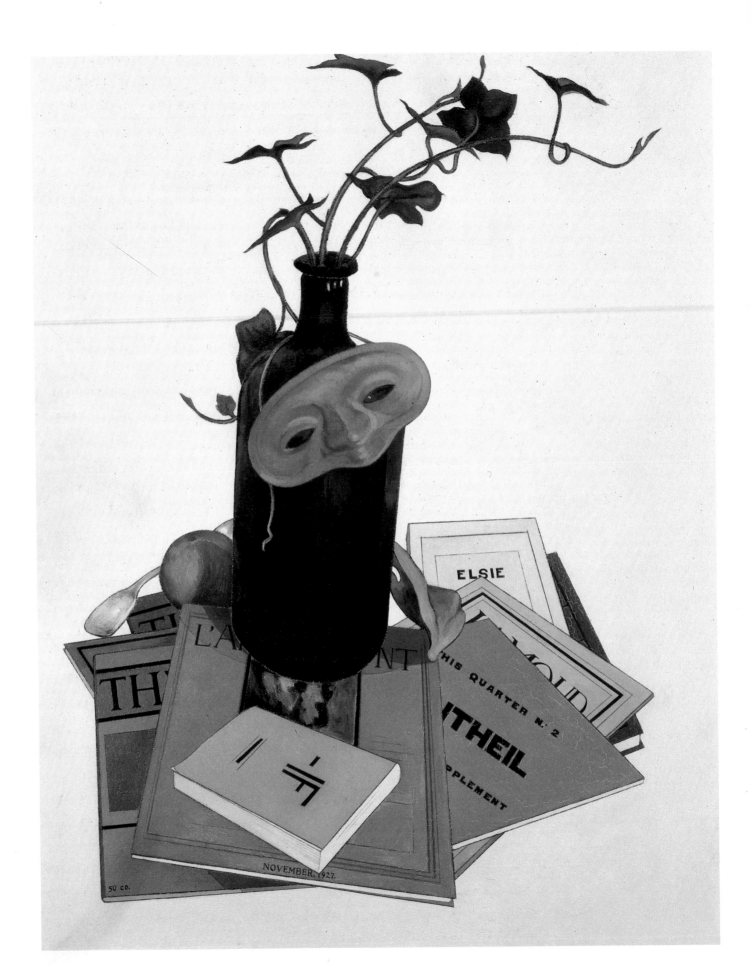

From Demuth's isolated position in Lancaster, Broadway and the theatrical world it epitomized radiated a magic aura. His final visual essay inspired by Broadway was exhibited, unfinished, in his 1929 exhibition at Stieglitz's gallery under the title *Design for a Broadway Poster* (Pl. 95). After the show, Demuth gave the painting to Locher, who kept it until his death in 1956. It was then sold at auction, where it was purchased as an untitled "poster" by the art dealer Edith Halpert, who exhibited it in her gallery shortly thereafter under the title *Love, Love, Love (Homage to Gertrude Stein)*. Halpert's invention of this title is something of a mystery. She undoubtedly knew of Demuth's respect for Stein and may have concluded from the similarity between the repetition of the word LOVE in the painting and Stein's repetitive writing style that the work was made as a tribute to Stein. However, Demuth's correspondence underscores the title he gave the painting at the time of its exhibition. Long a partisan of vernacular entertainment, Demuth expressed to Stieglitz in January 1929 his desire to "do something of Broadway."[46] That less than five months elapsed between this statement and the exhibition of the painting would explain why it was unfinished at the time of the show—and listed as such in the exhibition checklist. Demuth's pleasure at Locher's identification of the painting with Broadway further corroborates that Broadway was the intended subject: "Bobby took the poster with the white mask—he said it was the only painting which touched Broadway—and New York. I was so touched that I let him have it."[47]

Compositionally, *Design for a Broadway Poster* is among Demuth's most austere works. Three elements dominate the canvas: a white mask on a diagonally divided background of russet red, brown, and black; the numerals 1, 2, and 3; and the implied repetition of the word LOVE running on a diagonal. Iconographically, the mask symbolized theater, as it had in Demuth's *Stockbridge Stocks* and *Longhi on Broadway*. The numerals "1 2 3" may have signified the number of acts in a standard play and the fragmented words LOVE LOVE LOVE either his generalized affection for Broadway or the one-act play *Love! Love! Love!* by Evelyn Emig Mellon, which was broadcast over the radio in the spring of 1922 and published in 1929.[48] Perhaps a reference to the predominant theme of Broadway's conventional romantic plots, the words also may have alluded to Demuth's lifelong obsession with the question of affection and intimacy that formed the subtext of many of his own playwriting efforts. On another level, the suddenness with which the words enter and exit the painting may express Demuth's sense of the capriciousness of the American public in bestowing praise and recognition.

Notes

1. Demuth first mentioned the posters in a letter to Alfred Stieglitz, January 16, 1924, Stieglitz Collection, Collection of American Literature, Beinecke Rare Book and Manuscript Library, Yale University, New Haven (hereafter cited as Yale), in which he stated that O'Keeffe's poster portrait was on its way and those of Dove and Duchamp were started. When he finished O'Keeffe's on Valentine's day, he said the portrait had taken three months; see postcard to Stieglitz, February 15, 1924, Yale. For descriptions of each of Demuth's poster portraits, see Isabel Brenner, "Charles Demuth: The Poster Portraits" (Master's thesis, Hunter College, The City University of New York, 1974). Demuth's poster portraits are also discussed in Abraham A. Davidson, "The Poster Portraits of Charles Demuth," *Auction*, 3 (September 1969), pp. 28–31, and Davidson, "Demuth's Poster Portraits," *Artforum*, 17 (November 1978), pp. 54–57.

2. Stieglitz had exhibited De Zayas' abstract caricatures at 291 in 1913 and printed nine of them in *Camera Work* the following year; see Marius De Zayas, "Caricature: Absolute and Relative," *Camera Work*, no. 46 (April 1914), pp. 19–21, 34. In his accompanying article, De Zayas argued that the failure to consider portraiture as a modern expression derived from the mistaken attempt of artists to represent, by abstract means, the "material body." Instead of the subjects' physical selves, he favored adumbrations of their "intrinsic expression."

3. See n. 1, above.

4. Matthew Josephson, "After Dada," *Broom*, 2 (July 1922), pp. 346–51. That Demuth read the *Broom* is confirmed by his letter to Agnes and Eugene O'Neill, February 19, 1923, Yale.

5. Quoted in "Demuth Was 'Better' Friend," [Lancaster] *New Era*, March 7, 1986, p. 2.

6. Paul Rosenfeld, *Port of New York* (New York: Harcourt Brace and Company, 1924), p. 168.

7. Demuth to Stieglitz, July 7, 1924, Yale.

8. See Davidson, "Demuth's Poster Portraits," p. 56.

9 See Kermit Champa, "Charles Demuth," unpublished manuscript, 1973, p. 73.

10. The band has been described as a "pole" by Alvord L. Eiseman, "A Study of the Development of an Artist: Charles Demuth," 2 vols. (Ph.D. dissertation, New York University, 1976), II, p. 737; and as a "pole or ribbon" by Davidson, "The Poster Portraits of Charles Demuth," p. 28. I agree with Brenner, "Charles Demuth: The Poster Portraits," p. 19, that it is more likely a slice of sky with a portion of a rainbow.

11. That the lily and winter scene also implied the "precious artistic spirit blossoming within Marsden Hartley, contrasted with the intractability of an unreceptive environment . . ." is a bit farfetched, although it does confirm how open-ended the interpretations of Demuth's posters can be; see Timothy Anglin Burgard, "Charles Demuth's 'Longhi on Broadway: Homage to Eugene O'Neill,'" *Arts Magazine*, 58 (January 1984), p. 111.

12. Demuth to Stieglitz, January 16, 1926, Yale.

13. Demuth to Stieglitz, July 30, 1922, Yale.

14. In addition to these three new oils, Demuth included sketches or watercolors (the reviews do not specify) of a still life, a Hartley poster, or both in the "Seven Americans" show. Several reviewers mentioned a Hartley poster and one mentioned two still lifes, although the most reliable reviewer listed Demuth's other entry as a still life; see Forbes Watson, "Seven American Artists Sponsored by Stieglitz," *The* [New York] *World*, March 15, 1925, section 3, p. 5. One reviewer got mixed up and called the Duncan poster a portrait of Marin; see Helen Appleton Read, "New York Exhibitions: Seven Americans," *The Arts*, 7 (April 1925), p. 231.

15. The only other "official" relationship between Stieglitz and Demuth was in 1922, when Stieglitz organized an auction at the Anderson Galleries that included Demuth's work; see "Art Notes: American Modernists' Work to Be Auctioned at Anderson's," *The New York Times*, February 22, 1922, p. 14.

16. Demuth wrote to Stieglitz, August 13, 1921, Yale, that he felt that Daniel was a "crook."

17. The official statement of The Intimate Gallery, printed on all gallery announcements, read: "It is used more particularly for the intimate study of Seven Americans: John Marin, Georgia O'Keeffe, Arthur G. Dove, Marsden Hartley, Paul Strand, Alfred Stieglitz, and Number Seven (Six + X)."

18. Stieglitz to Demuth, January 28, 1930, Yale.

19. Edmund Wilson supported this assessment: "My admiration for these artists was genuine, but if I had not been subjected to Stieglitz's spell, I might perhaps have discussed them in different terms. I note that there were pictures by Charles Demuth, and I do not now remember what they were; yet Demuth—as I realize today—interests me more than Marin, whose reputation I now suspect Stieglitz of having rather unduly inflated, and I might have discovered this if I had been left alone with the pictures. If Stieglitz layed Demuth down, it was undoubtedly for the reason that he did not belong to the inner group of the artists whom he had himself introduced and to promoting whose reputations he had so jealously devoted his energies . . ."; see Wilson, *The American Earthquake* (New York: Doubleday Anchor Books, 1958), p. 102.

20. In September 1922, Demuth wrote to A.E. Gallatin asking whether the collector was still interested in seeing any of his vaudeville and architectural watercolors as he was "rather in need of selling at the moment"; see Demuth to Gallatin, September 11, 1922, Archives of American Art, Smithsonian Institu-

tion, Washington, D.C. And in the twenties Daniel thanked Ferdinand Howald for sending a check in payment for one Demuth work by noting that ". . . Demuth will be relieved for a while"; Demuth to Howald, n.d., Archives of American Art, Smithsonian Institution, Washington, D.C. In writing to Stieglitz about not having been paid (Demuth to Stieglitz, September 10, 1931, Yale), he remarked: "If I were only as well off as they think,—I'd give them away."

21. As late as 1950, when O'Keeffe donated several of Demuth's paintings to museums, she chose to give four of the portraits to the Beinecke Library at Yale, the repository of Stieglitz's correspondence, but a facility unequipped to exhibit paintings.

22. Demuth to Stieglitz, n.d. [July 1925], Yale.

23. Henry McBride, "Charles Demuth's Cerebral Art," *The New York Sun*, April 10, 1926, p. 6. Reprinted in Daniel Catton Rich, ed., *The Flow of Art: Essays and Criticisms of Henry McBride* (New York: Atheneum Publishers, 1975), p. 219.

24. For full text, see pp. 41–42.

25. Wilson, *The American Earthquake*, p. 60.

26. Davidson, "The Poster Portraits of Charles Demuth," p. 30. This was reiterated in Davidson's later article, "Demuth's Poster Portraits," p. 56.

27. Davidson, "The Poster Portraits of Charles Demuth," p. 30. Demuth himself, in a letter to Stieglitz, March 27, 1926, Yale, felt the poster might be interpreted in a negative light: "I'm sure everyone will take it as an insult (not Marin, however). I've put that on too thick, I think, for any mistake in that direction."

28. Demuth to Stieglitz, March 27, 1926, Yale.

29. Demuth to Stieglitz, July 12, 1926, Yale.

30. Demuth wrote to Agnes O'Neill that he had "done" a portrait of Williams, August 13, 1926, Yale. The catalogue for the 1929 show at The Intimate Gallery gives the date for *The Figure 5 in Gold* as 1927. However, the date on the reverse of the painting is 1928.

31. William Carlos Williams, *The Autobiography of William Carlos Williams* (New York: Random House, 1951), p. 172.

32. Demuth's output had so diminished by 1929 that this exhibition was originally planned to include only two paintings. Five were eventually shown: *Longhi on Broadway, The Figure 5 in Gold, Design for a Broadway Poster, Rhubarb and Cabbages* (now *Red Cabbages, Rhubarb, and Orange*, Pl. 113), and an unidentified 1918 work entitled *Provincetown*.

33. Williams to Demuth, May 7, 1929, quoted in Brenner, "Charles Demuth: The Poster Portraits," p. 58.

34. Ibid. After this compliment, however, Williams went on to a lengthy and rather audacious critique of

the painting: "I feel in this picture that the completion that was once felt and made the whole composition a whole has been lost and that you have tried twenty times to recapture and that every try has left a trace somewhere so that the whole is tortured. It needs some new sweep of the imagination through the whole to make it one . . . the thing's got to be imagined over again. See if you can't recall your first thought."

35. Demuth to Stieglitz, February 5, 1929, Yale.

36. Demuth to Stieglitz, September 19, 1926, Yale.

37. For the identification of *Longhi on Broadway* with Eugene O'Neill, see Timothy Aglin Burgard, "Charles Demuth's 'Longhi on Broadway,'" pp. 110–13. Brenner, "Charles Demuth: The Poster Portraits," p. 50, has been the only scholar to question the subtitle of *Longhi on Broadway*.

38. For example, Demuth to Stieglitz, January 3, 1929, Yale, where he said that the "still life . . . the one with the masks" was what he wished Lee Simonson to reproduce along with his article "Across a Greco Is Written." *Longhi on Broadway* was the reproduction in question. And as late as March 1931 he wrote of "the big still life with the masks," a clear reference to *Longhi* since it is one of Demuth's biggest paintings; see Demuth to Stieglitz, March 7, 1931, Yale.

39. Demuth to Stieglitz, February 5, 1929, Yale.

40. In a letter to Agnes and Eugene O'Neill, September 17, 1921, Yale, Demuth wrote that the play was "quite good," but that he expected it to fail in New York. The play concerns the adventures of a man given a wishing crystal that permits him to relive, in a different way, ten years of his life. At the end of the play he returns to his wife, apparently happily resigned to his "real" existence.

41. Demuth to Stieglitz, May 12, 1926, Yale.

42. The visual relationship between Demuth's depiction and the actual covers of these magazines is discussed in Brenner, "Charles Demuth: The Poster Portraits," pp. 45–46. Essentially, he duplicated the coloring, format, and lettering of the periodicals. The only substitutions he made were to change "50 cents" to "50 CD," and the date on *L'Amour de l'art* from 1923 to 1927.

43. See W[aldemar] G[eorge], "Les Expositions," *L'Amour de l'art*, 4 (November 1923), pp. 762–65.

44. Antheil, quoted in Randall Thompson, "Contemporary Composers V: George Antheil," *Modern Music*, 8 (May–June 1931), p. 20.

45. Demuth to Stieglitz, January 16, 1924, Yale.

46. Demuth to Stieglitz, January 3, 1929, Yale.

47. Demuth to Stieglitz, September 26, 1929, Yale.

48. See Brenner, "Charles Demuth: The Poster Portraits," pp. 62–63.

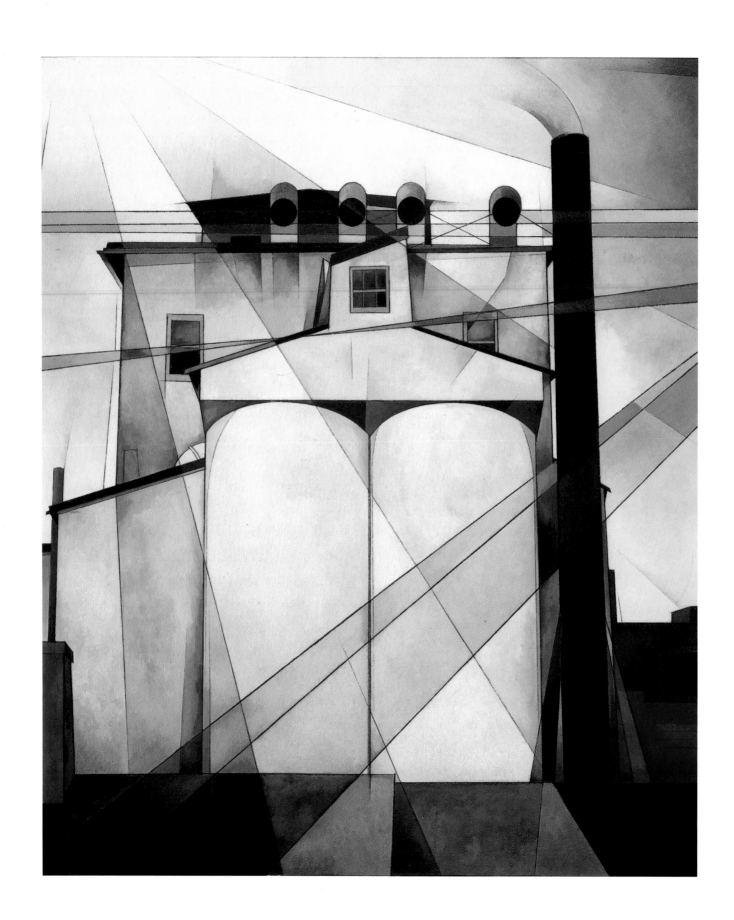

VII.

Late Works 1927-1935

In 1927 Demuth began a new series of architectural paintings of Lancaster —a subject he had not addressed since 1921.[1] The critical disregard of his poster portraits the previous year had led him to pursue different modes. One direction culminated in *The Figure 5 in Gold* and *Longhi on Broadway*. The other resulted in a group of architectural depictions of Lancaster executed between 1927 and 1933, in which he dispensed with the iconographic impulses and multivalent viewpoints of the poster portraits in favor of a synthesis of form and content. He no longer used objects symbolically as he had in his poster portraits, nor did he apply thematically contradictory titles, as he had in his 1920–21 Lancaster series.

 Lancaster remained the subject of Demuth's last group of paintings. His goal, however, was not to create a likeness of the city but to use likeness as a means through which to record his times and his response to them. It was this kind of representation that he identified as fundamental to all successful portraits.[2] In these Lancaster scenes he intended to represent his state of mind as well as to express "certain things in forms of this own America."[3] Demuth felt he had succeeded in this pursuit for he reported to Stieglitz that his new paintings looked "almost American" and "quite American."[4] Although he was no longer tentative or apologetic about his native roots, he was not unaware of the dilemma faced by American artists: "Europe was to us all nearer and dearer,—but,—well you know, what could any of us add to Europe? Perhaps, I like to suffer, at times, I think that I do. It may never flower,—this our state, but, if it does I should like to feel from some star, or whatever, that my living added a bit;—for in this flower, if it does, I can imagine Rome in its glory looking very mild."[5] This same ambivalence had formed the core of his unpublished play *"You Must Come Over," A Painting: A Play*, in which his celebration of America—"My God what a time and what a country"—had been tempered by the remark "and yet what a country, to wish to do anything in or about."[6]

97. **My Egypt**, 1927
Oil on board, 35¾ x 30 in.
(90.8 x 76.2 cm)
Whitney Museum of American Art, New York Purchased with Funds from Gertrude Vanderbilt Whitney
31.172

Demuth's first attempt to pictorialize his engagement with America was *My Egypt* (Pl. 97), perhaps his best known and most powerful late work.[7] Stylistically, the painting resembled the concurrent *The Figure 5 in Gold*. In *My Egypt*, the commanding presence of the Lancaster grain elevator owned by John W. Eshelman and Sons monumentally dominates the composition like a hieratic icon, just as the figure five dominated the Williams canvas. Similar, too, are the diagonally overlapping shafts of light, which communicate the passage of time by suggesting the experience of different light and color conditions.

Demuth's title exploited the Egyptomania that followed Howard Carter's discovery of Tutankhamen's tomb in 1922. It also drew inspiration from the same ironic impulse that had motivated many of the mechanomorphs of the Dadaists: coincidental visual similarity. The resemblance of the grain elevators to the Egyptian pyramids did not go unnoticed by others, despite Lewis Mumford's ironic disclaimer "that a great part of the success of these new buildings is due to the fact that the designer did not attempt to model his grain elevator after an Egyptian temple."[8] In fact, the associations between American grain elevators and Egyptian pyramids were rampant during the 1920s. To equate these symbols of American industry with the pyramids confirmed industry's position at the pinnacle of American achievement. In 1923, Le Corbusier had prefaced his book *Towards a New Architecture* with eight photographs of American grain elevators that he likened to the pyramids of Egypt. The analogy must have been widespread, for Amédée Ozenfant used it later when applauding America's industrial landscape.[9] The connection between American industrial buildings and Egyptian pyramids suggested a more biting irony as well, since the pyramids had been built by slaves. Because some viewed industry as exploitative of workers, the industry-pyramid parallel took on a double-edged social meaning, particularly on the eve of the Depression.

If the above explains the word "Egypt" in the title, the possessive "my" yields to a biblical interpretation. Egypt was the place of Hebrew bondage, as Demuth surely knew from his childhood religious education. Within the context of the biblical narrative, the Jews' very enslavement in Egypt is generally understood as fundamental to the formation of their religion and national self-consciousness. Thus Egypt—the Hebrew word for which means "trouble"—was at once a symbol of the Jews' oppression and the point of reference for their self-identity and emergence as a distinct people. That it

was the Jews who built the pyramids in their captivity only increased the aptness of the symbol for Demuth.

Lancaster—and America—was to Demuth what Egypt was to the Jews: a place to which he was tied involuntarily, through the physical debilitation of diabetes, and simultaneously the decisive source of his inspiration and creativity. Denied the stimulation he had once found in New York's sophisticated social and intellectual milieu, he was at the same time thrown in with a citizenry not only less worldly than he, but also generally hostile to his art. Yet however much he dreamed of traveling elsewhere, he had come to realize that his residence in Lancaster provided a measure of compensation. Looking back in 1928 on his youth, he felt he had "given up" his life trying to find out about the world and that maybe he should have done more painting.[10] His "imprisonment" in Lancaster forced him to concentrate on his art. "I'll stay here and work," he had written resignedly to Stieglitz as early as 1923. "I don't see anything else. I like a few places and a few people but I see them seldom. Perhaps I wouldn't work at all if I did—."[11] Despite Lancaster's remove from "any contact with ones interested in the 'thing,'" its very isolation made it possible for him to work.[12] Now, instead of going in for "hysterics," all he could go in for was another picture.[13] *My Egypt* was Demuth's radical assertion of the dilemma of the American artist as well as his acknowledgment that the very difficulties America posed were also the ultimate source of his aesthetic invention and creative freedom. "America doesn't really care," he wrote, "—still, if one is really an artist and at the same time an American, just this not caring, even though it drives one mad, can be artistic material.[14]

The combination of threatening forms and delicate paint handling in *My Egypt* encapsulated the complexity of Demuth's feelings about America in a way that words could not. Words, Demuth insisted in his 1929 article "Across a Greco Is Written," "explain too much and say too little."[15] From the beginning of his career, Demuth had asserted that painting was as capable as literature of communicating ideas. Color and line "said" something; they were not simply elements of a formal composition. "Across the final surface—the touchable bloom, if it were a peach—of any fine painting is written for those who dare to read that which the painter knew, that which he hoped to find out, or, that which he—whatever."[16] Pictures, he believed, were "painted sentences" which spoke in "larger letters than any printed page would ever dare to hold."[17] Thus, by the time he painted *My Egypt*, he had come to

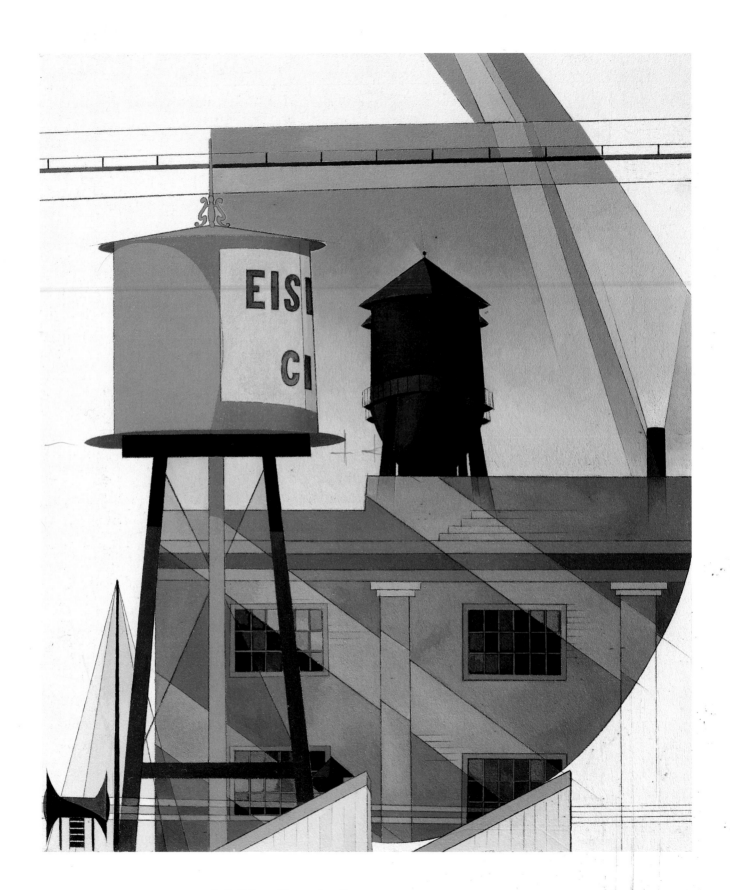

98. **Buildings Abstraction, Lancaster**, 1931
Oil on panel, 27⅞ x 28⅝ in. (70.8 x 72.7 cm)
The Detroit Institute of Arts; Founders Society Purchase, General Membership Fund

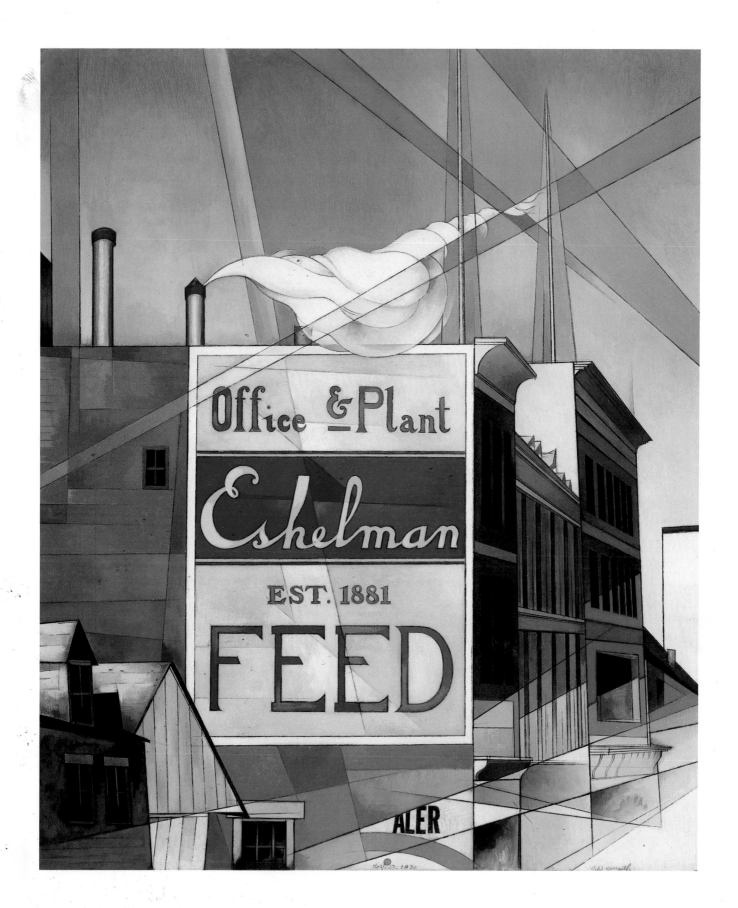

99. **Buildings, Lancaster**, 1930
 Oil on board, 24 x 20 in. (61 x 50.8 cm)
 Whitney Museum of American Art, New York; Gift of an Anonymous Donor 58.63

believe that images were more than equal to texts—that painting was in fact a superior means of expression. Words, Demuth now felt, could not generate sufficient ambiguity or force one to internalize the levels of meaning in a work of art.

Stylistically, *My Egypt* marked the culmination of Demuth's efforts to visually suggest the passage of time through shafts of light. In his subsequent Lancaster paintings, occasional ray lines extend beyond the boundaries of forms, but their effect is restrained; surface complexity and multiple viewpoints give way to structural solidity. The result is a sense not of time passing, but of emotional certainty, of a lifetime's experience of a specific place distilled down to a single vision. The once pronounced tactility of paint became a smooth, almost effortless facture. Demuth saturated the palette so that color seems deeper and more radiant. This was "colour as colour, not as volume, or light—only as colour."[18] It was as if he had finally found a means of transferring the sharp clarity of his watercolors to an oil medium. Even he observed the intensity of these new works, describing them to Stieglitz as having a "strange, inner strange look, about them. They look some times like I think my own things do or should and then again when I look at them they seem to look very different & strange with a strange strangeness."[19]

Demuth continued in these paintings to use enigmatic titles and to incorporate words as signposts to meaning. On the reverse of *Buildings, Lancaster* (Pl. 99), he attached the inscription, "A fragment, overlooked by Henry James / who conveniently named the whole." The consummate expatriate, James had celebrated America while remaining tied to Europe. In describing his country from different vantage points, he had "named" all of its aspects except industrialization. James had been an important figure for Demuth, but he now came to feel that James had proffered an incomplete and thus unsatisfactory description of America. His urbanity and European cultivation inhibited James from confronting industry. It was precisely this aspect of America, "overlooked" by James, that Demuth's art—his visual fragments of Lancaster—presented.

Demuth elaborated on the subject of America by changing the title of one of his late Lancaster paintings from *And in the Land of the Brave* to *And the Home of the Brave* (Pl. 102). The revised title not only reiterated his belief that artists in America had to be psychologically strong to survive, but it identified this "land," whatever its defects, as his home. That it also quoted the national anthem accentuated the American focus of Demuth's subject.

The title of Demuth's last oil, *After All* (Pl. 103), vernacularly affirmed his acceptance of Lancaster as his home. "After all was said and done," Demuth seemed to be saying, he had found in Lancaster's so-called "limitations" powerful aesthetic sources of inspiration; out of his psychic and visual rapport with a specific place, he had created a compelling art. And he had done so without falsifying that environment or robbing it of its authenticity. In this context Emily Farnham's suggestion that *After All* derived its title from Walt Whitman's *Leaves of Grass* makes sense:[20]

> *After all not to create only, or found only,*
> *But to bring perhaps from afar what is already founded,*
> *To give it our own identity, average, limitless, free,*
> *To fill the gross, the torpid bulk with vital religious fire,*
> *Not to repel or destroy so much as accept, fuse rehabilitate,*
> *To obey as well as command, to follow more than to lead,*
> *These are also the lessons of our New World;*
> *While how little the New after all, how much the Old, Old World!*

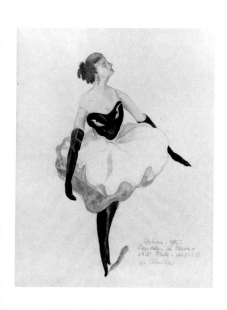

Watercolor after Beardsley, 1928
Pencil and watercolor on paper, 10½ x 8 in. (26.7 x 20.3 cm)
Collection of Holly and Arthur Magill

The formal economy and strength that characterized Demuth's late oils found expression as well in his concurrent watercolors. In these, colors no longer effusively bleed into one another; nor do subjects merge indiscriminately into atmospheric backgrounds. Instead, the restraint and authority of these works recall Chinese flower painting. As with his oils, Demuth's output in watercolor in these years was vastly curtailed. Although he executed a few figure studies—among which were several versions of the costume he designed "after Beardsley" for his wealthy Lancaster friend Blanche Steinman—most of his efforts were directed at still life. The precision and impeccable execution of these late watercolors culminated in a series of still lifes in 1929. Structurally taut and almost botanical in detail, works such as *Red Poppies* (Pl. 115) tap a vein of psychological power which transcends this genre. Spiky, angular forms displaced soft, sensual ones. These watercolors are not so much expositions on plant and vegetal motifs as on the transience of life: Demuth's depiction of the three stages in the life of the poppy flower represents his reflection on the cycles of existence. In 1925 he had inscribed "youth and old age" on a flower watercolor (Pl. 71); only in his late still lifes did he render the impact of those words visible.

In the late twenties, Demuth's isolation in Lancaster was relieved somewhat by the arrival of Darrell Larson to direct the community theater group and

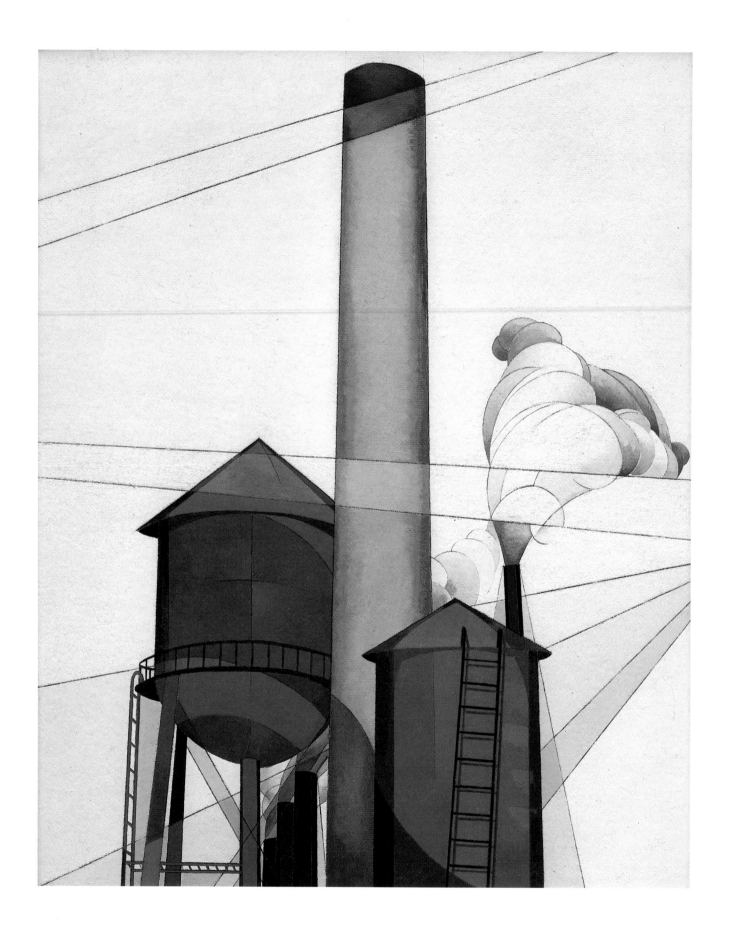

100. **Buildings**, c. 1931
Tempera and pencil on board, 30 x 24 in. (76.2 x 61 cm)
Private collection; courtesy James Maroney, Inc., New York

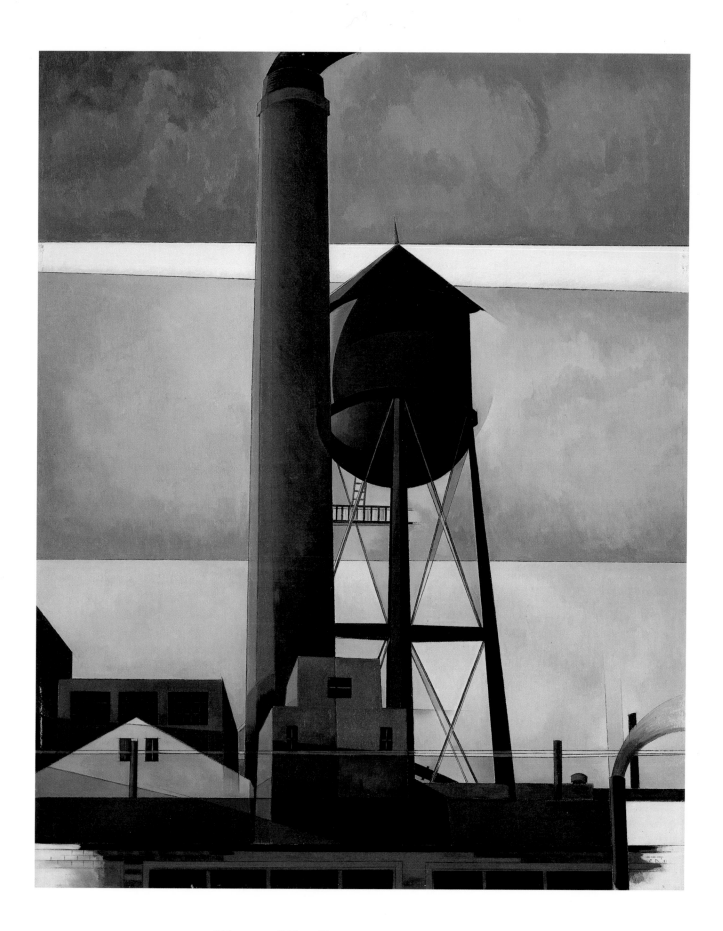

101. **Chimney and Water Tower**, 1931
Oil on board, 29¼ x 23¼ in. (74.3 x 59.1 cm) Private collection

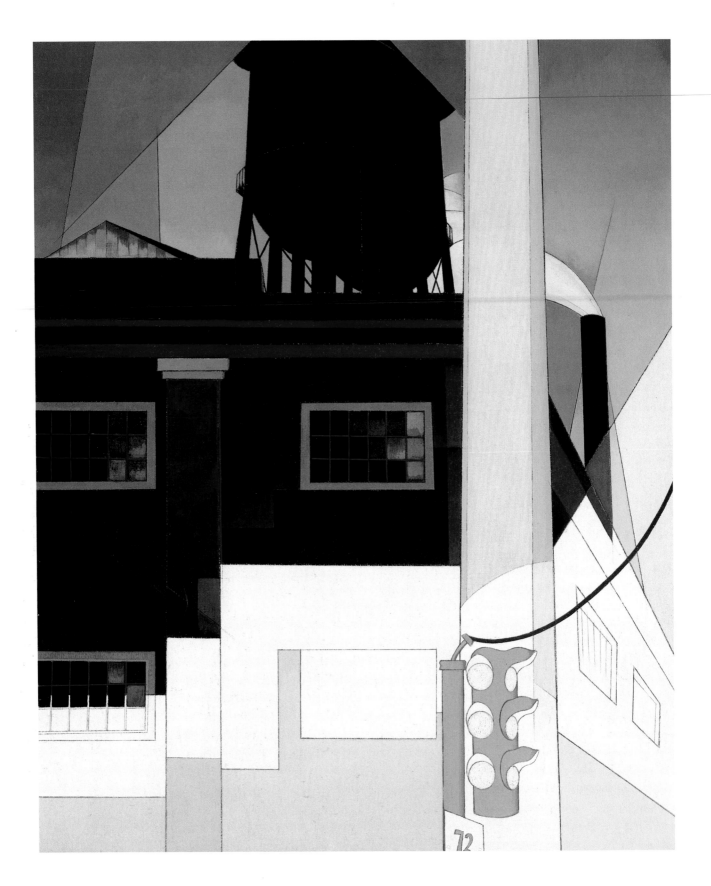

102. **And the Home of the Brave**, 1931
Oil on board, 30 x 24 in. (76.2 x 61 cm) The Art Institute of Chicago; Gift of Georgia O'Keeffe

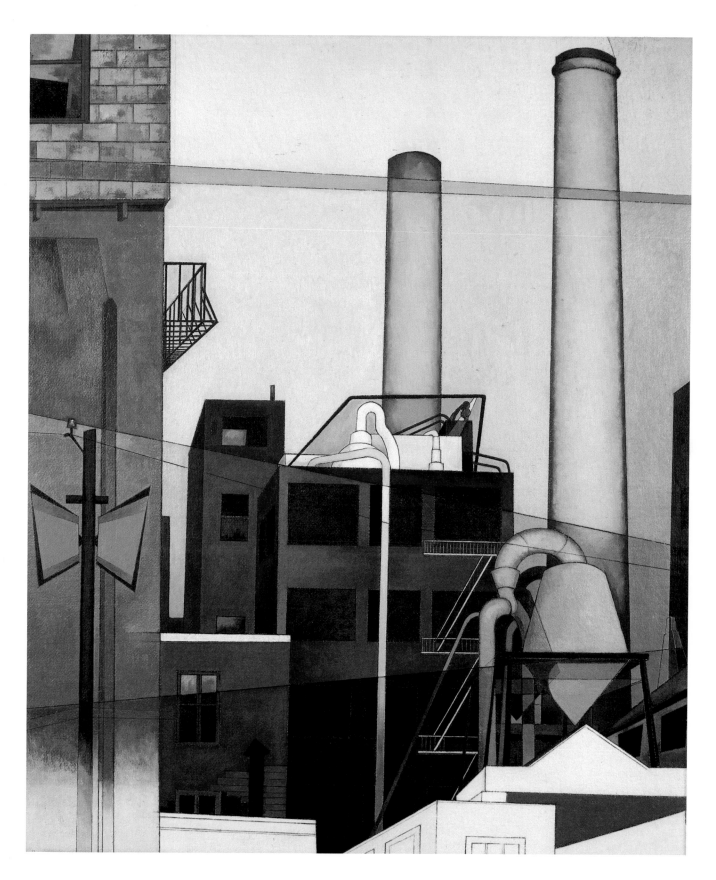

103. **After All**, 1933
Oil on board, 36 x 30 in. (91.4 x 76.2 cm)
Norton Gallery and School of Art, West Palm Beach, Florida

then the Green Room Theater at Lancaster's Franklin and Marshall Academy. Larson, a homosexual, later recounted that he and Demuth would attend drinking parties together in Lancaster at least twice a week. At this same time, Robert Locher was establishing an alliance with the young and handsome Richard Weyand, with whom he would eventually live in the Demuth house after Augusta Demuth's death (p. 25). It was to this alliance that Demuth might have been referring when he reported to Stieglitz in 1930 that he had not been well during the summer "and then too something else happened to me which almost finished me in another direction."[21] Whether or not these events had any bearing on Demuth's work, the year 1930 marked the resurgence of his aesthetic engagement with themes of sex and underground amorality. Again it was literature that encouraged him to explore these otherwise forbidden issues. The impetus was Robert McAlmon's short story "Distinguished Air," one of three which had been published under that name by McAlmon's Contact Editions in 1925 in a run of only 115. Demuth read the story in a typewritten version sent to him by McAlmon.[22] The story concerns the decadent world of sex and drugs in postwar Berlin, and its impoverished and deluded men and women for whom alcohol, promiscuous sex, and cocaine offered insufficient escape. The title "Distinguished Air" derived from the description by McAlmon's narrator of a worldly but dissolute homosexual American, Foster Graham, who "has, or had distinction—a real air."[23] That the description was also applicable to Demuth reinforces the autobiographical impulses that led him to illustrate the story. While the world McAlmon detailed had become too much for most of his characters, he cast no moral or psychological judgments about it himself.

Demuth took heed of McAlmon's detachment and adopted the same morally opaque stance in his illustration (Pl. 104). He portrayed a scene in one of Berlin's "queer cafes," frequented by transvestites and male whores whom the narrator noted could be mistaken for sightseers if one did not know them. However, rather than replicate the specific narrative of McAlmon's story as he had done with his earlier literary illustrations, Demuth used it as a springboard to a totally independent creation by recasting one of McAlmon's bar scenes as the opening of an art exhibition. His depiction of a homosexual couple and a provocative woman in evening dress obliquely mirrored the events of McAlmon's story: Foster Graham's maudlin infatuation with a beautiful soldier and the woeful attempt of an elegantly dressed American woman to ignore her cocaine-alcohol stupor and establish that she was a lady.

104. **Distinguished Air**, 1930
Watercolor on paper, 14 x
12 in. (35.6 x 30.5 cm)
Whitney Museum of Amer-
ican Art, New York; Pur-
chased with Funds from the
Friends of the Whitney
Museum and Charles Simon
68.16

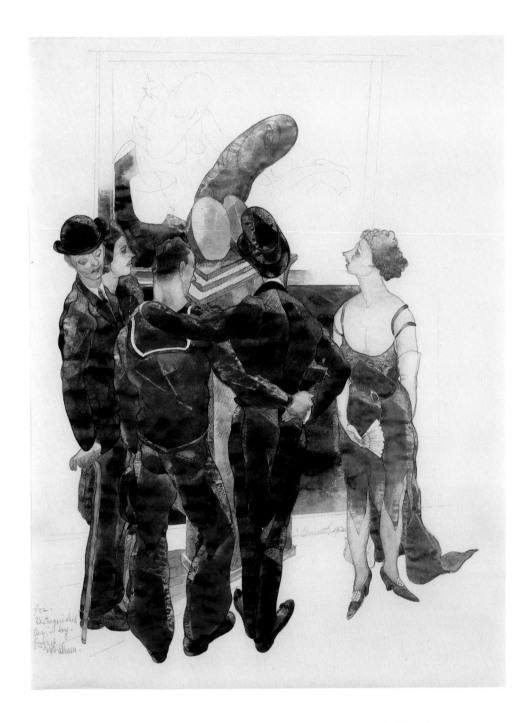

Demuth's presence in the scene as voyeur-narrator is signaled by the cane
being held by the heterosexual male—the same symbol Stettheimer had used
for him in her portrait of Stieglitz (p. 174). In a replay of his dancing sailor
watercolors of the teens (Pl. 26), Demuth depicts this alter ego intently
observing the homosexual sailor, though now his glance is directed toward
the sailor's crotch. By setting the scene in the world of art, Demuth trans-
posed McAlmon's story into his own arena. And he narrowly skirted the line
of respectability by centering the attention of the crowd on Brancusi's

overtly phallic *Princess X* and including a clearly homosexual couple among those viewing it.[24] The risqué sexual dimenson of the illustration did not go undetected and the work was banned from several exhibitions. Curiously, Demuth had not been as aesthetically overt about homosexuality while living in the bohemian world of New York; that he proclaimed it in this way while in provincial Lancaster indicates a fierce rebellion against the town's complacent conventionality.

Demuth's exploration of overtly sexual themes took an even more rebellious posture in the summer of 1930 when he embarked on a series of pornographic watercolors (Pls. 105–107). In contrast to his sexually ambiguous works from the teens, these works are blatant in their depictions of exaggeratedly erect penises. In this they resembled Beardsley's flagrantly erotic illustrations and indicated Demuth's continuing attachment to an artist who had been so important to him as an art student. No longer were Demuth's scenes populated by diffident young males, but by virile men who flaunted their sexuality. They describe a world of "rough trade" and sexually bargained favors rather than one of discreet homosexual encounters. The "nice" boys who populated his erotically tinged watercolors of the teens had grown up into muscular, sexual aggressors. Technically, these works bypassed the strict formalism of Demuth's vaudeville style to rehearse a looser, more illustrational approach to genre subjects. They eschewed the refinement and nuance that typically characterized his work in favor of a bold presentation of subject. In outline drawings such as *Two Figures in a Bedroom*, Demuth adopted the neoclassic linearity of Jean Cocteau's contemporary depictions of self-styled Greek shepherd boys. In so doing he associated his work—and his person—with that of a prominent and overtly homosexual artist.

The conspicuous display of genitalia in these works, which made them unexhibitable in Demuth's lifetime, gives rise to speculation about his motives, especially at a time when his strength for picture-making was limited. It is possible that the strain of cloaking his homosexuality in conservative Lancaster had simply become too great and that these watercolors represented an outlet for his frustrations. It is also possible that at this time Demuth became worried about impotence—which is often a consequence of severe diabetes—and that these watercolors manifested a compensatory obsession with virility. That they were fantasies rather than chronicles of actual encounters seems probable. Demuth, of course, would have seen sailors during his 1930 visit to Provincetown and may have fancied having a relationship with one, as

Two Figures in Bedroom, 1930
Pencil on paper, 8½ x 10½ in.
(21.6 x 26.7 cm)
Destroyed

his initials on the sailor's arm in *Three Sailors on the Beach* (Pl. 106) suggest. But although the attraction of a self-styled aristocrat like Demuth to lower-class males would have followed a known homosexual pattern, Demuth's weakened physical condition at this stage makes his participation in such promiscuous behavior as the images depict seem unlikely.

By 1932 the overtness of this series seems to have run its course, for Demuth retreated to the camouflaged sexual innuendos of earlier years. *On "That" Street* (Pl. 108) could easily pass for a casual conversation between dandy and sailor if "that" street had not been rumored to refer to Sand Street in Brooklyn, a well-known site of homosexual assignations.[25]

Demuth made his last group of watercolor subjects during the summer of 1934 at the Provincetown home of Lancaster friends, Frank and Elsie Everts. He was apparently in relatively good health that summer; although his social schedule was subdued, it was not inactive. He spent many of his days on the beach, sketching the sunbathers (Pl. 109). Thematically, this small series of watercolors—which treat the same subject with only minor variations —recalls the genre illustrations he had developed after he first left the Pennsylvania Academy. But either through choice or diminished physical strength, his execution was less precise. Because his figures were more generalized and less detailed, they were also more sculptural and monumental. In keeping with a technique he had used with his flower and fruit still lifes, he often outlined the silhouettes of forms with pencil and left the interior uncolored.

After his Provincetown idyll, Demuth spent the next fourteen months in Lancaster, too ill to paint. Fifteen years of diabetes had finally overtaken him, and in July 1935 he began to suffer from dropsy and swollen legs induced by arterial sclerosis. On the afternoon of October 25 he suffered a hypoglycemic attack. Following the advice of his Lancaster doctor, he retired to bed. When his mother looked in on him later that evening, she found he had died quietly in his sleep.

Charles Demuth amalgamated European modernism with American subjects at a time when most American artists were still firmly committed to the conventions of realism. From the beginning of his career, the refinement, coloristic subtlety, and precise craftsmanship of his work earned him a prominent position within vanguard circles. Yet Demuth's work, even for his contemporaries, was difficult to assess. Although no one ever questioned the

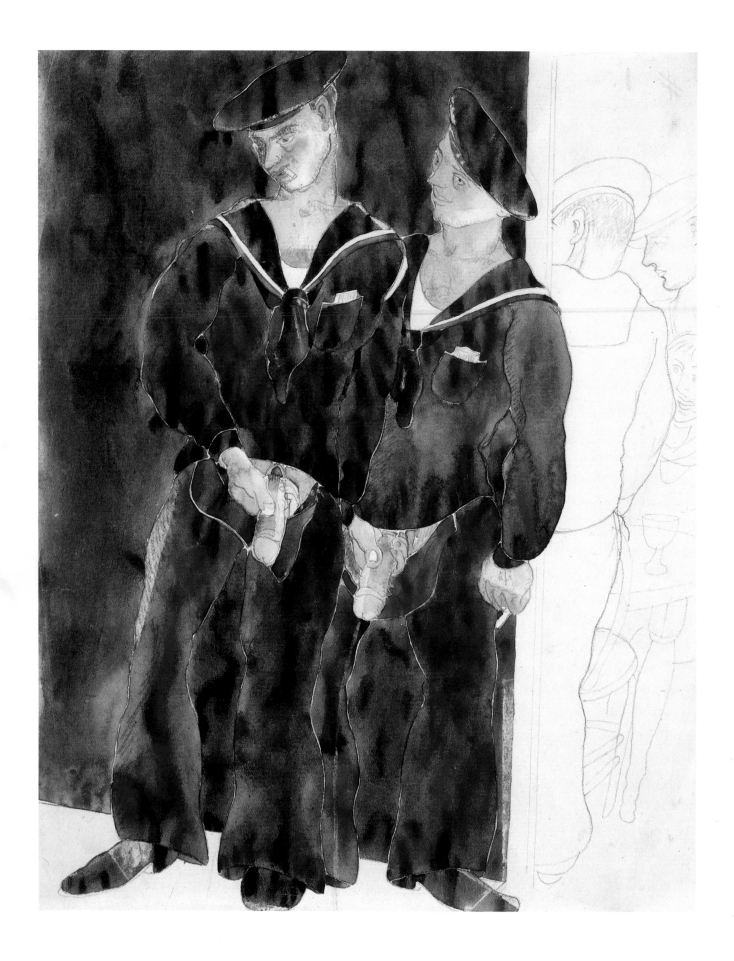

Opposite page

105. **Two Sailors Urinating,**
1930
Watercolor and pencil on
paper, 9½ x 13¼ in. (24.1 x
33.7 cm)
Private collection

106. **Three Sailors on the Beach,**
1930
Watercolor on paper, 13½ x
16½ in. (34.3 x 41.9 cm)
Private collection

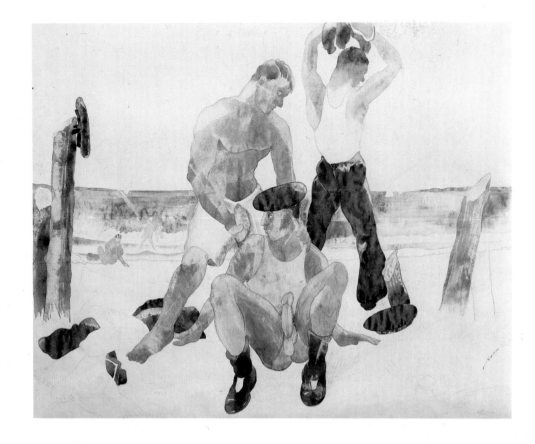

107. **Four Male Figures,** 1930
Watercolor on paper, 13 x
8 in. (33 x 20.3 cm)
Collection of William Rush

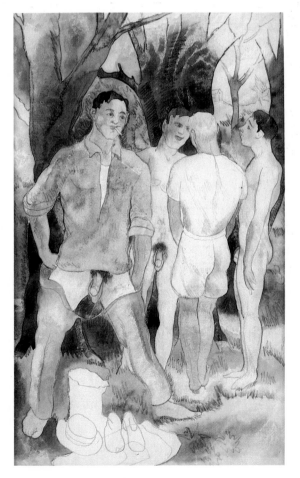

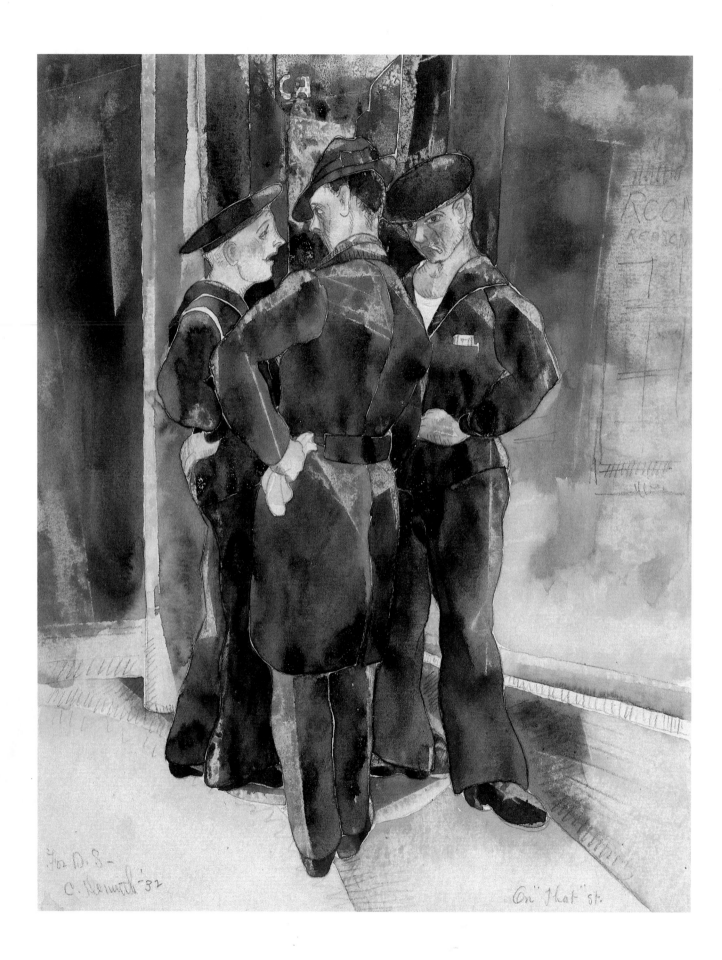

For D. S—
C. Demuth '32

On "that" st.

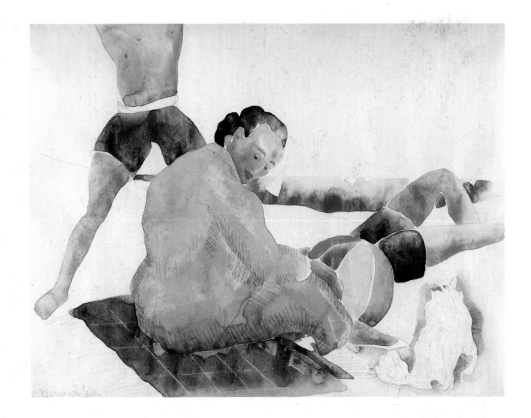

consummate artistry and sumptuous elegance of his flower and still-life water-
colors, some critics relegated them to a secondary status, believing that oil was
the only medium of ambition and substance. Others were so awed by the
delicate beauty of these watercolors that they failed to recognize their formal
and psychological strength. Even Demuth's pioneering Precisionist landscapes
were not easily judged since their wit and intellectuality, no less than their
pictorial gracefulness, distinguished them from those of his contemporaries.
Moreover, apart from *The Figure 5 in Gold*, Demuth's poster portraits
were so seldom seen that they were rarely included in evaluations of his over-
all achievement. His figure scenes and literary illustrations, though sensually
charged, evocative statements equal in intensity and psychological complexity
to the most powerful Expressionist work done anywhere, were also inade-
quately exhibited and published. Finally, Demuth's protean range of subjects
made it difficult to neatly categorize his art. Few seemed to realize that he
worked in the manner of a writer, adopting different "voices" for different
characters. Concerned less with the evolution of a single style than with
the pictorial transmission of ideas, he developed discrete vocabularies for
different subjects.

110. **Yellow Calla Lily Leaves,**
c. 1925
Watercolor and pencil on
paper, 20⅛ x 13¹⁵⁄₁₆ in. (51.1 x
35.4 cm)
Yale University Art Gallery,
New Haven; Gift of Philip
L. Goodwin, B.A. 1907

Today, all of these obstacles to a full understanding of Demuth's achievement have been removed. We are now in an age when refinement and elegance are no longer seen as incompatible with strength; when watercolor has achieved the status of a major medium; when conceptual issues are considered relevant to pictorial statement; and when figurative expressionism is once again a legitimate area of exploration. In such a climate, the undeniable beauty as well as the haunting poignancy and emotional richness of Demuth's art can at last be properly appreciated.

Notes

1. In 1925 Demuth reworked an architectural painting, *From the Garden of the Château* (Pl. 69), which he had begun in 1921.

2. Charles Demuth, "A Foreword: Peggy Bacon," in *Peggy Bacon Exhibition*, exhibition brochure (New York: The Intimate Gallery, 1928).

3. Ibid.

4. First quote, Demuth to Alfred Stieglitz, December 12, 1929, Stieglitz Collection, Collection of American Literature, Beinecke Rare Book and Manuscript Library, Yale University, New Haven (hereafter cited as Yale); second quote, Demuth to Stieglitz, October 12, 1930, Yale.

5. Demuth to Stieglitz, August 6, 1928, Yale.

6. For the full text of the quoted passage, see pp. 41–42.

7. *My Egypt* is comprehensively discussed in Karal Ann Marling, "My Egypt: The Irony of the American Dream," *Winterthur Portfolio*, 15 (Spring 1980), pp. 25–39. Marling's proposition that the grain elevator represents a barrier between the machine and the pastoral and that "Demuth is, perhaps, our greatest painterly prophet of the great American dream of the redemptive quest westward, an artistic pilgrim in search of the Terra Bimene of eternal regeneration" (p. 39) is belied by Demuth's total disinterest in the rural landscape or the frontier. Never having gone west of Lancaster, he had no relationship with those who saw the grain elevators as "symbols of life on the Great Plains (p. 37)."

8. Lewis Mumford, "Beauty and the Industrial Beast," *The New Republic*, June 6, 1923; quoted in Karal Ann Marling, "My Egypt," p. 37.

9. Amédée Ozenfant, transcript of "Charles Demuth," radio talk delivered on *Voice of America*, April 19, 1950, p. 5, Whitney Museum of American Art archives, New York.

10. Demuth to Stieglitz, June 4, 1928, Yale.

11. Demuth to Stieglitz, June 4, 1923, Yale.

12. Demuth to Stieglitz, September 4, 1923, Yale.

13. Demuth to Stieglitz, July 1927, Yale.

14. Demuth to Stieglitz, August 15, 1927, Yale.

15. Charles Demuth, "Across a Greco Is Written," *Creative Art*, 5 (September 1929), p. 629.

16. Ibid., pp. 629, 634.

17. Ibid., p. 634.

18. Charles Demuth, in *Georgia O'Keeffe Paintings, 1926*, exhibition brochure (New York: The Intimate Gallery, 1927).

19. Demuth to Stieglitz, August 6, 1928, Yale.

20. Farnham, *Charles Demuth: Behind a Laughing Mask* (Norman, Oklahoma: University of Oklahoma Press, 1971), p. 67.

21. Demuth to Stieglitz, October 12, 1930, Yale.

22. This typescript is now in the Demuth Papers at Yale along with McAlmon's short story "The Fourth of July," which he had inscribed to Demuth.

23. Robert McAlmon, *Distinguished Air* (Paris: Contact Editions, 1925), p. 15.

24. Dickran Tashjian, *William Carlos Williams and the American Scene 1920–1940* (Berkeley: University of California Press, 1978), p. 71, and Pamela Edwards Allara, "The Water-Color Illustrations of Charles Demuth (Ph.D. dissertation, Johns Hopkins University, Baltimore, 1970), p. 248, incorrectly identified the sculpture as *Madame Pogany*. In fact, it represents the marble version of *Princess X* that was owned by H.R. Roche, an Arensberg regular, until its sale by De Zayas to John Quinn in 1917. A bronze version was owned by Walter Arensberg, who acquired it ca. 1917; see Sidney Geist, *Constantin Brancusi 1876–1957: A Retrospective Exhibition*, exhibition catalogue (New York: The Solomon R. Guggenheim Museum, 1969), p. 79.

25. See Emily Farnham, "Charles Demuth: His Life, Psychology and Works," 3 vols. (Ph.D. dissertation, Ohio State University, Columbus, 1959), II, p. 634.

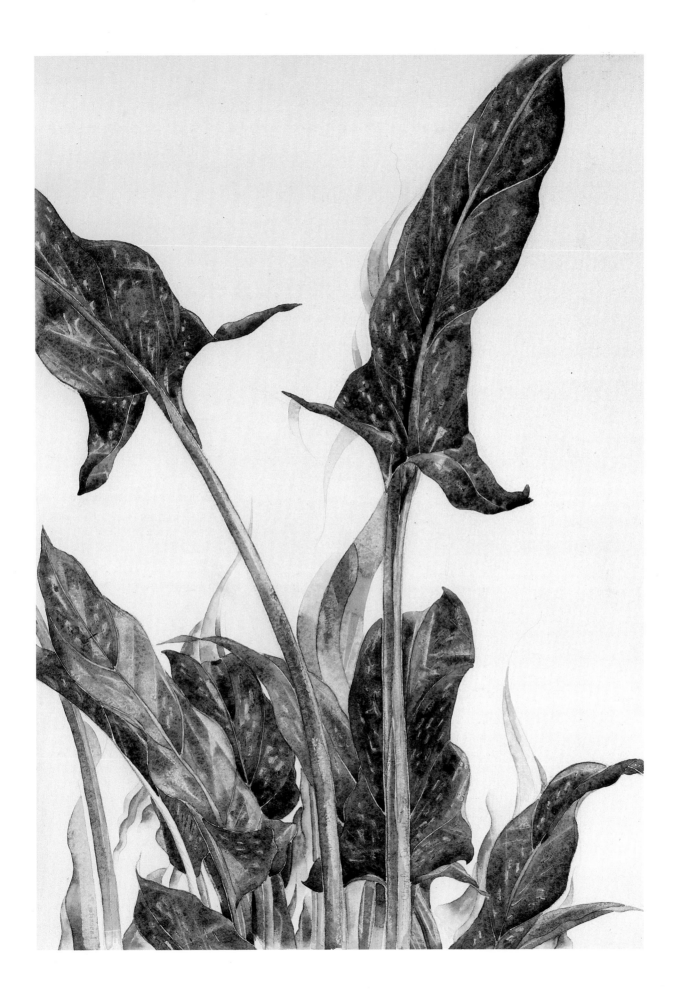

III. **Gladiolus**, 1928
Watercolor on paper, 20 x
14 in. (50.8 x 35.6 cm)
Private collection

Opposite above

112. **Green Pears**, 1929
Watercolor on paper, 13⅝ x
15⅝ in. (34.6 x 39.7 cm)
Yale University Art Gallery,
New Haven; The Philip L.
Goodwin, B.A. 1907, Collec-
tion (Gift of James L. Good-
win, B.A. 1905, Henry Sage
Goodwin, B.A. 1927, and
Richmond L. Brown, B.A.
1907)

Opposite below

113. **Red Cabbages, Rhubarb,
and Orange**, 1929
Watercolor on paper, 14 x
19⅞ in. (35.6 x 50.5 cm)
The Metropolitan Museum of
Art, New York; Alfred
Stieglitz Collection

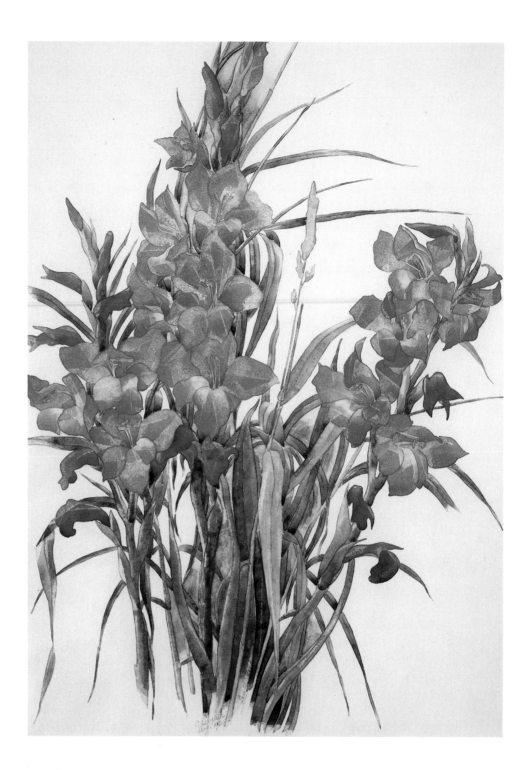

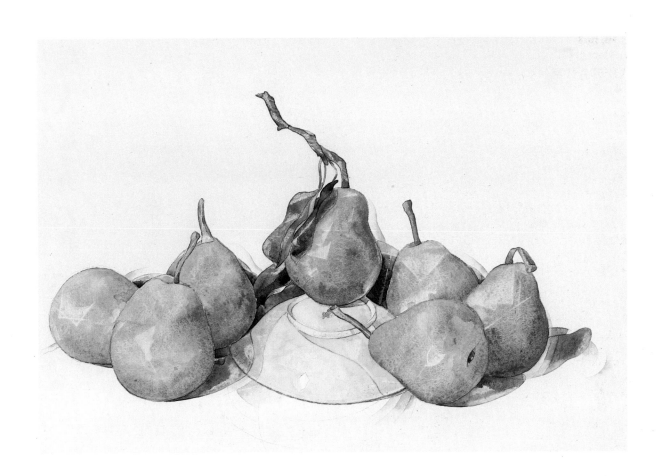

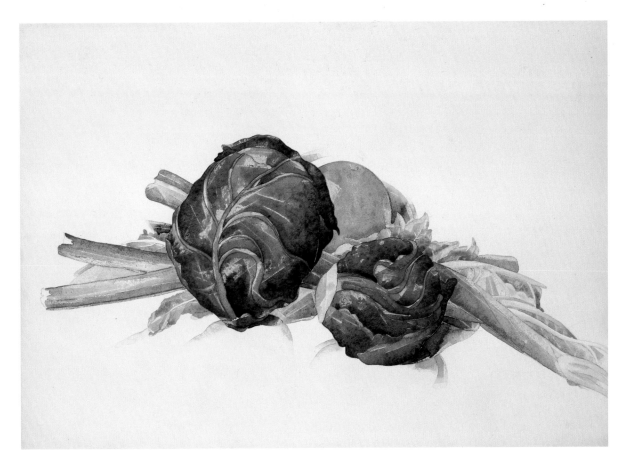

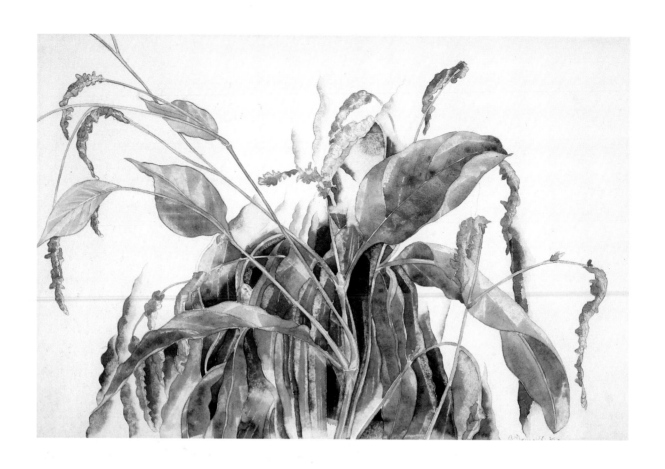

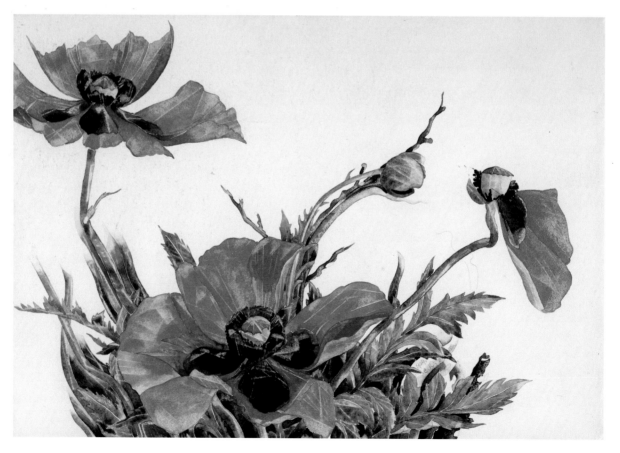

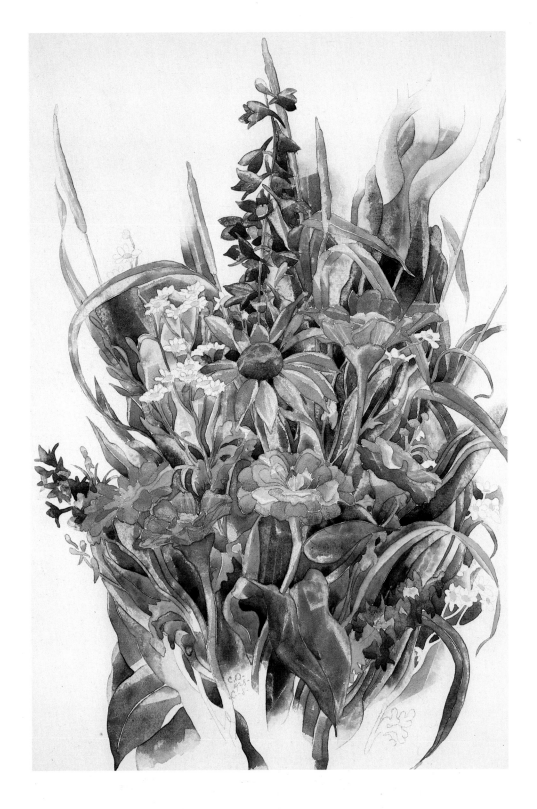

Exhibition History

Compiled by Marilyn Kushner

Exhibitions held after the artist's death in 1935 are selected.
Reviews are listed alphabetically by author or title immediately following each exhibition.

1907 The Pennsylvania Academy of the Fine Arts, Philadelphia. "8th Annual Exhibition of the Fellowship of the Pennsylvania Academy of the Fine Arts." October 28–November 27 (catalogue).

1908 The Pennsylvania Academy of the Fine Arts, Philadelphia. "9th Annual Exhibition of the Fellowship of the Pennsylvania Academy of the Fine Arts and Philadelphia Watercolor Club." October 19–November 9 (catalogue).

1911 The Pennsylvania Academy of the Fine Arts, Philadelphia. "One Hundred and Sixth Annual Exhibition of the Pennsylvania Academy of the Fine Arts." February 5–March 26 (catalogue).

1912 The Pennsylvania Academy of the Fine Arts, Philadelphia. "10th Annual Philadelphia Watercolor Exhibition." November 10–December 15 (catalogue).

The Iris Club and The Lancaster County Historical Society, Woolworth Building, Lancaster, Pennsylvania. "Loan Exhibition of Historical and Contemporary Portraits." November 23–December 13 (catalogue).

1913 The Pennsylvania Academy of the Fine Arts, Philadelphia. "One Hundred and Eighth Annual Exhibition." February 9–March 30 (catalogue).

The Pennsylvania Academy of the Fine Arts, Philadelphia. "11th Annual Philadelphia Watercolor Exhibition & 12th Annual Exhibition of Miniatures." November 9–December 14 (catalogue).

1914 Daniel Gallery, New York. "Watercolors by Charles Demuth." October–November.

> "Art at Home and Abroad: News and Comment, At the Daniel Gallery."
> *The New York Times*, November 1, 1914, section 5, p. 11.
>
> "Art Notes." *New York Post*, October 24, 1914, n.p.
>
> "Art Notes." *New York Post*, October 31, 1914, p. 9.
>
> "Art of Painter, Etcher & Sculptor Fills the Galleries." *New York Herald*, October 26, 1914, p. 6.
>
> Cole, Robert J. "Studio and Gallery." *The New York Evening Sun*, October 30, 1914, p. 13.
>
> McBride, Henry. "What Is Happening in the World of Art." *The New York Sun*, November 1, 1914, section 6, p. 5. Reprinted in Daniel Catton Rich, ed. *The Flow of Art: Essays and Criticisms of Henry McBride*. New York: Atheneum Publishers, 1975, pp. 69–70.
>
> "To Sell Pictures for War Victims." *The Philadelphia Inquirer*, November 1, 1914, section 2, p. 2.

The Pennsylvania Academy of the Fine Arts, Philadelphia. "12th Annual Philadelphia Watercolor Exhibition & 13th Annual Exhibition of Miniatures." November 8–December 13 (catalogue).

1915 Daniel Gallery, New York. "Watercolors by Charles Demuth." October 30–November 9.

"Art and Artists." *The* [New York] *Globe and Commercial Advertiser*, October 29, 1915, p. 10.

"Artist Finds Portugal in This Country." *New York Herald*, November 4, 1915, p. 12.

"Art Notes." *The* [New York] *Evening Post*, October 30, 1915, p. 7.

Eddy, Frederick W. "News of the Art World." *The* [New York] *World*, October 21, 1915, section 2, p. 3.

"New Art at the Daniel Gallery." *The New York Times*, October 24, 1915, section 4, p. 22.

"Paintings by Mr. Demuth and Others at the Daniel Galleries." *The New York Times Magazine*, October 31, 1915, p. 22.

"What Is Happening in the World of Art." *The New York Sun*, October 31, 1915, section 3, p. 8.

The Pennsylvania Academy of the Fine Arts, Philadelphia. "13th Annual Philadelphia Watercolor Exhibition & 14th Annual Exhibition of Miniatures." November 7–December 12 (catalogue).

1916 The Pennsylvania Academy of the Fine Arts, Philadelphia. "14th Annual Philadelphia Watercolor Exhibition & 15th Annual Exhibition of Miniatures." November 5–December 10 (catalogue).

Daniel Gallery, New York. "Watercolors by Charles Demuth." December.

"Art Notes." *New York Post*, December 4, 1916, p. 9.

Eddy, Frederick W. "News of the Art World." *The* [New York] *World*, December 3, 1916, Editorial section, p. 6.

Kobbe, Gustav. "Art Season Forging Ahead—Exhibitions in Galleries, Museums, Studios. . . ." *New York Herald*, December 3, 1916, section 3, p. 7.

McBride, Henry. "News and Comment in the World of Art." *The New York Sun*, December 3, 1916, section 5, p. 12.

1917 Gamut Club, New York. "An Exhibition of Futurist Paintings by American Artists." February.

Society of Independent Artists, Grand Central Palace, New York. "First Annual Exhibition." April 10–May 6 (checklist).

Coady, R[obert] J. "The Indeps." *The Soil*, 1 (July 1917), pp. 202–11.

Daniel Gallery, New York. "Opening Exhibition of Modern Americans." October.

"A New Exhibition at Daniel Galleries." *The Brooklyn Daily Eagle*, October 21, 1917, p. 8.

Daniel Gallery, New York. "Watercolors by Charles Demuth & Oils by Edward Fiske." November–December.

"Art and Artists." *The* [New York] *Globe and Commercial Advertiser*, November 30, 1917, p. 12.

"Art Notes: Demuth and Fiske." *The New York Times*, November 27, 1917, p. 12.

Eddy, Frederick W. "News of the Art World." *The* [New York] *World*, November 25, 1917, Editorial section, p. 5.

Kobbe, Gustav. "Many Novelties in Art Will Mark Exhibitions in the Galleries." *New York Herald*, December 2, 1917, section 3, p. 10.

Nelson, H.C. "Art and Artists." *The* [New York] *Globe and Commercial Advertiser*, November 30, 1917, p. 12.

Wright, Willard Huntington. "Modern Art: Four Exhibitions of the New Style of Painting." *International Studio*, 60 (January 1918), pp. 97–98.

The Pennsylvania Academy of the Fine Arts, Philadelphia. "15th Annual Philadelphia Watercolor Exhibition & 16th Annual Exhibition of Miniatures." November 4–December 9 (catalogue).

1918 The Penguin Club, New York. "Exhibition Contemporary Art." Opened March 16 (brochure; checklist).

Eddy, Frederick W. "News of the Art World." *The* [New York] *World*, March 24, 1918, Editorial section, p. 5.

Daniel Gallery, New York. "Exhibition of Watercolors and Drawings by Charles Demuth." November–December.

"Art Notes." *The* [New York] *World*, December 1, 1918, Editorial section, p. 7.

"Cubism Has Share in Demuth Exhibit." *The New York Sun*, December 1, 1918, p. 11.

du Bois, Guy Pène. "Among the Art Galleries." *The* [New York] *Evening Post Magazine*, December 7, 1918, p. 21.

"Exhibitions of Paintings in Great Variety: Art at Home and Abroad." *The New York Times*, December 1, 1918, section 7, p. 11.

"Mr. Demuth Makes Sketches of Ghosts." *New York Herald*, December 8, 1918, section 3, p. 9.

1919 Daniel Gallery, New York. "Annual Watercolor Exhibition by Modern Americans." April.

du Bois, Guy Pène. "Among the Art Galleries." *The* [New York] *Evening Post Magazine*, April 12, 1919, p. 7.

———. "Among the Art Galleries." *The* [New York] *Evening Post Magazine*, April 26, 1919, pp. 7, 11.

Field, Hamilton Easter. "News, Views and Reviews in the World of Art." *The Brooklyn Daily Eagle*, April 6, 1919, Magazine section, p. 10.

The Penguin Club, New York. "Exhibition of Paintings, Sculpture, Etc. by a Temporary Group." Opened April 5 (brochure; checklist).

du Bois, Guy Pène. "Among the Art Galleries." *The* [New York] *Evening Post Magazine*, April 12, 1919, p. 7.

Gregg, Frederick James. "New York's Art Galleries: Sculptors Have the Best of It at the Penguin Show." *New York Herald*, April 13, 1919, section 3, p. 8.

"Random Impressions in Current Exhibitions." *New York Tribune*, April 13, 1919, section 4, p. 9.

The Pennsylvania Academy of the Fine Arts, Philadelphia. "17th Annual Philadelphia Watercolor Exhibition & 18th Annual Exhibition of Miniatures." November 9–December 14 (catalogue).

Daniel Gallery, New York. "Watercolors by Demuth, Marin, Morton, Zorach and Zarrow." 1919.

1920 Museum of History, Science and Art, Los Angeles. "Exhibition of Paintings by American Modernists." February 1–29 (catalogue, with text by Stanton Macdonald-Wright).

The Pennsylvania Academy of the Fine Arts, Philadelphia. "18th Annual Philadelphia Watercolor Exhibition & 19th Annual Exhibition of Miniatures." November 7–December 12 (catalogue).

Daniel Gallery, New York. "Paintings by Charles Demuth." December.

> Field, Hamilton Easter. "Comment on the Arts." *The Arts*, 1 (January 1921), pp. 29–31.
>
> McBride, Henry. "Charles Demuth Displays His Beautiful Landscapes at Daniel's." *New York Herald*, December 5, 1920, section 3, p. 9.
>
> Watson, Forbes. "At the Galleries." *Arts & Decoration*, 14 (January 1921), p. 230.
>
> "The World of Art: Russian and American Paintings and a Group of Etchings." *The New York Times*, December 19, 1920, Magazine section, p. 20.

Syracuse Museum of Fine Arts, New York. "Water Colors by a Group of American Artists." December (brochure).

1921 Memorial Art Gallery, Rochester, New York. "Watercolors by Nine American Artists." January (catalogue).

The Buffalo Fine Arts Academy, Albright Art Gallery, New York. "An Exhibition of Water Colors by American Artists." March 4–28 (brochure; checklist).

The Detroit Institute of Arts. "Exhibition of Water Colors by American Artists." April 1–18 (brochure; checklist). Traveled to the Milwaukee Art Institute.

> K., J. "Vanguard of Modernists Is on Hand." *The Milwaukee Journal*, June 12, 1921.
>
> Prence, Judith. "Art Institute Showings." [Milwaukee] *Wisconsin News*, June 12, 1921.

Dallas Art Association. "2nd Annual Exhibition of American and European Art." April 7–21 (catalogue, with text by Forbes Watson).

The Art Institute of Chicago. "First Annual International Exhibition of Watercolors." April 15–May 15 (brochure; checklist).

The Pennsylvania Academy of the Fine Arts, Philadelphia. "Exhibition of Paintings and Drawings Showing the Later Tendencies in Art." April 16–May 15 (catalogue).

Junior Art Patrons, Fine Arts Building, New York. "First Retrospective Exhibition of American Art under the Auspices of Junior Art Patrons." May 6–21.

Daniel Gallery, New York. Group of modern paintings. November.

> "Studio and Gallery." *The New York Sun*, November 5, 1921, p. 9.

The Brooklyn Museum, New York. "Water Color Paintings by American Artists." November 7–December 18 (catalogue).

> Seligmann, Herbert J. "American Water-Colours in Brooklyn." *International Studio*, 74 (December 1921), pp. clviii–clx.
>
> Strand, Paul. "American Watercolors at the Brooklyn Museum." *The Arts*, 2 (January 20, 1922), pp. 148–52.

1922 Wanamaker Gallery of Modern Decorative Art, New York. "Black and White: Drawings by American Artists." May 4–31 (brochure; checklist).

Daniel Gallery, New York. "Opening Exhibition 1922–1923." Closed November 27 (brochure; checklist).

Dallas Art Association. "Third Annual Exhibition: American Art, from the Days of the Colonists to Now." November 16–30 (catalogue).

1923 The Baltimore Museum of Art. "Inaugural Exhibition." February 21–April 1 (brochure, with text by Florence N. Levy; checklist).

Daniel Gallery, New York. "Watercolors by Charles Demuth." November–December.

"American Art." *New York Tribune*, December 2, 1923, section 6, p. 7.

"American Note in Demuth's Art: Water Colors of Rare Distinction Displayed at Daniel's." *The* [New York] *World*, December 2, 1923, Editorial section, p. 8.

Breuning, Margaret. "Water Colors Popular in Art Exhibitions." *New York Evening Post,* December 1, 1923, p. 11.

" . . . Interestingly Personal Display at the Wildenstein Galleries—Notes Elsewhere." *The* [New York] *Sun and the Globe*, December 13, 1923, p. 24.

McBride, Henry. "Works of Charles Demuth Shown in Daniel Galleries." *New York Herald*, December 2, 1923, section 8, p. 7.

Galeries Durand-Ruel, Paris. "Exposition de tableaux par Charles Demuth, Walt Kuhn, H.E. Scha-ckenberg [*sic*], Charles Sheeler, Eugene Speicher, Allen Tucker, Nan Watson." November 12–December 1 (checklist). Traveled to the Whitney Studio, New York.

G[eorge], W[aldemar]. "Les Expositions." *L'Amour de l'art*, 4 (November 1923), pp. 762–65.

"Some French Critics Voice Opinion on American Art." *New York Evening Post*, February 2, 1924, section 1, p. 15.

"Whitney Studio and Club." *The New York Times*, January 27, 1924, section 7, p. 12.

1924 Whitney Studio, New York. "Exhibition by Charles Demuth, Walt Kuhn, Henry Schnakenberg, Charles Sheeler, Eugene Speicher, Allen Tucker, Nan Watson." January 23–February 2 (checklist).

"Art Exhibitions of the Week: Whitney Studio and Club." *The New York Times,* January 27, 1924, section 7, p. 12.

Boswell, Peyton. "American Art Is Exhibited in a 'Rebound.'" *New York American,* January 27, 1924, section 7, p. 11.

The Montross Gallery, New York. "Original Paintings, Drawings, and Engravings Being Exhibited with The Dial Folio/The Living Art." January 26–February 14 (checklist).

Worcester Art Museum, Massachusetts. "Exhibition of the Dial Collection of Paintings, Engravings, and Drawings by Contemporary Artists." March 5–30 (brochure, with text by Raymond Henniker-Heaton; checklist).

The Brooklyn Museum, New York. "Centennial of the Brooklyn Institute of Arts and Sciences." Opened November 20 (brochure, with text by W.H.F.; checklist).

1925 The Cleveland Museum of Art. "Second Exhibition: Water Colors and Pastels." January 15–February 15 (checklist).

Anderson Galleries, New York. "Alfred Stieglitz Presents Seven Americans." March 9–28 (catalogue, with texts by Sherwood Anderson, Arthur Dove, Arnold Rönnebeck, and Alfred Stieglitz).

"Art: Exhibitions of the Week, Seven Americans." *The New York Times*, March 15, 1925, section 8, p. 11.

Breuning, Margaret. "Seven Americans." *New York Evening Post*, March 14, 1925, section 5, p. 11.

Cortissoz, Royal. "291, Mr. Alfred Stieglitz and His Services to Art." *New York Herald Tribune*, March 15, 1925, section 4, p. 12.

Fulton, Deogh. "Cabbages and Kings." *International Studio*, 81 (May 1925), pp. 144–47.

Mullin, Glen. "Alfred Stieglitz Presents Seven Americans." *The Nation*, 120 (May 20, 1925), pp. 577–78.

Read, Helen Appleton. "New York Exhibitions: Seven Americans." *The Arts*, 7 (April 1925), pp. 229, 231.

Watson, Forbes. "Seven American Artists Sponsored by Stieglitz." *The* [New York] *World*, March 15, 1925, section 3, p. 5.

The Brooklyn Museum, New York. "A Group Exhibition of Water Color, Paintings, Pastels and Drawings by American & European Artists." April 14–May 10 (catalogue).

Read, Helen Appleton. "Three Exhibitions in One at the Brooklyn Museum." *The Brooklyn Daily Eagle*, April 19, 1926, p. 2.

Art Alliance, New York. "5th Annual Exhibition." October.

1926 The Cleveland Museum of Art. "Third Exhibition: Water Colors and Pastels." January 12–February 14 (checklist).

Wildenstein Galleries, New York. "Exhibition of Tri-National Art—French, British, & American." January 26–February 17 (catalogue, with text by Roger Fry).

Daniel Gallery, New York. Group exhibition. April.

Breuning, Margaret. "April in the New York Art Galleries—Some of the Exhibitions. . . ." *New York Evening Post*, April 17, 1926, section 5, p. 9.

The Montross Gallery, New York. Exhibition of a selected group of American watercolors. April.

Breuning, Margaret. "April in the New York Art Galleries—Some of the Exhibitions. . . ." *New York Evening Post*, April 17, 1926, section 5, p. 9.

The Intimate Gallery, New York. "Recent Paintings by Charles Demuth." April 5–May 2.

"Charles Demuth—Intimate Gallery." *Art News*, 24 (April 10, 1926), p. 7.

Cortissoz, Royal. "Works by Americans and by Old Masters." *New York Herald Tribune*, April 18, 1926, section 6, p. 10.

Kalonyme, Louis. "The Art Makers." *Arts & Decoration*, 26 (December 1926), p. 63.

McBride, Henry. "Charles Demuth's Cerebral Art." *The New York Sun*, April 10, 1926, p. 6. Reprinted in Daniel Catton Rich, ed. *The Flow of Art: Essays and Criticisms of Henry McBride*. New York: Atheneum Publishers, 1975, pp. 217–19.

"New Association Formed by Progressive Women Artists Will Open First Annual Exhibition April 20—Notes on Other Shows." *The* [New York] *World*, April 18, 1926, Metropolitan section, p. 8.

Boston Art Club. "Boston Art Club Exhibition." October.

The Pennsylvania Academy of the Fine Arts, Philadelphia. "24th Annual Philadelphia Watercolor Exhibition & 25th Annual Exhibition of Miniatures." November 7–December 12 (catalogue).

The Brooklyn Museum, New York. "An International Exhibition of Modern Art Assembled by the Société Anonyme." November 19, 1926–January 9, 1927 (catalogue, with text by Katherine S. Dreier). Traveled to Anderson Galleries, New York; Albright Art Gallery, Buffalo; Toronto Art Gallery, Ontario.

Breuning, Margaret. "News and Comment on Current Exhibitions in Local Art Galleries." *New York Evening Post*, November 27, 1926, section 5, p. 12.

McBride, Henry. "Brooklyn Museum Indulges in Most Modern of Art Displays, Mirroring the Time." *The New York Sun*, November 27, 1926, p. 5.

Read, Helen Appleton. "Modern Art of 22 Nations Shown at Brooklyn Museum." *The Brooklyn Daily Eagle*, November 21, 1926, section E, p. 6.

1927 Galerie Bernheim-Jeune, Paris. "Multi-National Exhibition." January.

Whitney Studio Club, New York. "Paintings and Drawings of Women by Men." January 5–22 (catalogue).

The Cleveland Museum of Art. "Fourth Exhibition: Water Colors and Pastels." January 17–March 14 (checklist).

The Intimate Gallery, New York. "Charles Demuth." April 5–May 2.

Kraushaar Galleries, New York. "Exhibition of Watercolors." December 3–24 (brochure; checklist).

Gallery of Living Art, New York University. "Opening Exhibition." December 13, 1927–January 25, 1928 (brochure; checklist).

McBride, Henry. "A Beginning at the N.Y.U." *The New York Sun*, December 17, 1927, p. 24.

1928 The Cleveland Museum of Art. "Fifth Exhibition of Water Colors and Pastels." March 7–April 10 (checklist).

The Art Institute of Chicago. "The Eighth International Exhibition of Watercolors, Pastels, Drawings & Miniatures." March 24–May 6 (catalogue).

The Intimate Gallery, New York. "Charles Demuth." April 5–May 2.

Phillips Memorial Gallery, Washington, D.C. "Paintings in Water Color by Sixteen American Artists." May (brochure; checklist).

Wadsworth Atheneum, Hartford, Connecticut. "A Loan Exhibition of Modern American Watercolors." June.

"Loan Exhibition of Contemporary American Watercolors." *Bulletin of the Wadsworth Atheneum*, 6 (July 1928), pp. 21–23.

Carnegie Institute, Pittsburgh. "Twenty-seventh Annual International Exhibition of Paintings." October 18–December 9 (catalogue).

The Pennsylvania Academy of the Fine Arts, Philadelphia. "26th Annual Philadelphia Watercolor Exhibition & 27th Annual Exhibition of Miniatures." November 4–December 9 (catalogue).

1929 The Harvard Society for Contemporary Art, Cambridge, Massachusetts. "An Exhibition of American Art." February 19–March 15 (brochure; checklist).

Museum of Fine Arts, Boston. "Exhibition of Watercolors by European & American Artists." February 26–April 14 (brochure; checklist).

The Cleveland Museum of Art. "Sixth Exhibition: Water Colors and Pastels." March 24–April 10 (checklist).

Whitney Studio Galleries, New York. "The Circus in Paint." April (brochure, with text by Lloyd Goodrich; checklist).

"The Art Galleries." *The New Yorker*, 5 (April 13, 1929), p. 93.

Arts Council of the City of New York, Grand Central Palace. "One Hundred Important Paintings by Living American Artists." April 15–27 (catalogue, with text by F[lorence] N. L[evy]).

The Intimate Gallery, New York. "Charles Demuth: Five Paintings." April 29–May 18 (brochure; checklist).

Breuning, Margaret. "Group Exhibitions Feature the Week and Indicate Closing of Art Season . . . Other Notes." *New York Evening Post*, May 11, 1929, section 4, p. 5.

"Charles Demuth—Intimate Gallery." *Art News*, 27 (May 4, 1929), p. 14.

Cortissoz, Royal. "Some Incidents of a Waning Season, Three Exhibitions." *New York Herald Tribune*, May 5, 1929, section 7, p. 10.

"'The Figure 5 in Gold': Strange New Painting in Oil by Demuth at Intimate Gallery." *The New York Sun*, May 4, 1929, p. 11.

"In His Intimate Gallery Mr. Stieglitz. . . ." *The Art Digest*, May 1, 1929, pp. 17–18.

"Paintings by Demuth." *The New York Times*, May 5, 1929, section 9, p. 10.

Daniel Gallery, New York. Summer exhibition. May.

Milwaukee Art Institute. "Exhibition of Paintings by Contemporary American Artists." May.

K.,J. "Vanguard of Modernists Is on Hand." *The Milwaukee Journal*, June 12, 1929, p. 3.

Prence, Judith. "Art Institute Showings." [Milwaukee] *Wisconsin News*, June 12, 1929.

Municipal Art Gallery, Atlantic City, New Jersey. "Contemporary American Art." June 19–October 1 (catalogue, with text by Holger Cahill and Louis E. Stern).

The Museum of Modern Art, New York. "Paintings by Nineteen Living Americans." December 13, 1929—January 12, 1930 (catalogue, with text by A[lfred] H. B[arr], Jr.).

Breuning, Margaret. "Museum of Modern Art Holds Exhibition of Work of American Artists." *New York Evening Post*, December 14, 1929, section 3, p. 7.

Cortissoz, Royal. "Another Show at the Modern Museum." *New York Herald Tribune*, December 15, 1929, section 8, p. 9.

Jewell, Edward Alden. "Modern Art Museum—Art Twixt Covers." *The New York Times*, December 22, 1929, section 7, p. 14.

"Modern Museum Opens American Exhibition." *Art News*, 28 (December 14, 1929), pp. 3–4, 6.

Watson, Forbes. "The All American Nineteen." *The Arts*, 16 (January 1930), pp. 301–11.

Little Gallery of Contemporary Art, Philadelphia. Work by John Marin, Charles Demuth, and Thomas Benton. 1929.

1930 The Newark Museum, New Jersey. "Modern American Water Colors." January 4–February 9.

Cary, Elisabeth Luther. "American Art in Newark—A Still Life Refuge." *The New York Times*, January 19, 1930, section 8, p. 12.

"Water Color Show at Newark Museum." *Art News*, 18 (December 28, 1929), p. 18.

"Water Colors at Newark Museum." *Art News*, 18 (January 18, 1930), p. 19.

Phillips Memorial Gallery, Washington, D.C. "An Exhibition of a Group of Lyric Painters." February–March (brochure, with text by Duncan Phillips; checklist).

Whitney Studio Galleries, New York. "Whitney Studio Gallery Flower Exhibition." March 17–29 (catalogue, with text by Lloyd Goodrich).

> "Whitney Shows Forty Colorful Flower Pieces." *New York American*, March 23, 1930, section M, p. 14.

The Art Institute of Chicago. "The Tenth International Exhibition of Watercolors, Pastels, Drawings & Miniatures." March 20–April 20 (catalogue). Traveled to the Milwaukee Art Institute.

An American Place, New York. "Retrospective Exhibition of the Work of O'Keeffe, Demuth, Marin, Hartley, and Dove." May.

> "Attractions in the Galleries." *The New York Sun*, May 3, 1930, p. 8.

Cincinnati Art Museum. "The Thirty-Seventh Annual Exhibition of American Art." June 1–29 (catalogue, with text by Walter Siple).

The Museum of Modern Art, New York. "Summer Exhibition: Retrospective." June 15–September.

The Cleveland Museum of Art. "Tenth Exhibition of Contemporary American Oils." Opened June 16 (checklist).

1931 California Palace of the Legion of Honor, San Francisco. "Exhibition of International Watercolors." January (checklist).

Columbus Gallery of Fine Arts, Ohio. "Inaugural Exhibition." January–February (checklist).

Albany Institute of History and Art, New York. "Exhibition of Watercolours by John Singer Sargent, Winslow Homer, Dodge Macknight and Charles Demuth." January 3–30.

The Downtown Gallery, New York. "Masters of Watercolor." March 16–30 (brochure, with text by Holger Cahill; checklist).

> "Seven Masters of Water Color—The Downtown Gallery." *Art News*, 29 (March 28, 1931), p. 12.

An American Place, New York. "Paintings by Charles Demuth." April.

> Breuning, Margaret. "Demuth at American Place." *New York Evening Post*, May 2, 1931, section 4, p. 5.
>
> "Charles Demuth." *New York Herald Tribune*, April 26, 1931, section 7, p. 8.
>
> "Demuth Water Colors on View." *The New York Sun*, April 18, 1931, p. 8.
>
> "Exhibitions in New York: Charles Demuth—An American Place." *Art News*, 29 (April 18, 1931), p. 10.
>
> Hagen, Angela E. "Around the Galleries—Demuth Watercolors and Oils at 'An American Place.'" *Creative Art*, 8 (June 1931), pp. 441–43.
>
> Harris, Ruth Green. "Demuth." *The New York Times*, April 19, 1931, section 9, p. 18.
>
> Jewell, Edward Alden. "Demuth's Retrospective Show." *The New York Times*, April 14, 1931, p. 32.
>
> Rosenfeld, Paul. "Art—Charles Demuth." *The Nation*, 133 (October 7, 1931), pp. 371–73.
>
> Schnakenberg, H[enry] E. "Exhibitions—Charles Demuth." *The Arts*, 17 (May 1931), p. 581.

The Art Institute of Chicago. "The Eleventh International Exhibition of Water Colors, Pastels, Drawings, Monotypes, and Miniatures." April 30–May 31 (catalogue).

An American Place, New York. "Group Show (Impromptu Exhibition of Selected Paintings): Marin, Hartley, O'Keeffe, Dove, Demuth." May.

Cincinnati Art Museum. "The Thirty-Eighth Annual Exhibition of American Art." June 5–28 (catalogue, with text by Walter Siple).

California Palace of the Legion of Honor, San Francisco. "Exhibition of Flower Paintings from the Seventeenth Century to the Present Day." June 15–July 15 (brochure; checklist).

Whitney Museum of American Art, New York. "Opening Exhibition—Part 1 of the Permanent Collection: Painting and Sculpture." November 18, 1931–January 2, 1932 (catalogue, with text by Herman More).

Westchester Workshop, Westchester County Center, White Plains, New York. "Exhibition of 26 Paintings by 26 American Artists: Artists from the Collection of Morton R. Goldsmith." December 21, 1931–January 16, 1932 (brochure; checklist).

1932 The Cleveland Museum of Art. "Ninth Exhibition: Water Colors and Pastels." January 13–February 14 (checklist).

Whitney Museum of American Art, New York. "Exhibition of the American Society of Painters, Sculptors and Graveurs." February 6–28 (catalogue).

The Art Institute of Chicago. "The Twelfth Annual International Watercolor Exhibition." March 31–May 30 (catalogue).

Newhouse Galleries, New York. "Americontempo: An Exhibition of the Works of a Selected Group of American Moderns." April 4–25 (brochure, with text by Edward Alden Jewell; checklist).

Cincinnati Art Museum. "The Thirty-Ninth Annual Exhibition of American Art." April 30–May 29 (catalogue, with text by Walter Siple).

Mellon Galleries, Philadelphia. "Exhibition: Major Works by Distinguished American Artists." May 3–18 (checklist).

Whitney Museum of American Art, New York. "Summer Exhibition: A Selection of Paintings, Drawings and Prints from the Permanent Collection." Opened May 3 (catalogue).

An American Place, New York. "Impromptu Exhibition of Selected Paintings: Dove, Demuth, Marin, O'Keeffe, Hartley." May 16–June 14.

> "Attractions in the Galleries." *The New York Sun*, May 21, 1932, p. 9.

> Jewell, Edward Alden. "Works by Five Artists Shown." *The New York Times*, May 20, 1932, p. 17.

The Downtown Gallery, New York. Paintings and sculpture for $100 by well-known American artists. May 29–July 1.

Little Gallery of Contemporary Art, Philadelphia. Exhibition. October.

The Museum of Modern Art, New York. "American Paintings & Sculpture (1862–1932)." October 31, 1932–January 31, 1933 (catalogue).

Whitney Museum of American Art, New York. "First Biennial Exhibition of Contemporary American Painting." November 22, 1932–January 5, 1933 (catalogue, with text by Juliana Force).

> Grafly, Dorothy. "The Whitney Museum's Biennial." *The American Magazine of Art*, 26 (January 1933), pp. 5–12.

1933 Whitney Museum of American Art, New York. "Exhibition of 1932 Acquisitions." Opened January 10 (checklist).

The Cleveland Museum of Art. "Tenth Exhibition: Water Colors and Pastels." January 11–February 12 (checklist).

The Society of Arts and Crafts, Detroit. "European and American Watercolors and Drawings of the 19th and 20th Centuries." February 15–March 11 (checklist).

The Museum of Modern Art, New York. "Fruit and Flower Paintings." May 13–31.

> Watson, Forbes. "Gallery Explorations—Fruits and Flowers at the Modern Museum." *Parnassus*, 5 (April 1933), p. 5.

Addison Gallery of American Art, Phillips Academy, Andover, Massachusetts. "Water Colors by 12 Americans." May 22–June 26 (brochure; checklist).

The Downtown Gallery, New York. "Paintings and Sculpture: Recent Works by Leading American Contemporaries at $100." May 23–June 30 (brochure).

The Art Institute of Chicago. "A Century of Progress: Exhibition of Paintings and Sculpture." June 1–November 1 (catalogue).

The Cleveland Museum of Art. "The Thirteenth Exhibition of Contemporary American Oils." June 16–July 16 (checklist).

Art Association of Newport, Rhode Island. "Exhibition of Paintings and Prints from the Whitney Museum of American Art." August 5–September 5 (brochure; checklist).

The Pennsylvania Academy of the Fine Arts, Philadelphia. "The 31st Annual Water Color Exhibition & the 32nd Annual Exhibition of Miniatures." November 5–December 10 (catalogue).

Worcester Art Museum, Massachusetts. "Exhibition of American Painting of To-Day." December 1, 1933–January 15, 1934 (catalogue, with text by Francis Henry Taylor).

Whitney Museum of American Art, New York. "1st Biennial Exhibition of Contemporary American Sculpture, Watercolors and Prints." December 5, 1933–January 11, 1934 (catalogue).

William Rockhill Nelson Gallery of Art, Mary Atkins Museum of Fine Arts, Kansas City, Missouri. "Inaugural Exhibition." December 10, 1933–February 1934.

1934 The Forum, RCA Building, Rockefeller Center, New York. "First Municipal Art Exhibition." February 28–March 31 (catalogue, with text by Holger Cahill).

> Klein, Jerome. "The Art Week in Manhattan Galleries." *The* [Baltimore] *Sun*, March 11, 1934, section 2, p. 13.

The Art Institute of Chicago. "International Water Color Exhibition." March 29–April 29 (catalogue).

Palazzo dell'Esposizione, Venice. "19th International Biennial Art Exhibition." May 12–October 12 (catalogue, with text by Antonio Mariani).

Smith College Museum of Art, Northampton, Massachusetts. "5 Americans." May 19–June 19 (checklist).

> P., E.H. "American Exhibit at Smith Gallery." *The Springfield* [Massachusetts] *Sunday Union and Republican*, May 20, 1934, section E, p. 6.

> ———. "Water Color Exhibition at Smith College Museum." *The Springfield* [Massachusetts] *Sunday Union and Republican*, May 27, 1934, section E, p. 6.

The Cleveland Museum of Art. "The Fourteenth Exhibition of Contemporary American Oils." June 8–July 8 (checklist).

The Pennsylvania Academy of the Fine Arts, Philadelphia. "The 32nd Annual Water Color Exhibition & the 33rd Annual Exhibition of Miniatures." November 4–December 9 (catalogue).

The Museum of Modern Art, New York. "Modern Works of Art: 5th Anniversary Exhibition." November 20, 1934–January 20, 1935 (catalogue).

Whitney Museum of American Art, New York. "The Second Biennial Exhibition of Contemporary American Art." November 27, 1934–January 10, 1935 (catalogue).

The National Gallery of Canada, Ottawa. "Exhibition of Contemporary Paintings by Artists of the United States." 1934–35 (catalogue).

1935 Wadsworth Atheneum, Hartford, Connecticut. "American Painting and Sculpture of the 18th, 19th & 20th Centuries." January 29–February 19 (catalogue, with text by Henry-Russell Hitchcock, Jr.).

The Brooklyn Museum, New York. "Eighth Biennial Exhibition of Water Colors, Pastels and Drawings by American and Foreign Artists." February 1–28 (catalogue, with text by Herbert B. Tschudy).

Whitney Museum of American Art, New York. "Abstract Painting in America." February 12–March 22 (catalogue, with text by Stuart Davis).

> Morsell, Mary. "Whitney Museum Holds Exhibition of Abstract Art." *Art News*, 33 (February 16, 1935), pp. 3, 13.

The Art Institute of Chicago. "The Fourteenth International Exhibition of Water Colors, Pastels, Drawings and Monotypes." March 21–June 2 (catalogue).

The Corcoran Gallery of Art, Washington, D.C. "The Fourteenth Biennial Exhibition of Contemporary American Oil Paintings." March 24–May 5 (catalogue).

M.H. de Young Memorial Museum, San Francisco. "Exhibition of American Painting from the Beginning to the Present Day." June 7–July 7 (catalogue).

Fine Art Guild, Cambridge, Massachusetts. "Fine Art Guild Exhibition." November 14–December 7.

1936 An American Place, New York. "Exhibition of Paintings: Charles Demuth, Arthur G. Dove, Marsden Hartley, John Marin, Georgia O'Keeffe and New Paintings on Glass by Rebecca S. Strand." November 27–December 31 (brochure). Traveled to University Gallery, University of Minnesota, Minneapolis.

> "Attractions in the Galleries." *The New York Sun*, December 5, 1936, p. 43.

> Devree, Howard. "A Reviewer's Comment." *The New York Times*, December 6, 1936, section 12, p. 14.

> Klein, Jerome. "At An American Place." *New York Post*, December 5, 1936, p. 12.

> L., J. "New Exhibitions of the Week—A Typical Stieglitz American Group." *Art News*, 35 (December 19, 1936), pp. 23–24.

> "Late Oil of Demuth Seen in Art Show." *The New York Times*, November 28, 1936, p. 15.

> "A Note on Charles Demuth." *New York Herald Tribune*, November 29, 1936, section 7, p. 8.

1937 An American Place, New York. "Beginnings and Landmarks: '291' 1905–1917." October 27–December 27 (brochure, with text by Dorothy Norman; checklist).

Whitney Museum of American Art, New York. "Charles Demuth Memorial Exhibition."
December 15, 1937–January 16, 1938 (brochure, with text by Henry McBride; checklist).

Cortissoz, Royal. "The Delicate Art of the Late Chas. Demuth." *New York Herald Tribune*,
December 19, 1937, section 7, p. 8.

Davidson, Martha. "Demuth, Architecture of Painting—The Whitney's Complete Show
Permits a New Appraisal." *Art News*, 36 (December 18, 1937), pp. 7–8.

"Full Memorial of Demuth Art in New York Show." *Boston Transcript*, December 24, 1937,
section 2, p. 4.

Holme, B. "Exhibitions—New York." *The London Studio*, 15 (March 1938), p. 160.

Jewell, Edward Alden. "Demuth at the Whitney." *The New York Times*, December 19, 1937,
section 11, p. 11.

———. "Demuth Paintings on Exhibition Here." *The New York Times*, December 15, 1937, p. 28.

Klein, Jerome. "Precious Accent Features Demuth Art at Whitney." *New York Post*,
December 18, 1937, p. 14.

Lane, James W. "Notes from New York." *Apollo*, 27 (February 1938), pp. 96–97.

McBride, Henry. "Charles Demuth Memorial Show." *The New York Sun*, December 18,
1937, p. 14.

"Whitney Holds Memorial to Charles Demuth." *The Art Digest*, 12 (January 1, 1938), p. 5.

1938 Musée du Jeu de Paume, Paris. "Trois siècles d'art aux Etats-Unis—peinture, sculpture, architecture,
cinéma." May–June (catalogue, with text by Alfred H. Barr, Jr., A. Conger Goodyear, and John Zay).

An American Place, New York. "Demuth Oil and Water-Colors, in the White Room."
December 29, 1938–January 18, 1939.

Burrows, Carlyle. "Notes and Comments on Events in Art." *New York Herald Tribune*,
January 1, 1939, section 6, p. 8.

D[avidson], M[artha]. "New Exhibitions of the Week—Several Demuths. . . ." *Art News*, 37
(January 7, 1939), p. 14.

"A Reviewer's Notebook: Final Week of the Year Brings Forward Papers by Many Water-
Colorists." *The New York Times*, January 1, 1939, section 9, p. 10.

1939 The Society of Arts and Crafts, Detroit. Demuth watercolor exhibition. January 17–31.

Philadelphia Art Alliance. "Marin and Demuth: Wizards of Watercolor." February 14–March 5.

"Art Throughout America—Philadelphia: Marin; Demuth. . . ." *Art News*, 37 (March 4,
1939), p. 17.

"Marin and Demuth Die." *Arts in Philadelphia*, 1 (February 1939), p. 23.

"Marin and Demuth Wizards of Water Color." *The Art Alliance Bulletin*, February 1939, n.p.

1941 Fackenthal Library, Franklin and Marshall College, Lancaster, Pennsylvania. "Memorial Exhibition—
Watercolors by Charles Demuth (1883–1935)." January 20–26.

"Popular Pears." *Lancaster Sunday News*, January 26, 1941.

Cincinnati Art Museum. "A New Realism: Crawford, Demuth, Spencer, Sheeler." March 12–
April 7 (catalogue, with text by Elizabeth Sacartoff and statements by the artists.)

"Cincinnati Faces Life's New Realities." *Art News*, 40 (April 1–14, 1941), pp. 7, 36.

1942 Phillips Memorial Gallery, Washington, D.C. "Charles Demuth: Exhibition of Water Colors and
Oil Paintings." May 3–25 (checklist).

"Art News of America: A Demuth Show in Washington." *Art News*, 41 (May 15–31, 1942), p. 7.

1944 Philadelphia Museum of Art. "History of an American—Alfred Stieglitz: '291' and After." July 1–
November 1 (brochure, with text by Henry Clifford and Carl Zigrosser; checklist).

"Philadelphia Museum Show Honors Alfred Stieglitz." *New York World-Telegram*, July 29,
1944, p. 10.

1945 Dayton Art Institute, Ohio. Paintings by Charles Demuth. February.

"Advertising, Demuth Art Is Exhibited." *Dayton News*, February 11, 1945.

"Demuth Paints Delightfully." *Dayton Journal*, February 18, 1945.

1946 University of Chicago. "Exhibition of Paintings by Maurice Prendergast, with Watercolors by
Charles Demuth and Carl Kabler." January 29–February 28 (brochure; checklist).

Whitney Museum of American Art, New York. "Pioneers of Modern Art in America." April 9–
May 19 (catalogue, with text by Lloyd Goodrich).

Burrows, Carlyle. "Pioneers of Modern Painting: American Artists and Chagall."
New York Herald Tribune, April 14, 1946, section 5, p. 7.

"Paintings Bespeak Faith of Pioneers: Whitney Museum Shows Their Handiwork."
New York World-Telegram, April 13, 1946, p. 11.

Walker Art Center, Minneapolis. "Acuarela—EE. UU., Watercolor—U.S.A., Aquarela—EE. UU."
April 24–May 8 (catalogue). Traveled to Santiago, Chile; Rio de Janeiro, Brazil; Mexico City,
Mexico; Buenos Aires, Argentina; Lima, Peru; São Paulo, Brazil.

The Tate Gallery, London. "American Painting from the Eighteenth Century to the Present Day."
June 15–August 15 (catalogue, with text by John Rothenstein).

1947 The Museum of Modern Art, New York. "Alfred Stieglitz Exhibition: His Collection." June 10–
August 31 (checklist).

Burrows, Carlyle. "Art of the Week—A Notable Display Devoted to Stieglitz."
New York Herald Tribune, June 15, 1947, section 5, p. 6.

"The Stieglitz Collection." *The New York Sun*, June 13, 1947, p. 23.

Coleman Art Gallery, Philadelphia. "Five Prodigal Sons: Former Philadelphia Artists Ralston
Crawford, Stuart Davis, Charles Demuth, Julian Levi, Charles Sheeler." October 4–30 (checklist).

1948 Fackenthal Library, Franklin and Marshall College, Lancaster, Pennsylvania. "Twenty-Nine Water-
colors by Charles Demuth." January 3–11 (brochure; checklist).

"Demuth Exhibit Ends Sunday—Swan's Paintings to Be Shown." *The* [Lancaster] *New Era*, January 10, 1948, p. 14.

Lestz, Gerry. "Arts and Crafts." *The* [Lancaster] *New Era*, January 13, 1948, p. 10.

Venice, Italy. "24th International Biennial Art Exhibition." May 29–September 30 (catalogue, with text by Rudolfo Palluchini).

1949 Albertina, Vienna. "Amerikanische Meister des Aquarelles." Fall (brochure; checklist).

Knoedler Galleries, New York. "To Honor Henry McBride: An Exhibition of Paintings, Drawings, and Water Colours." November 3–December 17 (brochure, with text by Lincoln Kirstein; checklist).

McBride, Henry. "A Critic Confesses." *The New York Sun*, December 2, 1949, p. 29.

1950 Norton Gallery of Art, West Palm Beach. "Masters of Watercolor—Marin, Demuth & Prendergast." February 3–26 (brochure, with text by W.F.W.; checklist). Traveled to the High Museum, Atlanta.

The Museum of Modern Art, New York. "Charles Demuth." March 7–June 11 (catalogue, with texts by Marcel Duchamp and Andrew Carnduff Ritchie). Traveled to The Detroit Institute of Arts; University of Miami Art Gallery, Coral Gables, Florida; Winnipeg Art Gallery, Winnipeg, Manitoba, Canada; Lawrence Art Museum, Williams College, Williamstown, Massachusetts; Art Gallery, University of Delaware Memorial Library, Newark; Allen Memorial College Art Museum, Oberlin College, Oberlin, Ohio.

Breuning, Margaret. "Demuth's Fastidious Taste and Magic Craft." *The Art Digest*, 24 (March 15, 1950), p. 17.

Chanin, A.L. "Demuth Brings Feast of Delicate Sensuous Color." *The Sunday Compass*, March 12, 1950 (unidentified clipping, Whitney Museum of American Art archives).

"Charles Demuth—Early Modern American Artist Now Has His Biggest Show." *Look*, 14 (March 28, 1950), pp. 52–55.

Coates, Robert M. "The Art Galleries—Charles Demuth." *The New Yorker*, 26 (March 18, 1950), pp. 57–59.

Devree, Howard. "Demuth Art Work in Modern Museum." *The New York Times*, March 8, 1950, p. 30.

———. "Demuth Retrospective—Museum of Modern Art Event Impressive. . . ." *The New York Times*, March 12, 1950, section 2, p. 9.

Genauer, Emily. "Art and Artists—Evil or Exquisitely Stylized? Demuth's Art Raises Point of Essential Quality." *New York Herald Tribune*, March 12, 1950, section 5, p. 6.

McBride, Henry. "Demuth—Phantoms from Literature." *Art News*, 49 (March 1950), pp. 18–21.

Offin, Charles Z., ed. "Poetic Charles Demuth—A Large Retrospective at the Museum of Modern Art." *Pictures on Exhibit*, 12 (April 1950), p. 14.

"With a Teaspoon." *Time*, 55 (March 20, 1950), pp. 70–71.

Stedelijk Museum, Amsterdam. "Amerika Schildert." June 15–September 15.

The Downtown Gallery, New York. "Charles Demuth—Oils and Watercolors." July 6–28.

Burrows, Carlyle. "Art in Review—Some Shows for the Summer Season." *New York Herald Tribune*, July 9, 1950, section 5, p. 5.

"Demuth Paintings Exhibited in New York." [Lancaster] *Intelligencer Journal*, July 20, 1950, p. 20.

Devree, Howard. "Diverse Modernism . . . Demuth. . . ." *The New York Times*, July 16, 1950, section 2, p. 2.

K[rasne], B[elle]. "Fifty-Seventh Street in Review—Demuth Moves Downtown." *The Art Digest*, 24 (July 1, 1950), p. 19.

Louchheim, Aline B. "Museum Survey—Local Events." *The New York Times*, July 9, 1950, section 2, p. 6.

S[eckler], D[orothy]. "Reviews and Previews—Demuth's." *Art News*, 49 (September 1950), p. 48.

1951 Durlacher Gallery, New York. "Exhibition of Portraits by Florine Stettheimer and Watercolors by Charles Demuth." February 27–March 24.

B[reuning], M[argaret]. "Fifty-Seventh Street in Review—Charles Demuth." *The Art Digest*, 25 (March 15, 1951), p. 22.

McBride, Henry. "Nicholson, Stettheimer, Demuth." *Art News*, 50 (March 1951), p. 51.

"Varied Art Shown in Galleries Here." *The New York Times*, March 3, 1951, p. 11.

Museum fur Völkerkunde, West Berlin. "Berlin Festival Exhibition." September 5–30. Traveled to Galerie Walsuri, Vienna; Amerika Haus, Munich.

1953 All India Arts and Crafts Society, New Delhi. "Twenty American Painters." January–December. Traveled to Bombay, Madras, Hyderabad, and Calcutta.

Genauer, Emily. "Art and Artists: U.S. to Participate in Art Display in India, Countering Soviet Event." *New York Herald Tribune*, December 28, 1952, section 4, p. 5.

1954 The Downtown Gallery, New York. "Demuth—Watercolor Retrospective." April 6–May 1 (brochure, with text by Andrew Carnduff Ritchie, 1950).

"About Art and Artists." *The New York Times*, April 9, 1954, p. 16.

B[reuning], M[argaret]. "Fortnight in Review—Charles Demuth/Arthur Dove." *The Art Digest*, 28 (April 15, 1954), p. 20.

G[uest], B[arbara]. "Reviews and Previews—Charles Demuth, Arthur Dove." *Art News*, 53 (April 1954), p. 43.

Preston, Stuart. "Among Current Shows." *The New York Times*, April 11, 1954, section 2, p. 9.

Circulated by The American Federation of Arts, Washington, D.C. "Exhibition #3: American Watercolors for Asia." August 1, 1954–August 1, 1955. Traveled to New Delhi, Calcutta, Bombay, Madras.

1955 The Pennsylvania Academy of the Fine Arts, Philadelphia. "The One Hundred and Fiftieth Anniversary Exhibition." January 15–March 13 (catalogue, with texts by 25 authors). Traveled to National Library, Madrid; Palazzo Strozzi, Florence; Ferdinandeum Museum, Innsbruck, Austria; The Ghent Museum, Belgium; Royal Swedish Academy, Stockholm.

1957 Parke-Bernet Galleries, Inc., New York. "Watercolors and Paintings by Charles Demuth: Part One of the Collection Belonging to the Estate of the Late Richard W.C. Weyand, Lancaster, Pennsylvania." Public Auction Sale no. 1772. October 16 (brochure; checklist).

1958 Parke-Bernet Galleries, Inc., New York. "Watercolors and Paintings by Charles Demuth: Part Two [Final] of the Collection Belonging to the Estate of the Late Richard W.C. Weyand, Lancaster, Pennsylvania." Public Auction Sale no. 1804. February 5 (brochure; checklist).

The Downtown Gallery, New York. "Charles Demuth: 30 Paintings" May 20–June 7 (brochure, with text by Andrew Carnduff Ritchie, 1950; checklist).

Burrows, Carlyle. ". . . Demuth Art Recalled." *New York Herald Tribune*, May 25, 1958, section 6, p. 13.

M[usterberg], H[ugo]. "In the Galleries—Charles Demuth." *Arts Magazine*, 32 (May 1958), p. 62.

P[orter], F[airfield]. "Reviews and Previews—Charles Demuth." *Art News*, 57 (May 1958), pp. 13–14.

Preston, Stuart. "Then and Now—Watercolors by Davis and Demuth. . . ." *The New York Times*, May 25, 1958, section 2, p. 10.

Wagner, Charles A. "A Neglected Artist." *New York Sunday Mirror*, May 25, 1958, p. 65.

Pomona College Galleries, Claremont, California. "Stieglitz Circle: Demuth, Dove, Hartley, Marin, O'Keeffe, Weber." October 11–November 15 (catalogue, with text by Peter Selz and Frederick S. Wight).

Seldis, Henry J. "The Stieglitz Circle Show at Pomona College." *Art in America*, 46 (Winter 1958–59), pp. 62–65.

1960 Walker Art Center, Minneapolis. "The Precisionist View in American Art." November 13–December 25 (catalogue, with text by Martin L. Friedman).

Kramer, Hilton. "The American Precisionists." *Arts Magazine*, 35 (March 1961), pp. 32–37.

1961 Lancaster County Historical Society, Pennsylvania. "Paintings by Charles Demuth 1883–1935." November 6–21 (checklist).

1962 U.S. Embassy Residence, New Delhi, India. "Art in Embassies Program of the International Council of the Museum of Modern Art." 1962.

1964 The Katonah Gallery, Katonah, New York. "Charles Demuth: American Painter 1883–1935." April 12–May 19 (brochure; checklist).

1966 William Penn Memorial Museum, Harrisburg, Pennsylvania. "Charles Demuth of Lancaster." September 24–November 6 (catalogue, with text by Vincent R. Artz and Emily Genauer).

1968 The Akron Art Institute, Ohio. "Paintings by Charles Demuth 1883–1935." April 16–May 12 (brochure, with text by Andrew Carnduff Ritchie).

Los Angeles County Museum of Art. "Eight American Masters of Watercolor." April 23–June 16 (catalogue, with text by Larry Curry). Traveled to M.H. de Young Memorial Museum, San Francisco; Seattle Art Museum.

1969 Cincinnati Art Museum. "Three American Masters of Watercolor: Marin, Demuth, Pascin." February 14–March 16 (catalogue, with text by Philip R. Adams and Richard J. Boyle).

1971 The Art Galleries, University of California, Santa Barbara. "Charles Demuth: The Mechanical Encrusted on the Living." October 5–November 14 (catalogue, with text by David Gebhard and Phyllis Plous). Traveled to University Art Museum, University of California, Berkeley; The Phillips Collection, Washington, D.C.; Munson-Williams-Proctor Institute, Utica, New York.

Ames, Richard. "Demuth Exhibition Has Fascination." [Santa Barbara] *News-Press*, October 10, 1971, section C, p. 11.

"Channel City Lists Demuth Exhibit." *Los Angeles Times*, October 3, 1971, p. 60.

"Charles Demuth." *Artweek*, November, 1971.

"Charles Demuth Retrospective." *Munson-Williams-Proctor Institute Bulletin*, March 1972, p. 1.

"The Lancaster Lens." *Apollo*, 95 (February 1972), pp. 145–46.

Plous, Phyllis. "Charles Demuth Retrospective." *Artweek*, October 30, 1971, pp. 1, 20.

"Retrospective Exhibit of Demuth Due at UCSB." [Santa Barbara] *News-Press*, October 3, 1971, section C, p. 11.

Seldis, Henry. "Channel City Showcases a Pioneer U.S. Modernist." *Los Angeles Times*, October 24, 1971, p. 66.

1972 Museum of Art, Carnegie Institute, Pittsburgh. "Forerunners of American Abstraction." November 18, 1971–January 9, 1972 (catalogue, with text by Herdis Bull Teilman).

1973 Andrew Crispo Gallery, New York. "Pioneers of American Abstraction." October 17–November 17 (catalogue, with text by Andrew J. Crispo).

Campbell, Lawrence. "Pioneers of American Abstraction." *Art News*, 72 (December 1973), p. 96.

Doty, Robert. "The Articulation of American Abstraction." *Arts Magazine*, 48 (November 1973), pp. 47–49.

Mellow, James R. "Pioneers, Yes. Abstractionists? Well. . . ." *The New York Times*, November 4, 1973, section 2, p. 31.

1974 Andrew Crispo Gallery, New York. "Ten Americans." May 16–June 30 (catalogue, with text by Andrew J. Crispo).

Kramer, Hilton. "Art: Water-Color Mastery." *The New York Times*, May 25, 1974, p. 25.

1975 Washburn Gallery, New York. "Charles Demuth (1883–1935): The Early Years—Works from 1909 to 1917." February 4–March 1 (brochure, with text by Marcel Duchamp and Sherman E. Lee; checklist).

Derfner, Phyllis. "New York Letter." *Art International*, 19 (April 20, 1975), p. 59.

Kramer, Hilton. "Charles Demuth." *The New York Times*, February 8, 1975, p. 10.

Tannenbaum, Judith. "Charles Demuth." *Arts Magazine*, 49 (April 1975), p. 16.

Weissman, Julian. "New York Reviews—Charles Demuth." *Art News*, 74 (April 1975), pp. 94, 96.

National Collection of Fine Arts, Smithsonian Institution, Washington, D.C. "Pennsylvania Academy Moderns." May 5–July 6 (catalogue, with text by Richard J. Boyle). Traveled to The Pennsylvania Academy of the Fine Arts, Philadelphia.

1977 The Royal Scottish Academy, Edinburgh. "The Modern Spirit: American Painting 1908–1935." August 20–September 11 (catalogue, with text by Milton Brown). Traveled to the Hayward Gallery, London.

1978 Whitney Museum of American Art, New York. "William Carlos Williams and the American Scene, 1920–1940." December 12, 1978–February 4, 1979 (catalogue, with text by Dickran Tashjian).

1979 Städtische Kunsthalle Düsseldorf, West Germany. "2 Jahrzehnte Amerikanische Malerei 1920–1940 (American Modern Art Between the Two World Wars)." June 10–August 12 (catalogue, with text by Dore Ashton and Peter Selz). Traveled to Kunsthaus Zürich; Palais des Beaux-Arts, Brussels.

1980 Akademie der Künste, West Berlin. "America—Traum und Depression 1920/40." November 9–December 28 (catalogue, with text by 19 authors). Traveled to Kunstverein Hamburg.

Lawrence Oliver Gallery, Philadelphia. "Charles Demuth—Drawings and Watercolors." December 11, 1980–January 20, 1981 (checklist).

> Donohoe, Victoria. "Art." *The Philadelphia Inquirer*, January 1, 1982.

> Milstein, Alan. "Demuth Exhibit: Rare, Rewarding." *The* [Philadelphia] *Bulletin*, December, 1981 (unidentified clipping, Whitney Museum of American Art archives).

Musée National d'Art Moderne, Centre Georges Pompidou, Paris. "Les Realismes: 1919–1939." December 17, 1980–April 20, 1981. Traveled to Staatliche Kunsthalle, Berlin.

1981 Salander-O'Reilly Galleries, New York. "Charles Demuth: Watercolors and Drawings." April 30–May 30 (brochure; checklist).

> Fort, Ilene Susan. "Charles Demuth." *Arts Magazine*, 56 (September 1981), pp. 26–27.

> Raynor, Vivien. "Art: Chance to Compare Demuth and Gugliemi." *The New York Times*, May 22, 1981, section C, p. 20.

Tacoma Art Museum, Washington. "Charles Demuth Watercolors." November 19–December 31 (checklist).

> Tucker, Cheryl. "Art Museum Brings Demuth into Spotlight." *Tacoma News Tribune*, November 27, 1981, section D, p. 5.

1982 Barbara Mathes Gallery, New York. "Charles Demuth and His Circle." May 18–June 19 (checklist).

San Francisco Museum of Modern Art, California. "Images of America: Precisionist Painting and Modern Photography." September 9–November 7 (catalogue, with text by Karen Tsujimoto). Traveled to The Saint Louis Art Museum; The Baltimore Museum of Art; Des Moines Art Center; The Cleveland Museum of Art.

Salander-O'Reilly Galleries, New York. "Charles Demuth." September.

> "Charles Demuth." *The Christian Science Monitor*, September 28, 1982, p. 16.

> Fort, Ilene Susan. "Charles Demuth." *Arts Magazine*, 57 (December 1982), p. 37.

1983 Philadelphia Museum of Art. "Pennsylvania Modern: Charles Demuth of Lancaster." July 16–September 11 (catalogue, with text by Betsy Fahlman). Traveled to The Heritage Center of Lancaster County, Pennsylvania; Museum of Art, Carnegie Institute, Pittsburgh.

> "Demuth as a Bonus." *The Christian Science Monitor*, August 2, 1983.

> "Exhibits on Tour: 'Pennsylvania Modern: Charles Demuth of Lancaster.'" *American Artist*, 48 (August 1983), p. 16.

> Sozanski, Edward J. "Demuth of Lancaster: An Important Artist Sparkles." *The Philadelphia Inquirer*, July 19, 1983, section E, pp. 1, 10.

Museum of Art, Carnegie Institute, Pittsburgh. "The Beal Collection of Watercolors by Charles Demuth." November 23, 1983–January 22, 1984 (brochure, with text by Henry Adams; checklist).

Selected Bibliography

Compiled by Marilyn Kushner

Allara, Pamela Edwards. "Charles Demuth: Always a Seeker." *Arts Magazine*, 50 (June 1976), pp. 86–89.

———. "The Water-Color Illustrations of Charles Demuth." Ph.D. dissertation, Johns Hopkins University, Baltimore, 1970.

Born, Wolfgang. *American Landscape Painting*. New Haven: Yale University Press, 1948.

Breslin, James E. "William Carlos Williams and Charles Demuth: Cross-Fertilization in the Arts." *Journal of Modern Literature*, 6 (April 1977), pp. 248–63.

Burgard, Timothy Anglin. "Charles Demuth's 'Longhi on Broadway: Homage to Eugene O'Neill.'" *Arts Magazine*, 58 (January 1984), pp. 110–13.

Champa, Kermit. "Charles Demuth." Unpublished manuscript, 1973.

———. "'Charlie Was Like That.'" *Artforum*, 12 (March 1974), pp. 54–59.

"Charles Demuth's Watercolors." *The New York Sun*, April 2, 1927, p. 13.

Davidson, Abraham A. "Charles Demuth: Stylistic Development." *Bulletin of Rhode Island School of Design*, 54 (March 1968), pp. 9–16.

———. "Cubism and the Early American Modernist." *Art Journal*, 26 (Winter 1966–1967), pp. 122–29, 165.

———. "Demuth's Poster Portraits." *Artforum*, 17 (November 1978), pp. 54–57.

———. "The Poster Portraits of Charles Demuth." *Auction*, 3 (September 1969), pp. 28–31.

Dijkstra, Bram. *The Hieroglyphics of a New Speech: Cubism, Stieglitz, and the Early Poetry of William Carlos Williams*. Princeton: Princeton University Press, 1969.

Eiseman, Alvord L. *Charles Demuth*. New York: Watson Guptill Publications, 1982.

———. "A Study of the Development of an Artist: Charles Demuth." 2 vols. Ph.D. dissertation, New York University, 1976.

Fahlman, Betsy. "Charles Demuth's Paintings of Lancaster Architecture: New Discoveries and Observations." *Arts Magazine*, 61 (March 1987), 24–29.

Faison, S. Lane, Jr. "Fact and Art in Charles Demuth." *Magazine of Art*, 43 (April 1950), pp. 122–28.

Farnham, Emily. *Charles Demuth: Behind a Laughing Mask*. Norman, Oklahoma: University of Oklahoma Press, 1971.

———. "Charles Demuth: His Life, Psychology and Works." 3 vols. Ph.D. dissertation, Ohio State University, Columbus, 1959.

———. "Charles Demuth's Bermuda Landscapes." *Art Journal*, 25 (Winter 1965–1966), pp. 130–37.

Friedman, Martin. "The Precisionist View." *Art in America*, 48 (November 3, 1960), pp. 30–37.

Gallatin, A. E. *American Water-colourists*. New York: E.P. Dutton & Company, 1922.

———. *Charles Demuth*. New York: William Edwin Rudge, 1927.

Gallatin, A.E., Jean Helion, and James Johnson Sweeney. *Gallery of Living Art: A.E. Gallatin Collection*. New York: New York University, 1933.

Hale, Eunice Mylonas. "Charles Demuth: His Study of the Figure." Ph.D. dissertation, New York University, 1974.

Hartley, Marsden. "Farewell, Charles: An Outline in Portraiture of Charles Demuth—Painter." In Alfred Kreymborg, Lewis Mumford, and Paul Rosenfeld, eds., *The New Caravan*. New York: W.W. Norton & Co., 1936, pp. 552–62.

Henderson, Helen. "Charles Demuth." Typescript of a paper read before the Junior League of Lancaster, November 10, 1947. Richard Weyand Scrapbooks, Appendix, p. 159 (copy, Whitney Museum of American Art archives).

Kieffer, Josephine. "Charles Demuth: Lancaster Artist." Manuscript of a speech delivered on April 25, 1958. Lancaster County Historical Society, Pennsylvania.

Koskovich, Gerard. "A Gay American Modernist: Homosexuality in the Life and Art of Charles Demuth." *The Advocate*, June 25, 1985, pp. 50–52.

Kramer, Hilton. "The American Precisionists." *Arts*, 35 (March 1961), pp. 32–37.

Lane, James W. "Charles Demuth." *Parnassus*, 8 (March 1936), pp. 8–9.

Lee, Sherman E. "A Critical Survey of American Watercolor Painting." Ph.D. dissertation, Case Western Reserve University, Cleveland, 1941.

———. "The Illustrative and Landscape Watercolors of Charles Demuth." *The Art Quarterly*, 5 (Spring 1942), pp. 158–75.

Levi, Julian E. "Charles Demuth." *Living American Art Bulletin*, March 1939, pp. 1–3.

Levy, Herbert S. "Charles Demuth of Lancaster." *Journal of the Lancaster County Historical Society*, 68 (Easter 1964 [issued March 5, 1965]), p. 54.

Lewis, Emory. "'Innocents' Parallels Demuth Sketches." *Cue*, 19 (April 22, 1950), pp. 14–15.

McBride, Henry. "Charles Demuth, Artist." *Magazine of Art*, 31 (January 1938), pp. 21–23.

———. "Modern Art." *The Dial*, 70 (February 1921), pp. 234–36.

———. "An Underground Search for Higher Moralities." *The New York Sun*, November 25, 1917, section 5, p. 12.

———. "Water-colours by Charles Demuth." *Creative Art*, 5 (September 1929), pp. 634–35.

Malone, Mrs. John E. "Charles Demuth." *Papers of the Lancaster County Historical Society*, 52 (1948), pp. 1–14.

Marling, Karal Ann. "My Egypt: The Irony of the American Dream." *Winterthur Portfolio*, 15 (Spring 1980), pp. 25–39.

Marling, William. *William Carlos Williams and the Painters, 1909–1923*. Athens, Ohio: Ohio University Press, 1982.

Morris, George. "Some Personal Letters to American Artists Recently Exhibiting in New York." *Partisan Review*, 4 (March 1938), pp. 36–41.

Murrell, William. *Charles Demuth*. New York: Whitney Museum of American Art, 1931.

Norton, Thomas E., ed. *Homage to Charles Demuth: Still Life Painter of Lancaster*. Ephrata, Pennsylvania: Science Press, 1978. Introduction by Thomas E. Norton and essays by Alvord L. Eiseman, Sherman E. Lee, and Gerald S. Lestz. Valedictory by Marsden Hartley.

Norton, Thomas E. "The N'th Whoopee of Sight." *Portfolio*, 1 (August–September 1979), pp. 20–28.

Plous, Phyllis. *Charles Demuth: The Mechanical Encrusted on the Living* (exhibition catalogue). Santa Barbara: The Art Galleries, University of California, 1971.

Ritchie, Andrew Carnduff. *Charles Demuth* (exhibition catalogue). New York: The Museum of Modern Art, 1950.

Schwartz, Sanford. "Glimpsing the 'Hidden' Demuth." *Art in America*, 64 (September–October 1976), pp. 102–03.

Seligmann, Herbert J. "Letters." *The Art News*, 24 (April 17, 1926), p. 6.

Shorto, Sylvia. "Charles Demuth in Bermuda." In *Bermuda Heritage '86 Inspirations*. Bermuda, 1986, pp. 100–07.

Smith, Jacob Getlar. "The Watercolors of Charles Demuth." *American Artist*, 19 (May 1955), pp. 27–31, 73.

Swan, B.F. "In Perspective: Portrait of the Artist's Mother." *The Providence* [Rhode Island] *Journal*, March 21, 1950, p. 15.

Sweeney, John L. "The Demuth Pictures." *The Kenyon Review*, 5 (Autumn 1943), pp. 522–32.

Van Vechten, Carl. "Pastiches et Pistaches: Charles Demuth and Florine Stettheimer." *The Reviewer*, 2 (February 1922), pp. 269–70.

"Water-Color—A Weapon of Wit." *Current Opinion*, 66 (January 1919), pp. 52–53.

Watson, Forbes. "Charles Demuth." *The Arts*, 3 (January 1923), p. 78.

Weinberg, Jonathan. "'Some Unknown Thing': The Illustrations of Charles Demuth." *Arts Magazine*, 61 (December 1986), pp. 14–21.

Wellman, Rita. "Charles Demuth: Artist." *Creative Art*, 9 (December 1931), pp. 483–84.

Wolff, Theodore F. "Geometry with a Paintbrush." *The Christian Science Monitor*, January 19, 1984, p. 38.

———. "Stirring Reminders of Cézanne's Impact on Art: Demuth as Bonus." *The Christian Science Monitor*, August 2, 1983, p. 18.

**Demuth's
Published Writings**

"Aaron Eshleman." *Lancaster County Historical Society Papers*, 16 (October 1912), pp. 247–50.

The Azure Adder. In *The Glebe*, 1 (December 1913), pp. 5–31.

"Between Four and Five." *Camera Work*, no. 47 (July 1914), p. 32.

Filling a Page: A Pantomime with Words. In *Rogue*, 1 (April 1915), pp. 13–14.

"For Richard Mutt." *The Blind Man*, no. 2 (May 1917), p. 6.

"Foreword." In *Georgia O'Keeffe Paintings, 1926* (exhibition brochure). New York: The Intimate Gallery, 1927.

"A Foreword: Peggy Bacon." In *Peggy Bacon Exhibition* (exhibition brochure). New York: The Intimate Gallery, 1928.

"Foreword." In *Georgia O'Keeffe Paintings, 1928* (exhibition brochure). New York: The Intimate Gallery, 1929.

"Confessions: Replies to a Questionnaire." *The Little Review*, 12 (May 1929), pp. 30–31.

"Across a Greco Is Written." *Creative Art*, 5 (September 1929), pp. 629–35.

"Lighthouses and Fog." In Waldo Frank, Lewis Mumford, Dorothy Norman, Paul Rosenfeld, and Harold Rugg, eds., *America and Alfred Stieglitz: A Collective Portrait*. New York: The Literary Guild, 1934, p. 246.

Accompanying this catalogue is a separately published checklist of works exhibited at the Whitney Museum of American Art and the three other participating museums.